ALL OUR CHANGES

ALL OUR CHANGES

IMAGES FROM THE SIXTIES GENERATION

PHOTOGRAPHS BY **GERRY KOPELOW**

University of Manitoba Press

University of Manitoba Press
Winnipeg, Manitoba
Canada R3T 2M5
www.umanitoba.ca/uofmpress

Printed in Canada.

Book and cover design by Doowah Design Inc.

Library and Archives Canada Cataloguing in Publication

Kopelow, Gerry, 1949-
 All our changes : images from the sixties generation / photographs by Gerry Kopelow ; interview with Gerry Kopelow by Doug Smith.

Includes index.
ISBN: 978-0-88755-714-9

 1. Canada—Social life and customs—20th century—Pictorial works. 2. Nineteen sixties—Pictorial works. 3. Canada—Pictorial works. 4. Kopelow, Gerry, 1949-. I. Smith, Doug, 1954- II. Title.

TR655.K649 2009 971.064'40222 C2009-902824-7

The University of Manitoba Press gratefully acknowledges the financial support for its publication program provided by the Government of Canada through the Book Publishing Industry Development Program (BPIDP), the Canada Council for the Arts, the Manitoba Arts Council, and the Manitoba Department of Culture, Heritage, Tourism and Sport.

Publication of this book has been made possible by a Special Opportunities Grant provided by the Manitoba Arts Council.

Contents

Dedication

My indefatigable grade eight classroom teacher, Marjorie Colpitts, introduced me to photography. Between 1965 and 1970, Lorraine Monk, director, and Ron Solomon, curator, at the National Film Board Still Photography Division, took my teenage work seriously and provided a modest amount of operating cash plus lots of excellent technical and aesthetic advice. My parents Maurice and Ethel Kopelow gracefully tolerated my ever-expanding basement darkroom and paid my water bills without complaint. All these kind people are gone now, except for Lorraine Monk (http://lorrainemonk.com), who is still an active member of the photographic community.

Dreaming in Pictures: A Conversation with Gerry Kopelow

Interview by Doug Smith

SMITH: What is the genesis of most of the photographs in this book?

KOPELOW: In the summer in 1970 I had a National Film Board assignment to shoot youth culture. I got a small Canada Council grant, and I lived on that for that summer. I did some travelling—went to the Mariposa Folk Festival—and the Film Board paid for the film and processing.

SMITH: The late sixties and early seventies is an era that people celebrate as being the golden age of youth culture. Did you feel celebratory about being young?

KOPELOW: Taking these photos was hard work. I thought it was hard work. I was a depressive, I was struggling seriously with these issues. It wasn't an entertainment or a diversion. For whatever reason, I had this very earnest compulsion to understand why things were the way they were. I was looking at it through the lens of my own mental structure, and my mental structure was largely pretty negative at the time. I enjoyed making things that were beautiful or esthetically powerful, so I enjoyed making these photographs. There were brief outbreaks of joy. They didn't last very long—that's the nature of these blissful experiences, they're transient.

SMITH: What were you trying to do with these photographs?

KOPELOW: I was making aesthetically pleasing objects. That's an aspect of art I was drawn to. Not because I cared so much about the object, but the process was joyful, inherently joyful. Culturally and emotionally, I was predisposed to something that had intelligence, something that was stimulating, that had a certain vigour to it.

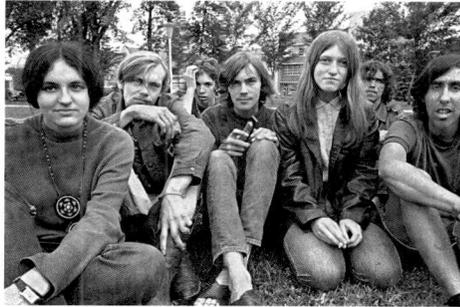

Even though I felt I was an outsider, I had friends—these photos are the proof. My cohorts were doing things that I found interesting. They were smart and they were doing creative things. I guess we shared this investigative tone, although I would say that for most of my friends the motivation was maybe more political. The whole hippie thing was an aspect of that—we were trying to order the world in a more harmonious way. It was kind of sweet, really, when you look at it, and it was—and the impulse was they wanted to really feel good more of the time. That's really what mattered, so we were all trying to feel good.

Through the course of this investigation, I gathered this evidence. I had a chance to reflect on things, because I handled these images. In the pre-digital days, you processed the film, made contact sheets, you studied the contact sheets, you selected which ones you were going to enlarge, and there was this whole process of making prints, refining the prints. So these moments in the

photos—they're very small segments of time when they were taken, but you were with them, you studied them, so you had this opportunity to investigate. And here we are, forty years later, doing it again, right? Trying to extract meaning. And what it turned out is, to sum it all up, feeling good is not the same as being good. That's what I learned. And being good is a different deal.

. . .

SMITH: So who were you shooting in these pictures? What was going on there?

KOPELOW: I guess most of them are university students or people who were out of school for a year or two. During this period I was living in a house with a bunch of other kids. It was very trusting and very open. People were moving across the continent, hitchhiking and travelling various ways. People would end up staying at our house and moving on. The guy with the sign that says "Vancouver," he showed up at our house that one summer (PHOTO 104). He claimed that he was the guy with the frizzy hair on the cover of the Woodstock album. We believed him more or less.

SMITH: Manitoba's centennial was in 1970—it was also the year after Woodstock. That year was the perfect summer to be photographing youth culture in Manitoba. There was a rock festival in Niverville, which was an attempt to have a Woodstock in Manitoba, the provincial government held Man-Pop to celebrate the province's centennial and brought in Led Zeppelin and Iron Butterfly, Janis Joplin and the Grateful Dead rolled through on the Festival

Express, and the Guess Who played a free concert at Assiniboine Park.

KOPELOW: I was at that Man-Pop thing and it got rained out. They moved it from the stadium to the arena. I actually photographed Led Zeppelin, but I can't find those images. I shot them on colour slides.

SMITH: You photographed a lot of concerts that summer. Were you a fan of those big outdoor rock festivals?

KOPELOW: Some people were excited by it, but it didn't impress me. A lot of people gathered together—it's just more density, more opportunity for a photographer. That's the way I looked at it. A political rally or a concert or even a downtown street: it was all density, density and activity. I thought it was interesting that this was happening, but they didn't move me in that way. A bunch of people gathered together made me more alert because there's more potential for trouble. It sharpens everything in an animal kind of way.

SMITH: You took lots of photographs of audience members at Niverville, the rock festival that got rained out on a farm south of Winnipeg. What would you be doing as a photographer at a place like that?

KOPELOW: Stalking. That's what I did, I stalked situations. There was this two-pronged approach, the making of the aesthetic object and the investigation of what people were engaging themselves in. To make a good photograph, the geometry had to be right, the timing had to be right, but

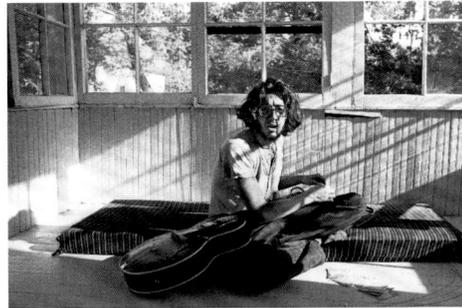

in order to have any geometry and any timing it had to be an activity. It's paramount things had to be moving, changing, so the events were places where things moved and changed, where all these people were constantly reconfiguring themselves. It was like a current that was stirring things up at the event.

So I'm looking, I'm watching this movement and reacting intuitively, but also more professionally—in the sense that I was training myself to be an acutely sharp observer—and picking off these things as they appear, things that were representative to me of what was going on. Then I'd have this aesthetic enjoyment of having created it, having found it, and then this intellectual and, later, spiritual experience of deconstructing it.

SMITH: This was a time when all the paraphernalia was available to people in Winnipeg to look a certain way. You could be part of the international youth culture. The elements of the uniform were here, there were head shops. Yet when I look at these pictures, I don't have a feel of people being in costume.

KOPELOW: My stalking involved discarding moments that seemed false to me, that seemed pretentious, and looking for unguarded circumstances. I was interested in faces in repose, not faces that were posed, but faces that were in repose, because I felt that they represented a more authentic view of the interior. They're often taken at times when people were feeling good. We were looking for things to do that were interesting and engaging and had to do

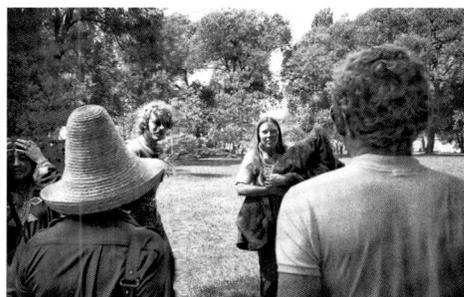

with possibly changing the way things were, which we thought were unsatisfactory. So there's an authenticity about these people in these photographs.

SMITH: Some of the pictures leap out at you as promotional photographs. What's different about doing that kind of work?

KOPELOW: Well, I didn't really think of myself as an artist. Even now, when I'm trying to apply for some grants, they keep telling me, "You've got to make more of an artistic statement," which I find very hard to do. I was always very interested in utility. I took a lot of pleasure in making things that I thought had that aesthetic buzz to them, but the practicality of photography for promoting the work of these other people, it just made immediate sense to me. There was also a countercultural colouring of money as evil, and somehow if it stayed in the community it seemed less evil. I wish I'd gotten rid of that feeling much earlier I'd be much better off today.

SMITH: Who would you be working for?

KOPELOW: Well, sometimes with the bands directly. Some of them were friends, of course. And to promote themselves in those days the bands had only a few options: they could buy space or time in a newspaper, on radio, or TV—and that was way out of the question in terms of cost. So it was mostly buying space in newspapers or posters. And, of course, if they recorded anything, there were albums, which needed photographs.

• • •

SMITH: When you were travelling in 1970 you visited Loon Island in the St. Lawrence River, land that was being reclaimed by the Akwesasne Mohawk Warrior Society (PHOTOS 81–83). What do you recall about that?

KOPELOW: We must have encountered that while we were hitchhiking. I remember that as kind of a random event. There were just the stirrings, militant stirrings among some Aboriginals. This island, they decided, used to be part of their territory. They wanted it back, so they occupied it. Somehow we ended up on this island, and there was an NFB crew. I took some photographs of what was going on there.

SMITH: Most of these pictures are of safe events, concerts, people together with one another who wanted to be together with one another or individually. But in one sequence you are seeing the police throw someone to the ground (PHOTOS 72-73). Did anything change for you as a photographer when you saw something like that?

KOPELOW: No, I was following the evolution of the situation. It just was a different configuration, different meanings. It was interesting, and I didn't rush off and sell the pictures to the *Winnipeg Free Press*. Again, it was this sort of solitary investigation that I was doing, more data for me. There's photographs from that same day of a girl I was friends with from university who was always very well put together. She's wearing a very nice little skirt and a sweater over her shoulder and she's defacing a sign on John Turner's car (PHOTOS 74-75). I was as interested in her

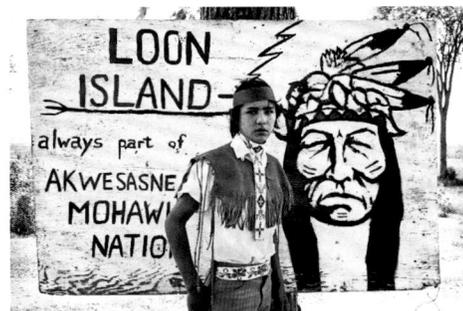

as I was in this half-naked kid who was being mashed into the cement.

SMITH: Why are there half a dozen people and a border guard crowded around a car on the middle of the prairie?

KOPELOW: There was a protest being held about the ICBM missiles that the US wanted to install in North Dakota (PHOTO 80). We tried to get across the border to protest. They wouldn't let us across. There were a bunch of little border stations crossings strung out between Manitoba and North Dakota, so we went to at least three of them. After the first one, I guess they phoned ahead since they knew we were coming and wouldn't let us in. I guess they were bemused by us.

I think they were taking pictures of us, so we said, "if you're taking pictures of us, can we take a picture of you?" So we just lined up, and the police came and joined us. They're so innocent—they stood there in a kind of a formal stance with a certain amount of dignity, and my irreverent friends are making fun of them behind their backs. We were kids.

. . .

SMITH: Tell me about the social community that you came from?

KOPELOW: My early years were in North End Winnipeg. When I was about twelve, we moved to River Heights in the South End. Everybody had a survivor mentality. My parents were first-generation immigrants. They were

small children when they came from Europe at the turn of the century. Their families were escaping the pogroms in Russia. The relatives that stayed in Europe were all killed later in the war. The gestalt was "get an education, become a professional." Material security was the big deal. So everything was observed through that filter.

My father was in life insurance. All that effort, after all that suffering, the war, and the Depression, was part of a huge noble effort to carve a place of safety. My parents' generation was largely unhappy. They just assumed the kids would appreciate it, but there is no happiness in external arrangements. This is the fundamental truth of human existence—there is no place of security—there is no way to do it.

SMITH: What was your teenage life like in this world?

KOPELOW: The whole thing is a dream. I just did not relate to school. All through high school I watched every late movie on the CBC. I'd wired up a set of headphones to the console TV and I used to come downstairs after my parents had gone to sleep and watch the movie. Then I would sleep all morning in school and in the afternoon read books that I brought to read.

I shot for the high school yearbook. That's where I found my technical skills. I can remember many, many twenty-below winter mornings, at four or five o'clock in the morning crunching my way to Grant Park, walking eight or ten blocks to school through the snow. The janitors always left one door open, and I knew what door that was. I used to sneak into the school early. I didn't want to turn any lights on—for some reason I felt this had to be done in secret. I remember crawling across the auditorium stage to get to the dark room, which was up a stairway at the side of the stage in the auditorium. I would print for a few hours and then, like I said, I would sleep in class and read in the afternoon.

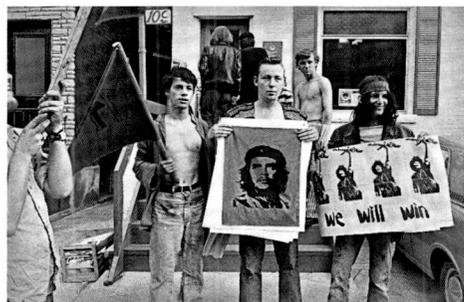

SMITH: So you didn't follow the anticipated pattern.

KOPELOW: I was supposed to be some kind of a professional, and the photography was tolerated. But I never finished university. I did one year of honours physics, but I never wrote the exams. I just didn't like it. The next year, I went into honours English, which I enjoyed, but didn't finish, and that was the end of my university career. Photography was really my only saleable skill, so that was how I supported myself when I was done with school.

. . .

SMITH: Tell me a bit about the person who was taking these pictures, and how you got to be a street photographer.

KOPELOW: I started when I was in grade eight, when I was thirteen or fourteen years old. It started with a teacher, Marjorie Colpitts. I was an unhappy kid, a depressed kid. I was depressed for years and years, and she decided that she was going to cheer me up. She tried different educational projects, different kits she brought in to get me interested in something, and nothing really worked.

Then, just as a kind of an off-hand gesture towards the end a year of trying, she just handed me her 35-mm camera, a little Yashica Lynx—I remember the camera very well—and said, "Here, try this. Maybe you'll like this." I put a roll of film in it and the very first roll of film that I took had strong images on it. I had an instant connection with technology and with the medium and it just took off like crazy from there. By the time I was in grade ten I was shooting stuff for the National Film Board. Looking back at these photographs, I have to say I was really, really good at this just a few years later. I had tremendous concentration. And it was one of the few things that was enjoyable or joyful for me, so I plunged in.

SMITH: Were you an archetypal outsider?

KOPELOW: I was fat, I was shy, I was ultra-sensitive, I was smart, I was hypersensitive to the social milieu that I felt I couldn't penetrate. So photography was a kind of a role—I became a professional outsider, professional observer.

SMITH: And what did you use photography to investigate?

KOPELOW: The fact that I was so unhappy for so long raised a question early on. When I was a little kid I wanted to know "Why am I unhappy? Why are the people around me unhappy?" I was looking to see what people were doing in order to deal with that. I thought it was a fundamental theme for all beings, trying to be happy. It turned out I was perfectly right, that's the main motivation of all beings. I was looking at what people were doing, and photography

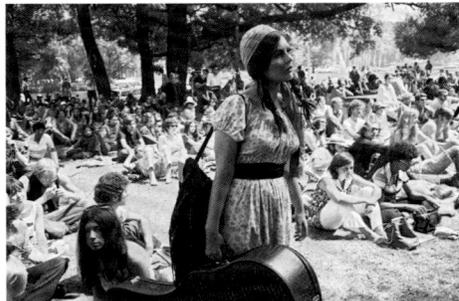

was a passport to this tentative, temporary kind of intimacy.

SMITH: To look at people and see what they were doing to make themselves happy?

KOPELOW: To see what people liked or didn't like. I was investigating the human condition, what we were up to, all of us.

SMITH: Even when you were fifteen or sixteen years old, were you a budding commercial photographer at the same time?

KOPELOW: Well, I had to pay for this somehow. Film and processing, printing, and equipment was expensive, so I had to make some money. Before that, I'd been a science whiz. I'd repair radios, TVs, and other small appliances. Once I got into photography, I started to figure out ways to make a little money from that. I did family pictures for relatives, a little later I did Bar Mitzvah pictures.

I had no sense of the art world, or the world of professional culture. I didn't know anything about that, but I saw a little ad in *Canadian Photography* magazine, which said that the National Film Board of Canada Still Photography Division was looking for original Canadian photographs. I thought, "Hey, that's what I do." I printed up a portfolio and I mailed it off and got an answer back right away. They liked these photographs and they started to buy them from me. I developed a relationship with an

editor there by the name of Ron Solomon, and also with Lorraine Monk, who was head of the Still Photography Division. For my high school years, I used to take the train down to Ottawa in the spring break and at Christmas time with a portfolio under my arm. Ron Solomon would meet me at the train station or I'd take a cab down there and they'd take me out to lunch. They treated me very seriously. Looking back, they were so kind to me. I didn't know anything about what people ought to do in these circumstances. I tried to behave grown up, and Ron gave me some critique on my images. I was pretty lucky. 've had a succession of mentors, people who liked me and were interested in what I was doing and gave me kind and good advice.

The NFB would buy images for twenty-five or fifty dollars a pop. That's the way I would make money to finance this addiction.

That went on for a few years. I actually had photographs in a few NFB exhibitions and a book they published. I was certainly the youngest photographer they were dealing with.

SMITH: What did they want you to shoot?

KOPELOW: I did an assignment on high school life. Once I went on a student exchange to Fredericton. I took photographs of the whole thing and they loved it. Lorraine Monk was this radical person who had taken over the Still Photography Division and turned it from a propaganda arm of the government to a fine arts institution. It lasted for quite a while and then the government kind of shut

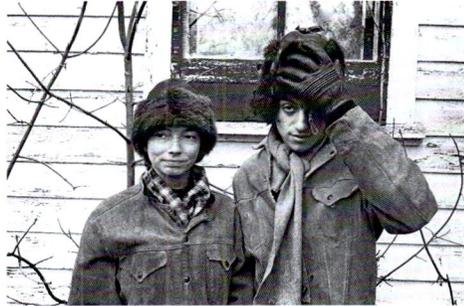

it down. I got there in the peak and so it was great to have that kind of support, because nobody around me in Winnipeg knew or cared what I was doing, but here these people did.

• • •

SMITH: Why did you stop doing this work?

KOPELOW: The end came from a realization I had while I was actually taking a photograph. It was of my friends Stephen and Leah (PHOTO 13). I took it in the backyard of our house on Stradbrook Avenue. They were two young Americans who had come up from Boston on a visit.

In order to refine my photographic abilities, I was learning how to be more and more aware of very small slivers of time, fractions of a second. With this kind of photography you're looking for things, things are changing and you're looking for configurations. I started training myself to be very, very steady and still and I really got it worked to a point of very, very fine concentration.

I was training myself to be able to put my concentration on what I'm interested in and hold it there, and wait and watch things move. There is a transition point that has to do with the way consciousness works. In meditation it's called absorption, where the mind actually is totally absorbed in the object and that moment. That absorption is intensely blissful. Consciousness likes to know what's going on, and that absorption is a very pure way of

knowing. You get these moments of joy—temporary moments of joy. We think this bliss is tied up in the making of an aesthetically pleasing object. But it turns out it's the joy we're interested in and the artistic process is actually incidental—it's the concentration on the object, the mental connection with it, that is a bridge to bliss.

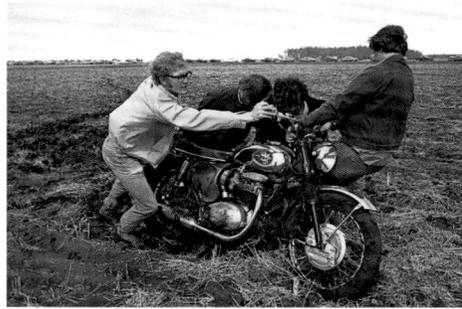

At the moment when I took that photograph, I thought, "I don't need a camera for this." There was a change in consciousness brought about by mental discipline, by development of the mind and being able to focus.

This whole episode brought me right to the door of meditation. I had this spontaneous realization that it wasn't the photography, it wasn't the technology, it wasn't the art, it was a mental state. I didn't require anything else to do this. And then the need to do it stopped.

I supported my family with photography and enjoyed it, but it wasn't the same after. It wasn't necessary. Now it was a skill that I could deploy, again as a discipline—making a living and all that, but I didn't have to do it. Up to this point I had to do it because it was my only opening.

• • •

SMITH: What is your response to these pictures forty years after the fact?

KOPELOW: I'm looking back and formulating a view of who took these photographs, and that person is long gone. That person had qualities that I liked, although I was unhappy. I was glad I had that earnestness, that energy, that persistence, that I was interested in wholesome things and not the unwholesome things. It set me on a good track. That comes from parents to a degree, from good luck, from certain kinds of friends who had energy and had interest in certain things and a fundamentally wholesome life. In that period there was a support of the wholesome that allowed the investigation to go on without too much corruption. Some of us didn't survive it, some of us went crazy. One of my friends committed suicide. Some folks came close, but then fell back into conventionality, ended up living out their conditioning. And a few people were able to use that possibility of wholesomeness to actually make some progress. It's heartening to look back and see that.

SMITH: Why publish these photographs now?

KOPELOW: These photographs stayed on the shelf for forty years. I looked at them once in a while and thought I should do something with them. I became a commercial photographer because it was practical and straightforward—money for services. But now I teach meditation. One of my meditation students is involved with the art gallery at the University of Winnipeg. He was looking at some photographs I'd taken of India and said, "You should submit these to the gallery." As I was putting together the pictures from India, which are pictures of shrines, I said, "What the heck, I'm going to make a proposal for this collection." I figured they'll take one of

them, or they won't take either. They accepted them both. And because I am a long-time admirer of John Paskievich and his work, I ended up doing all the scans for his book of photographs that the University of Manitoba Press published. I spoke with David Carr at the press about these pictures and asked if they would be interested in publishing them. So here we are. Something is actually going to be done with these photographs. I was hoping this would be helpful to people.

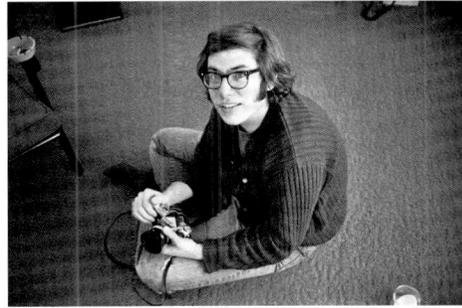

Gerry Kopelow, c. 1969

SMITH: How?

KOPELOW: We have a very tenuous relationship with history. Here was this particular bubble when a lot of people did change. Nowadays it's thought of by people who didn't experience it as quaint, cute, and silly, which it was. But there were aspects of this era which were, I hesitate to use the word, noble, but were much more authentic, much more profound, and worth looking at. It turns out that's what I was collecting during that period. I know it's a narrow slice of what went on, but we can only be in one place at a time.

SMITH: So this is a response to people who would denigrate the late sixties and early seventies as an era of youthful self-indulgence?

KOPELOW: There were times and places where it was more than that.

ALL OUR CHANGES

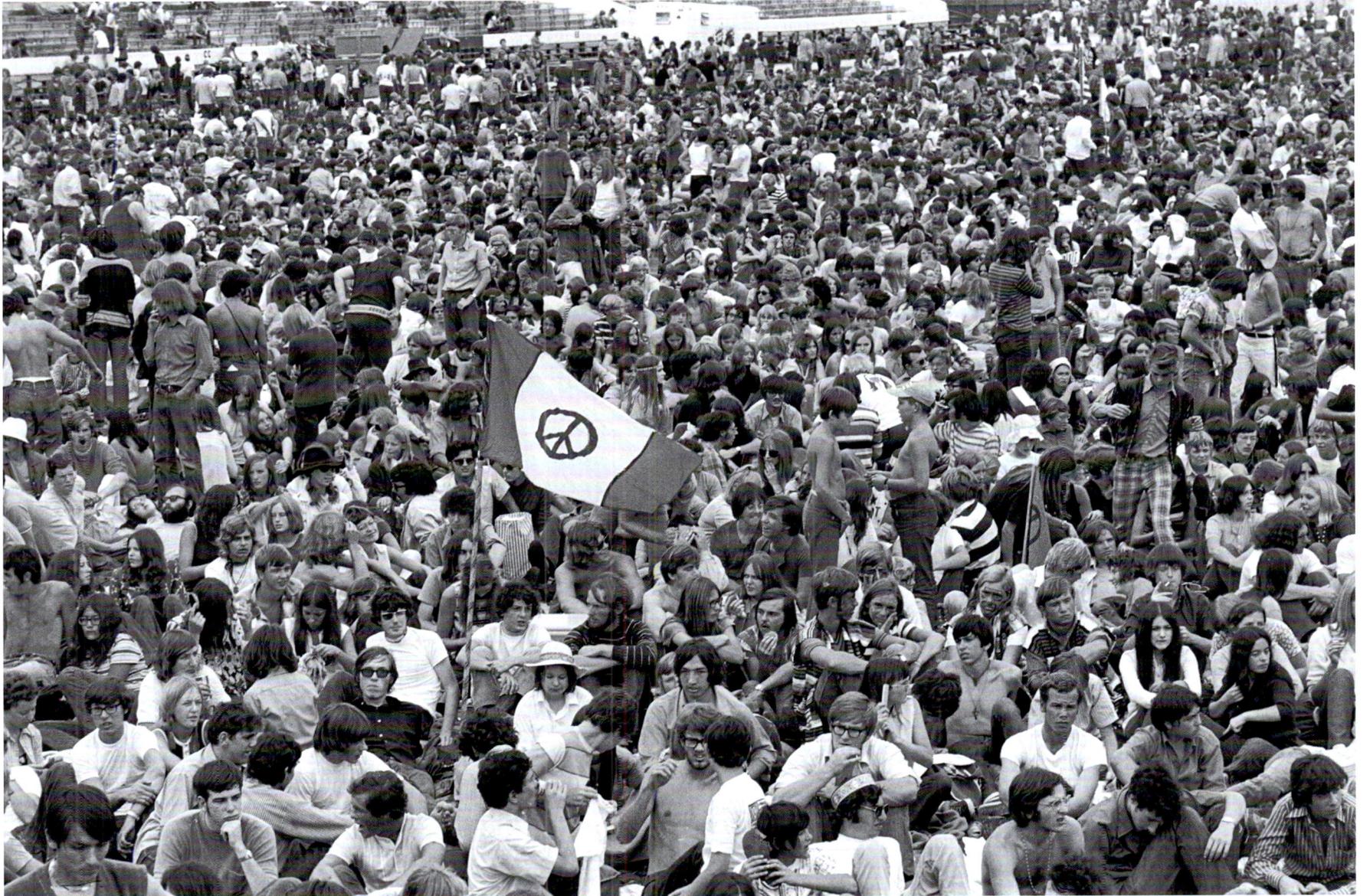

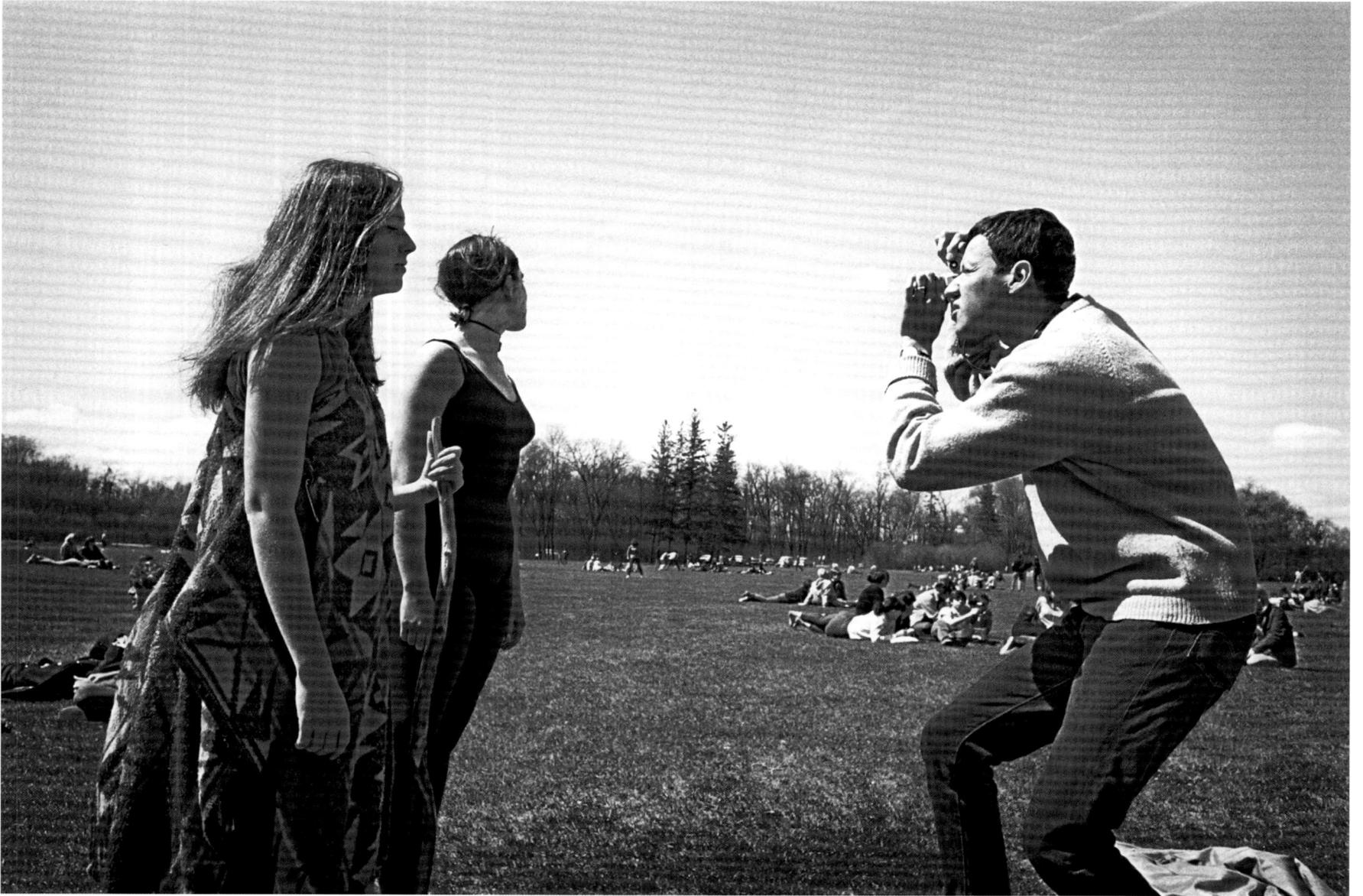

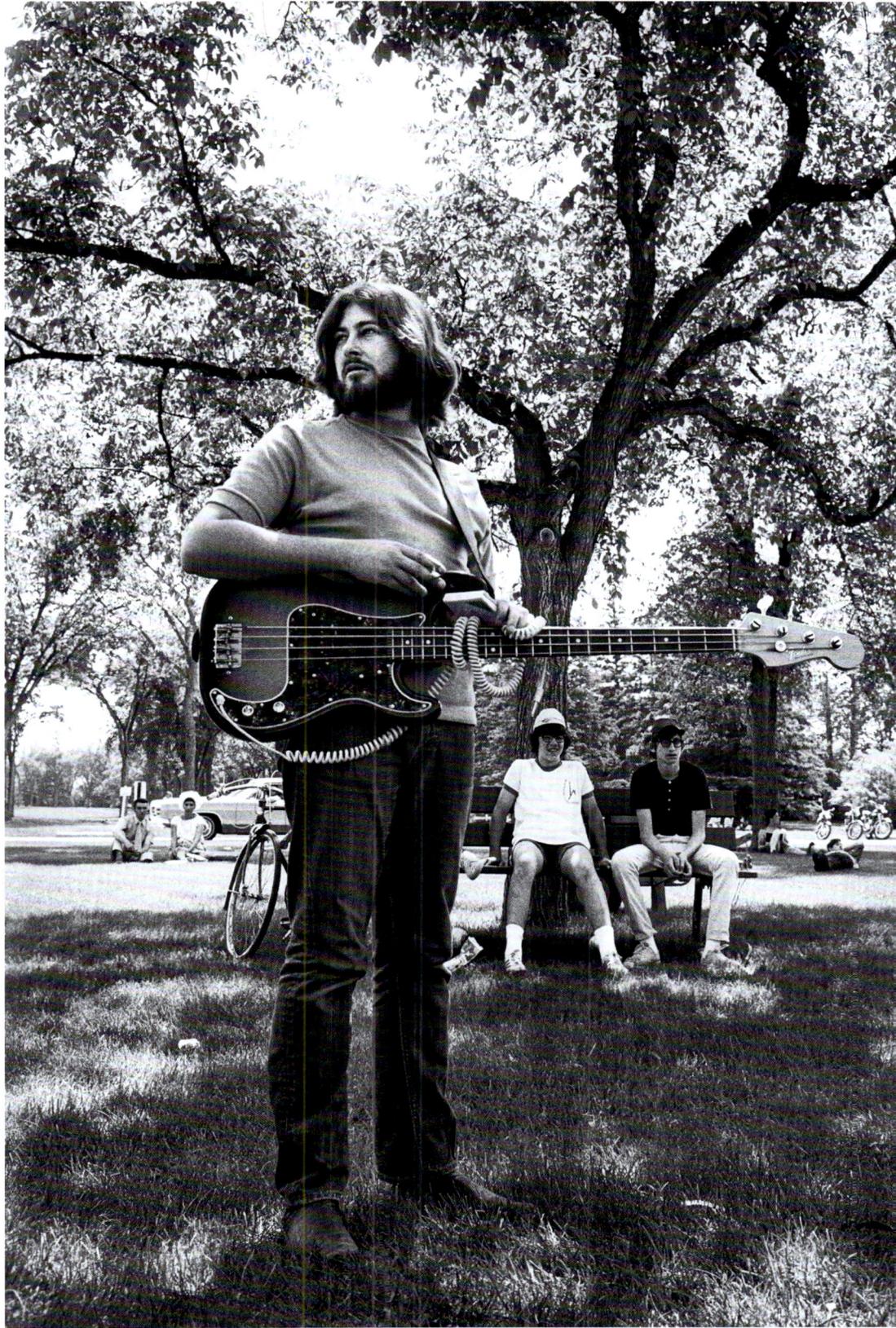

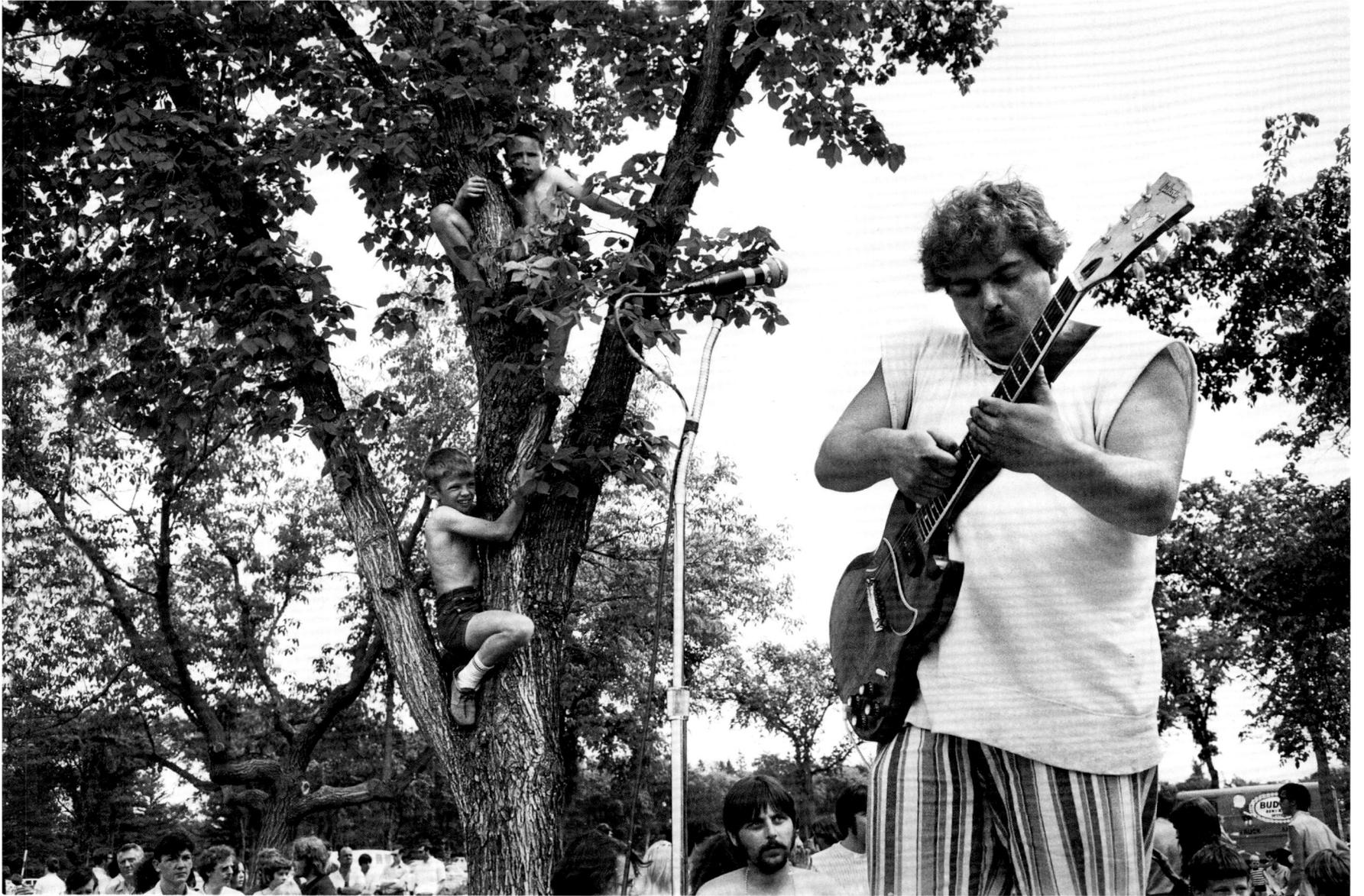

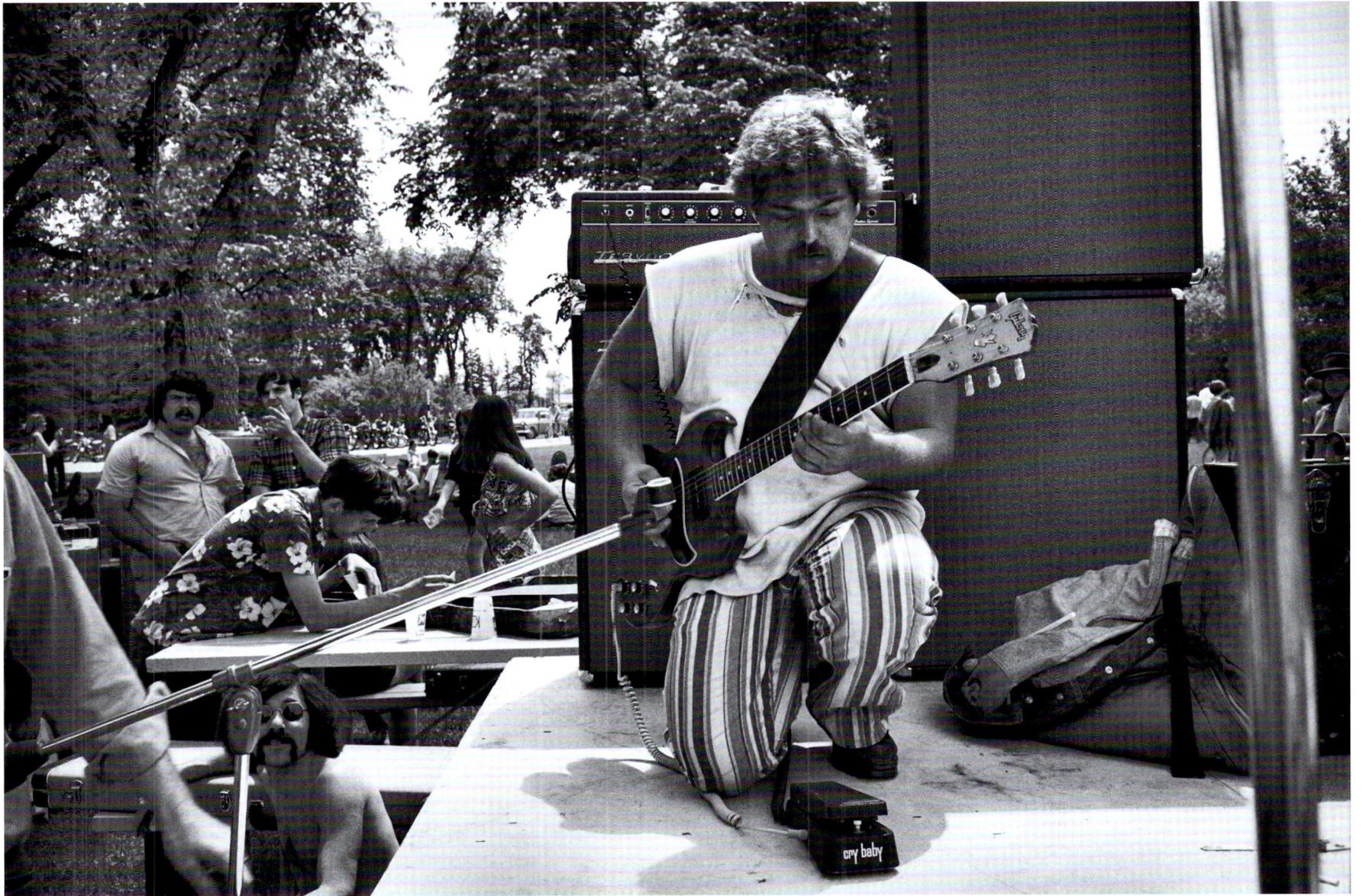

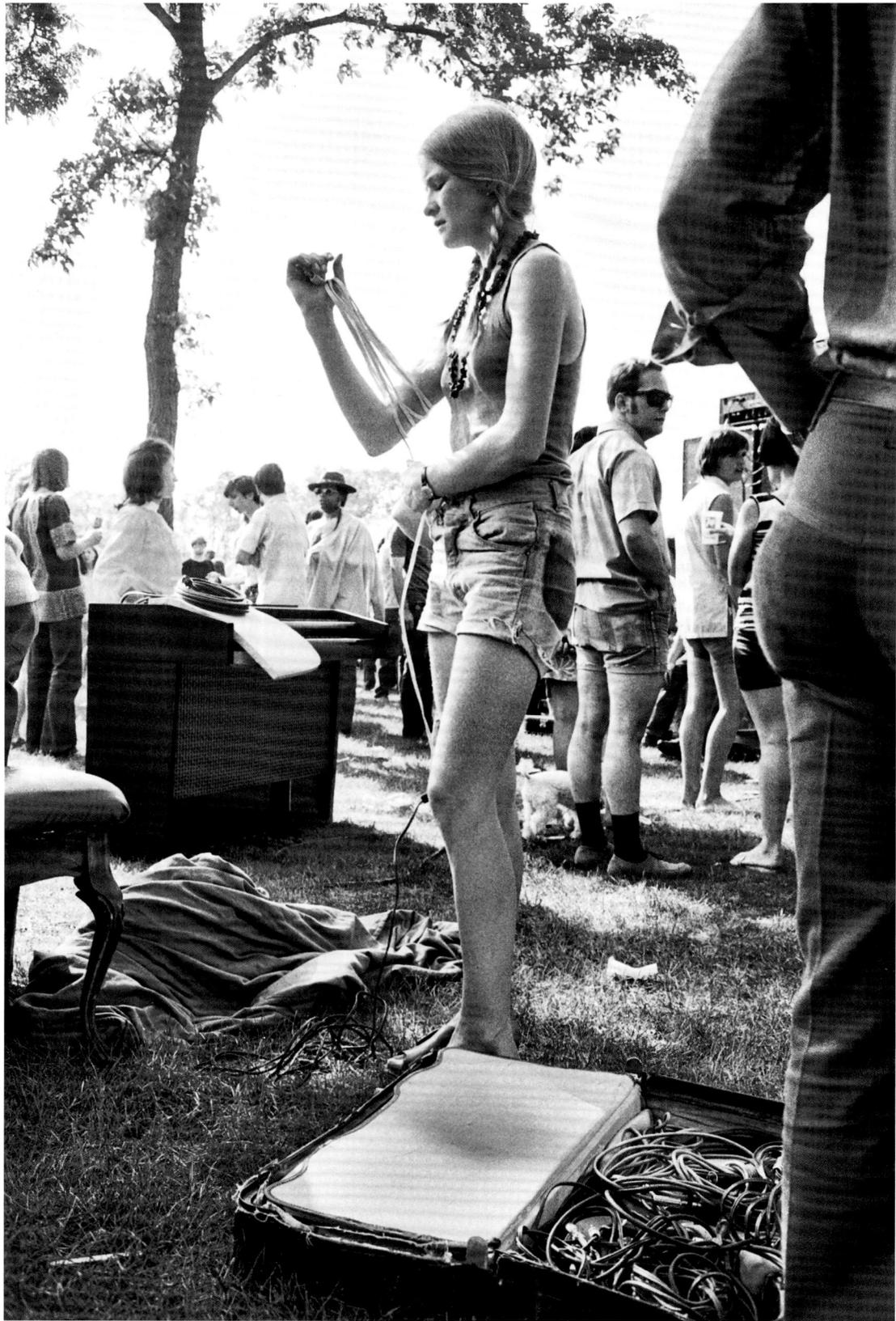

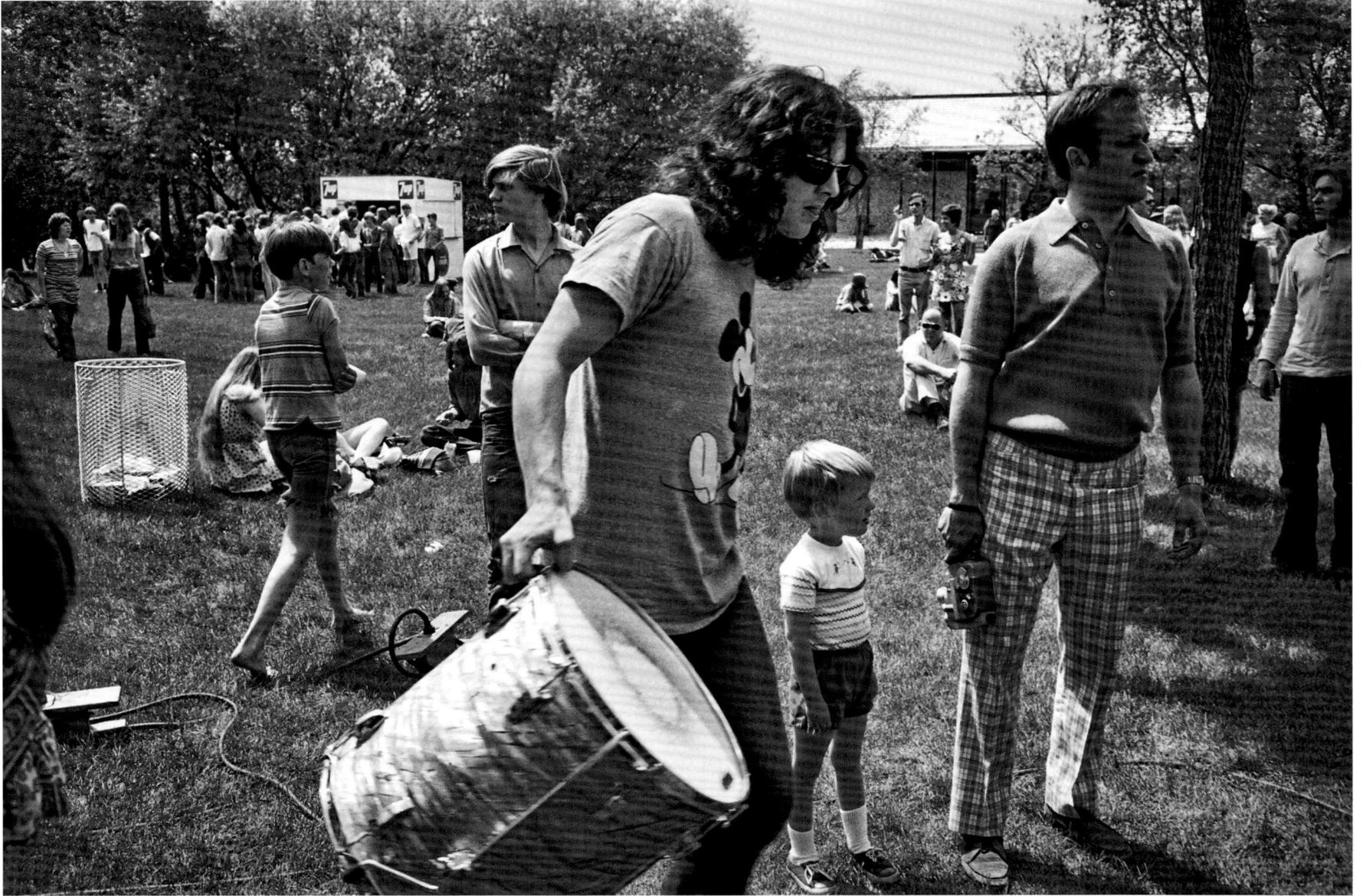

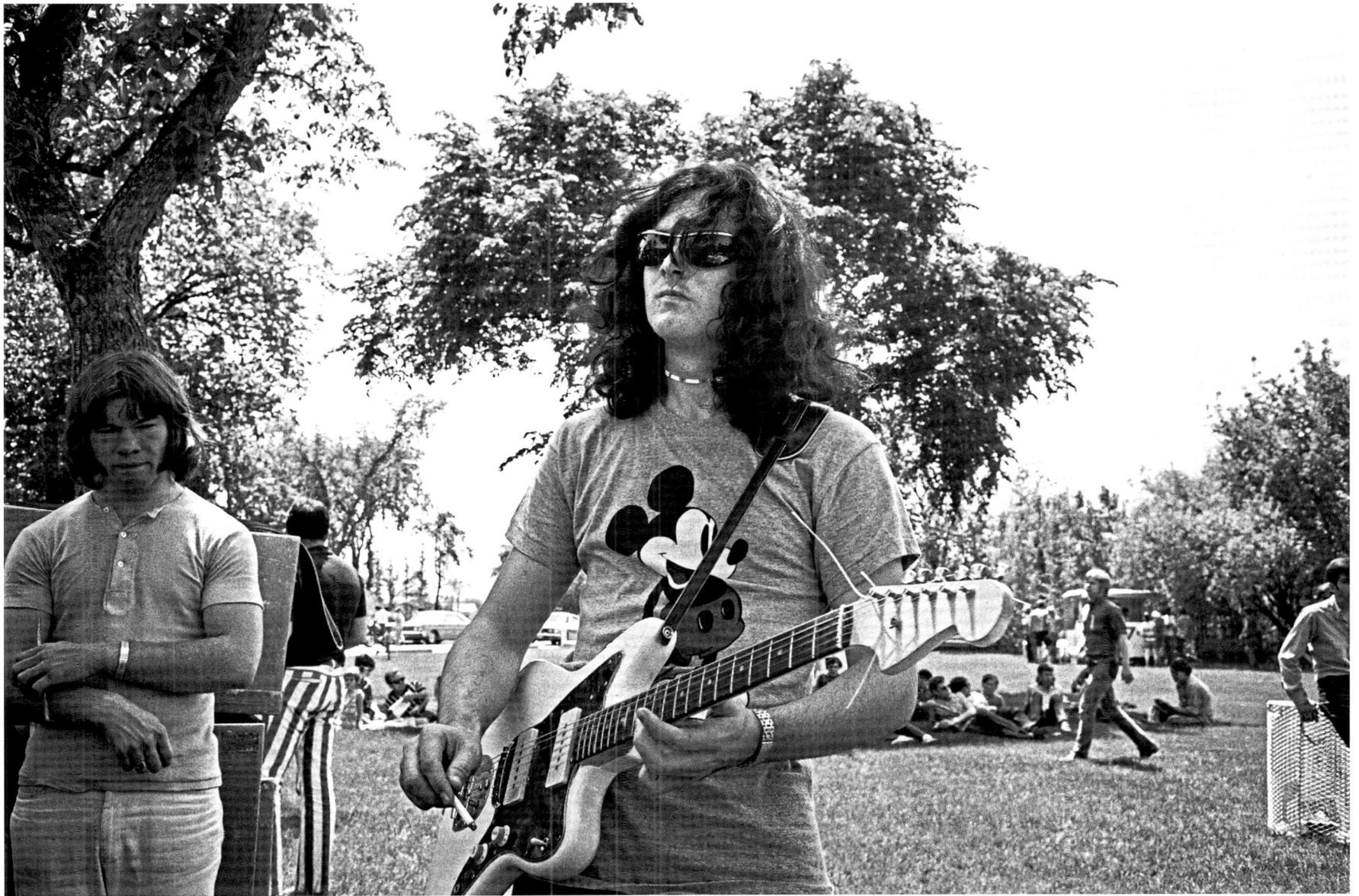

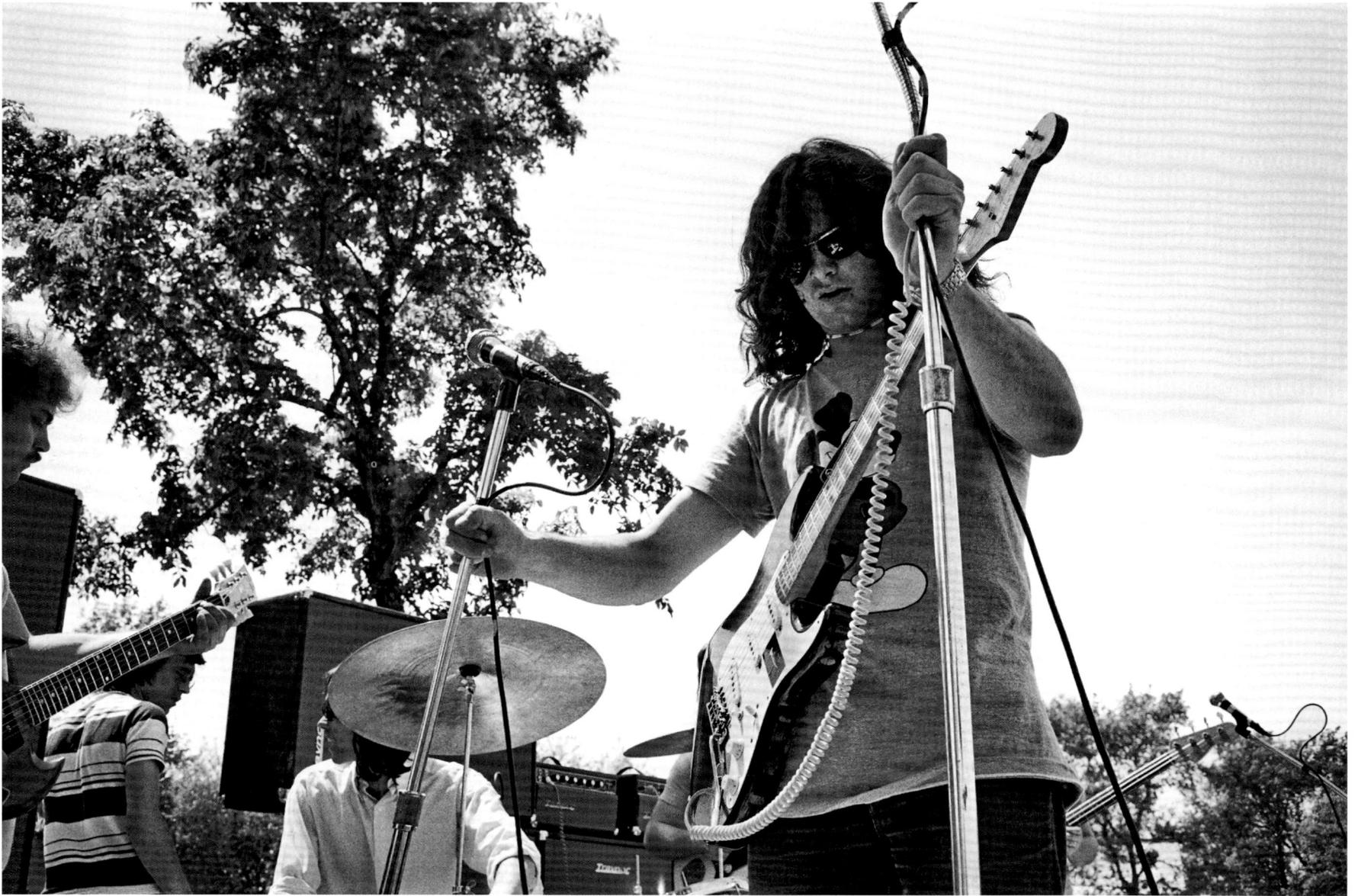

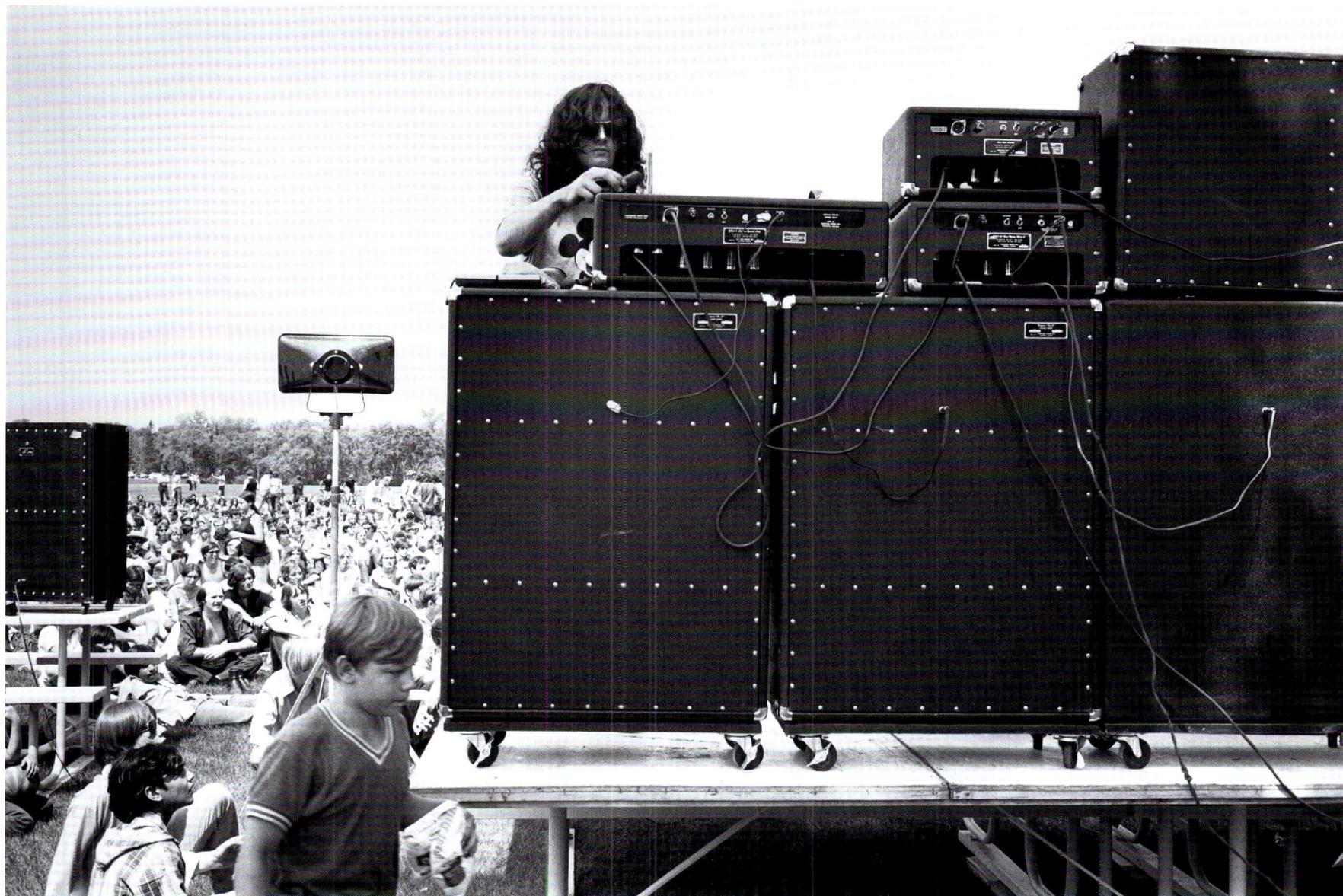

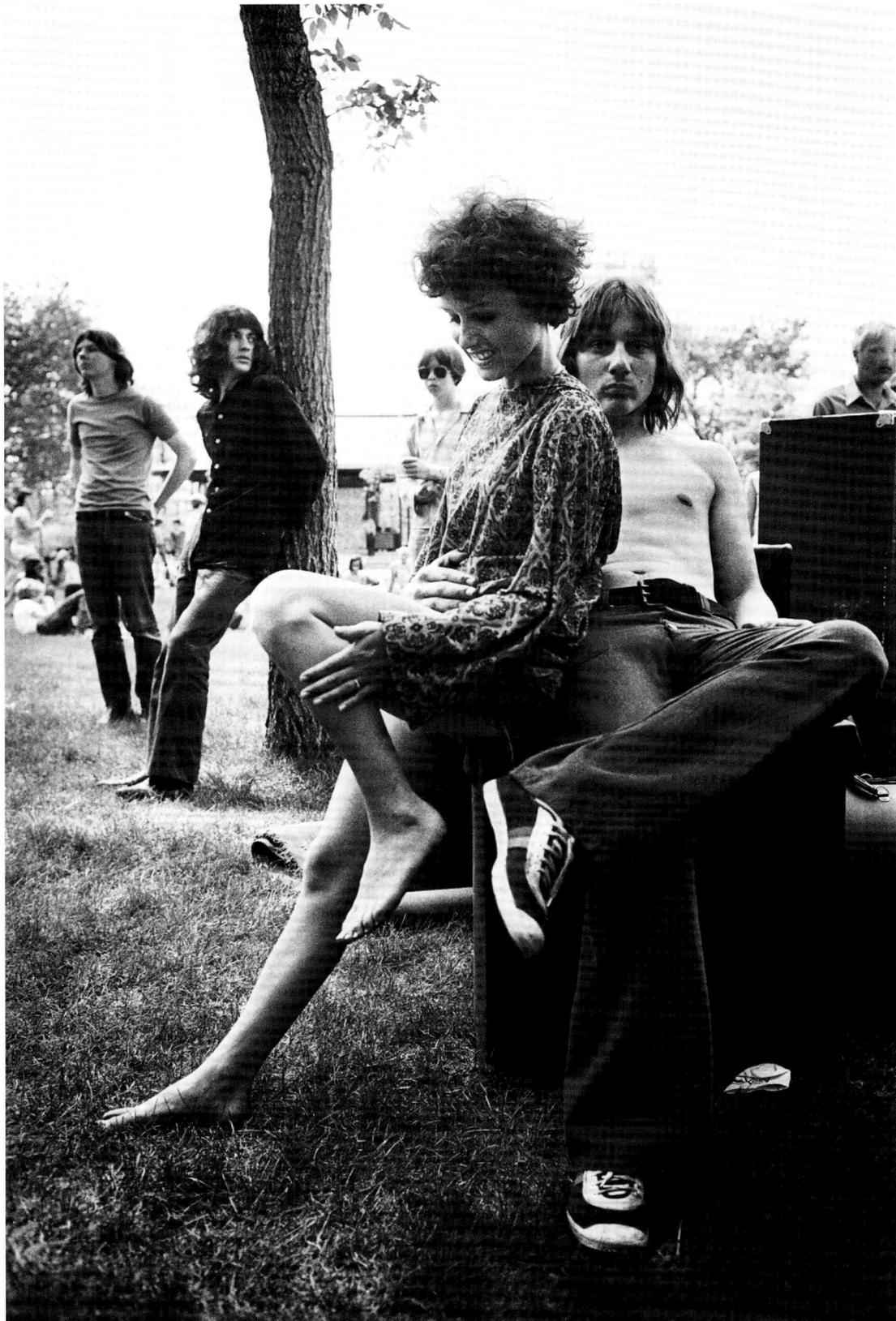

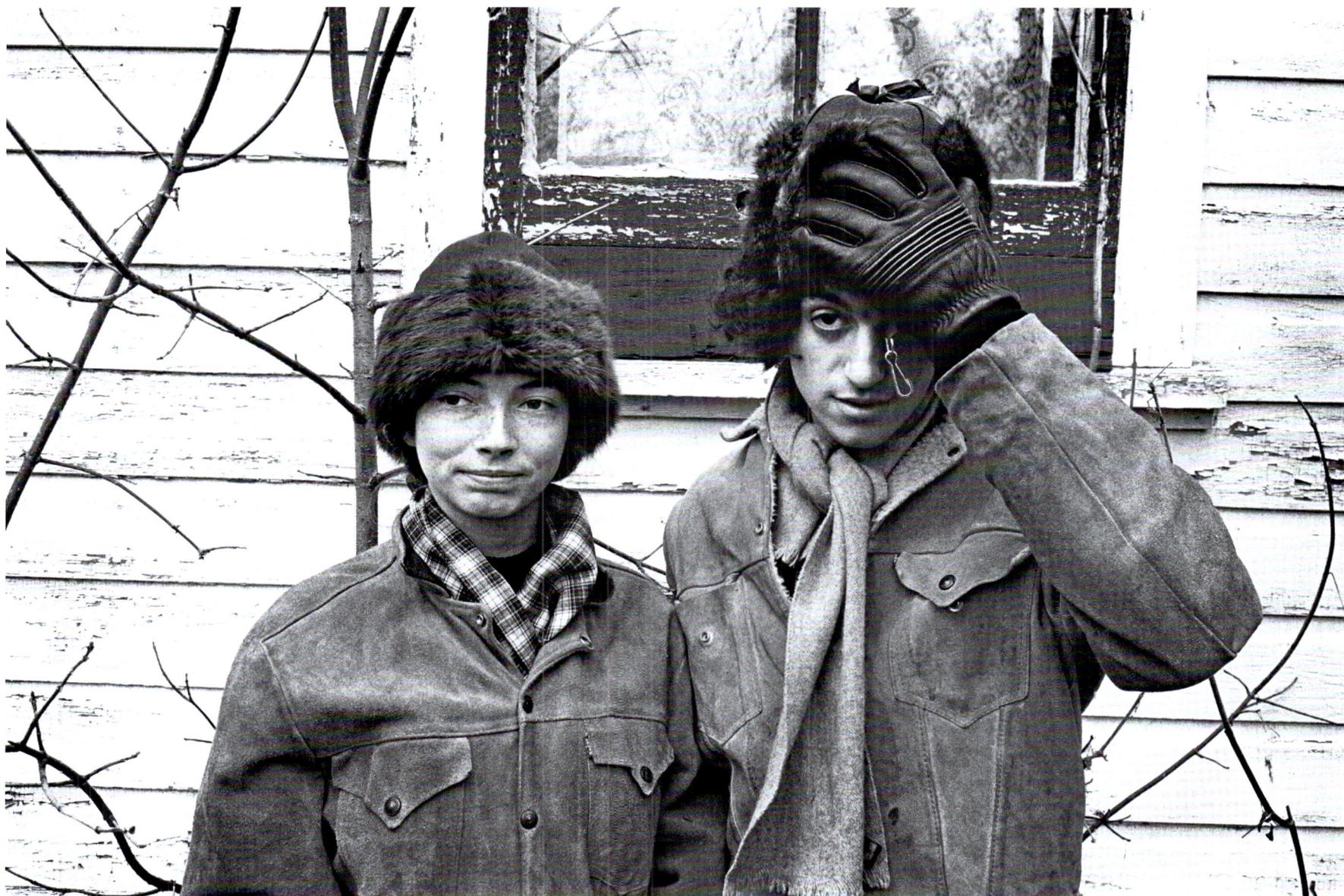

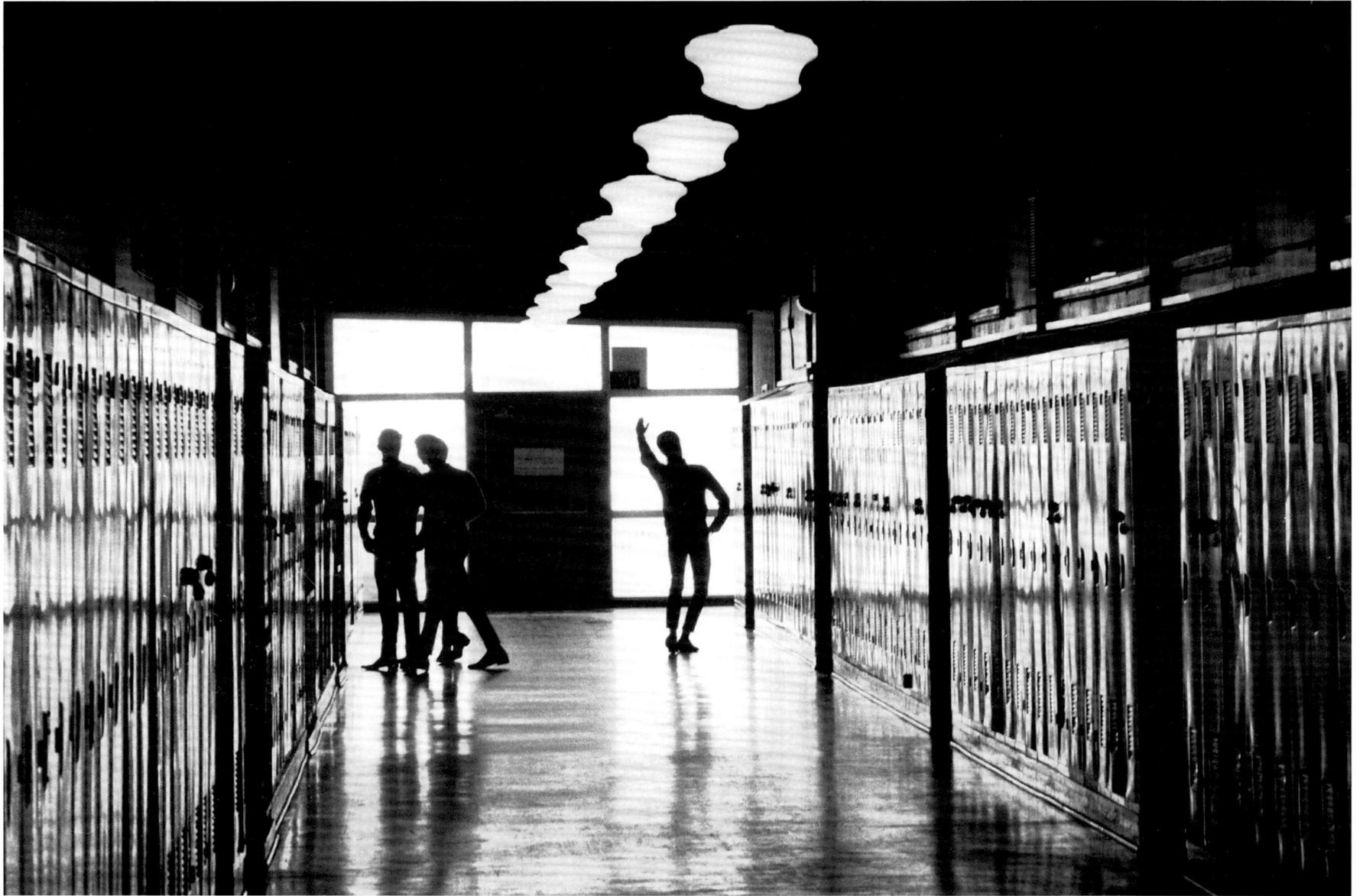

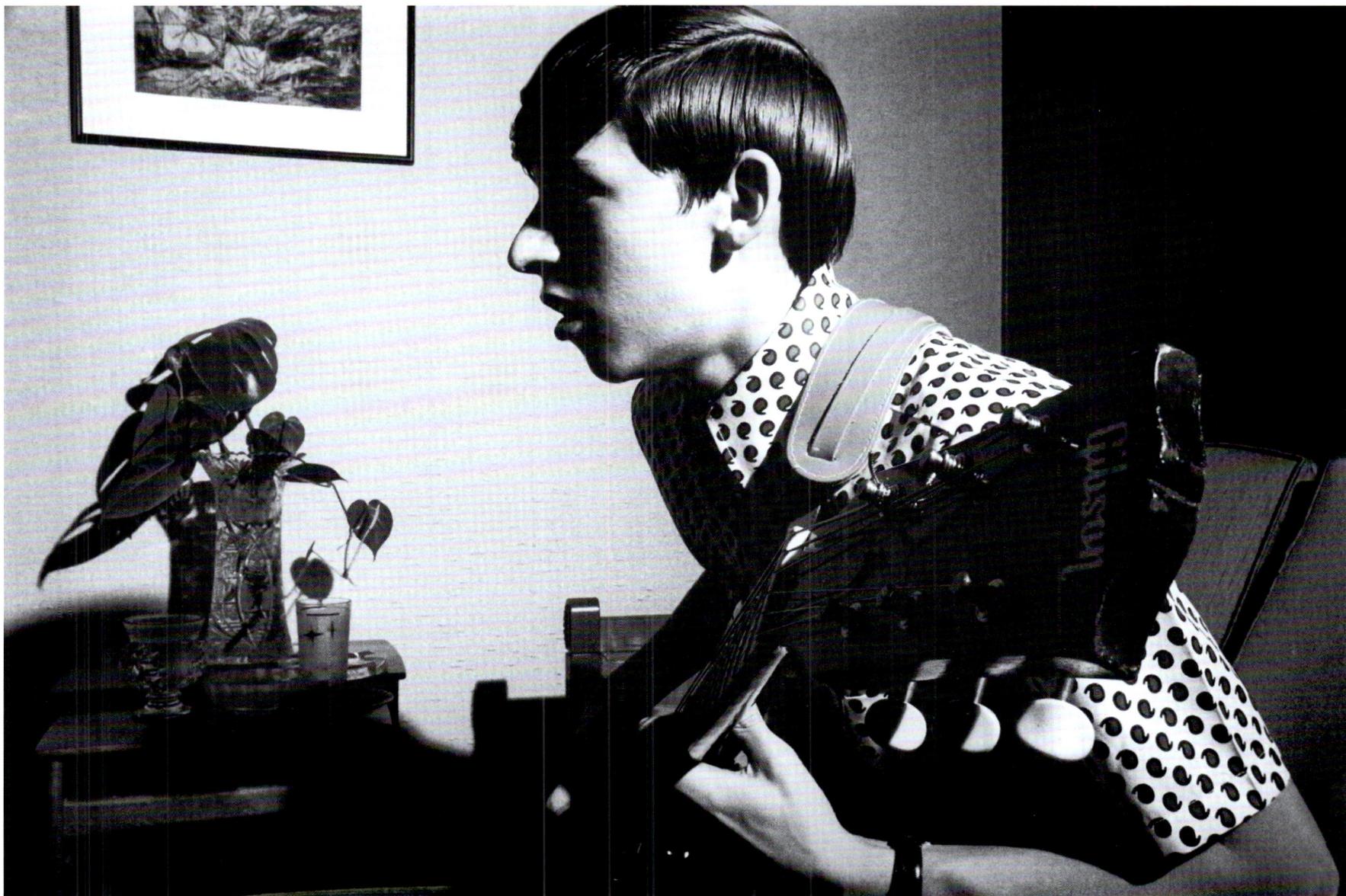

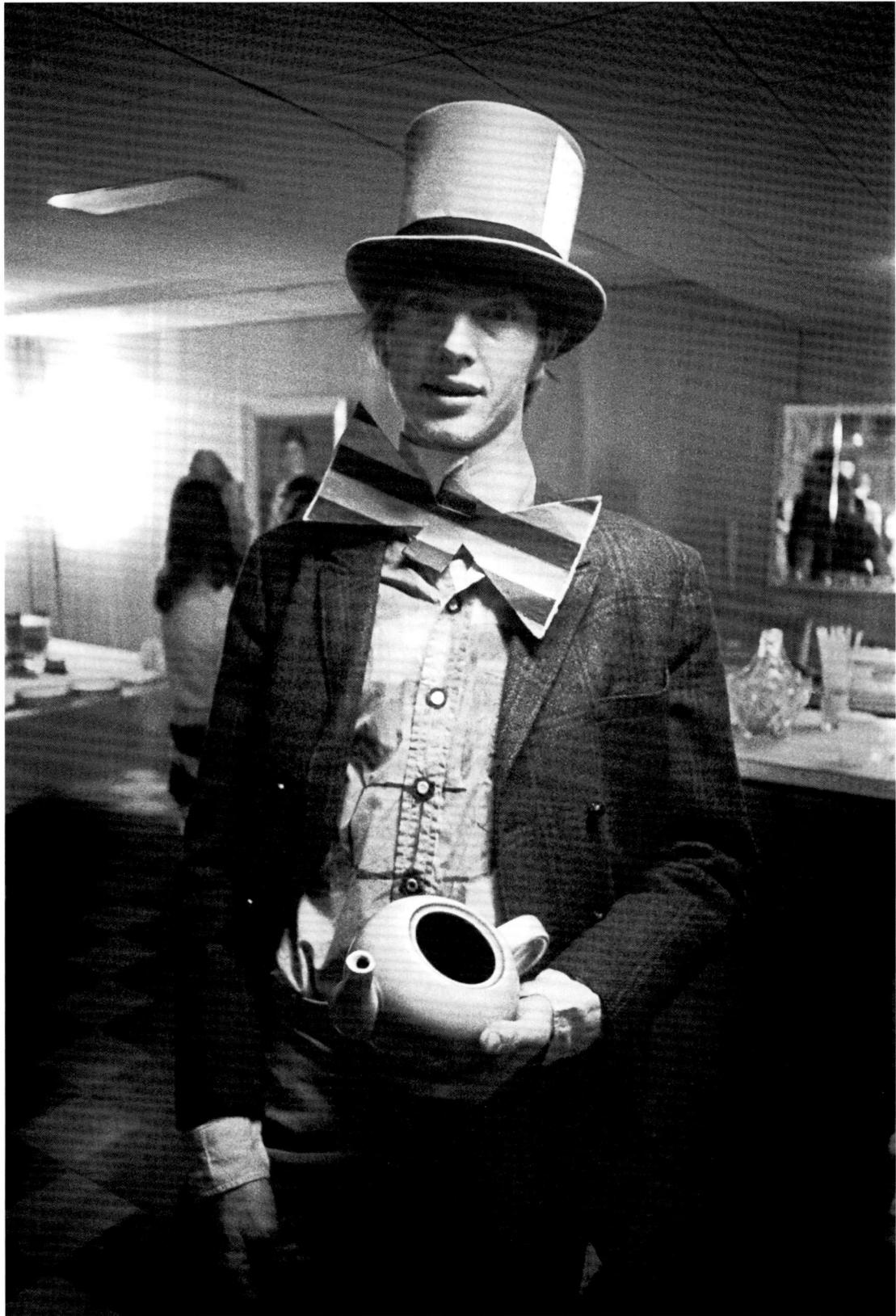

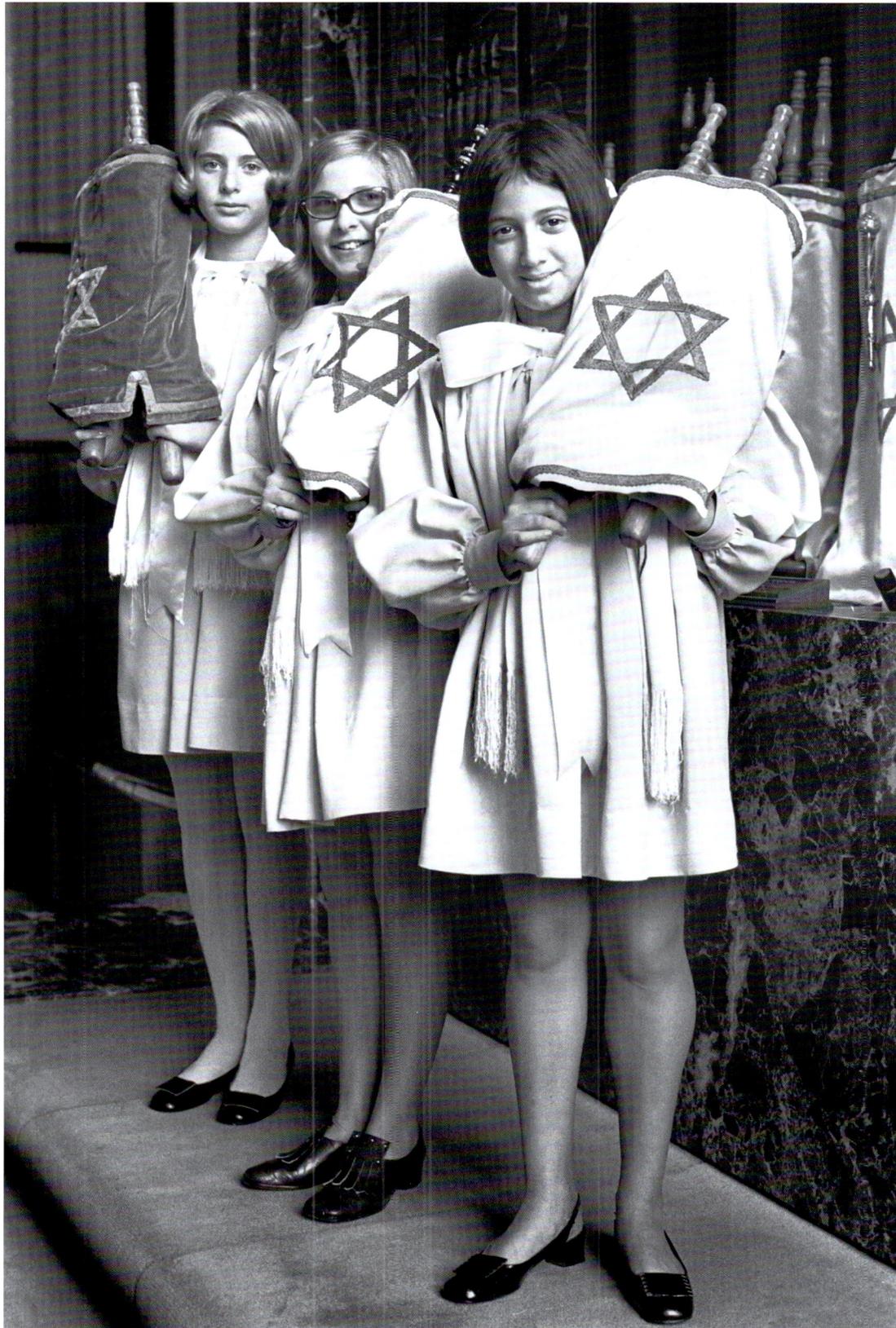

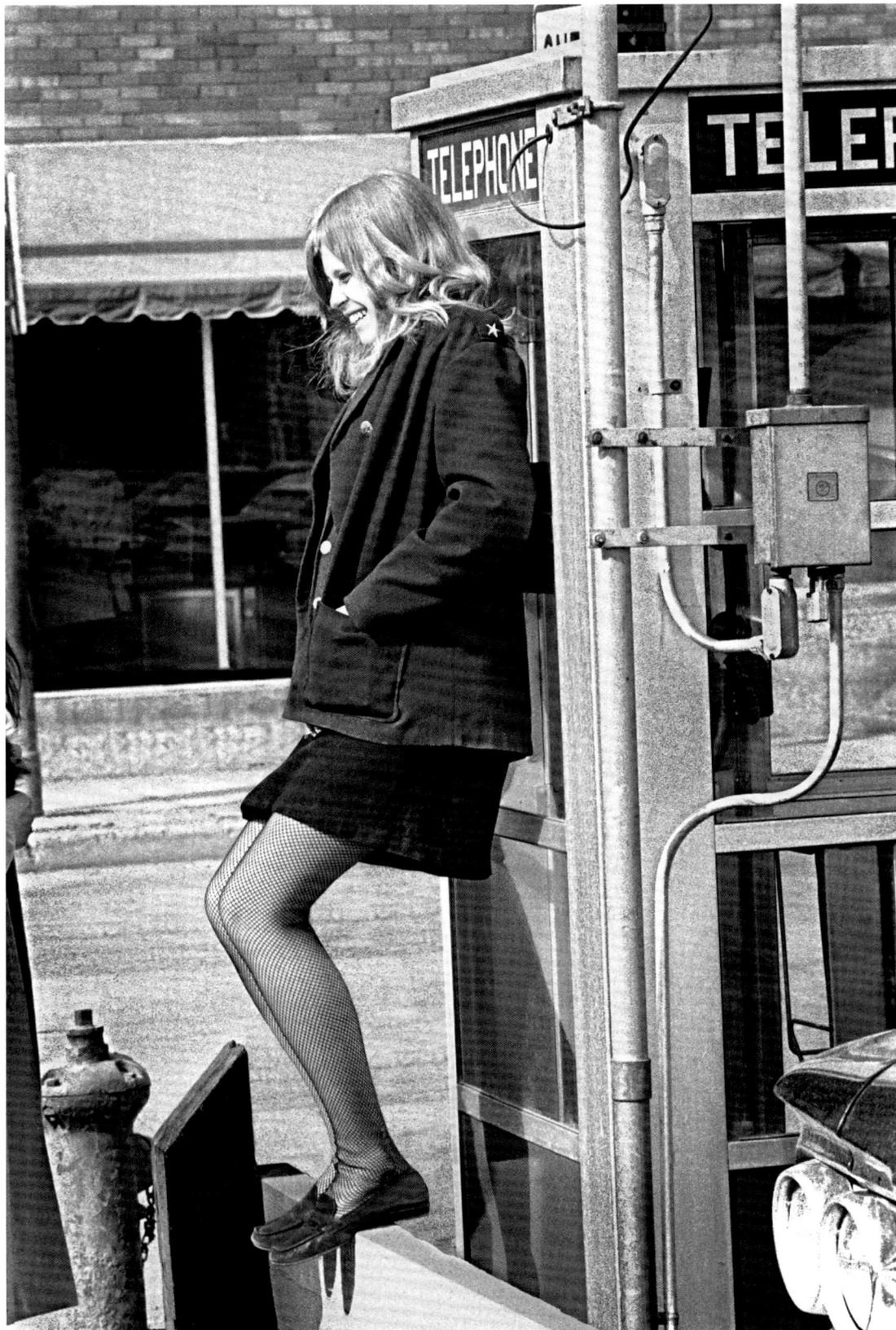

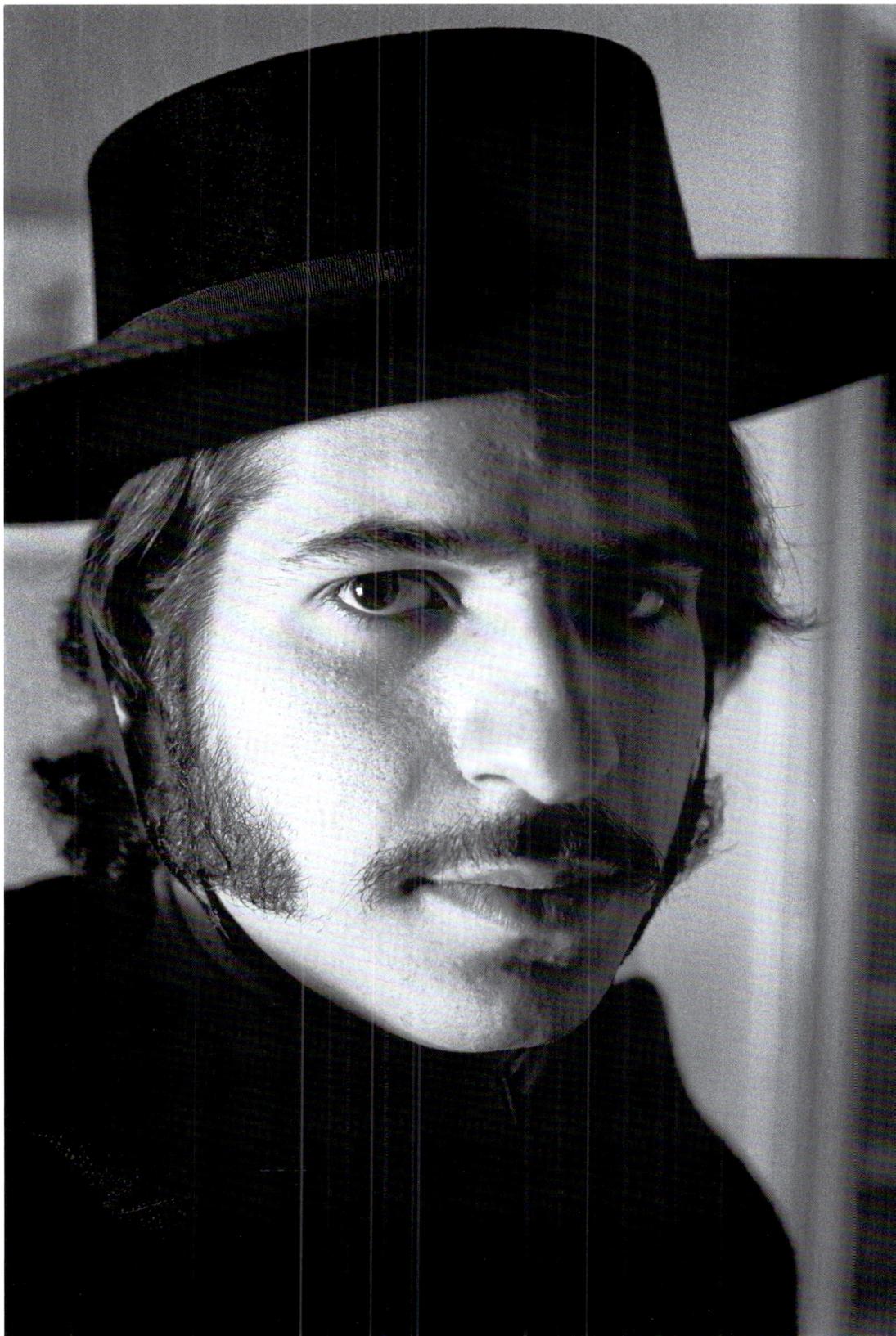

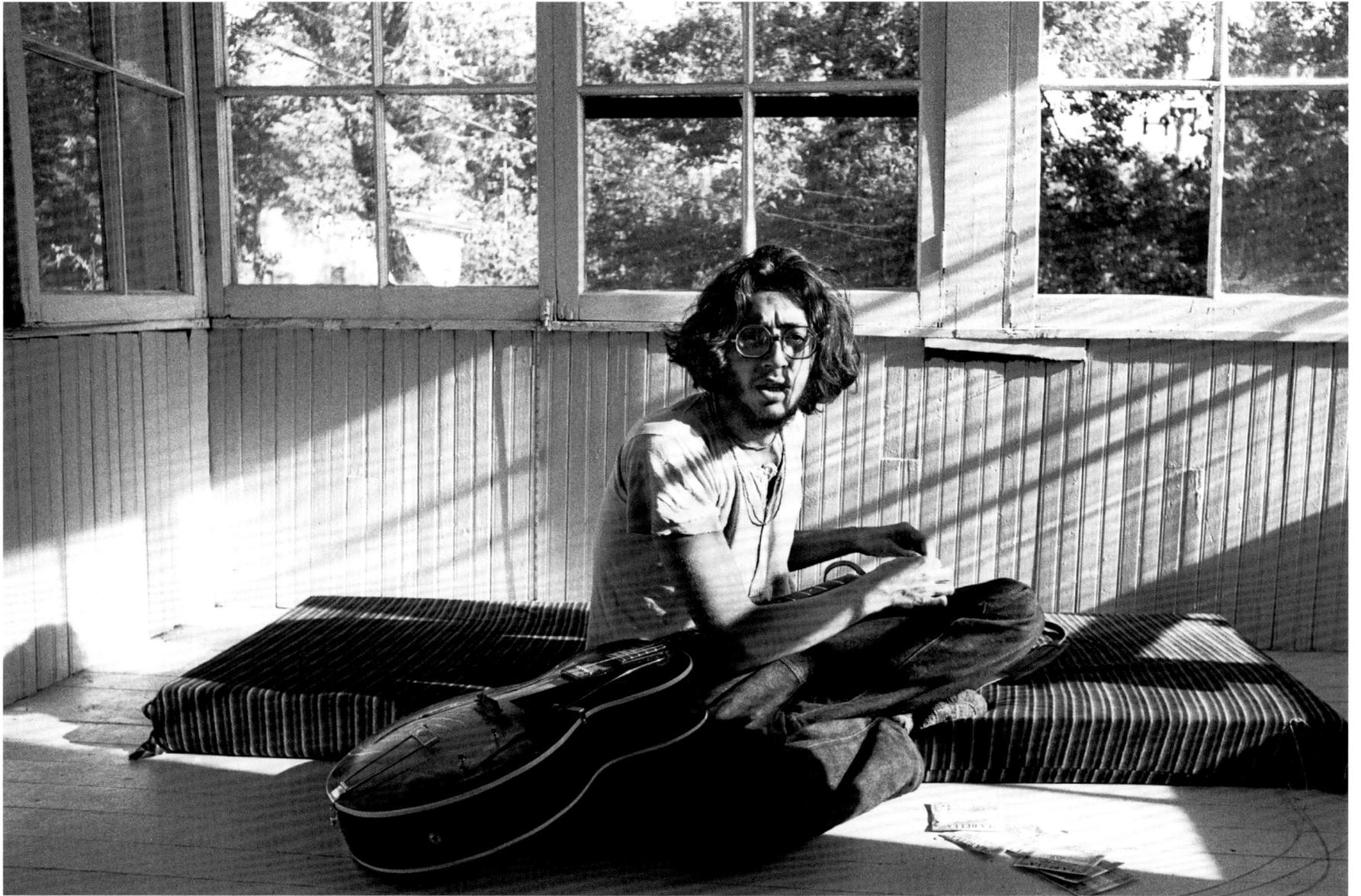

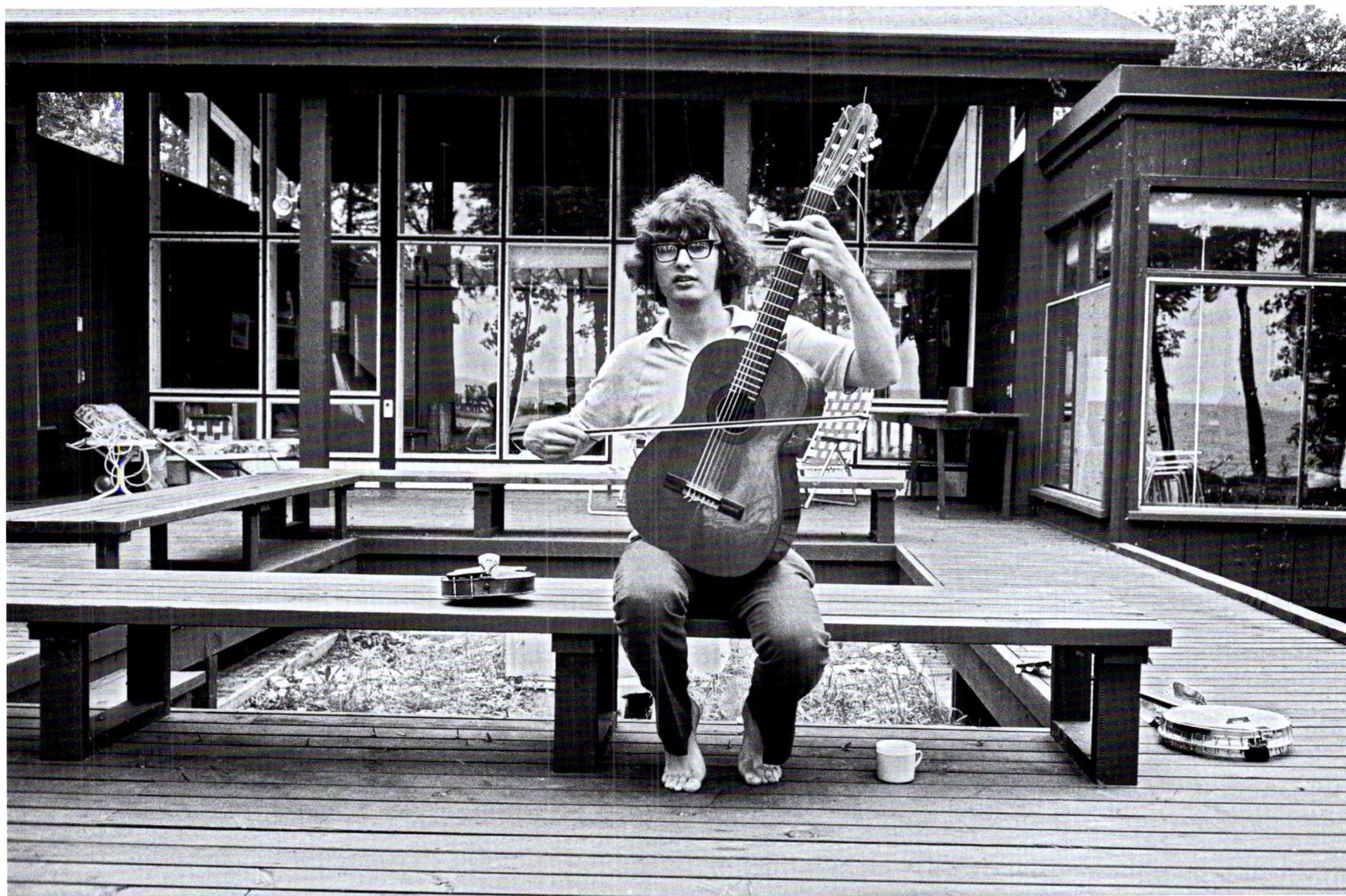

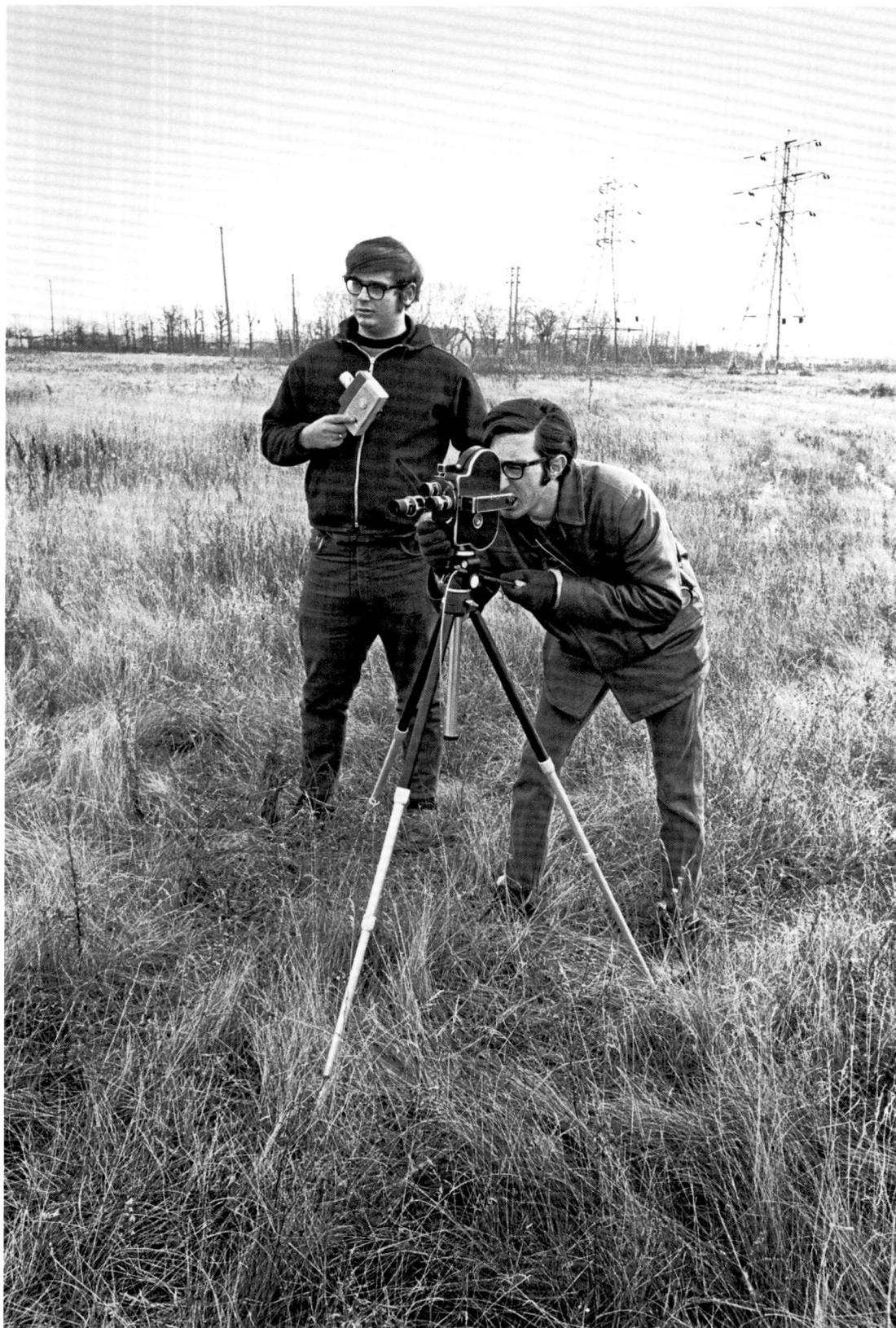

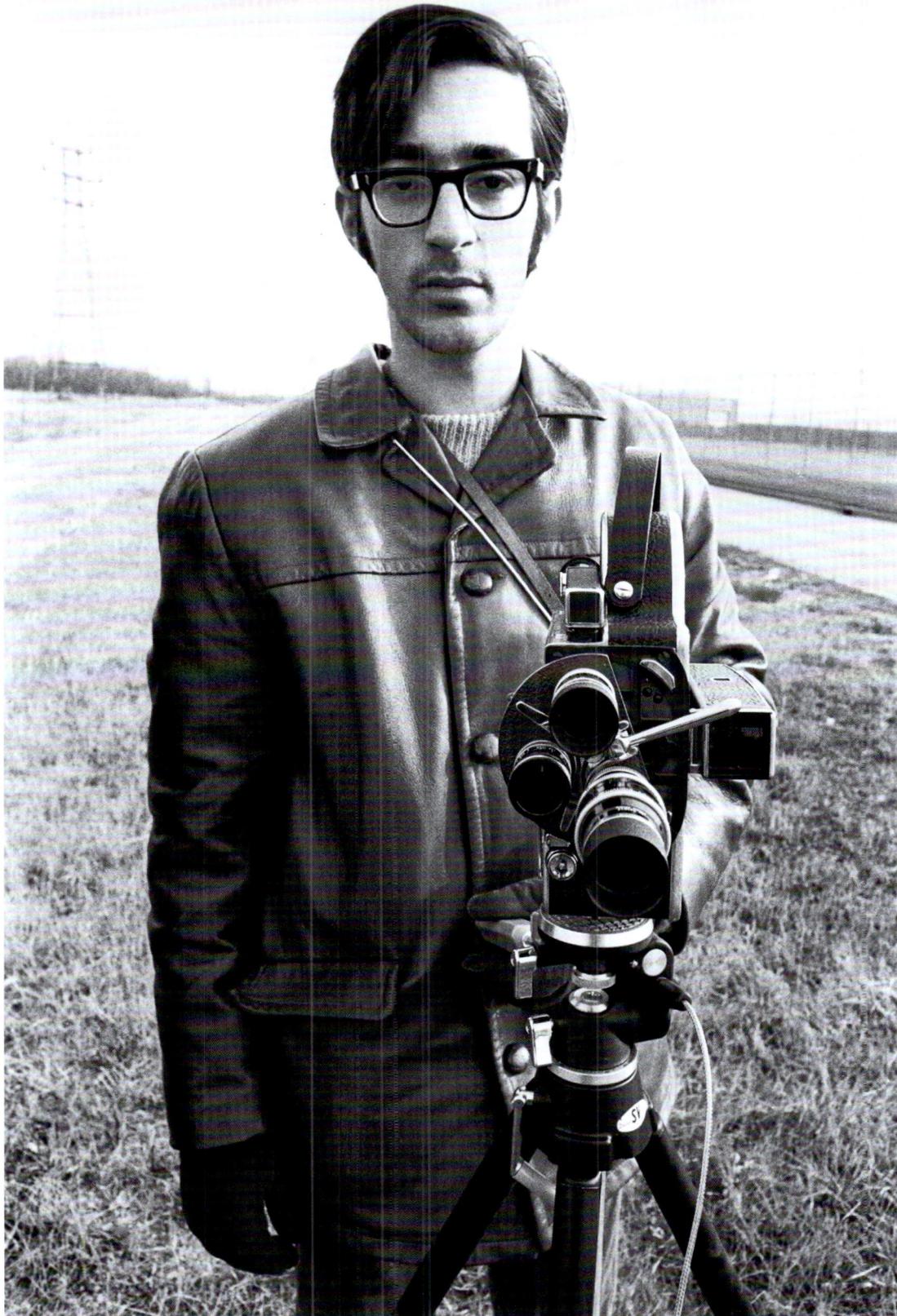

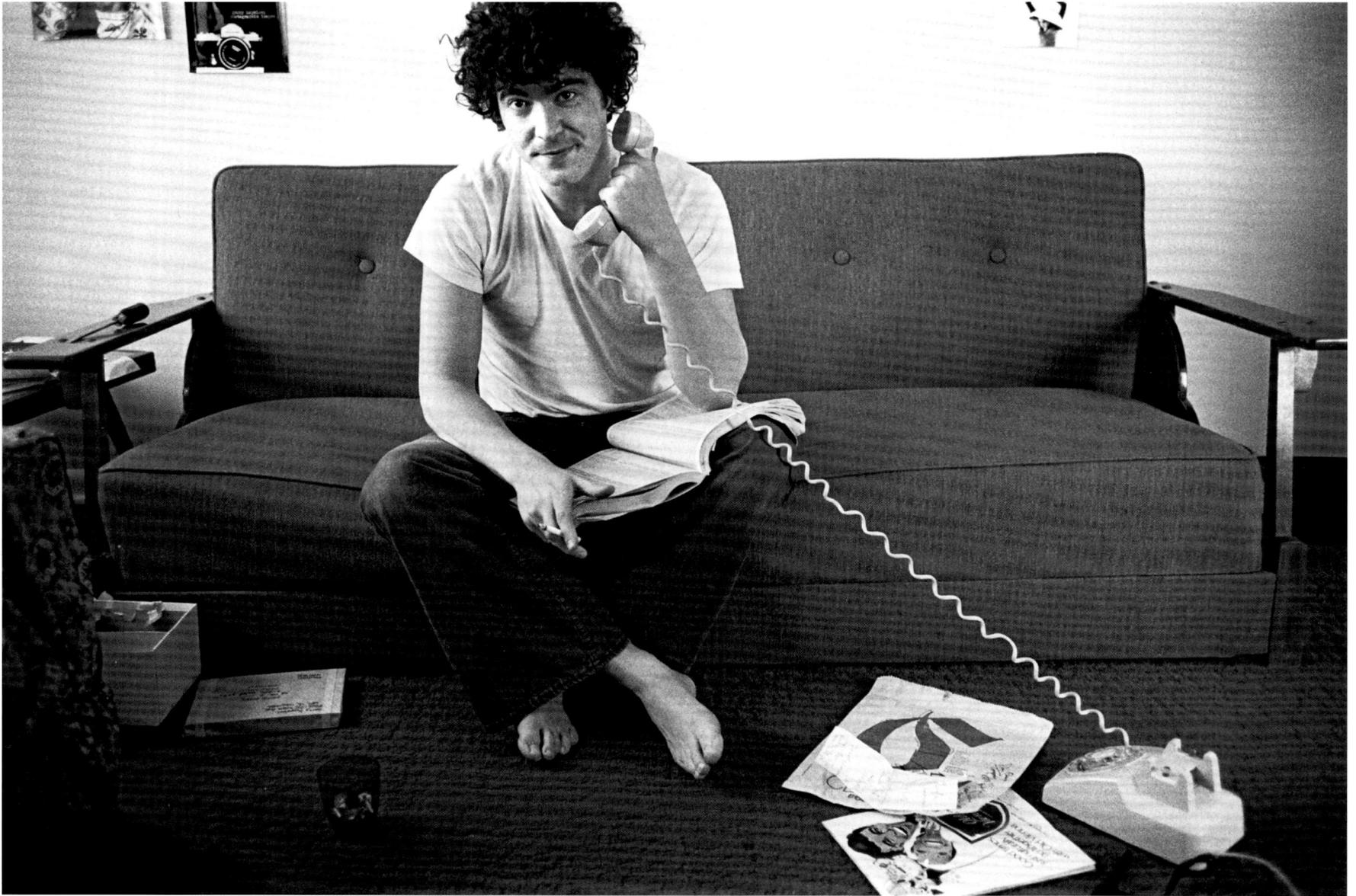

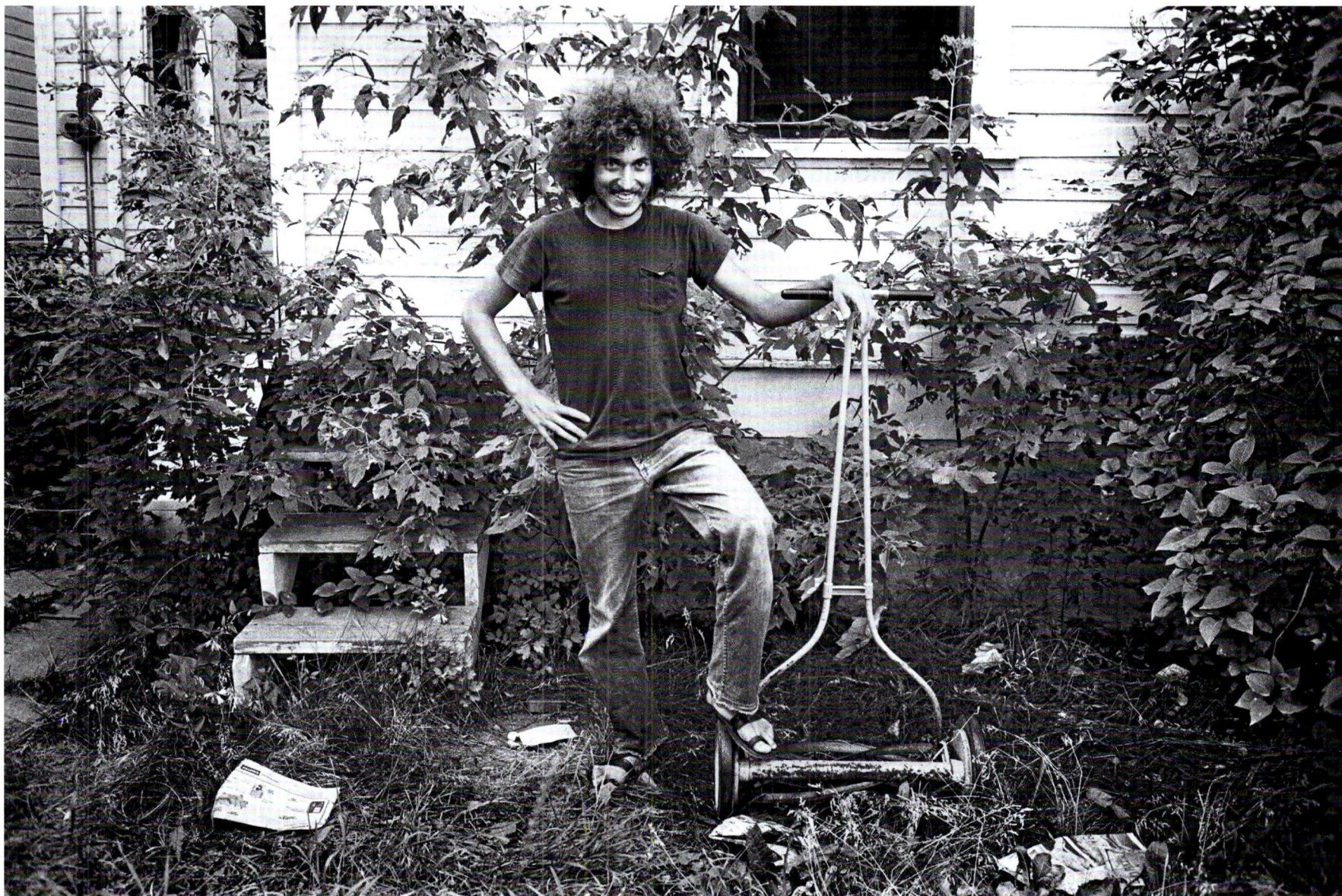

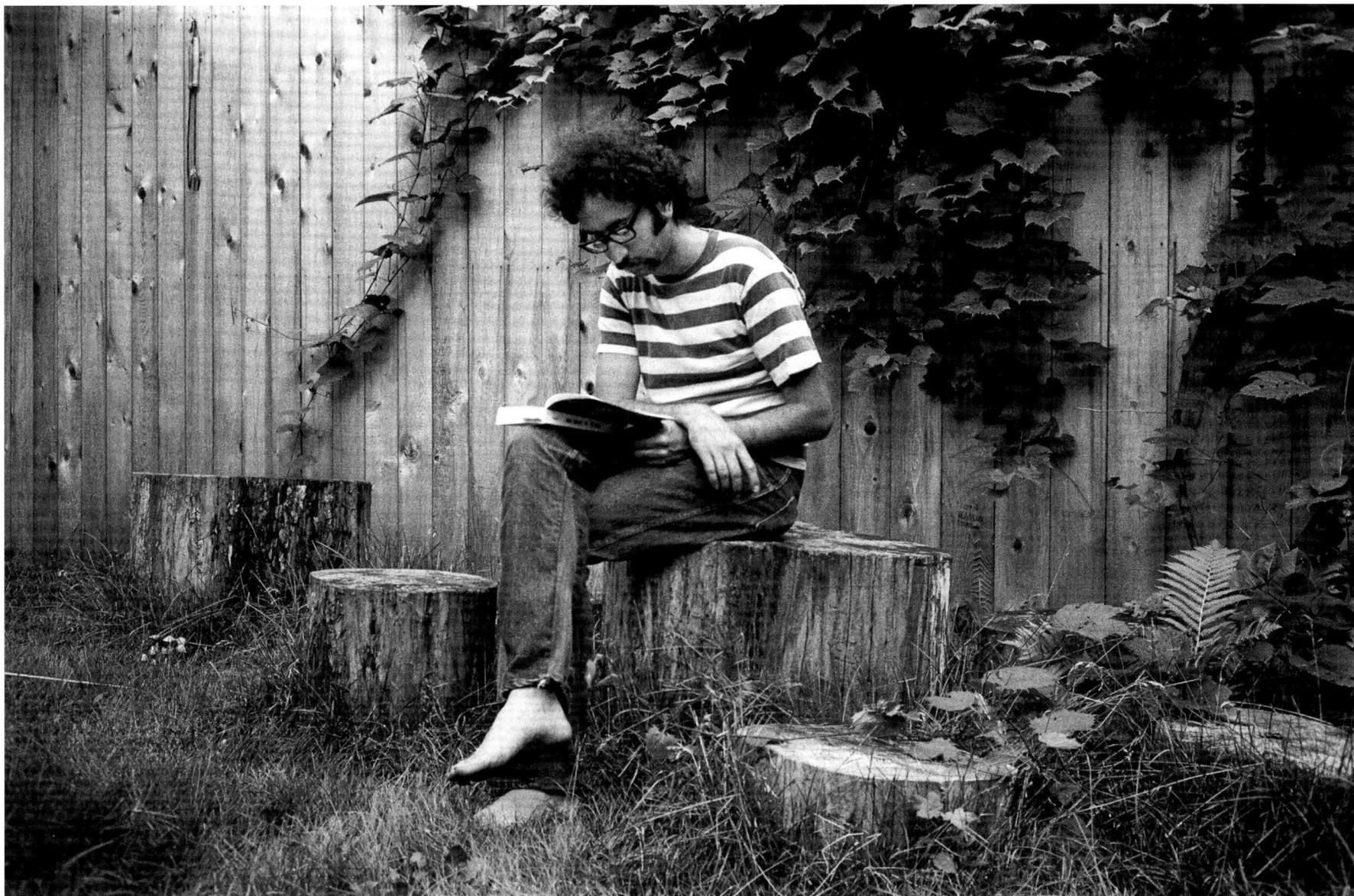

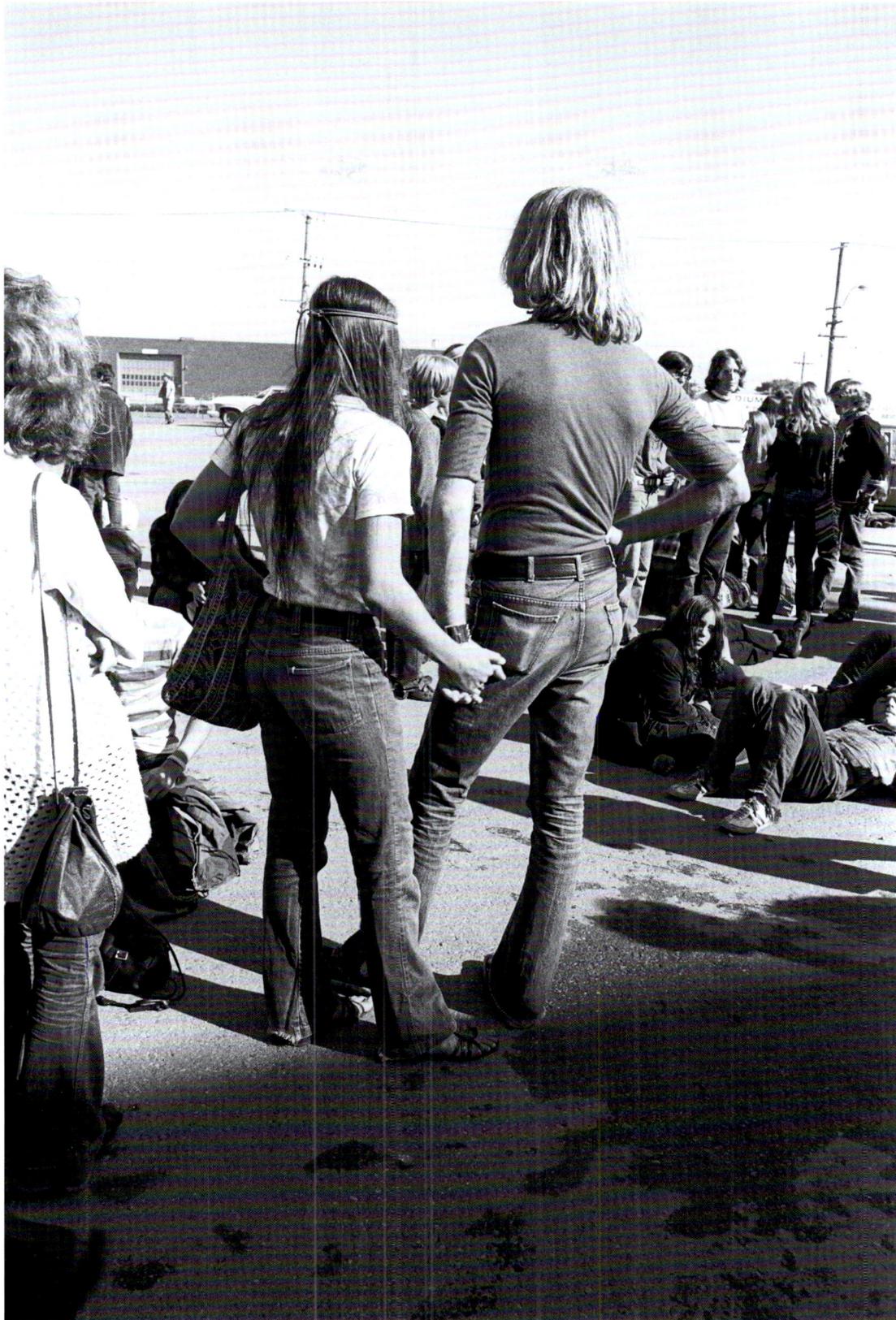

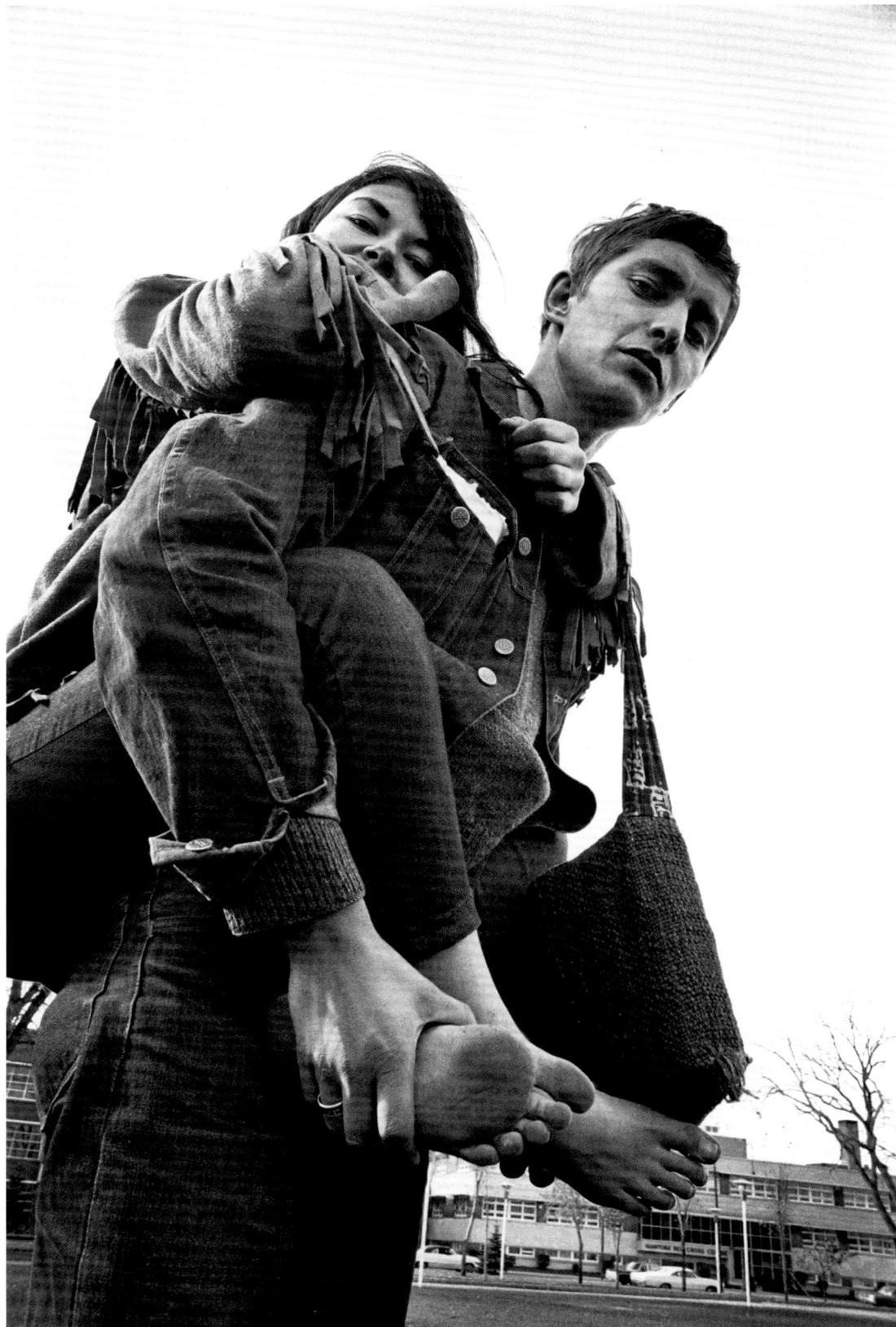

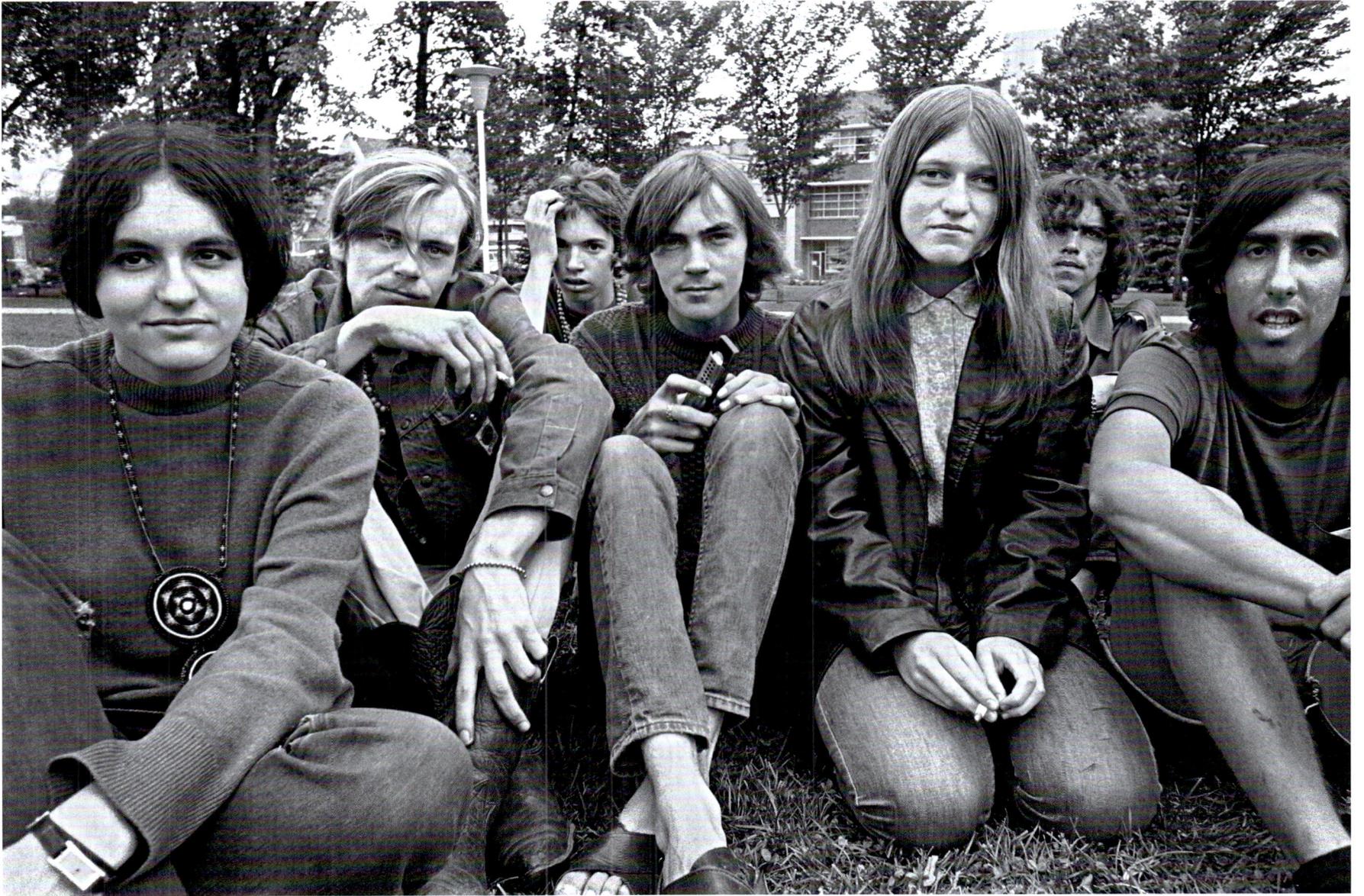

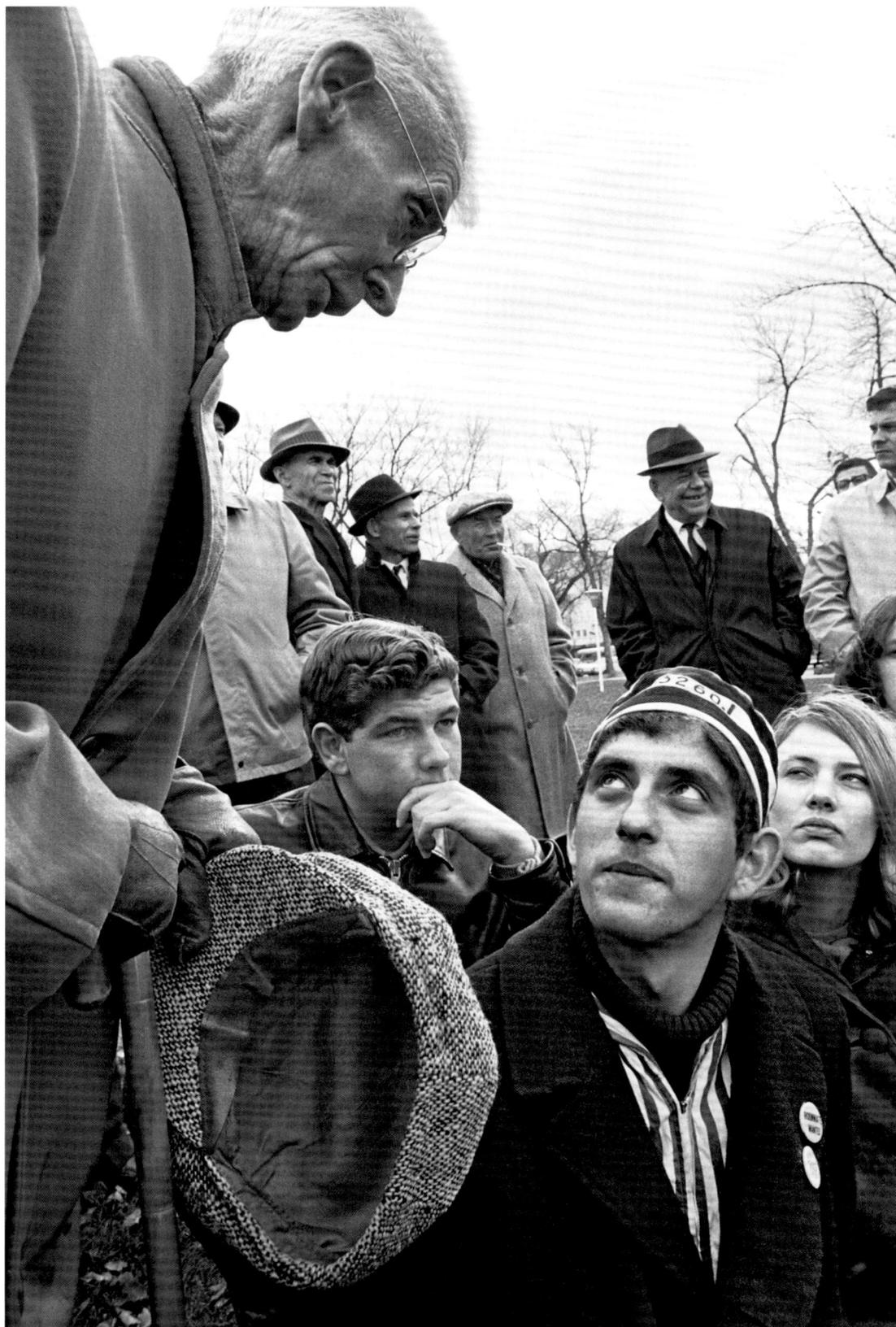

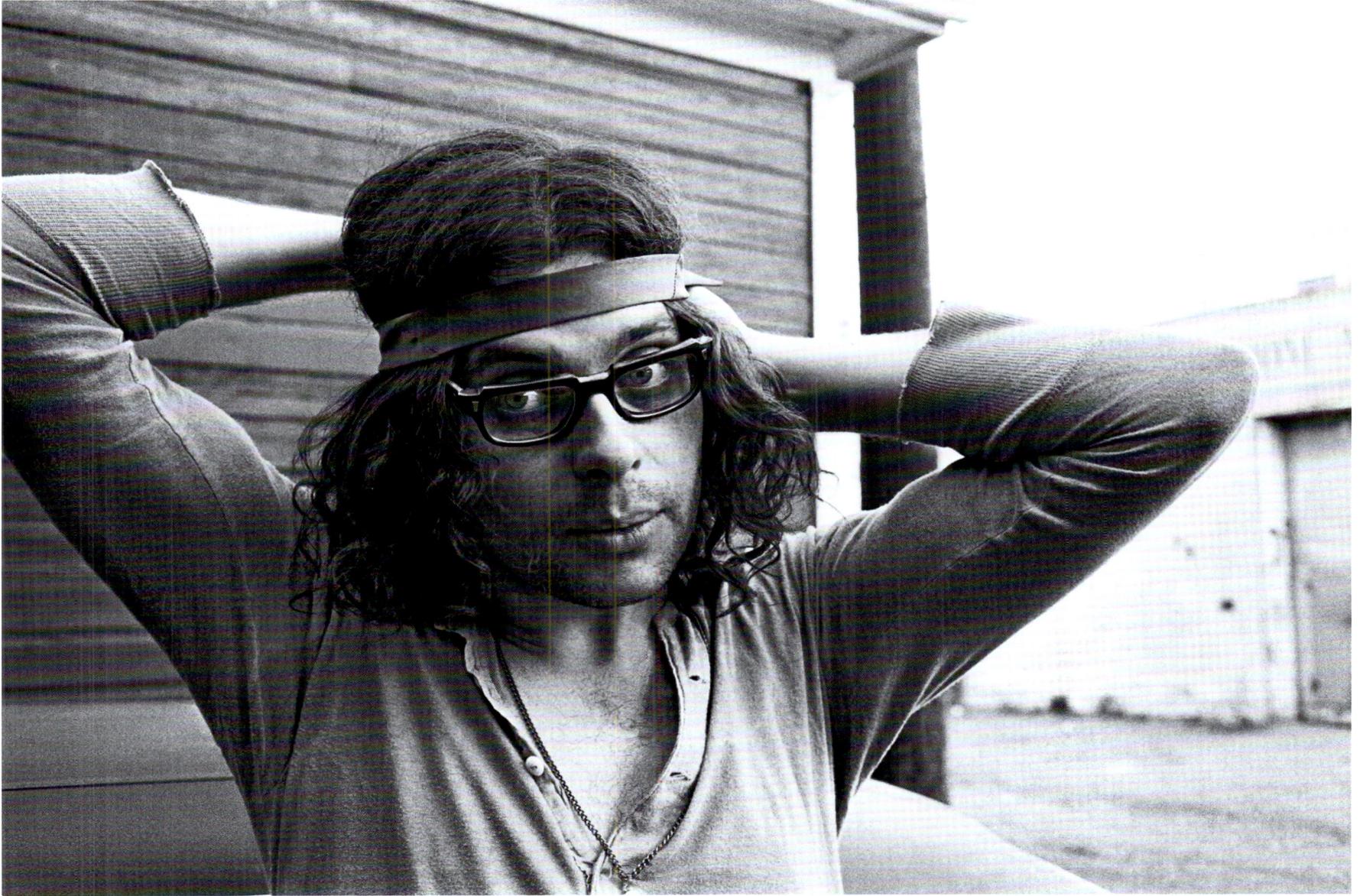

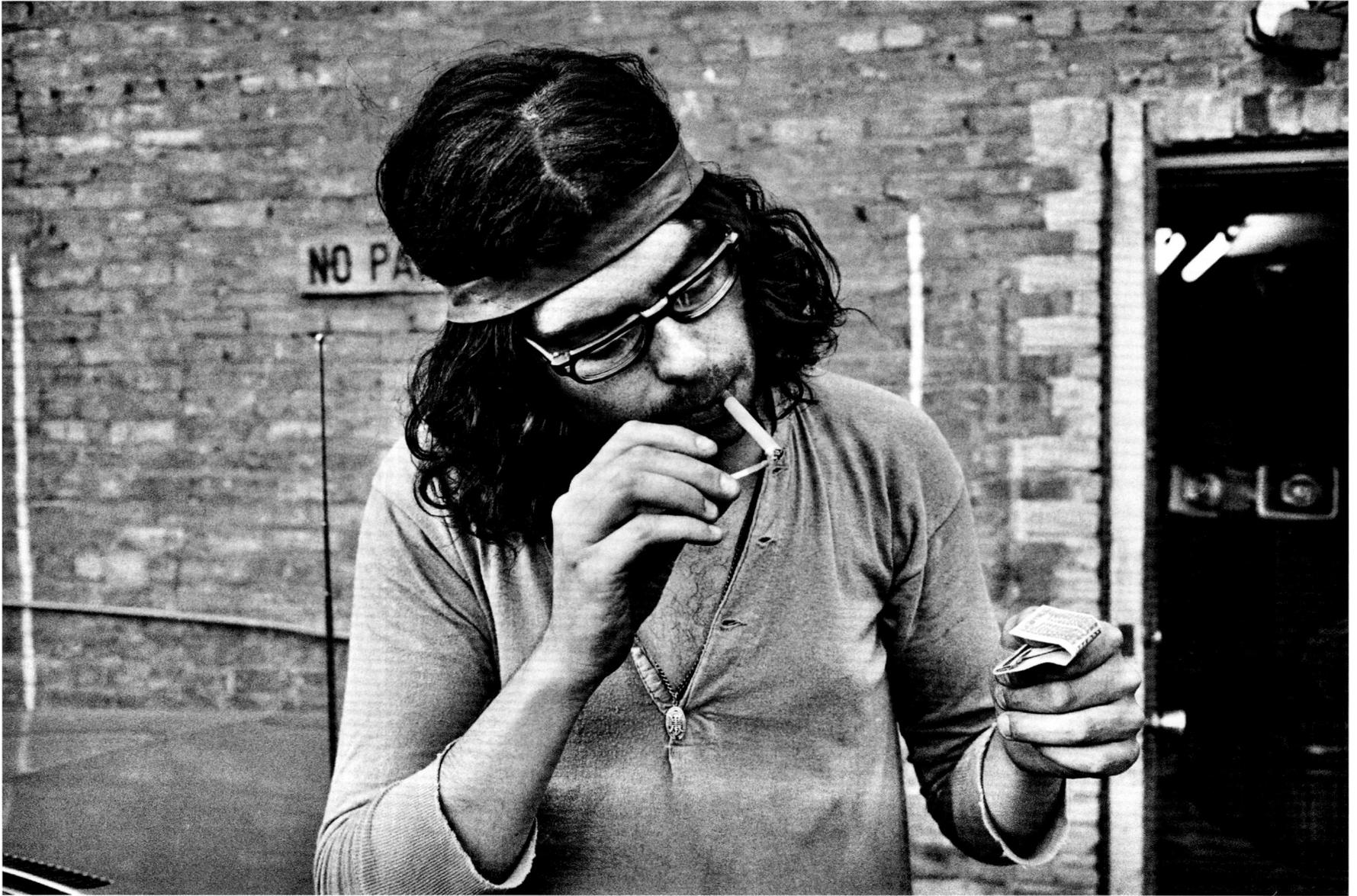

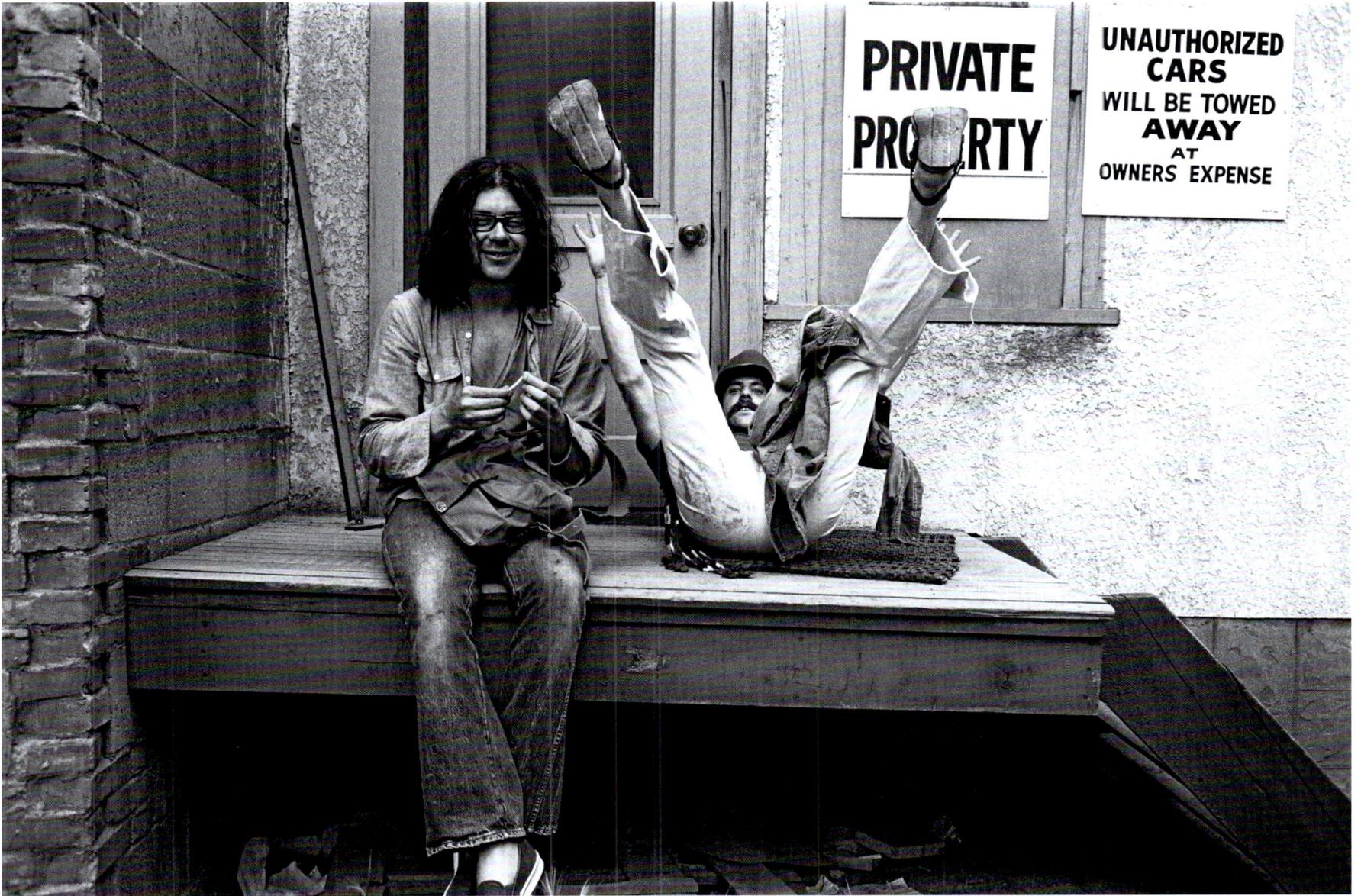

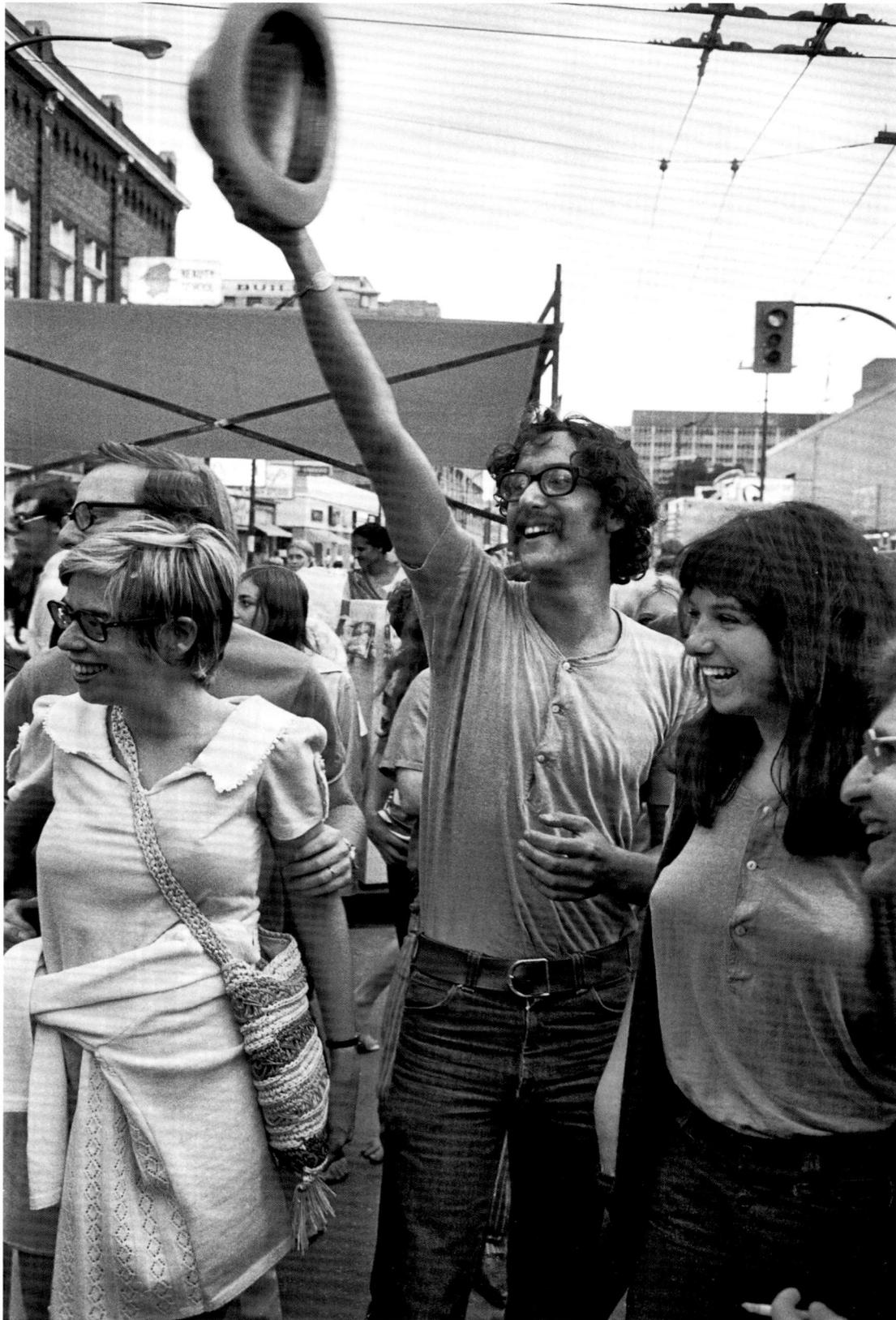

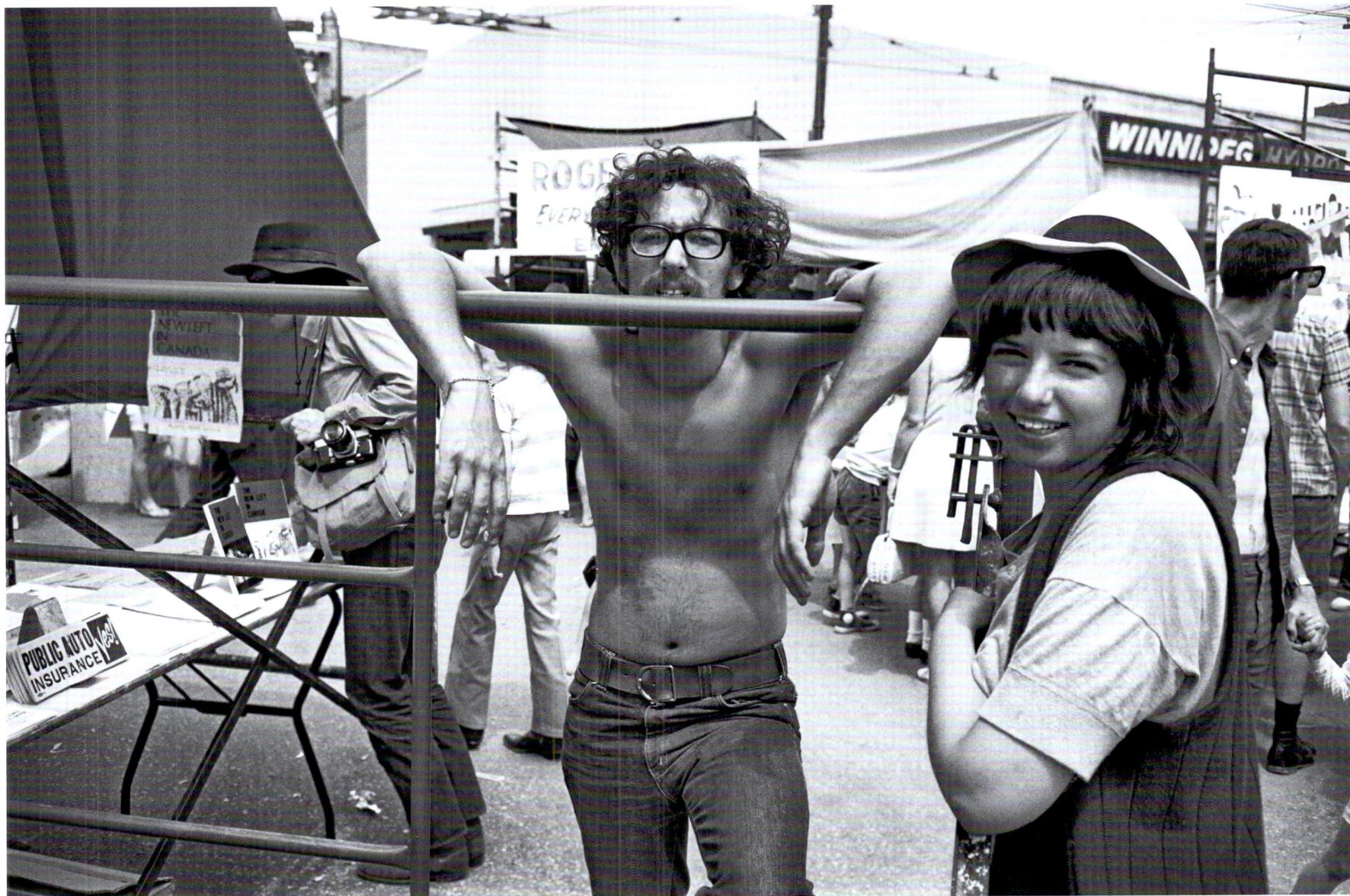

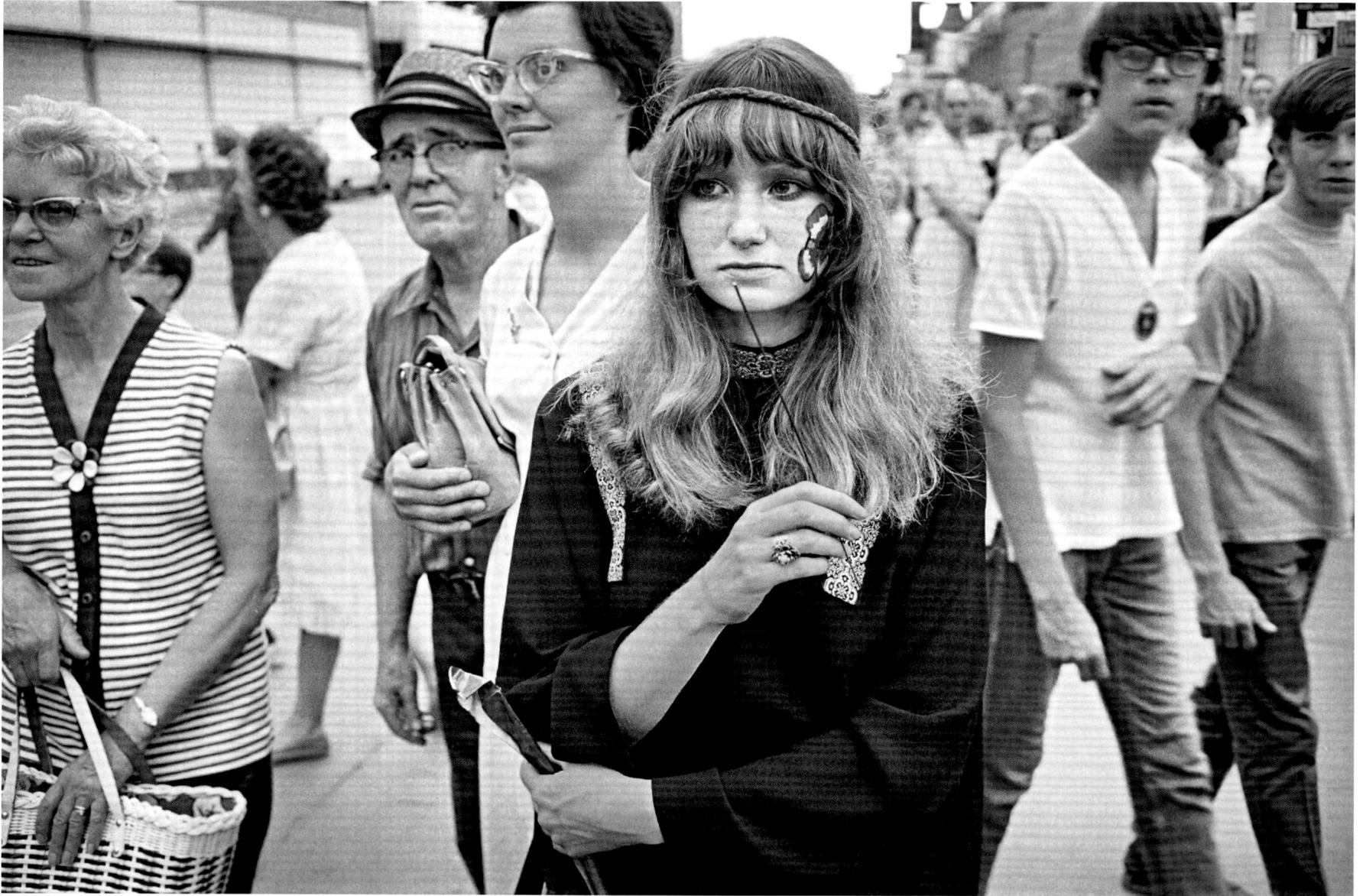

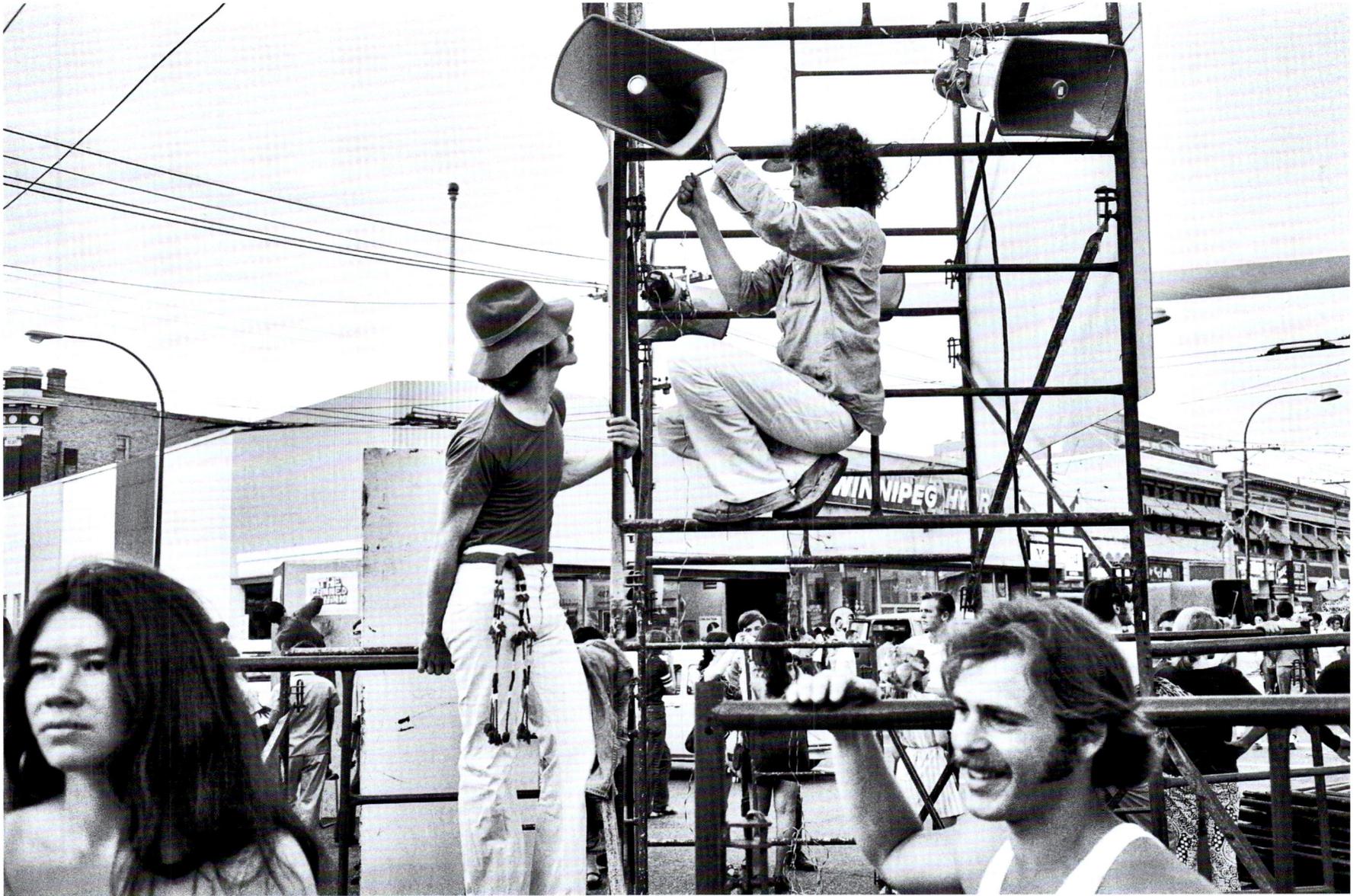

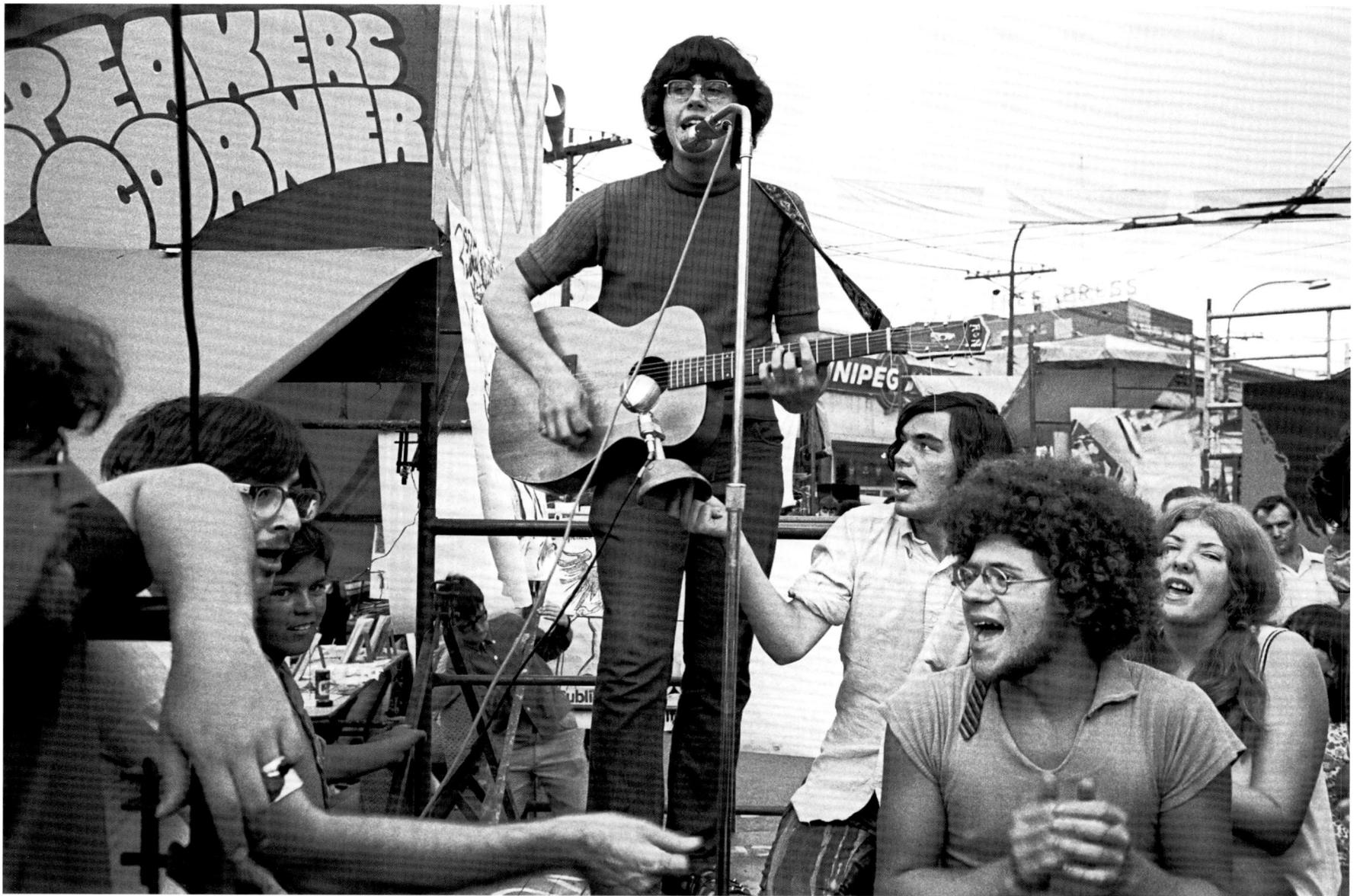

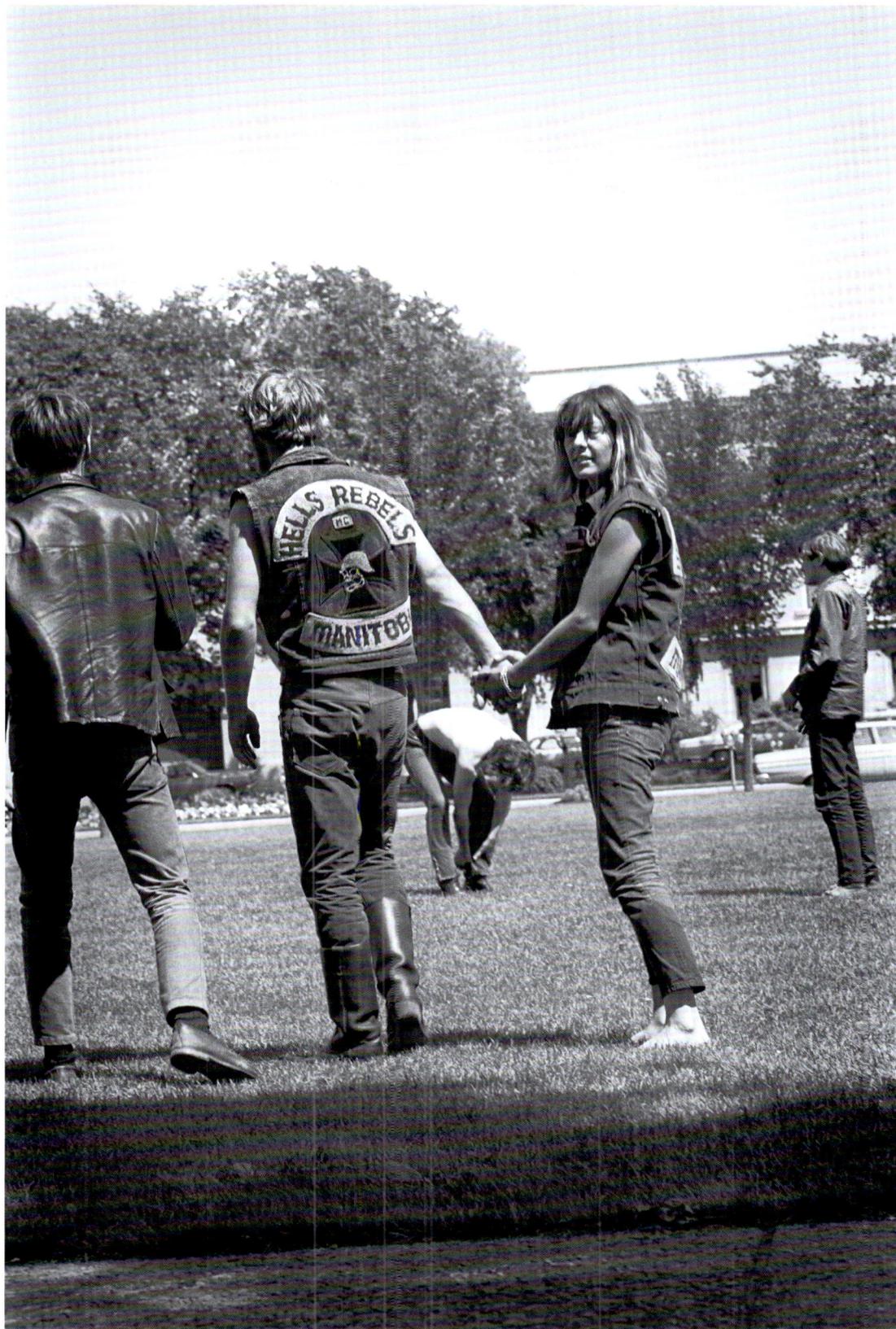

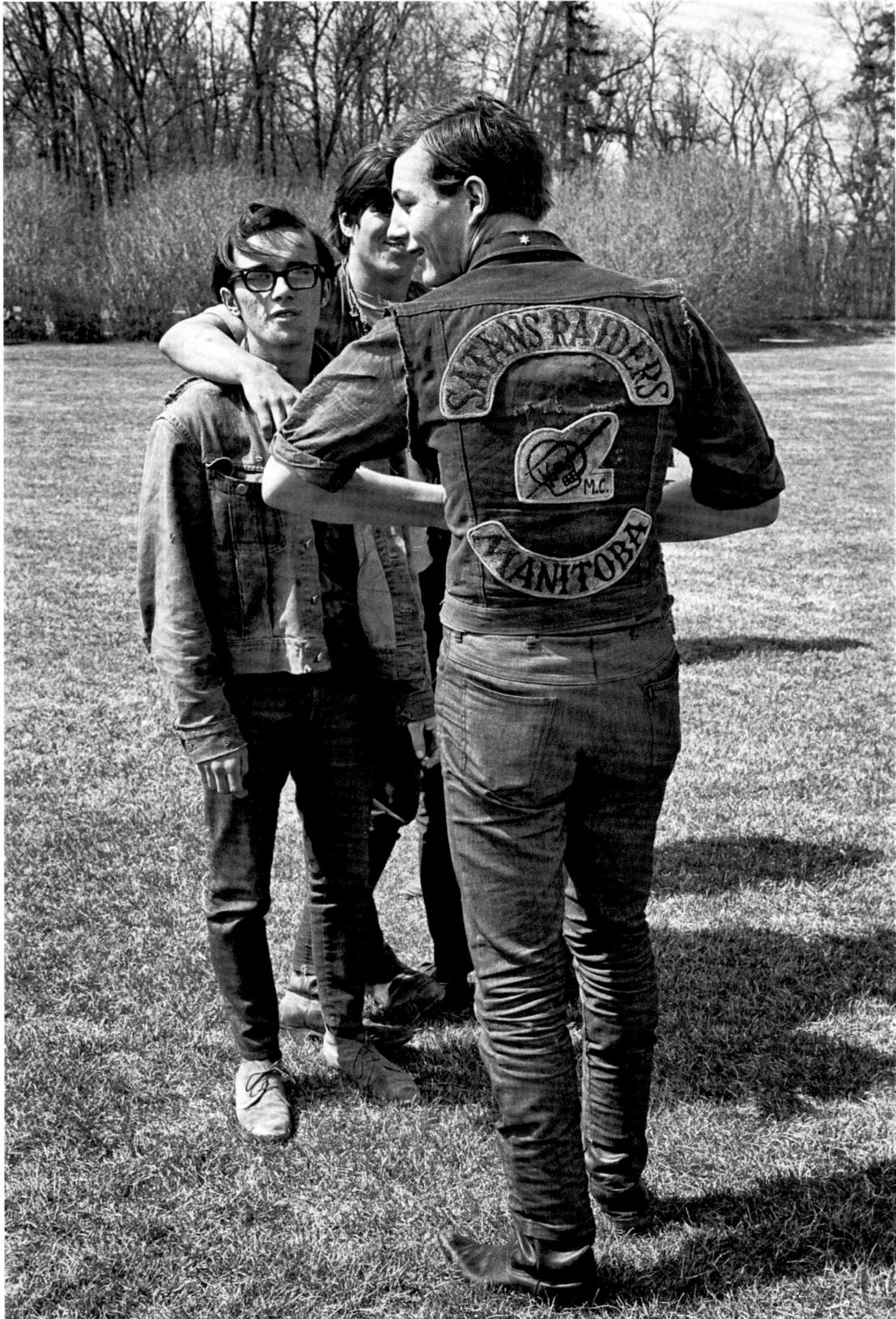

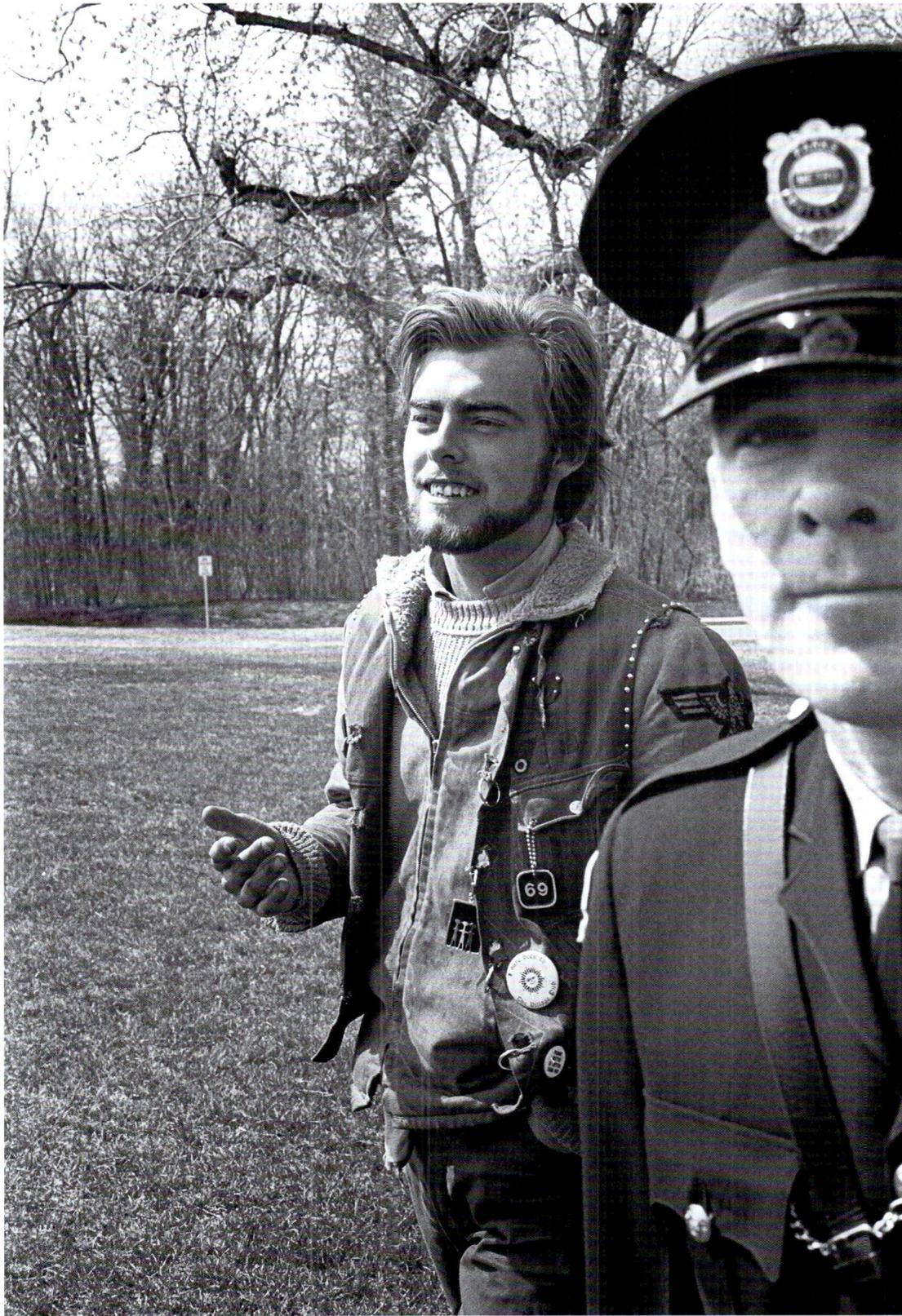

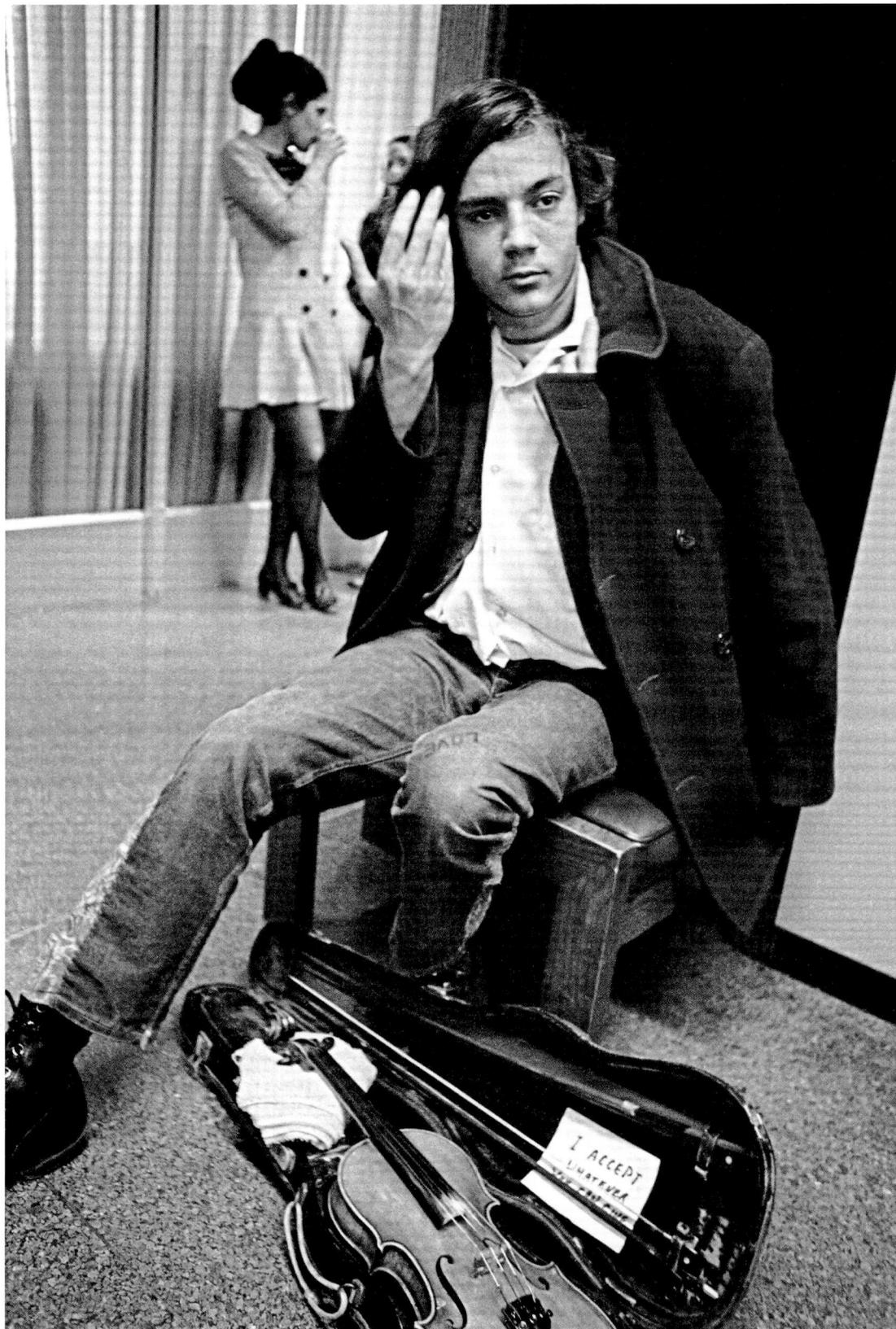

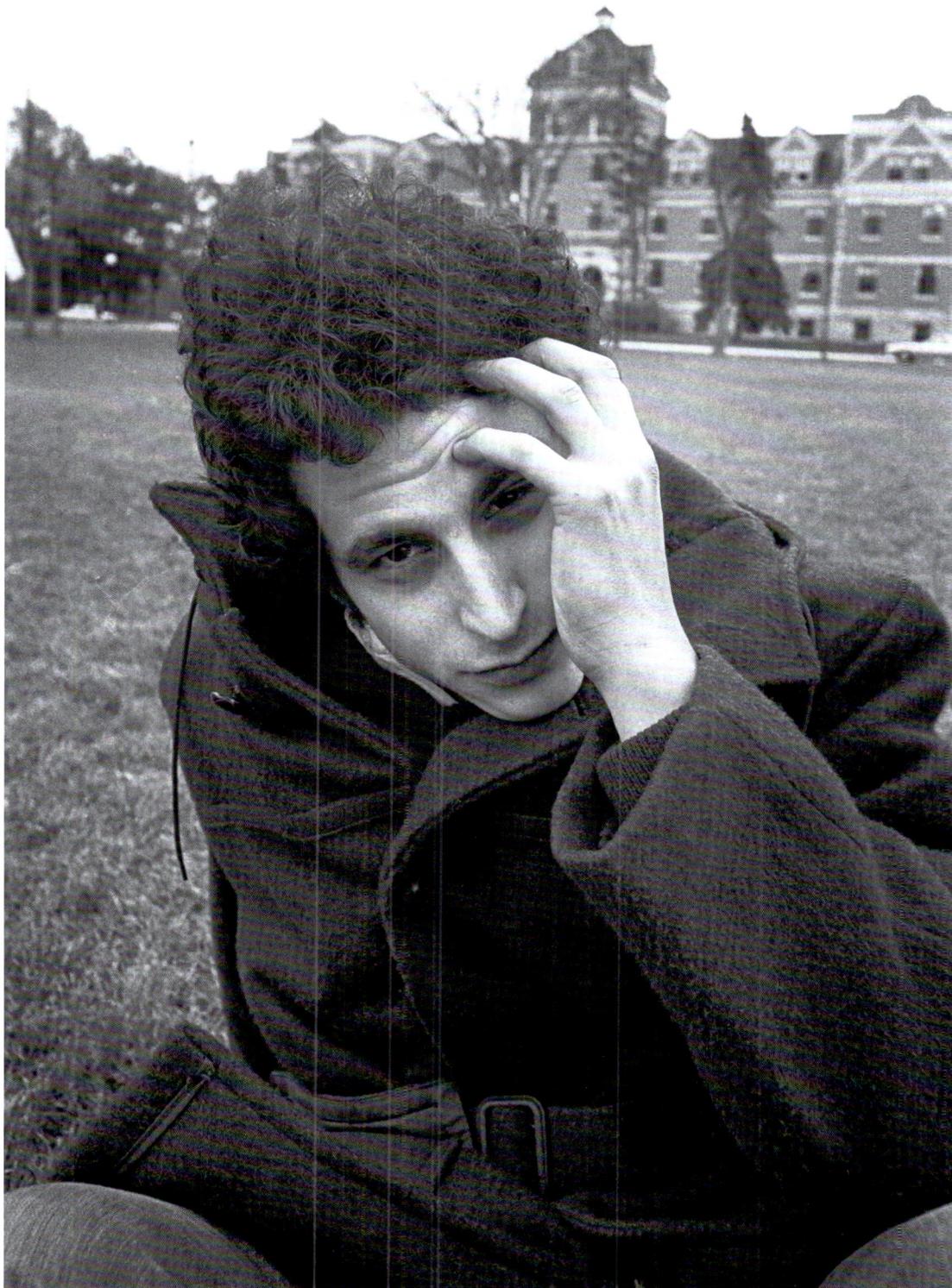

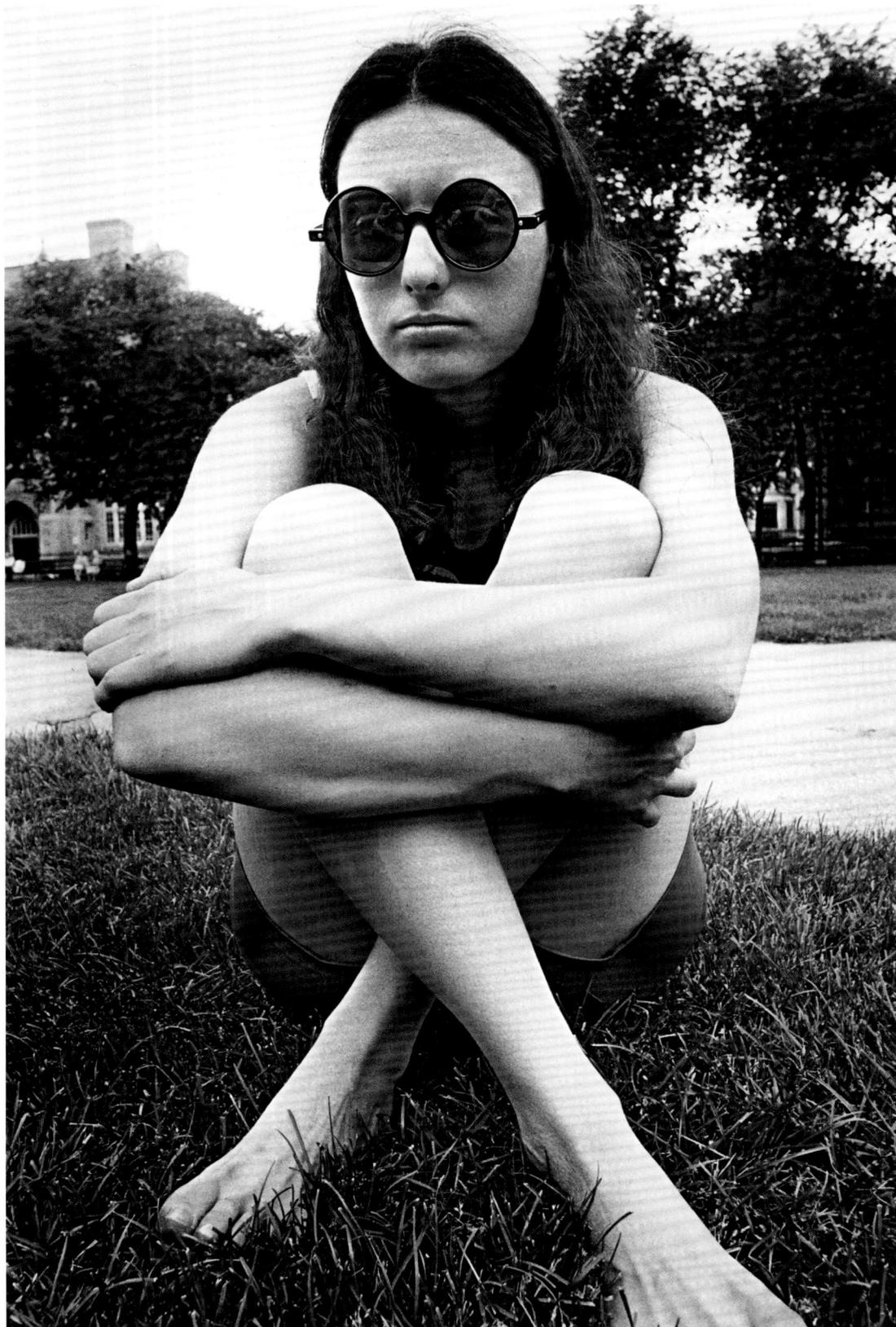

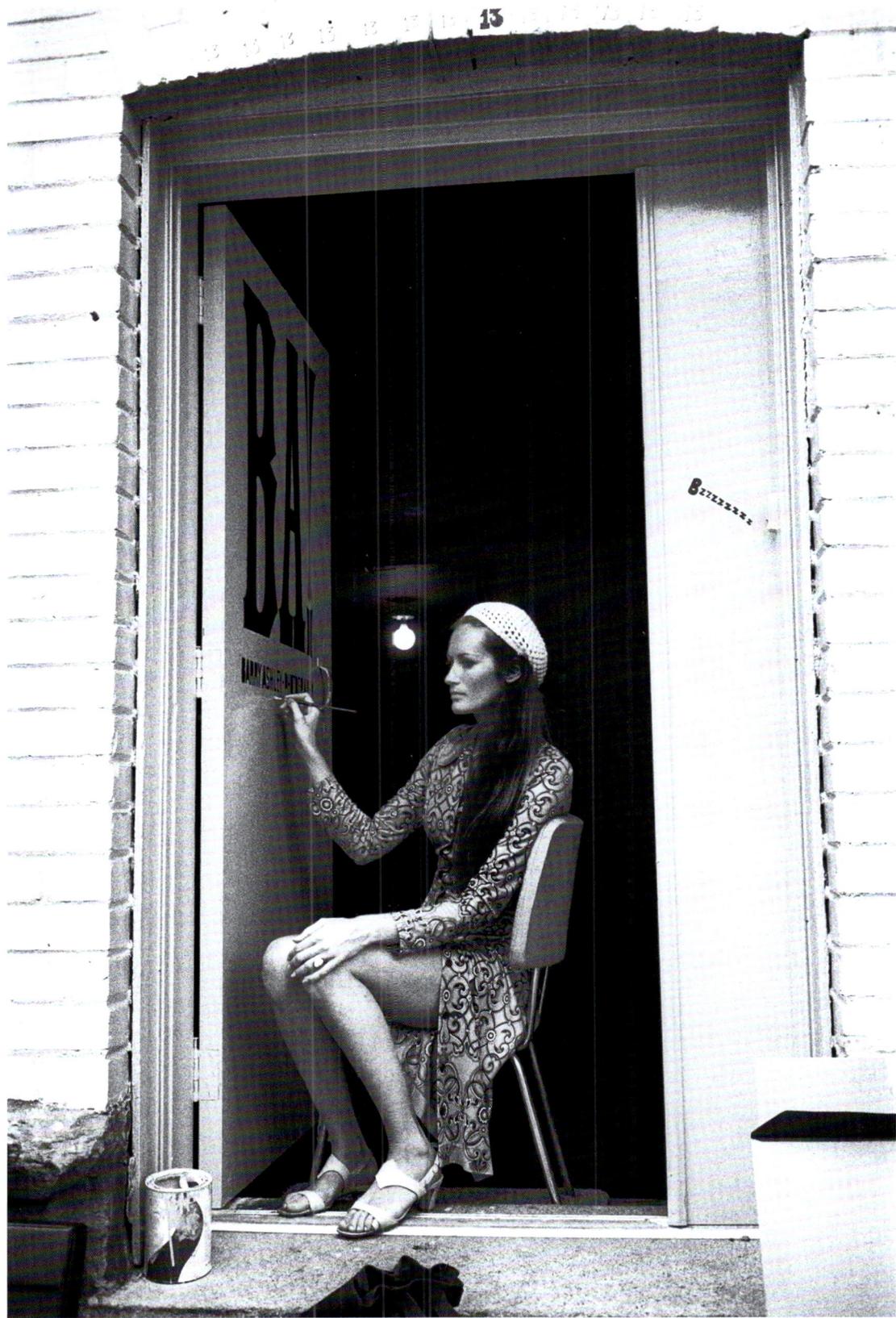

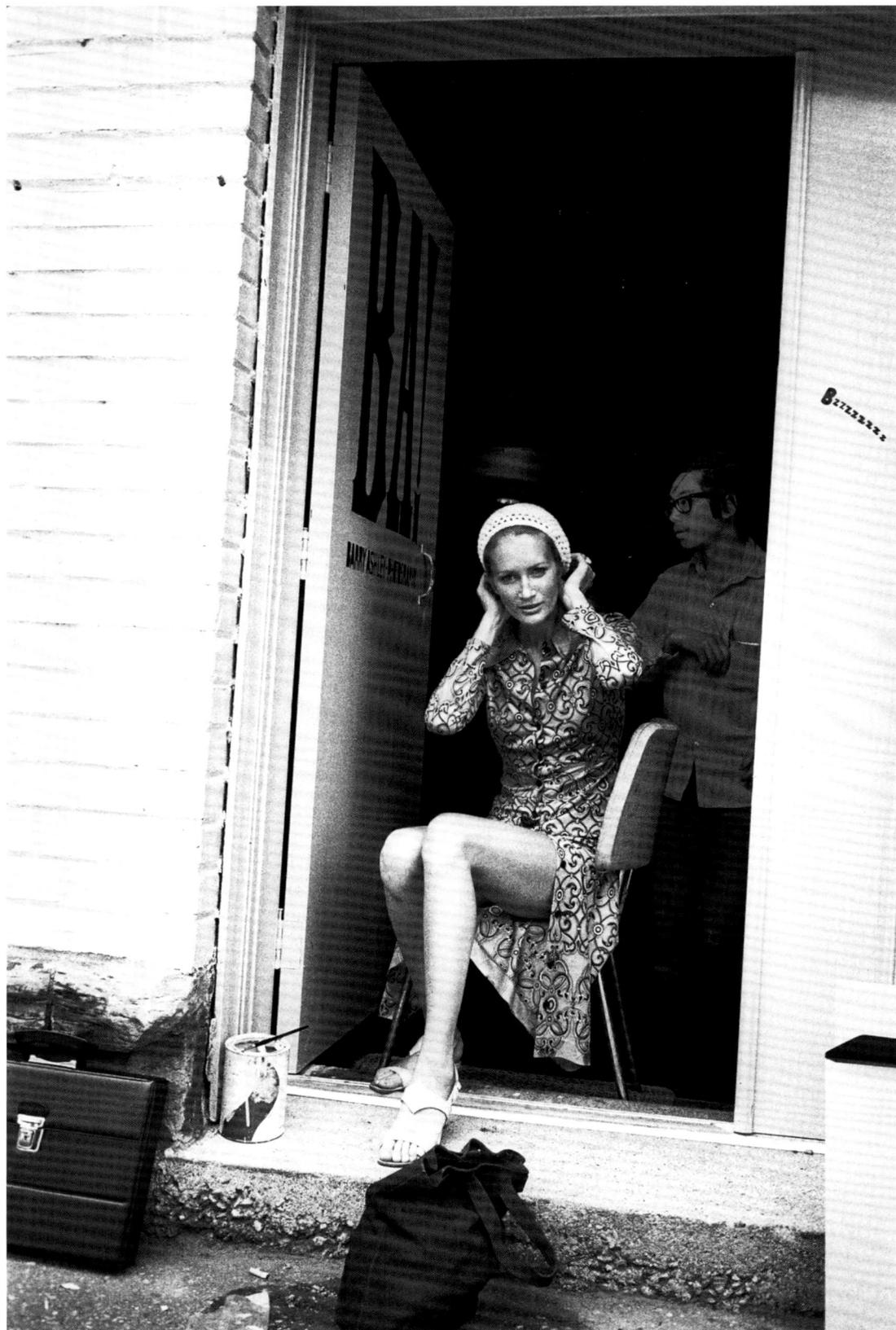

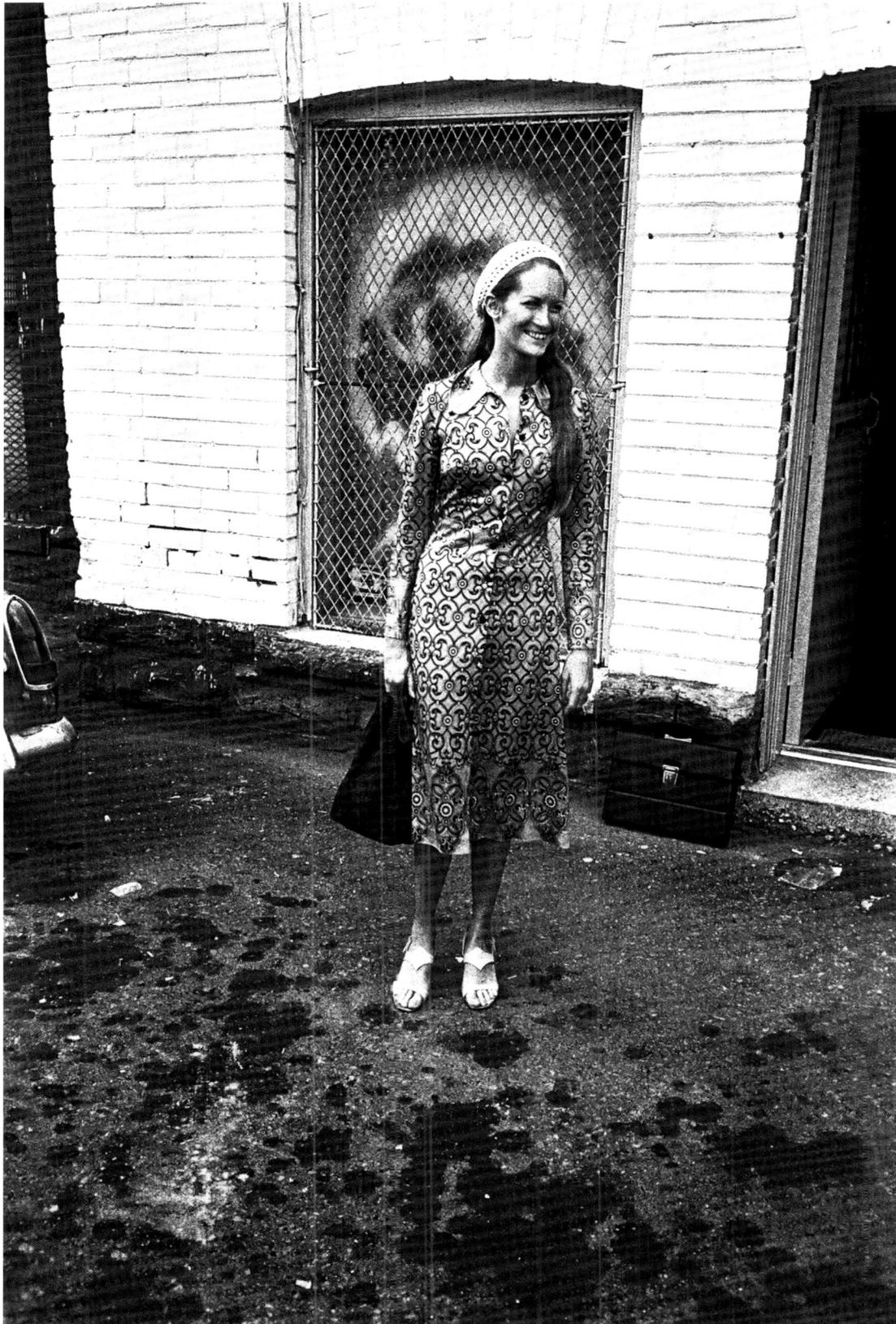

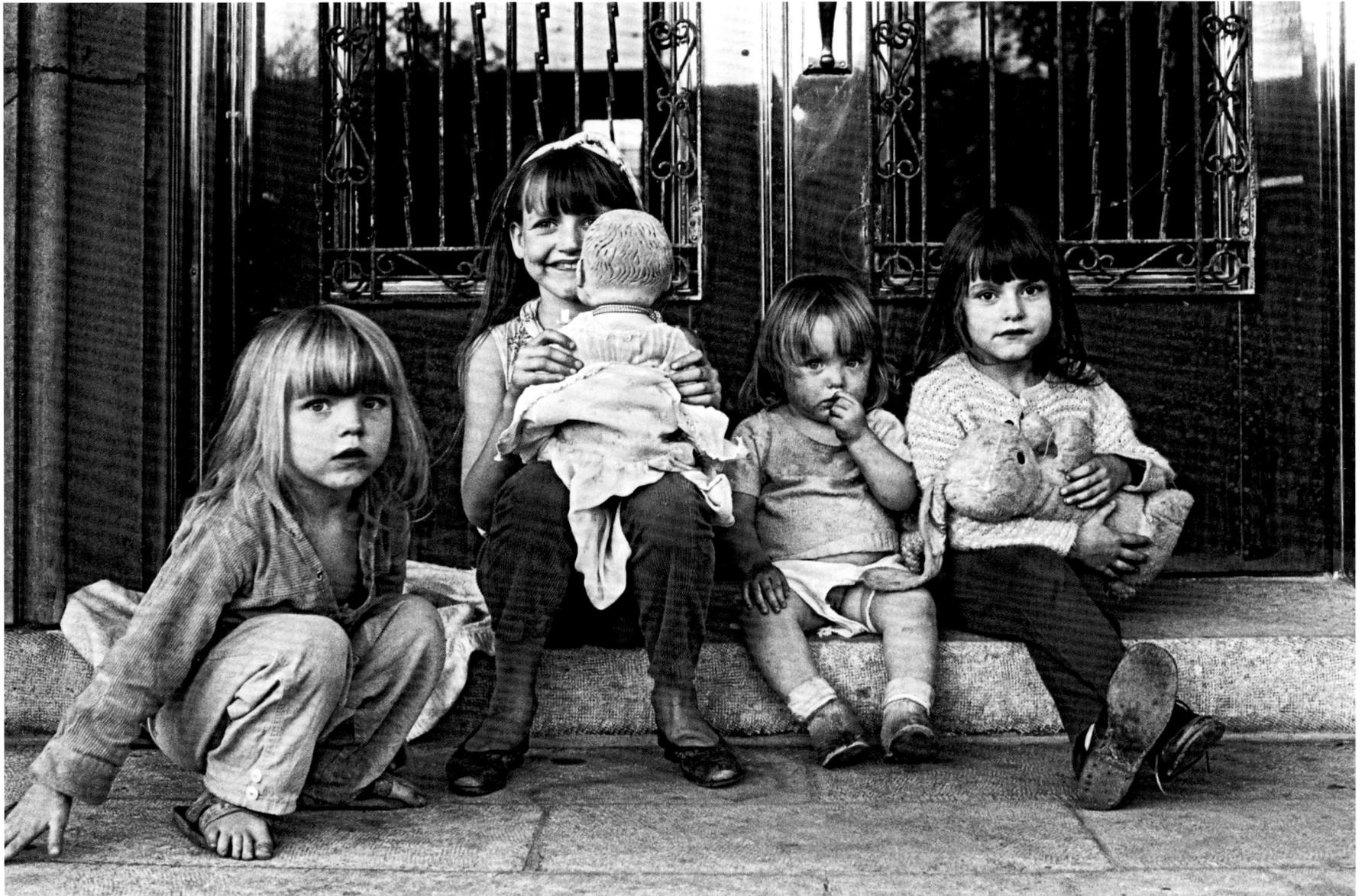

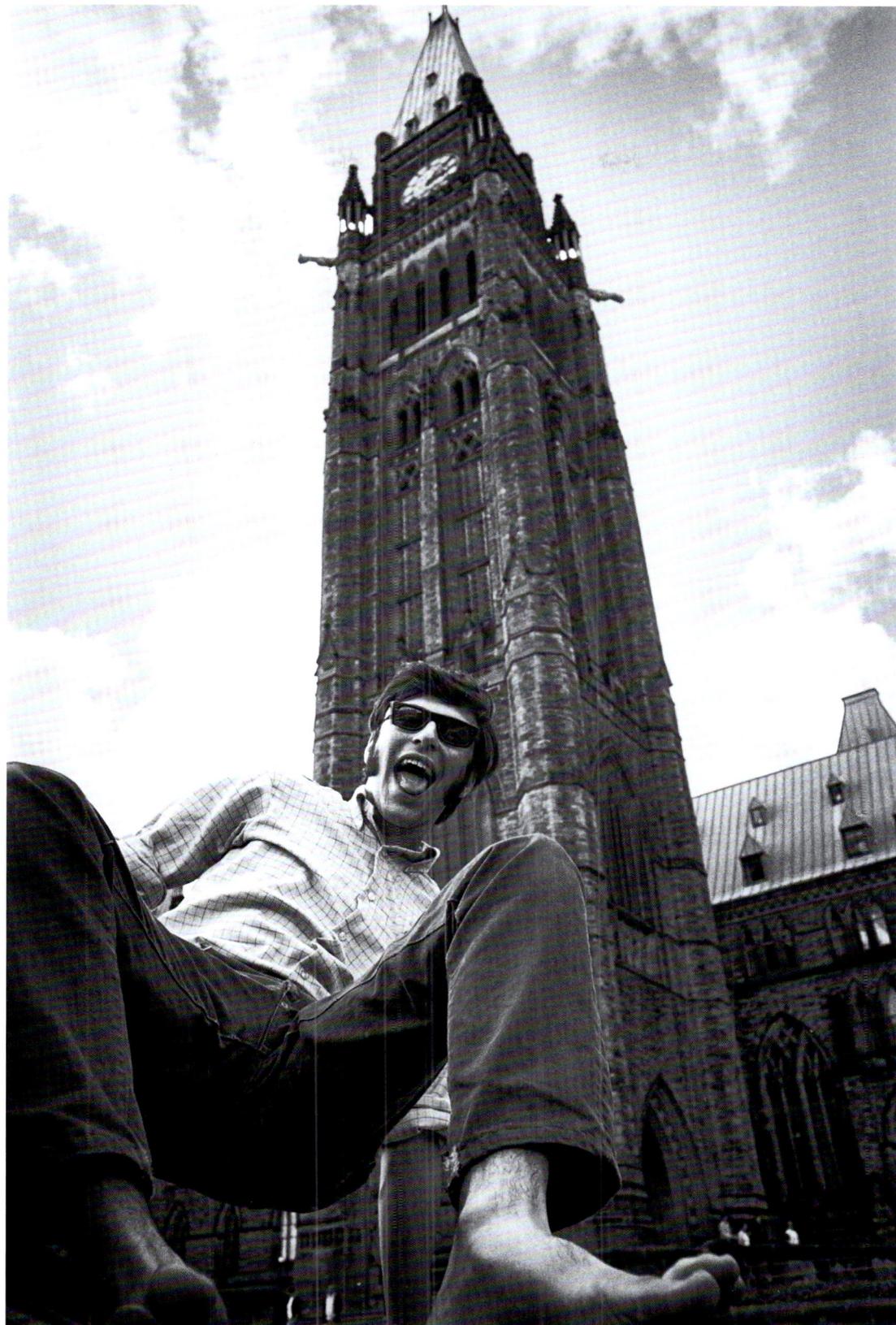

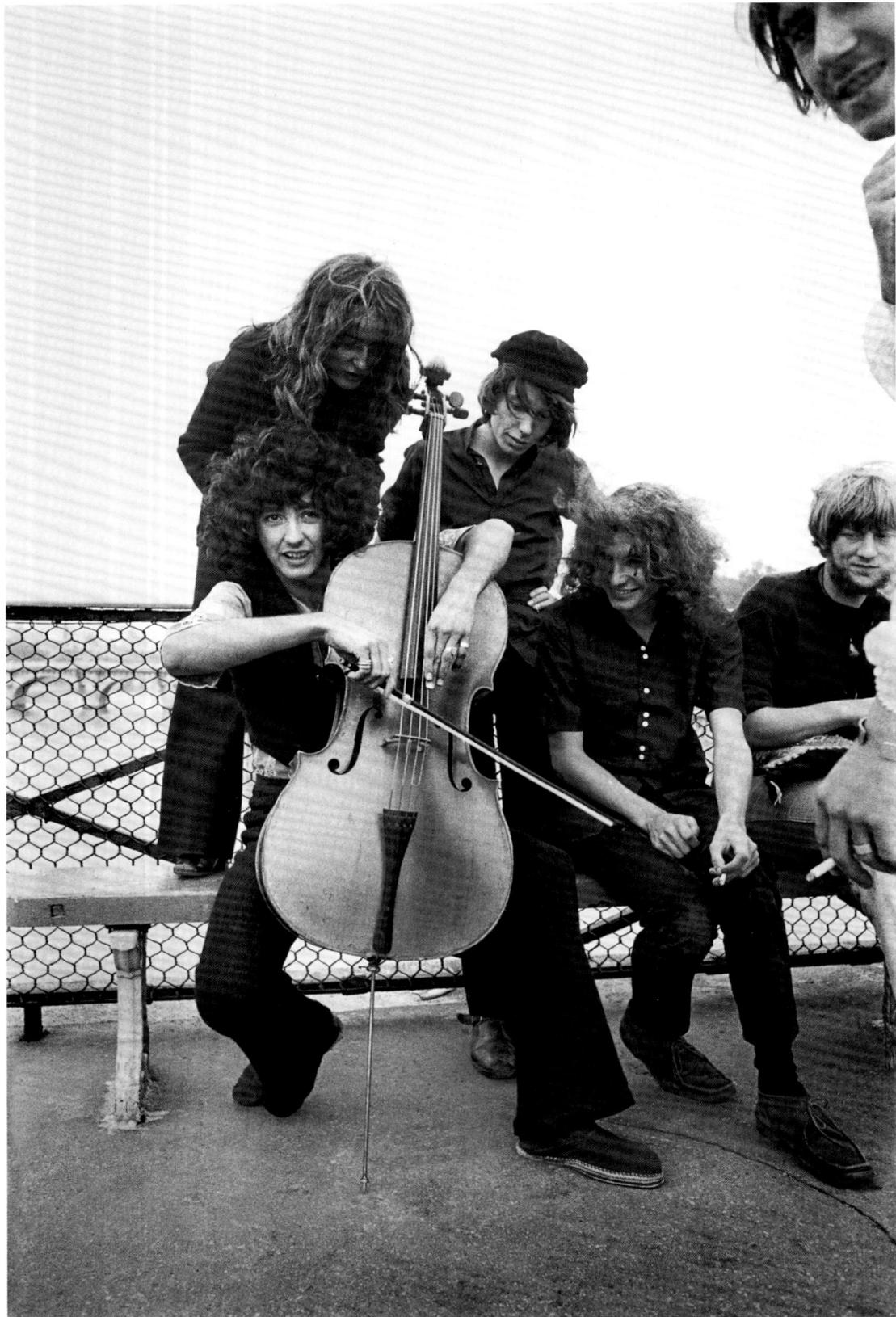

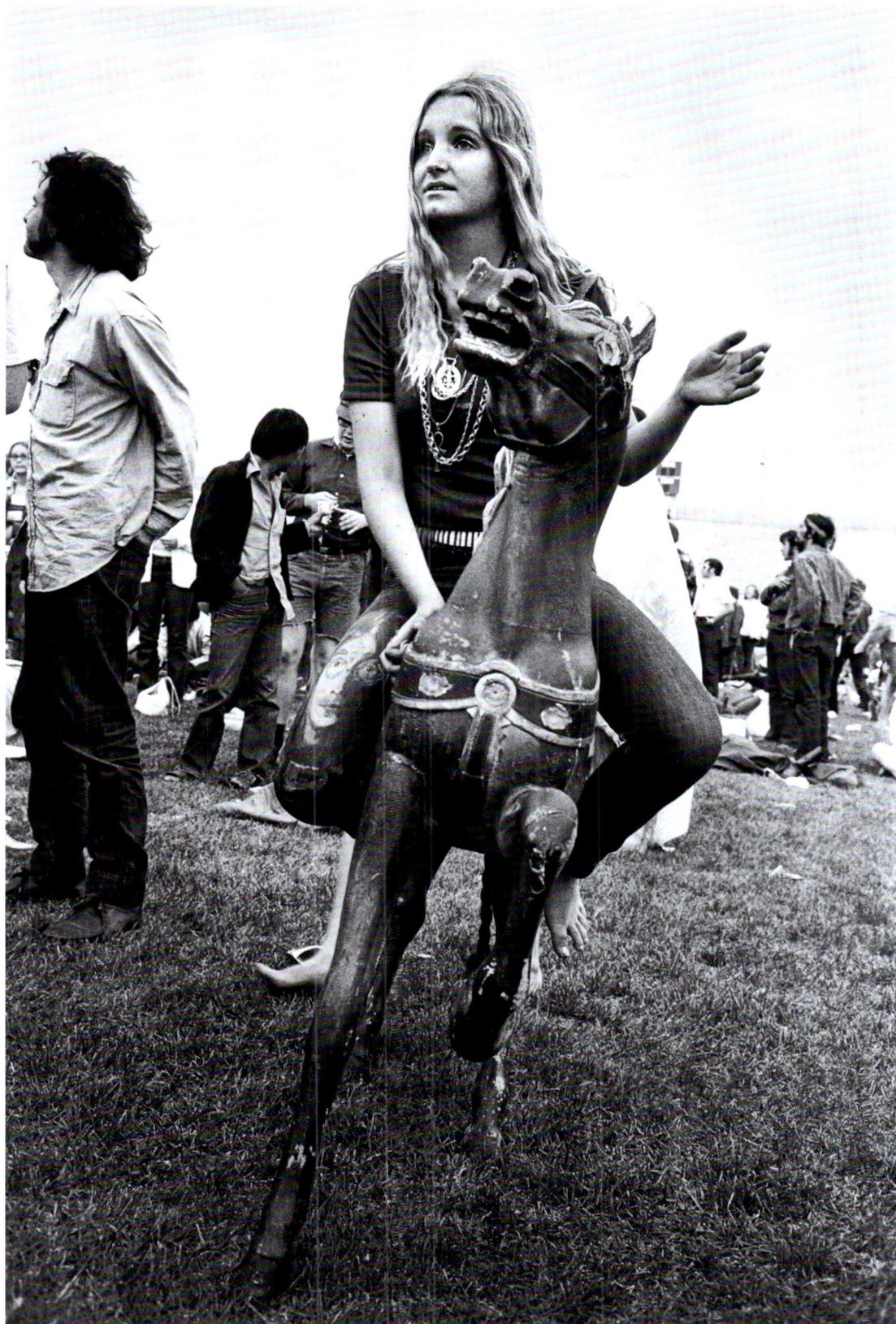

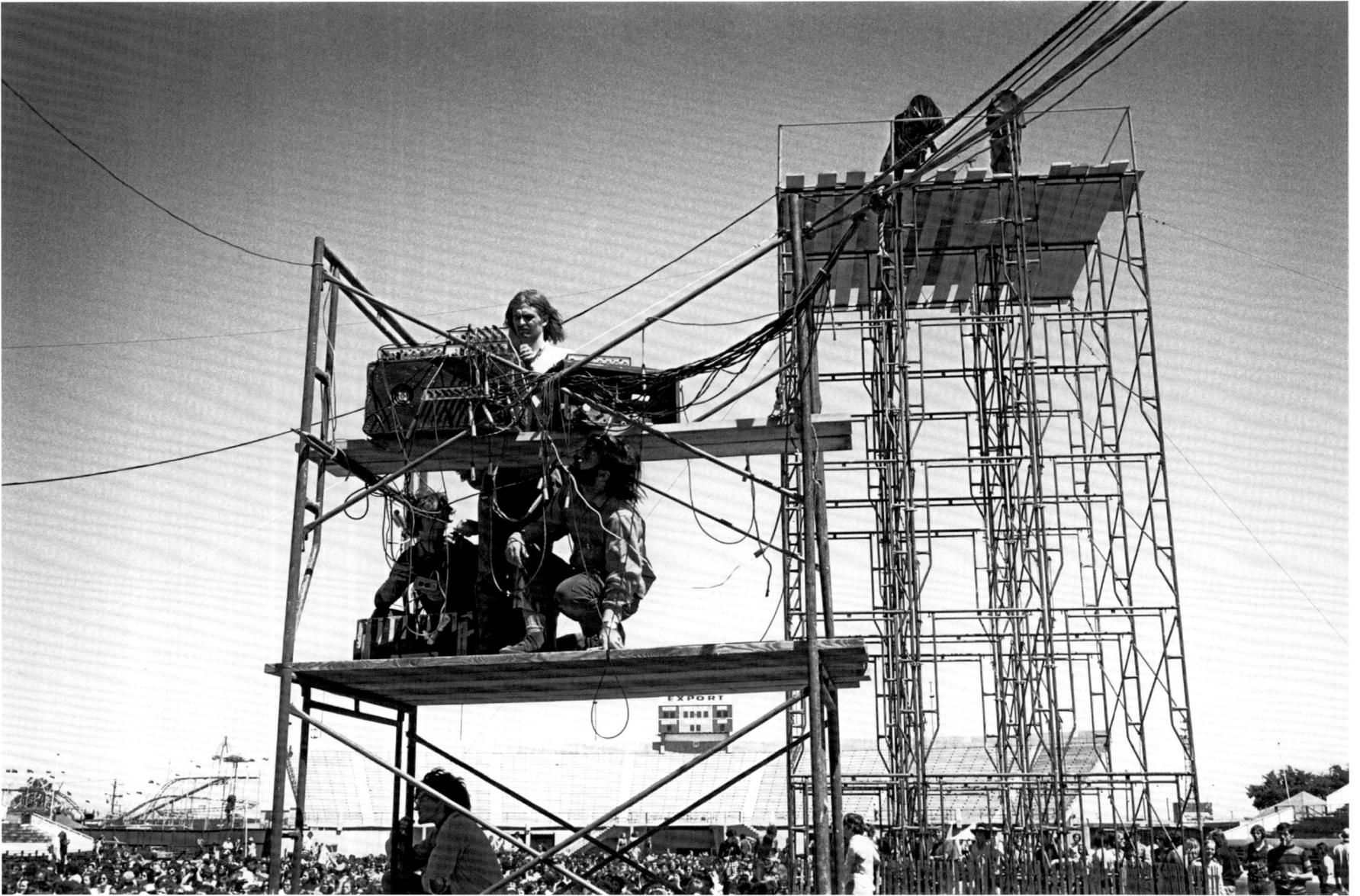

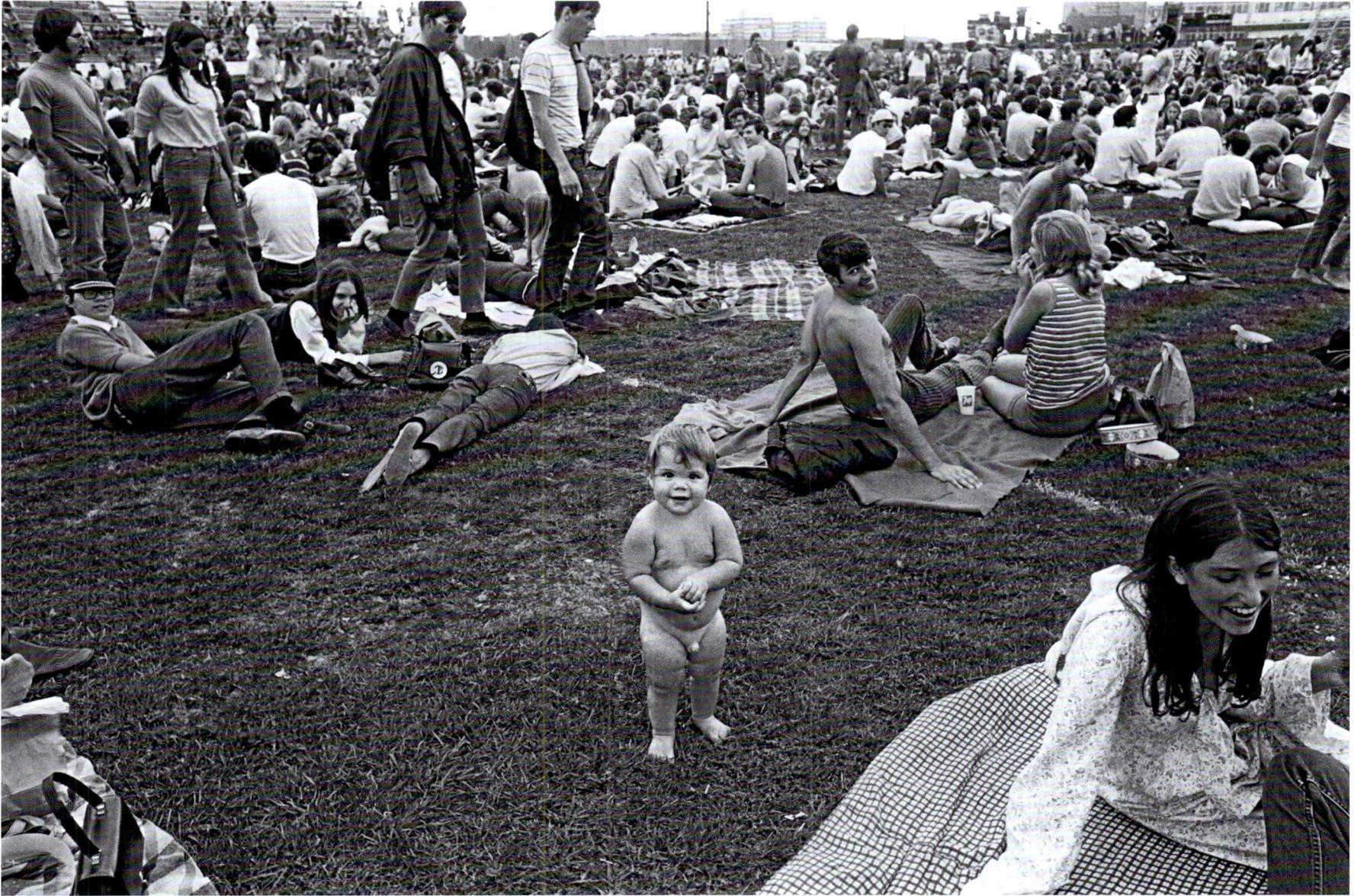

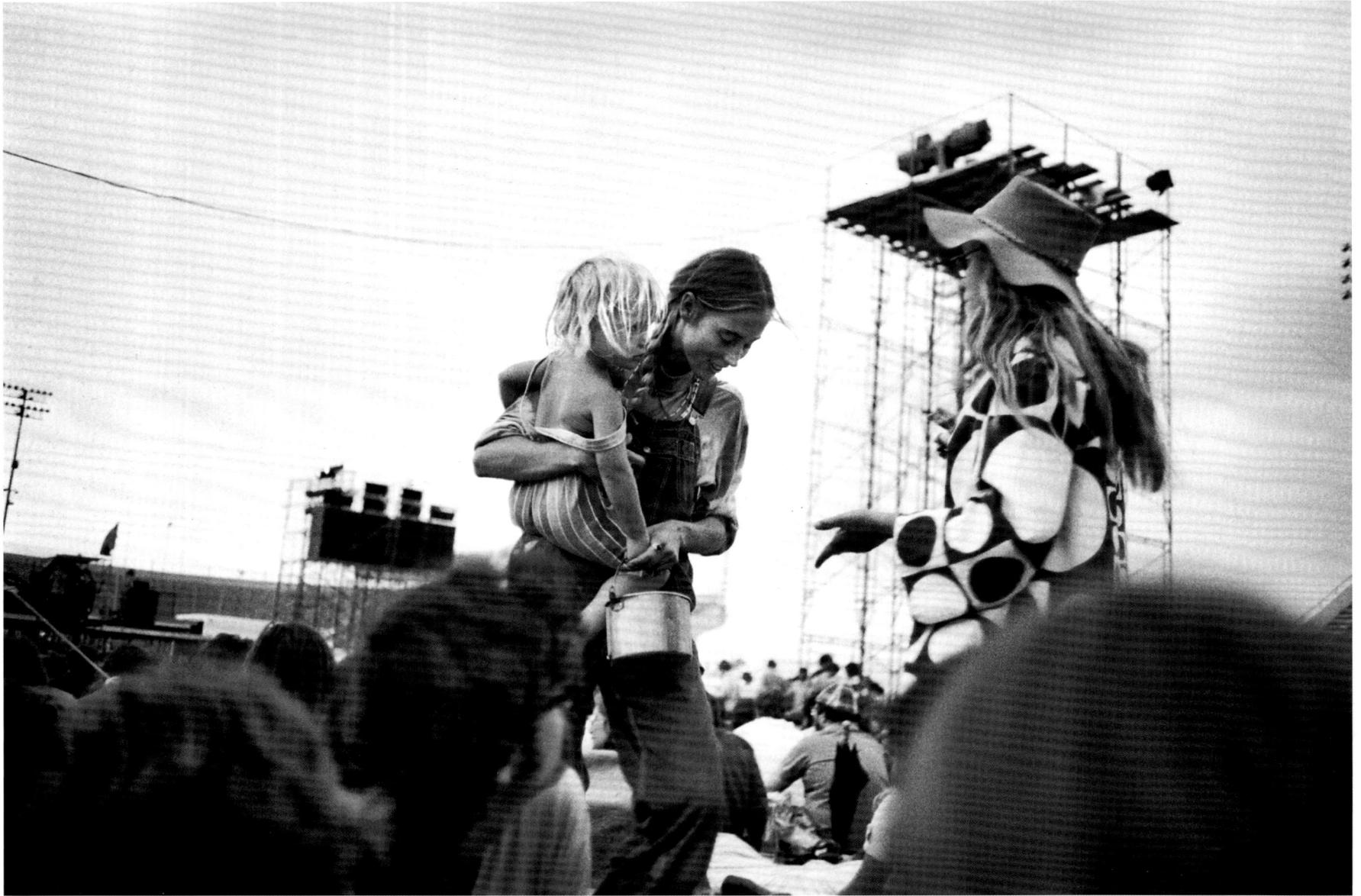

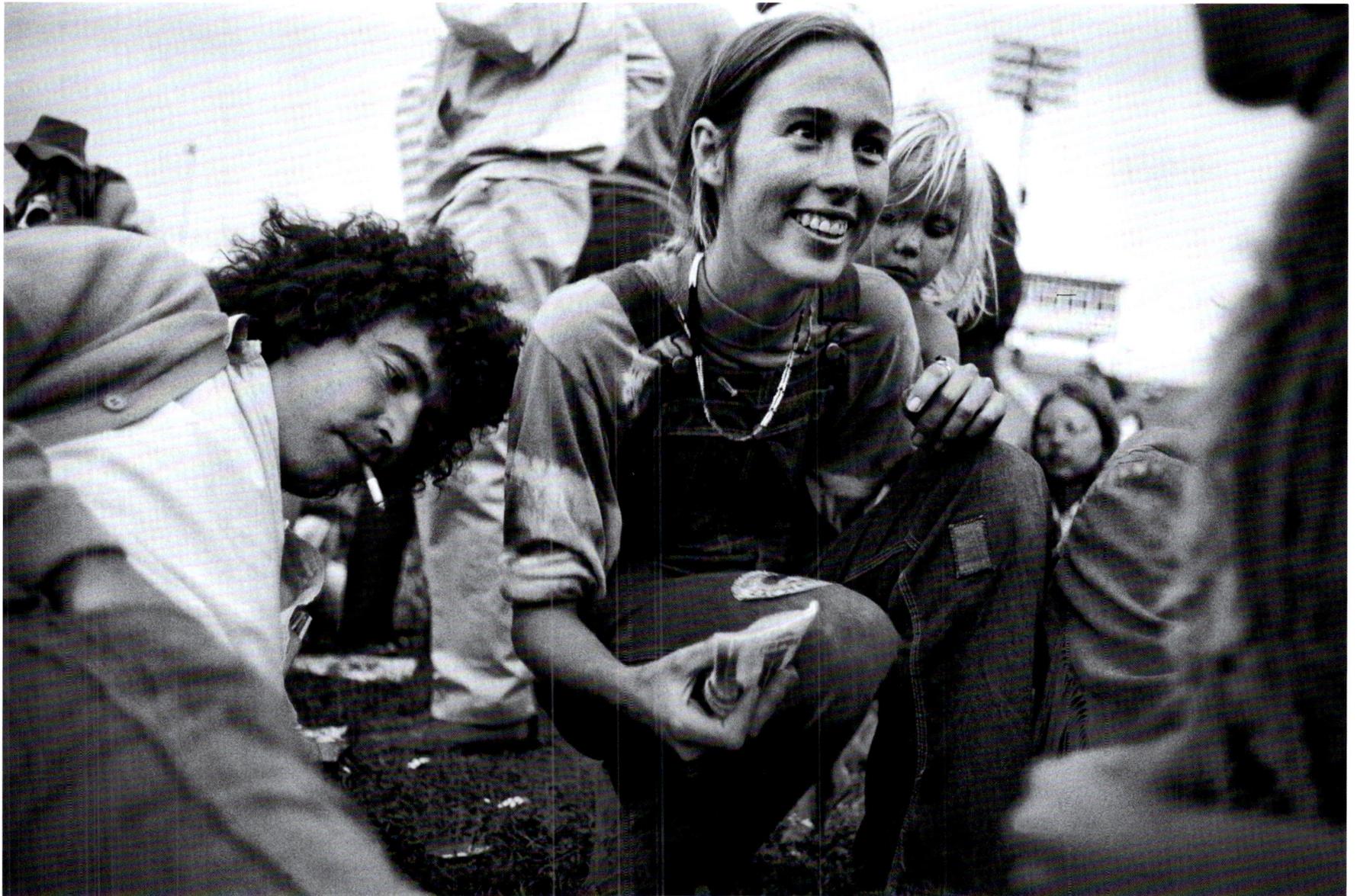

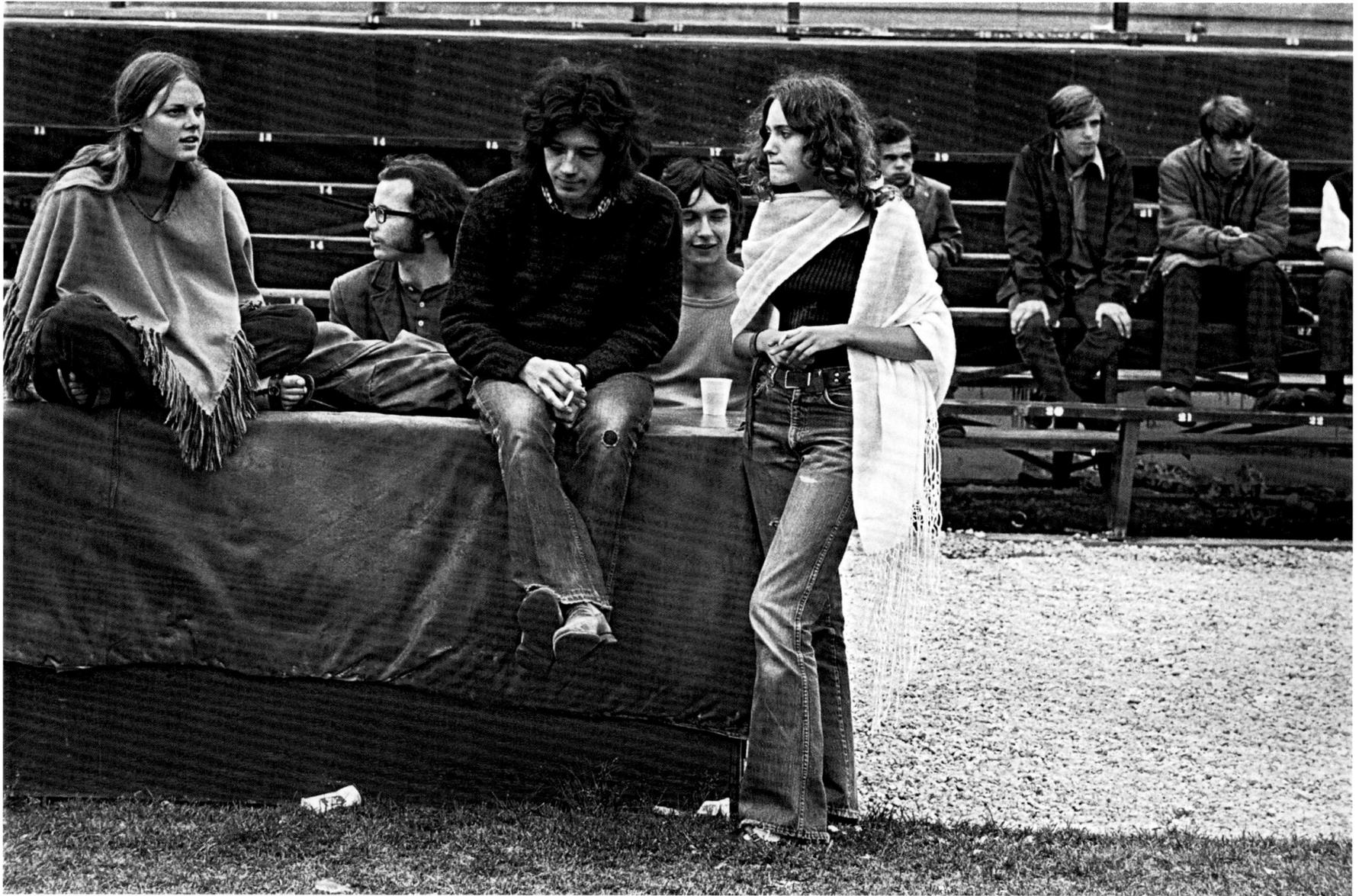

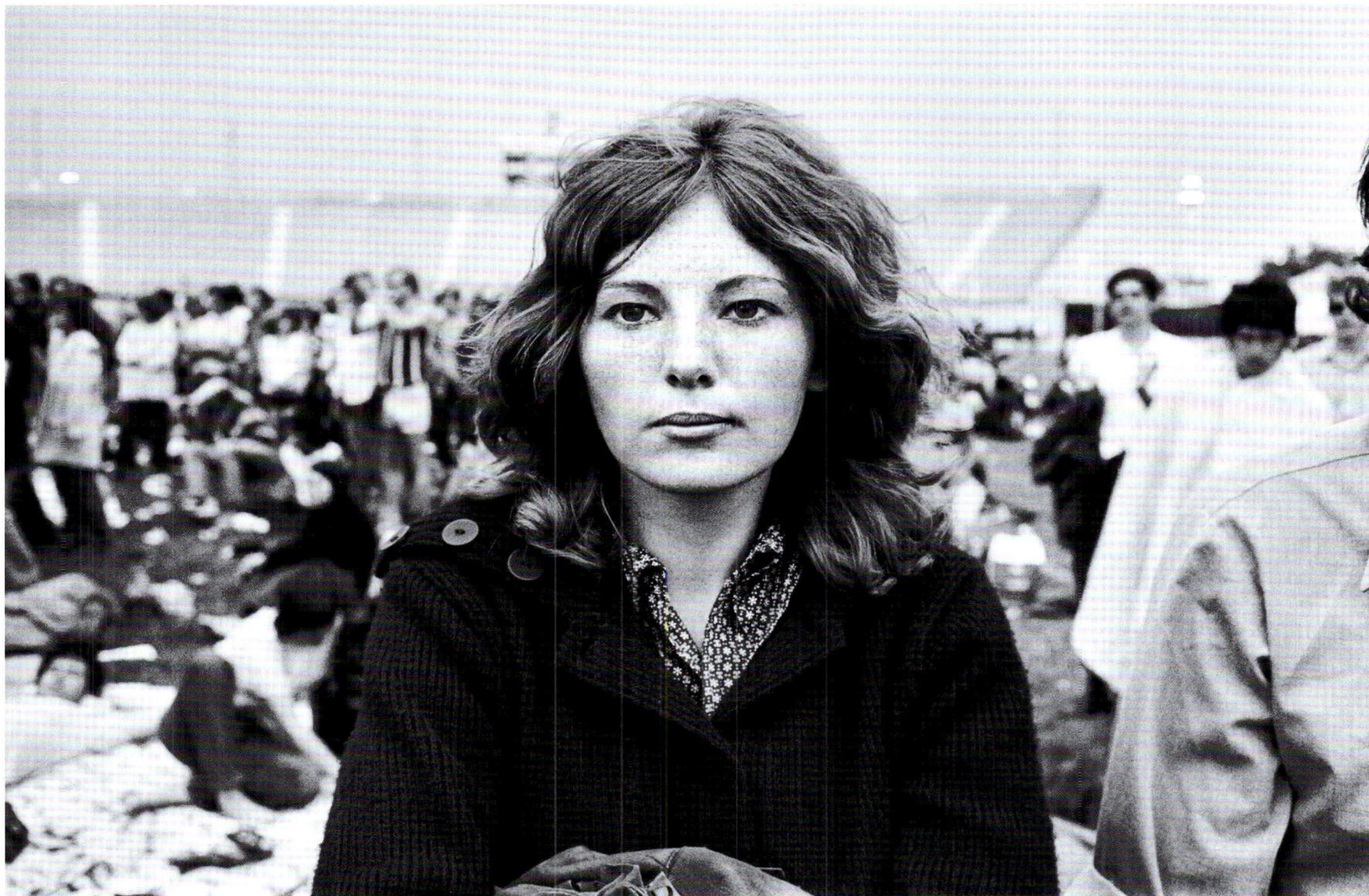

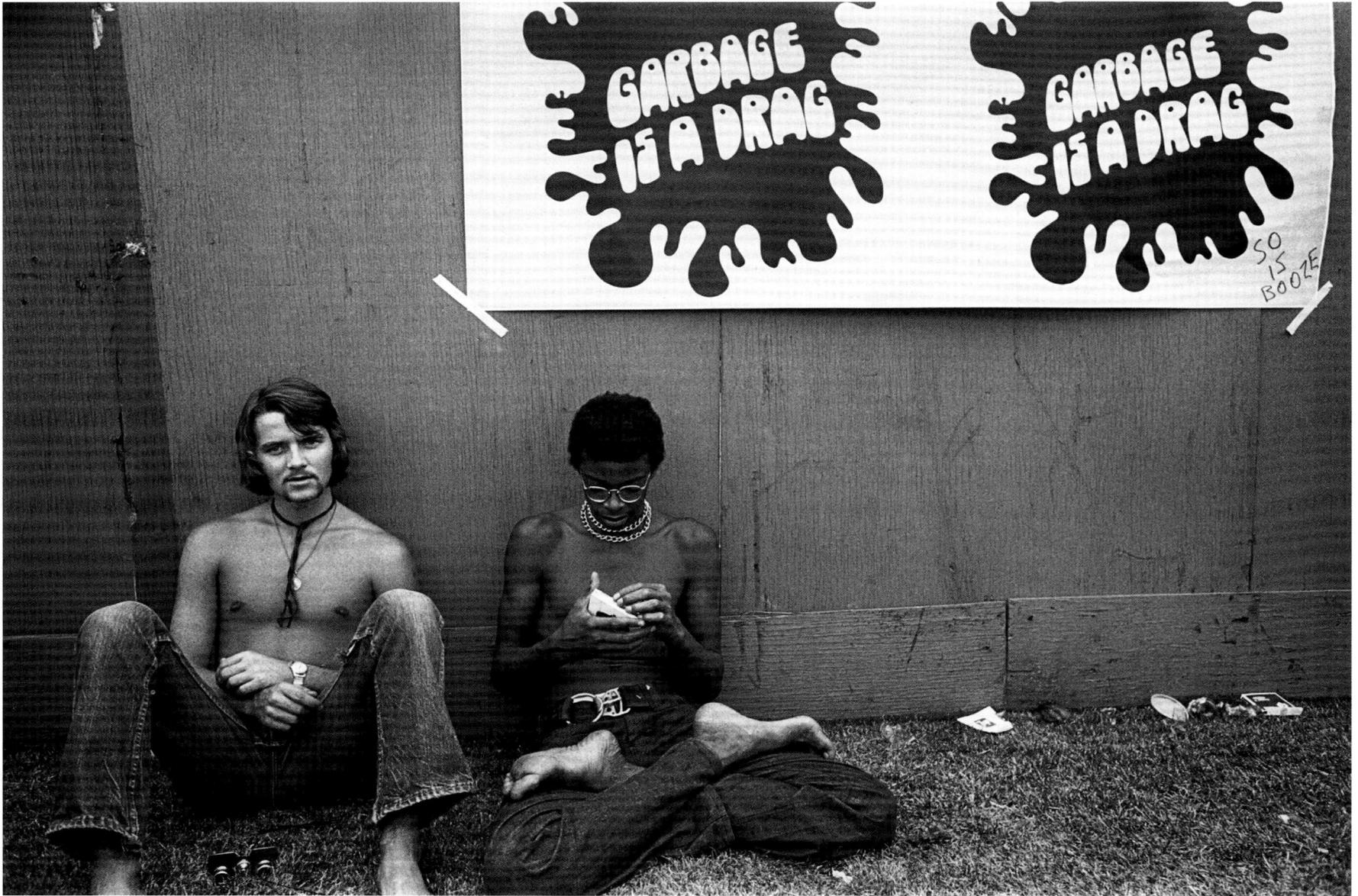

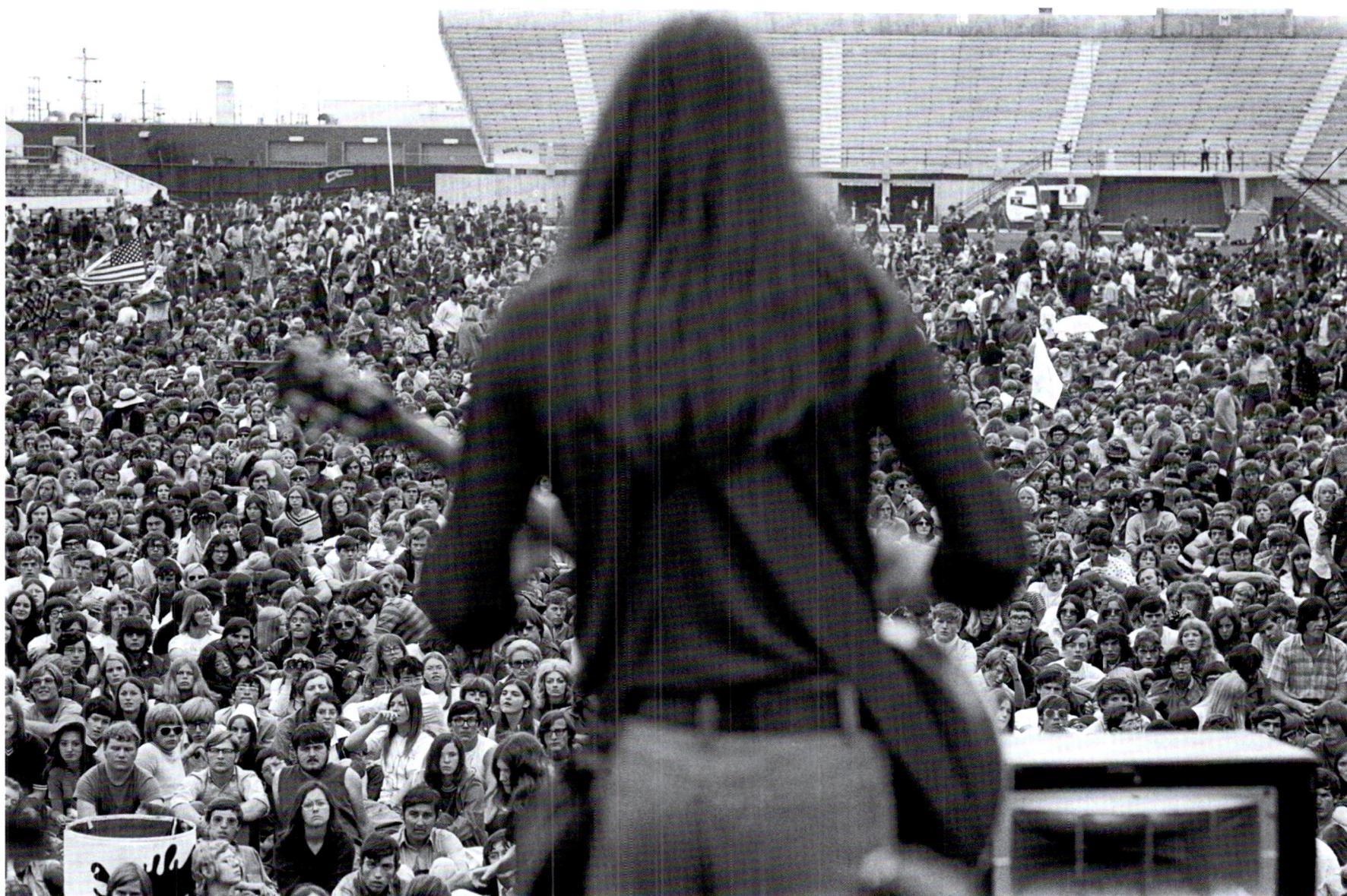

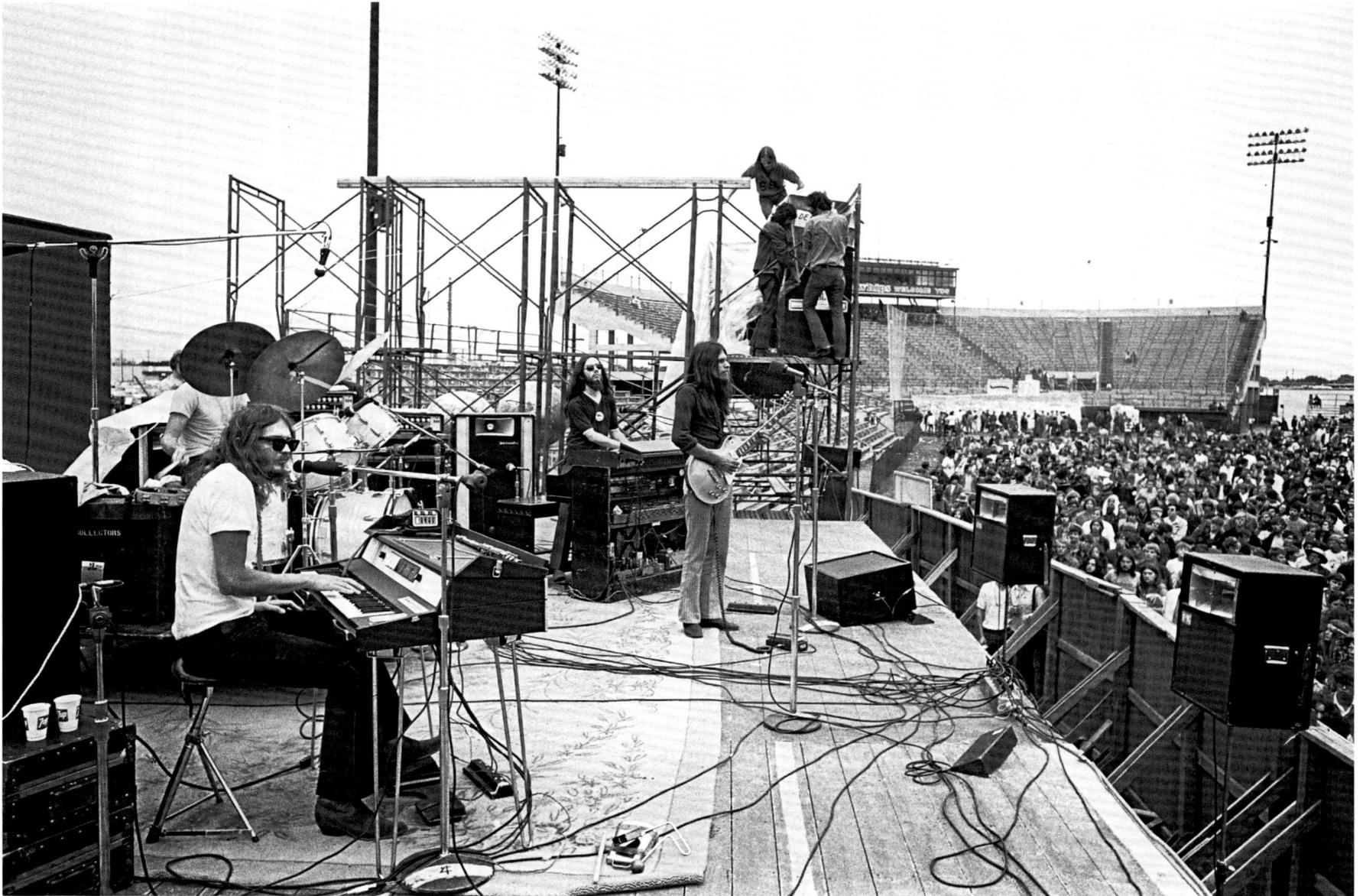

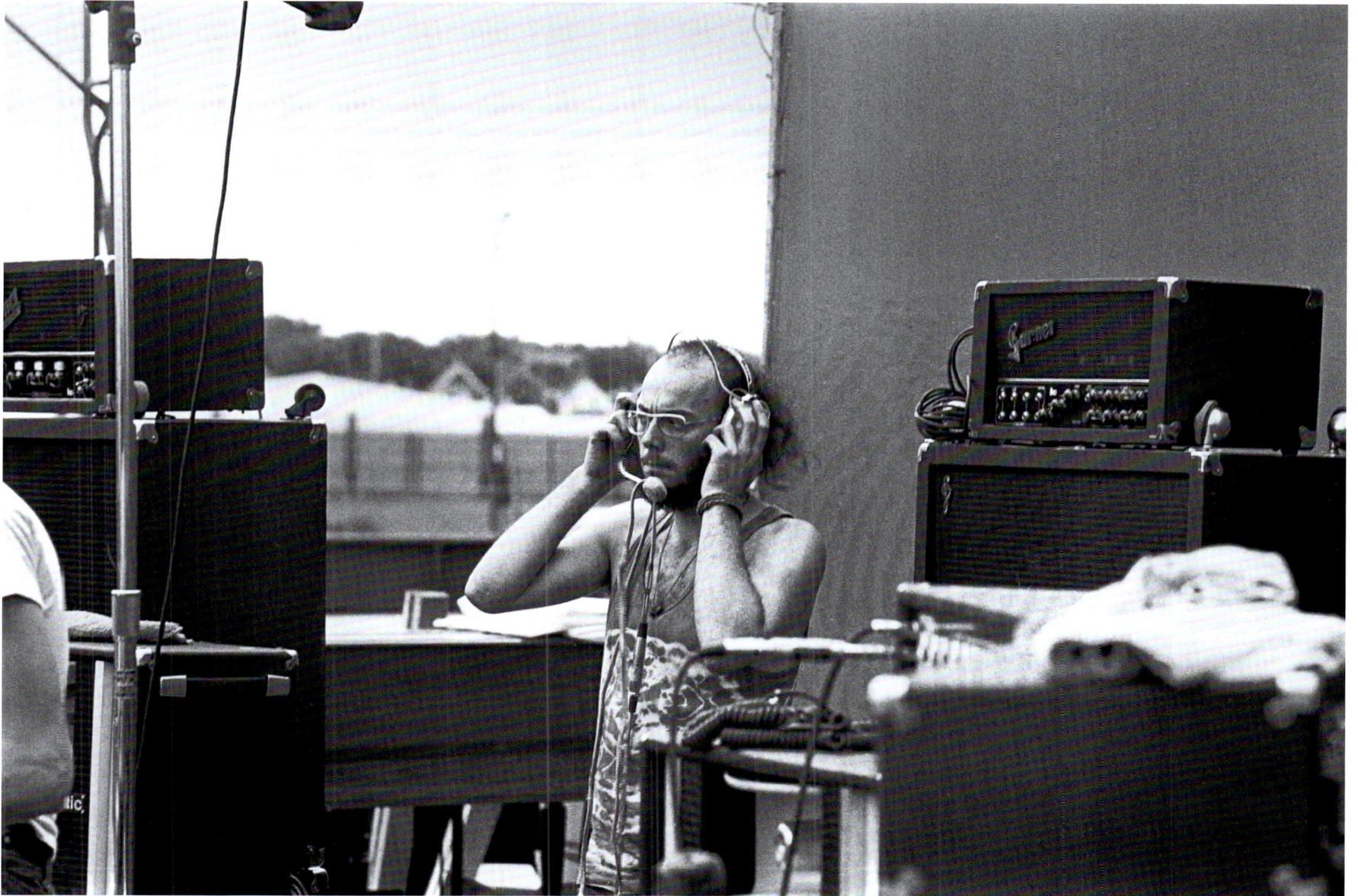

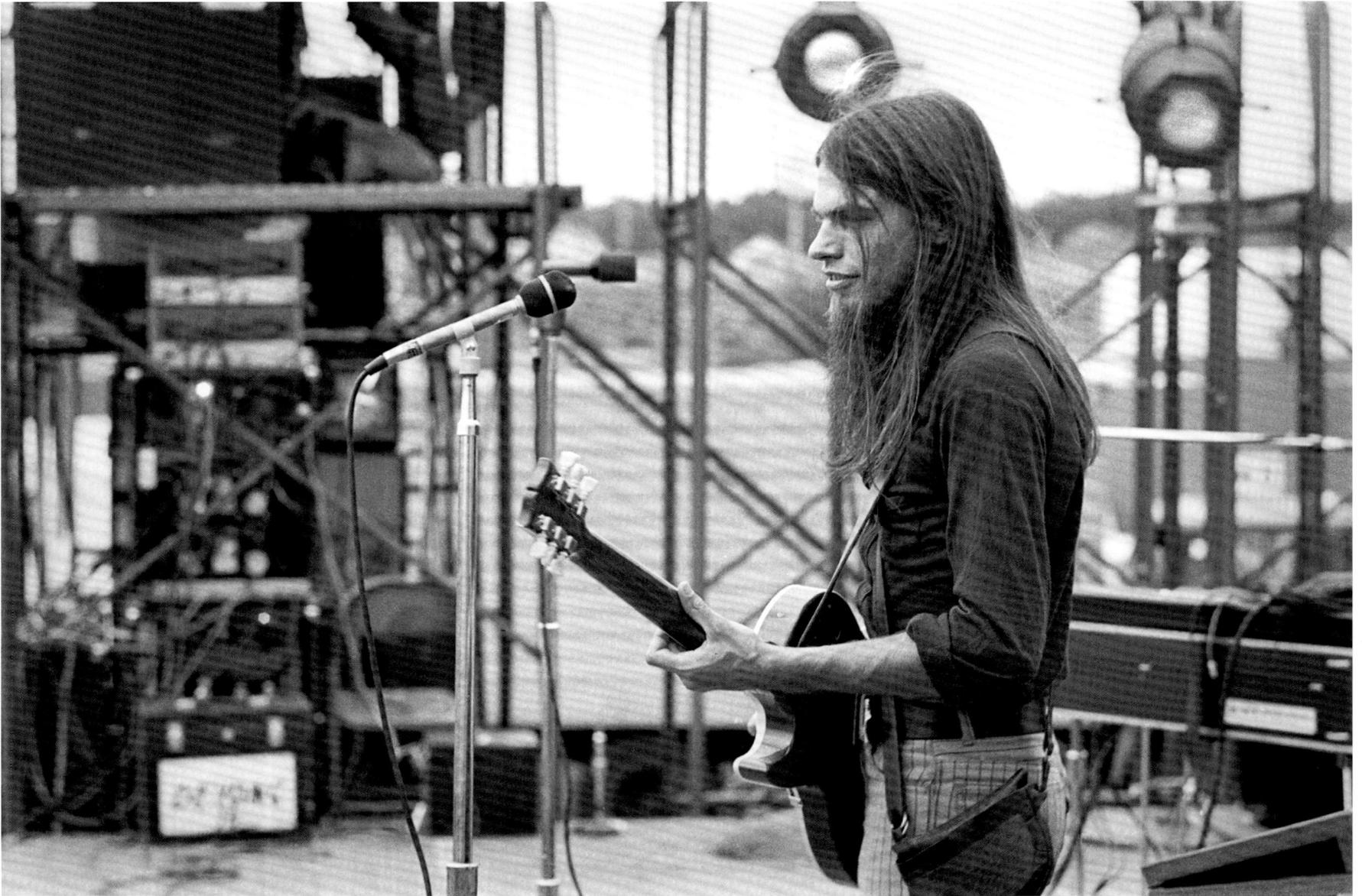

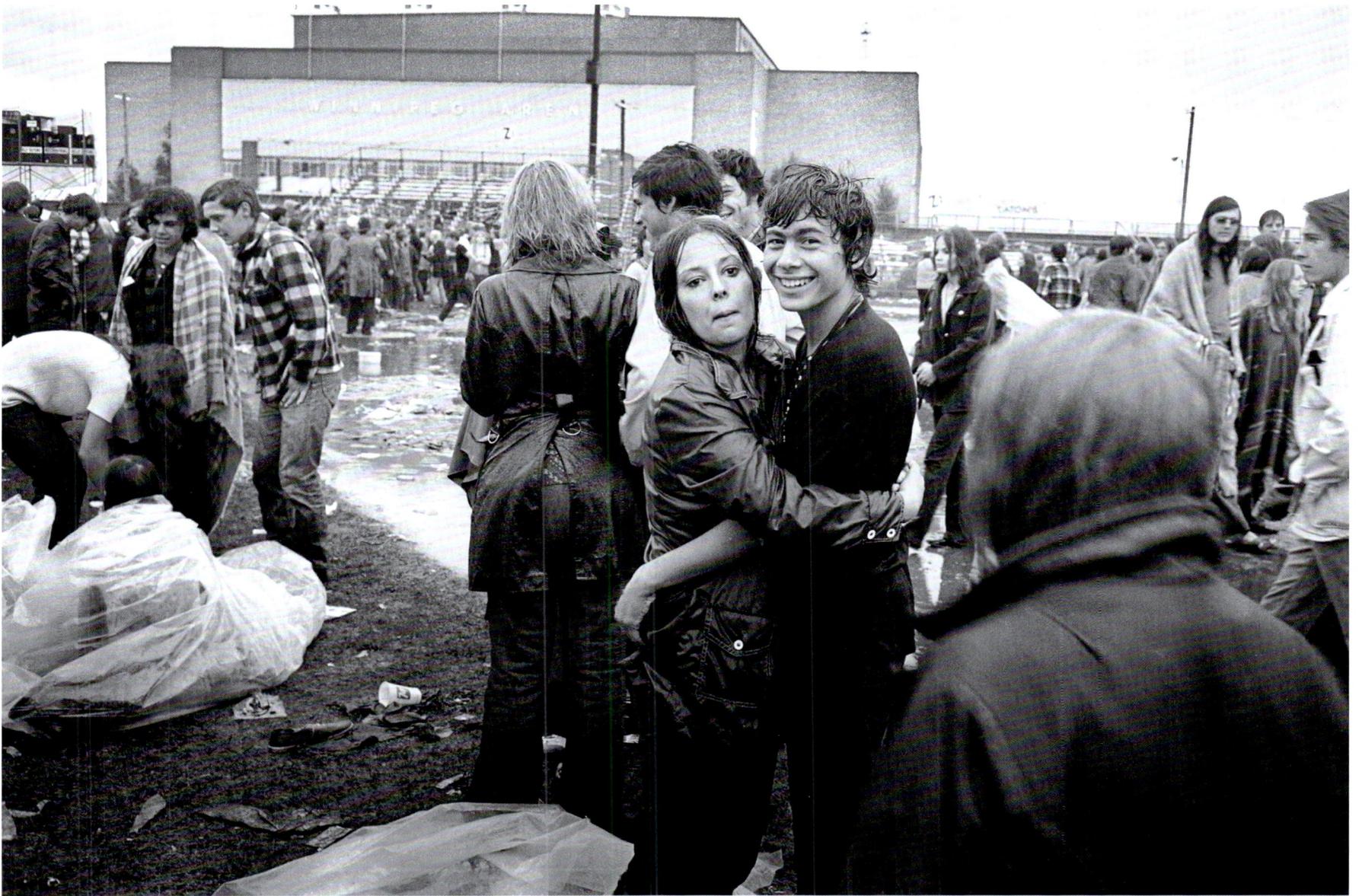

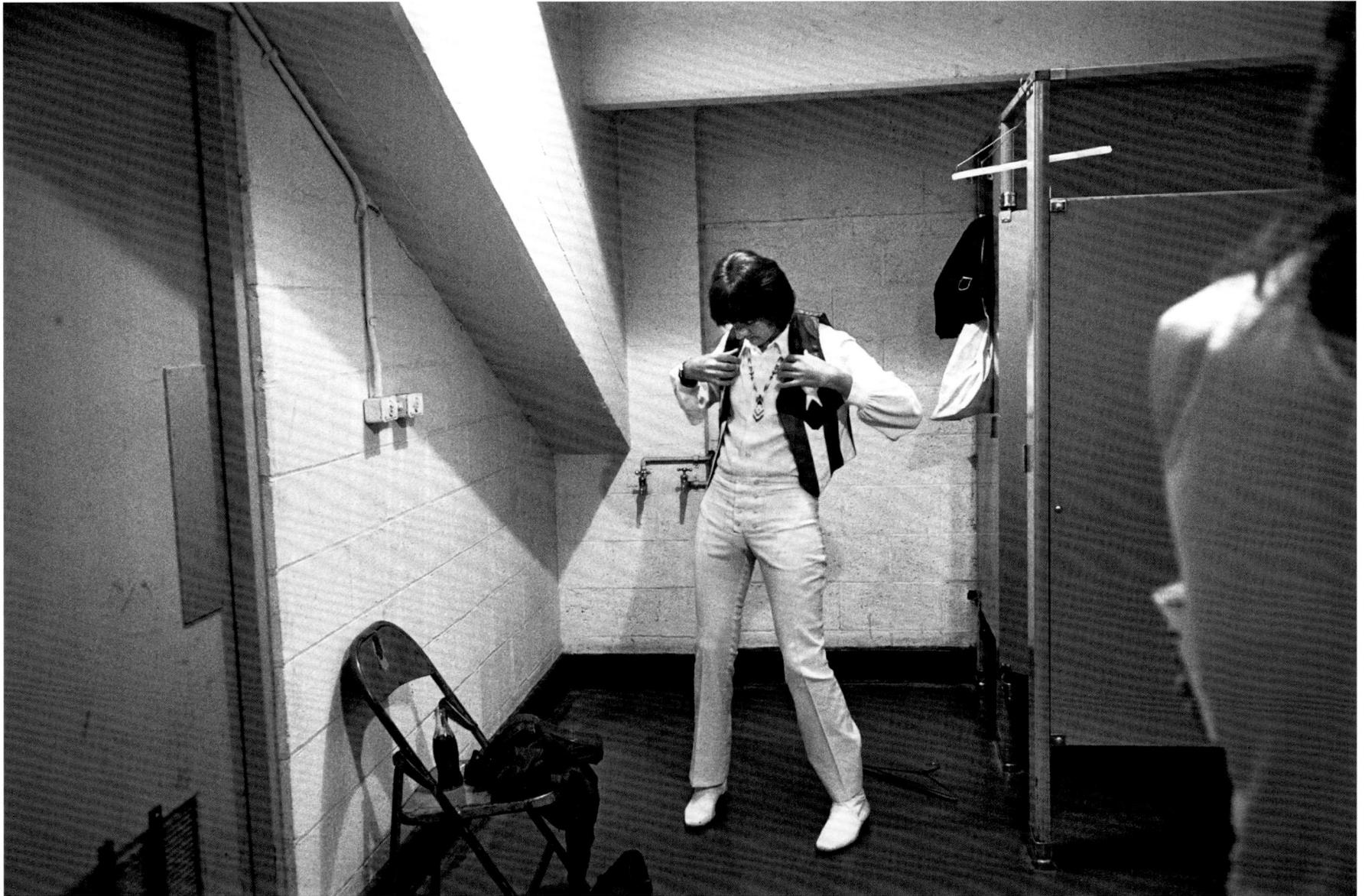

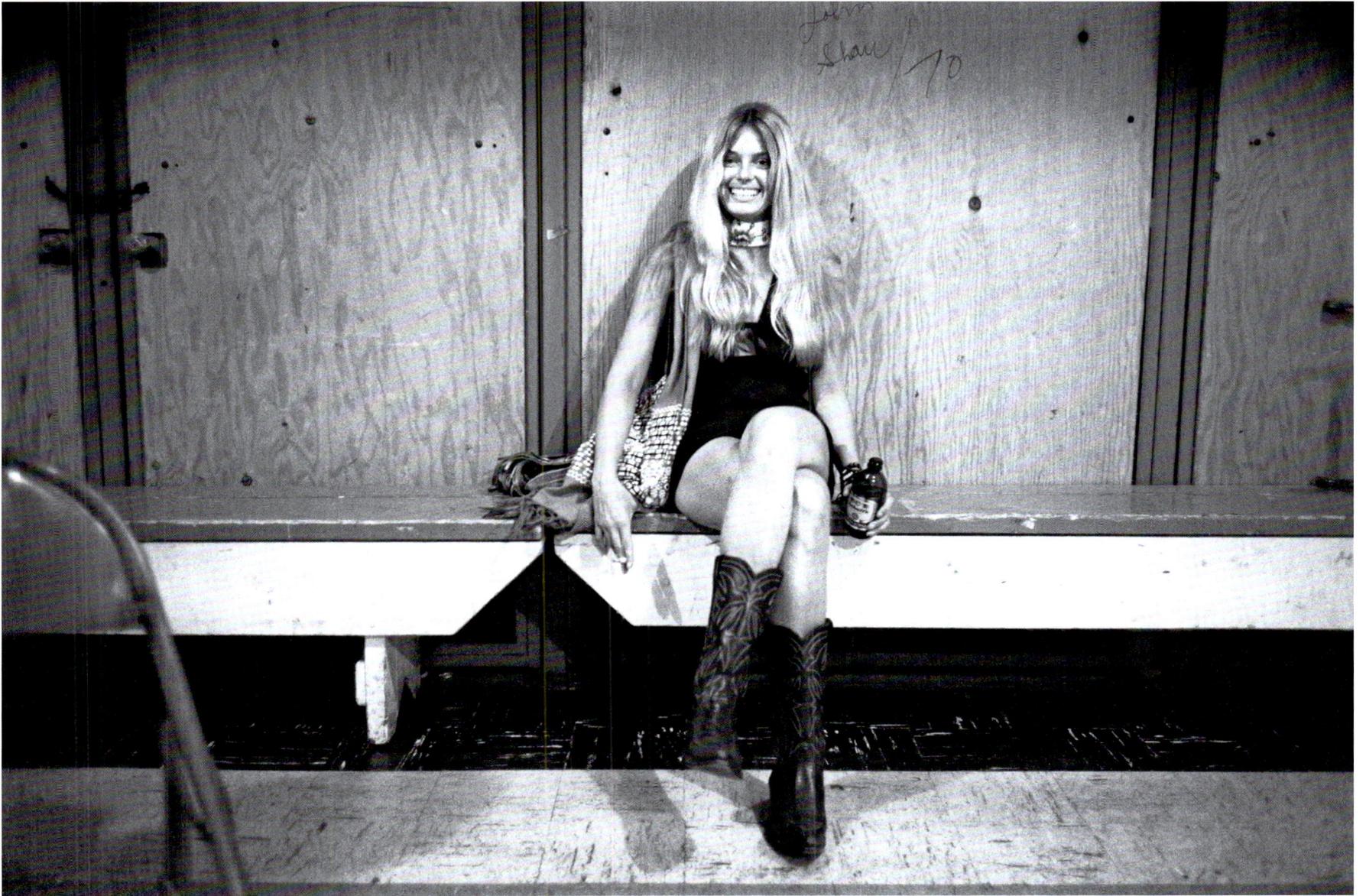

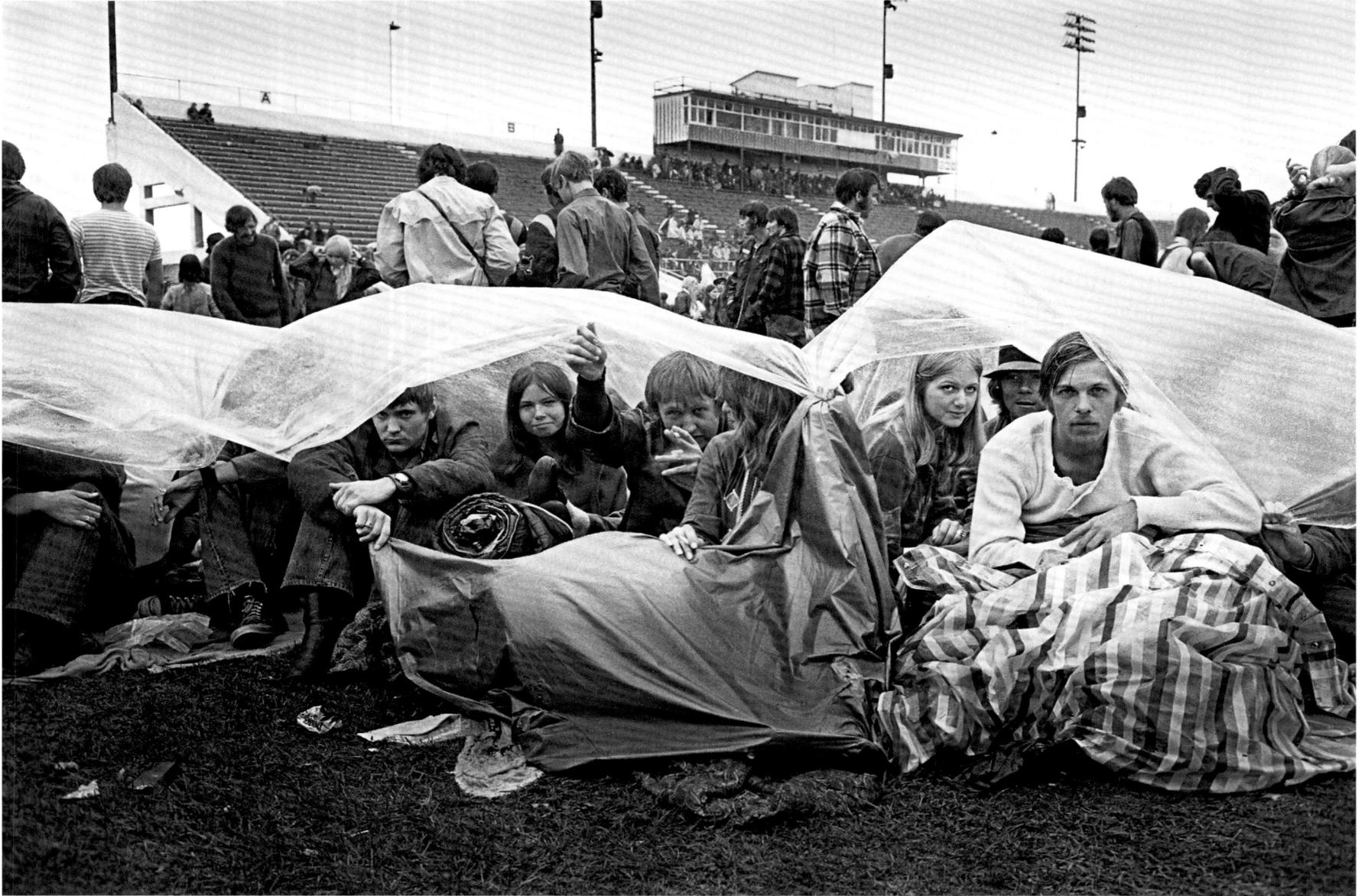

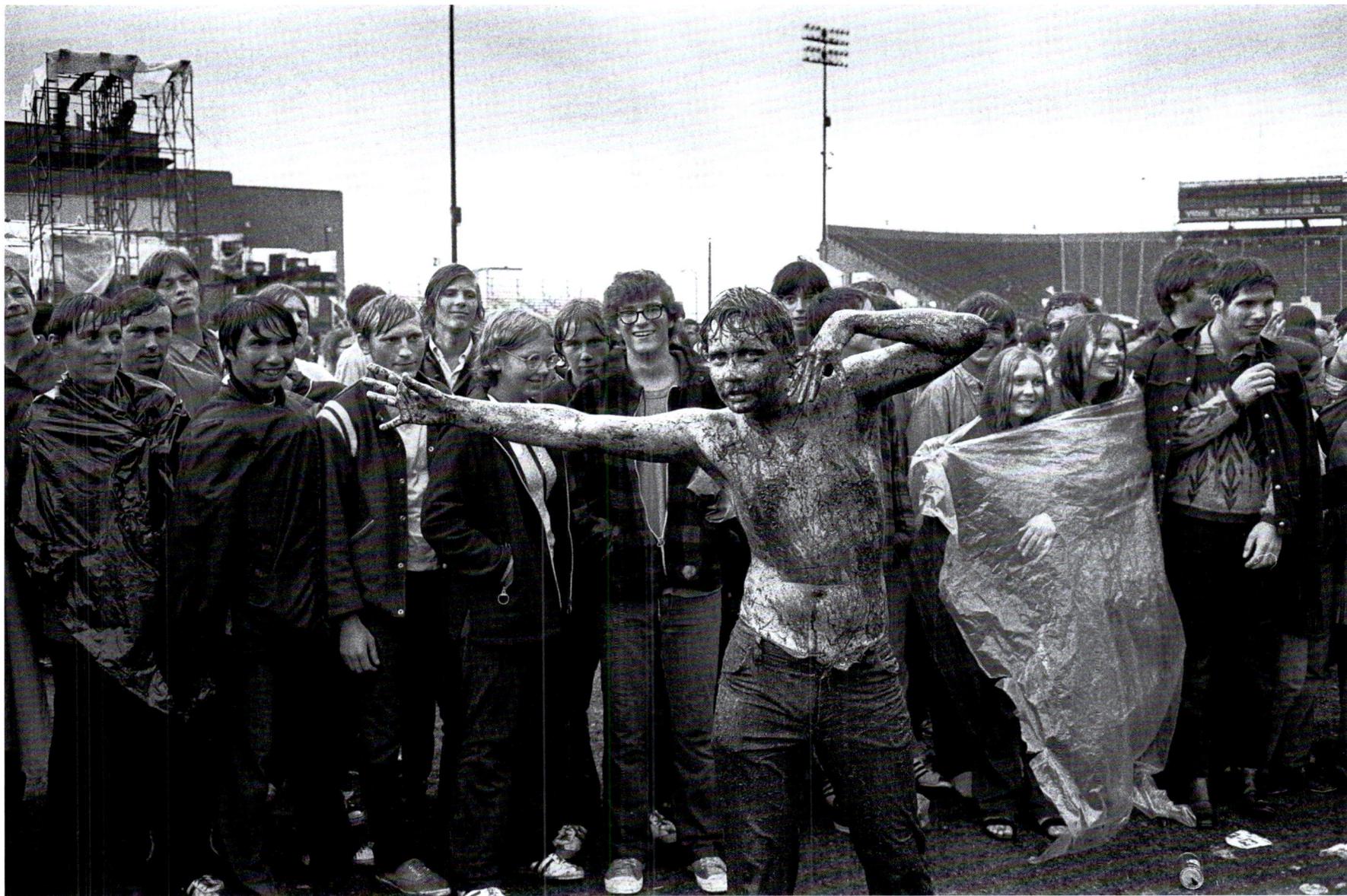

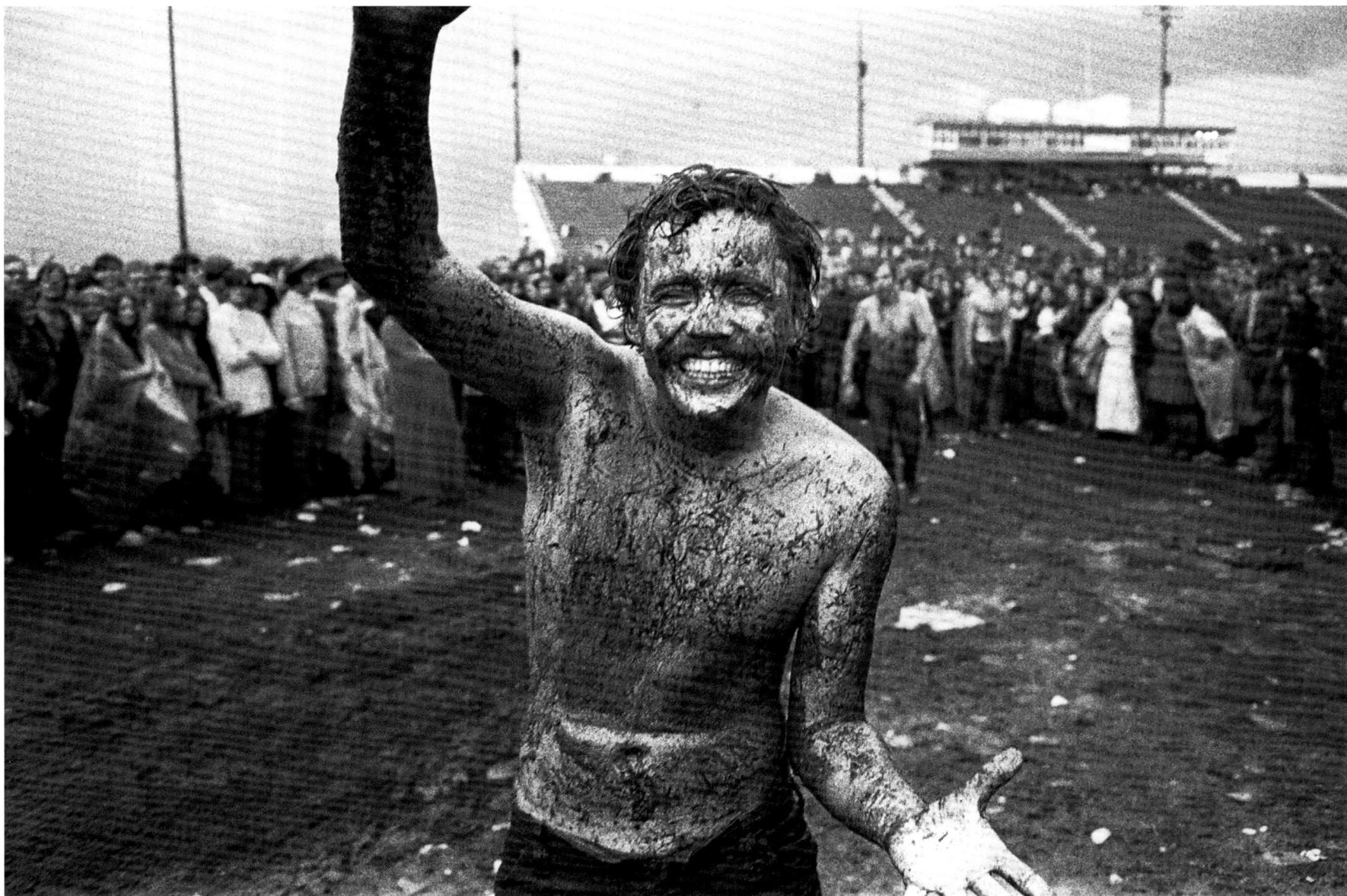

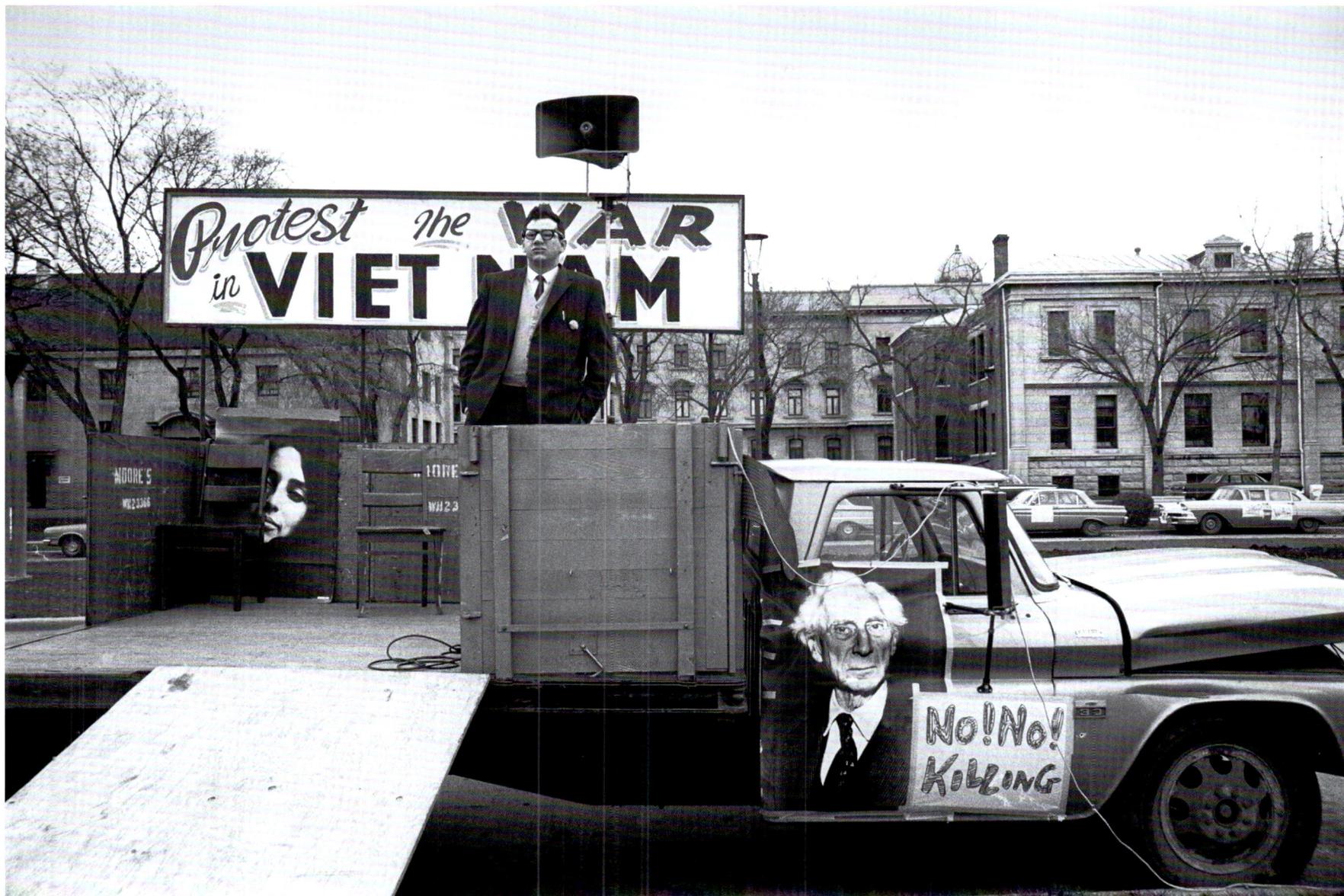

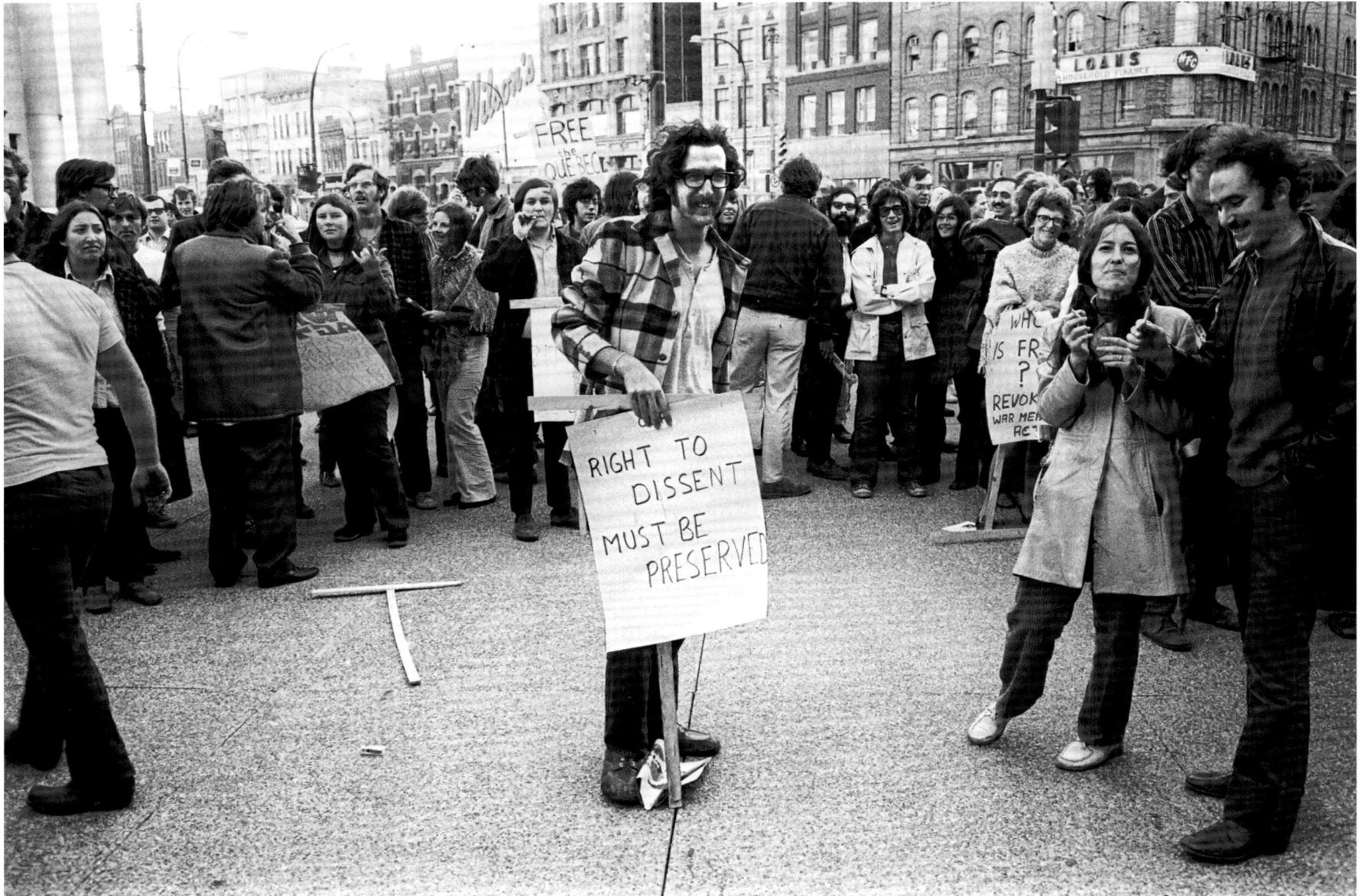

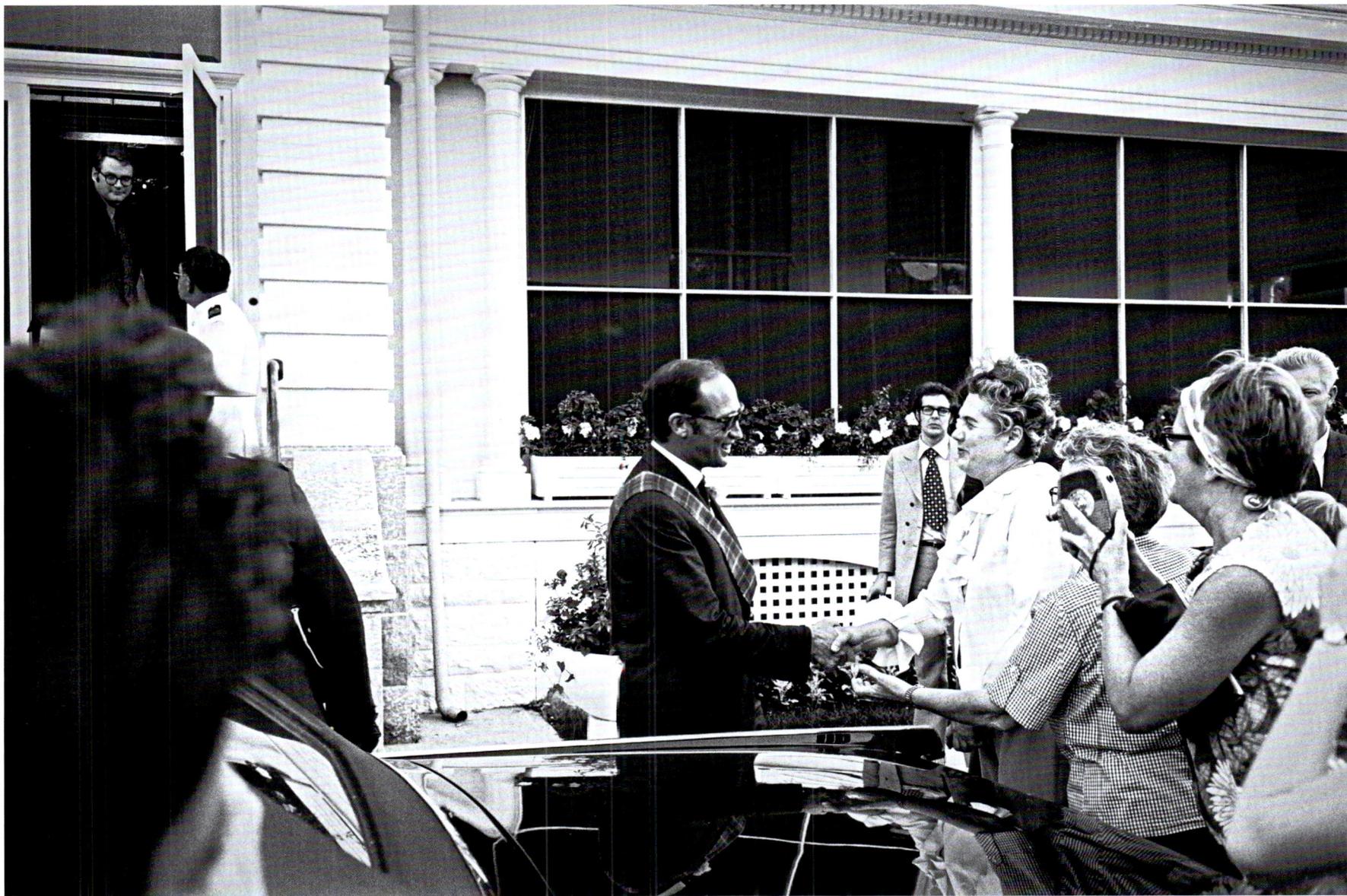

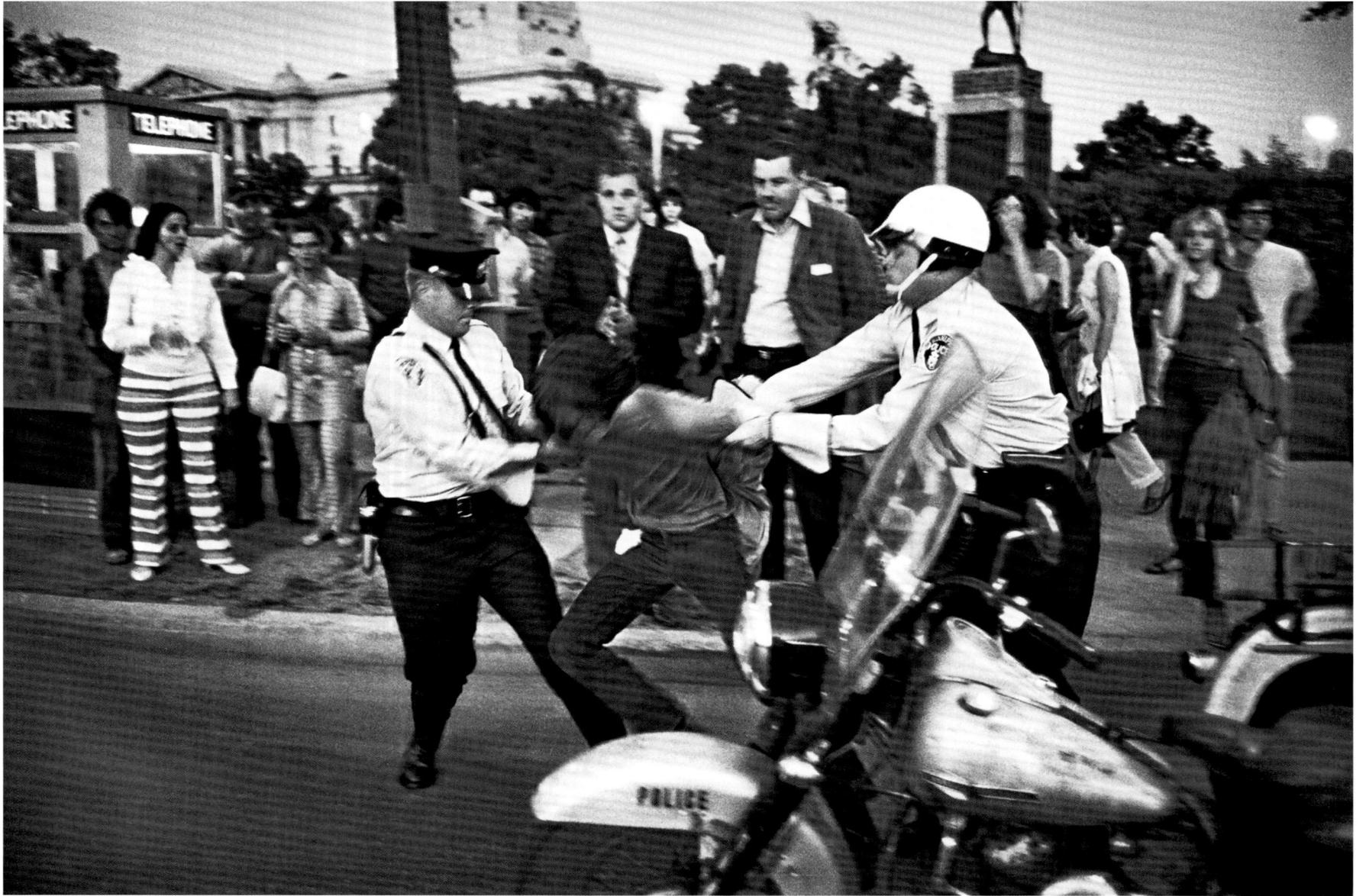

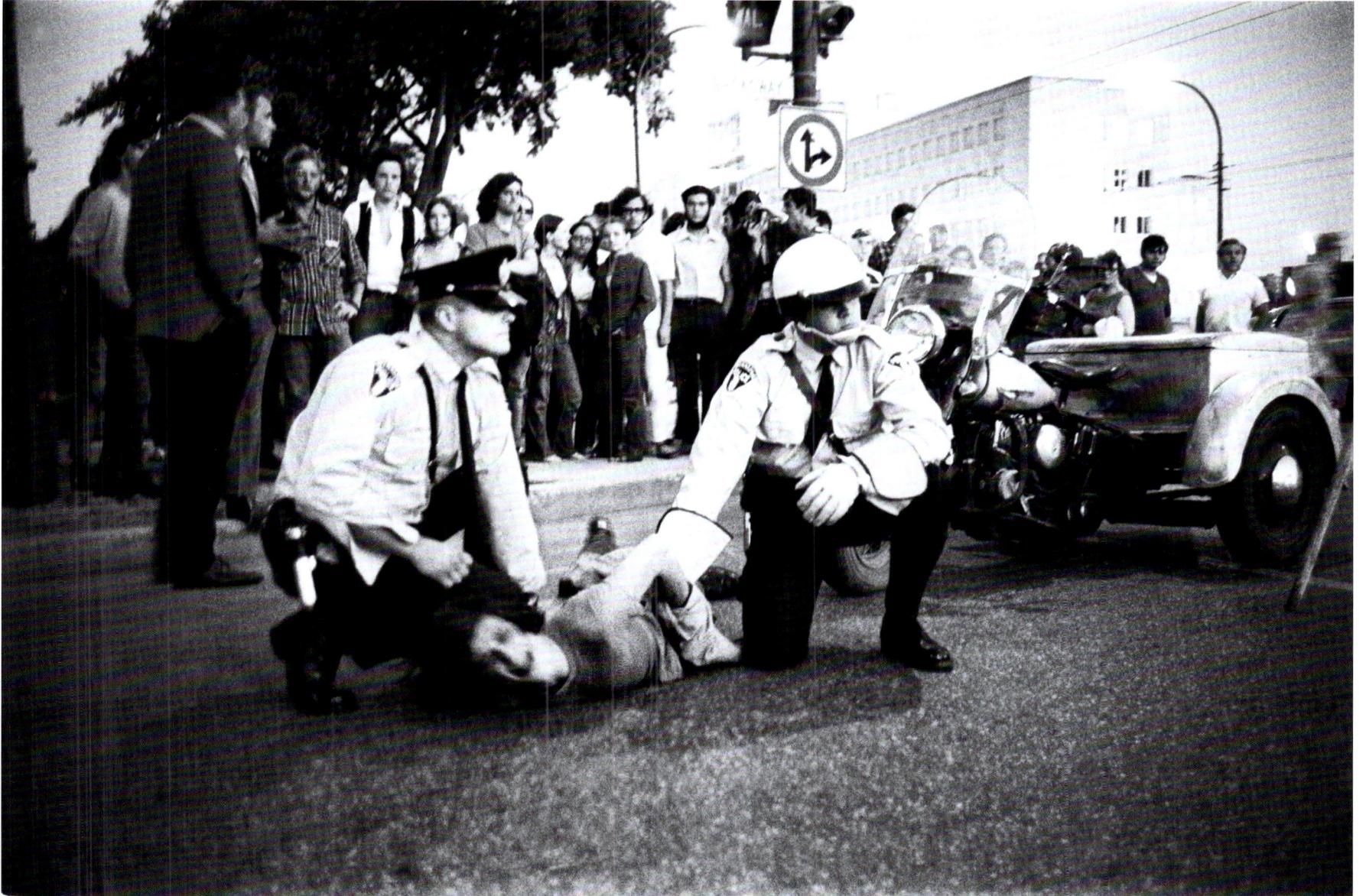

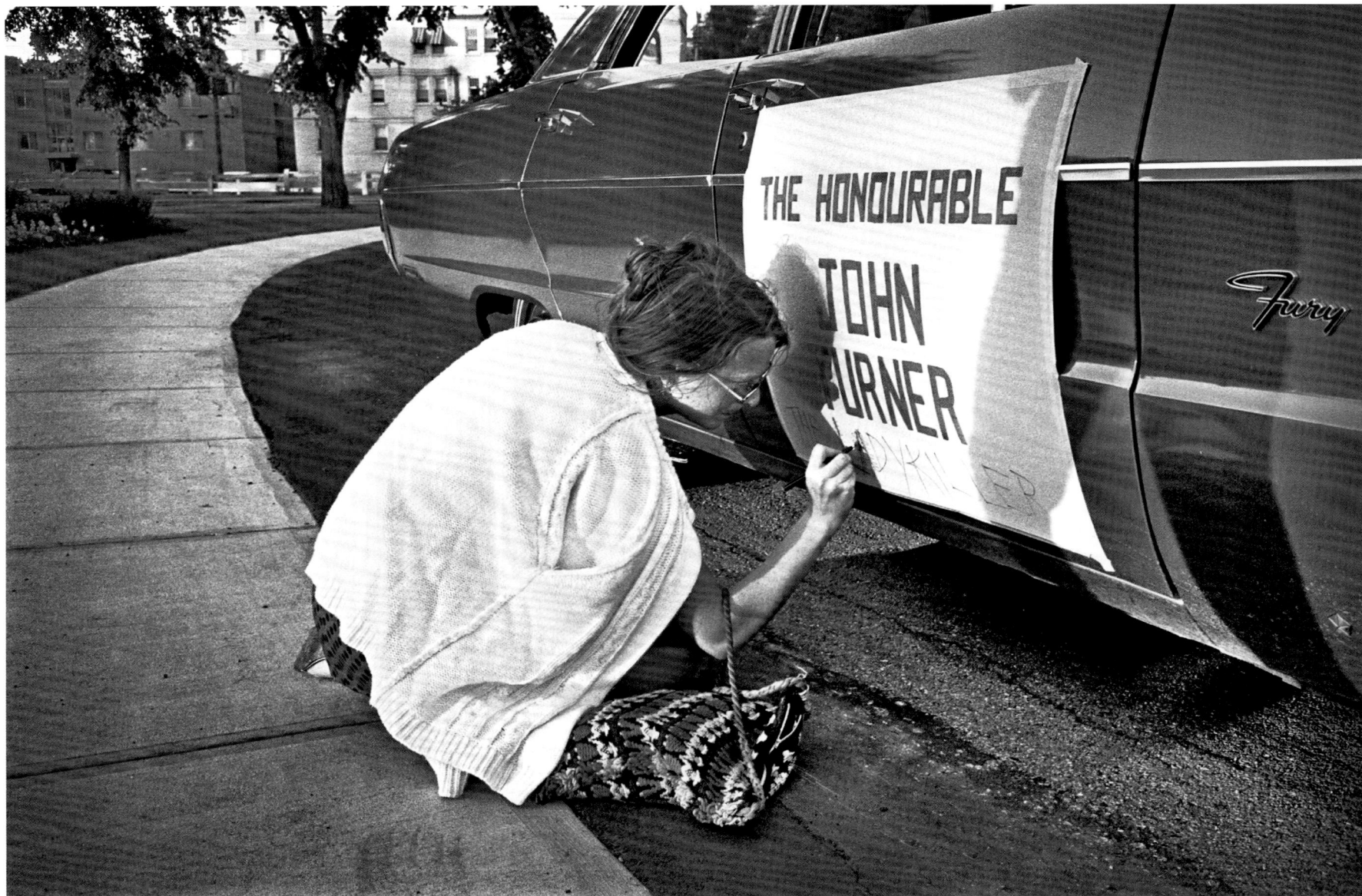

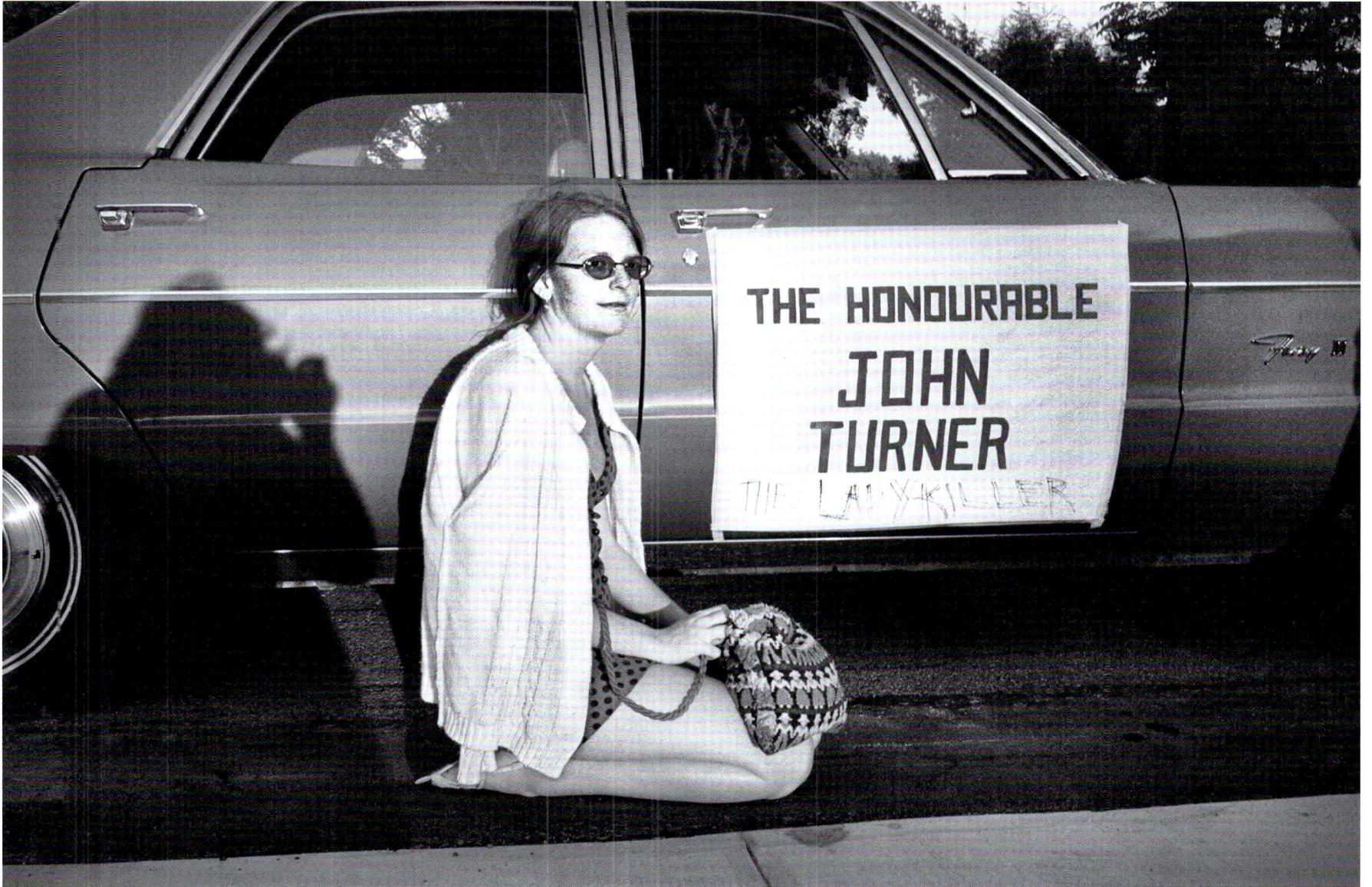

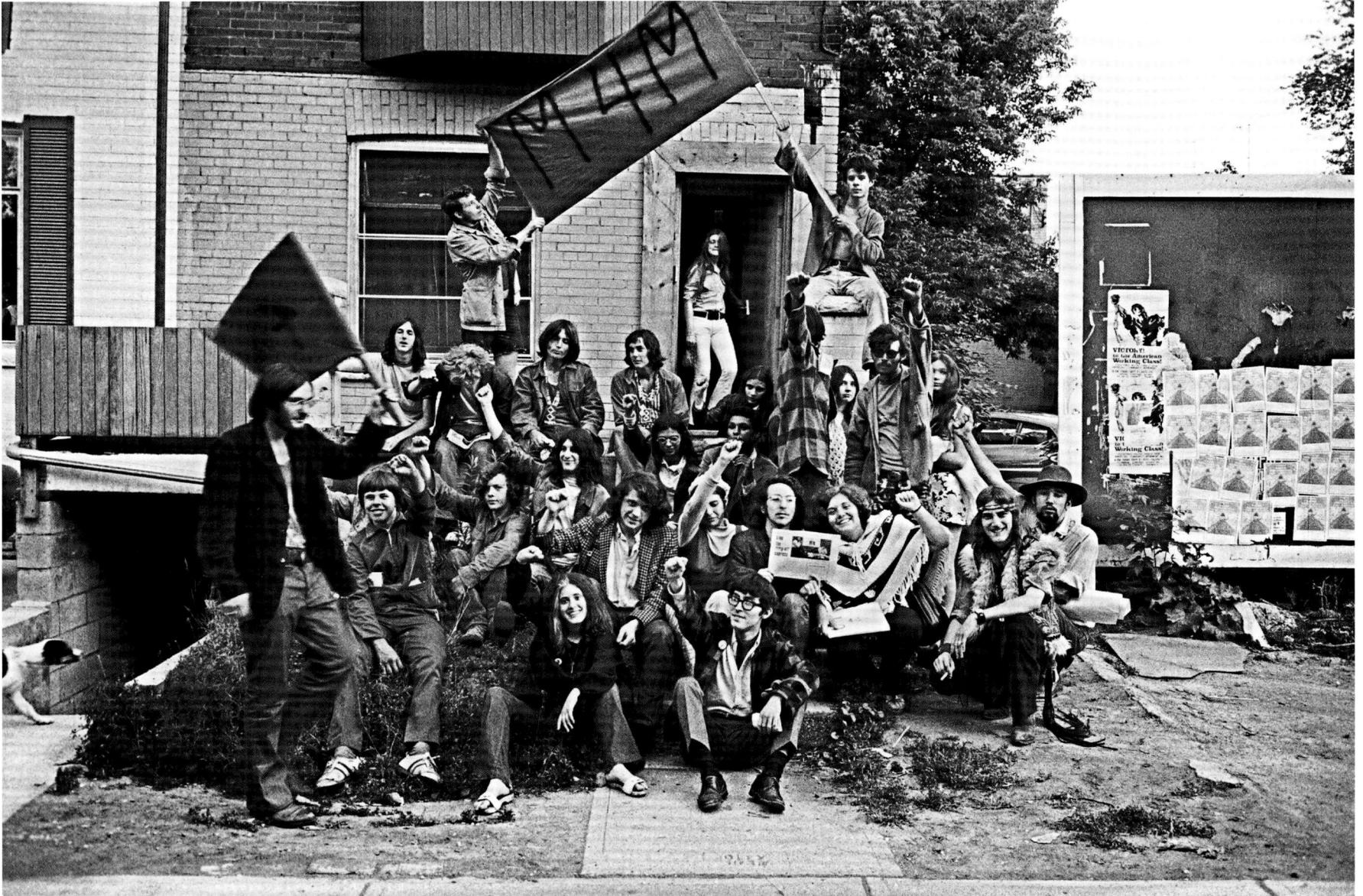

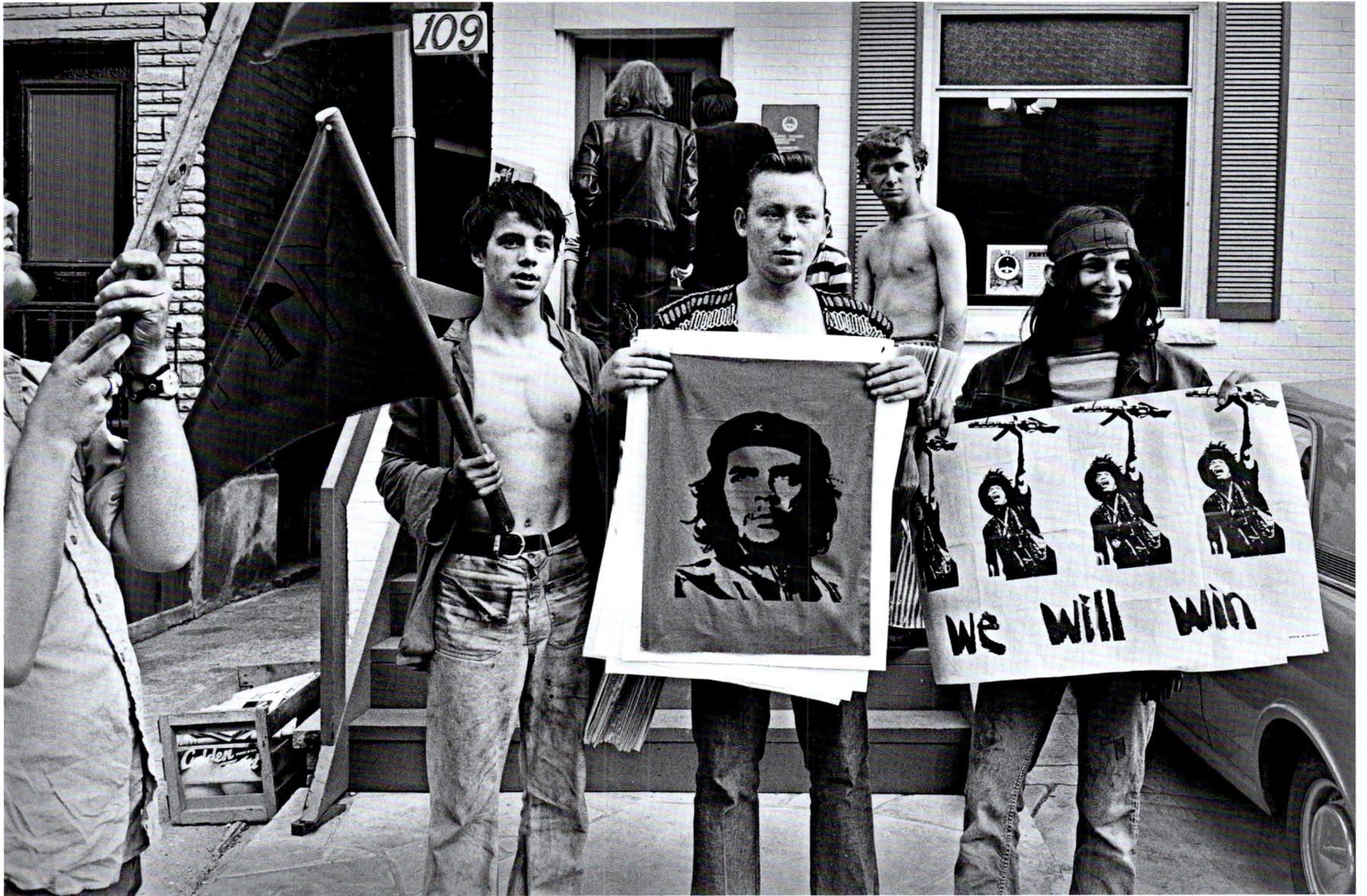

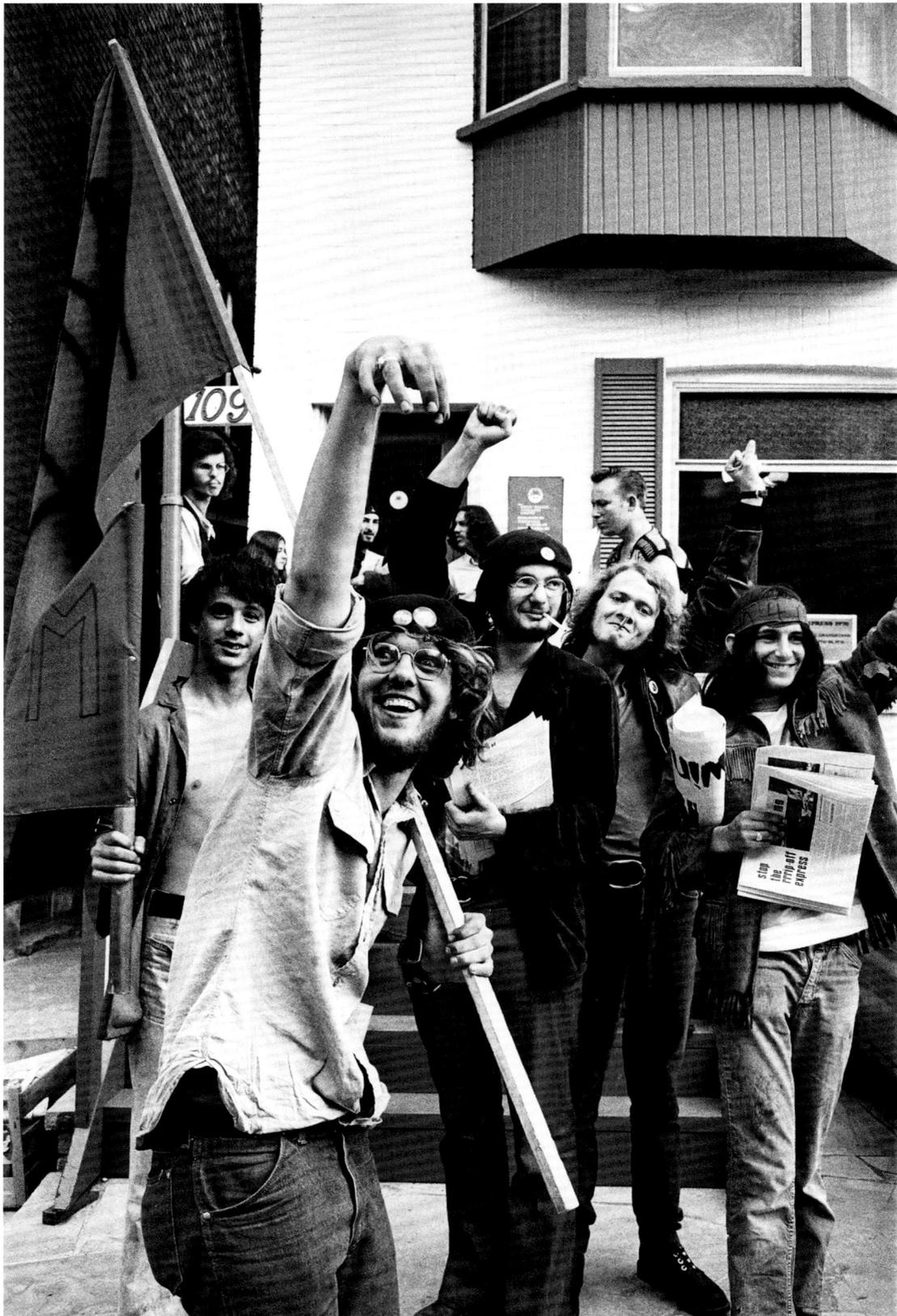

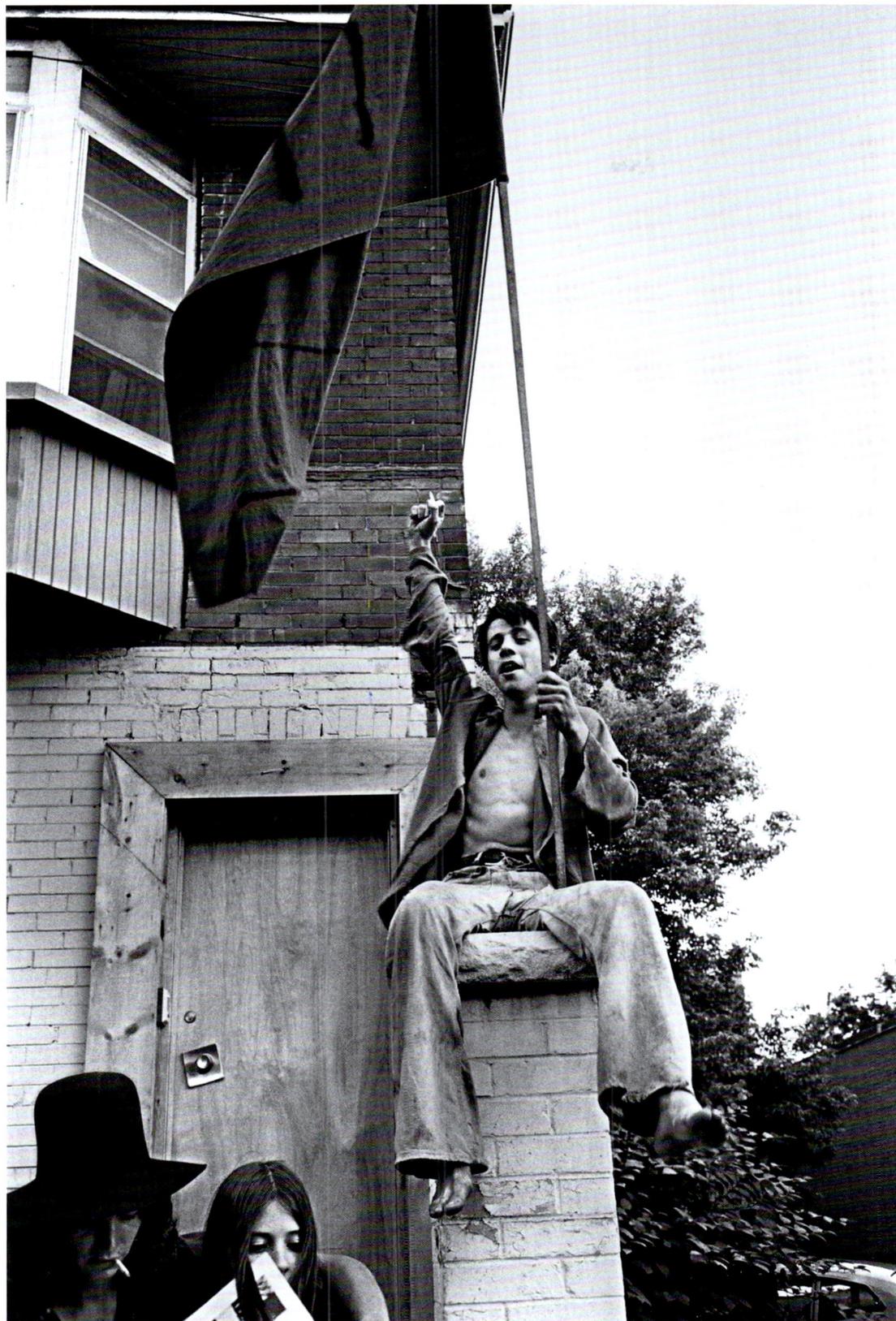

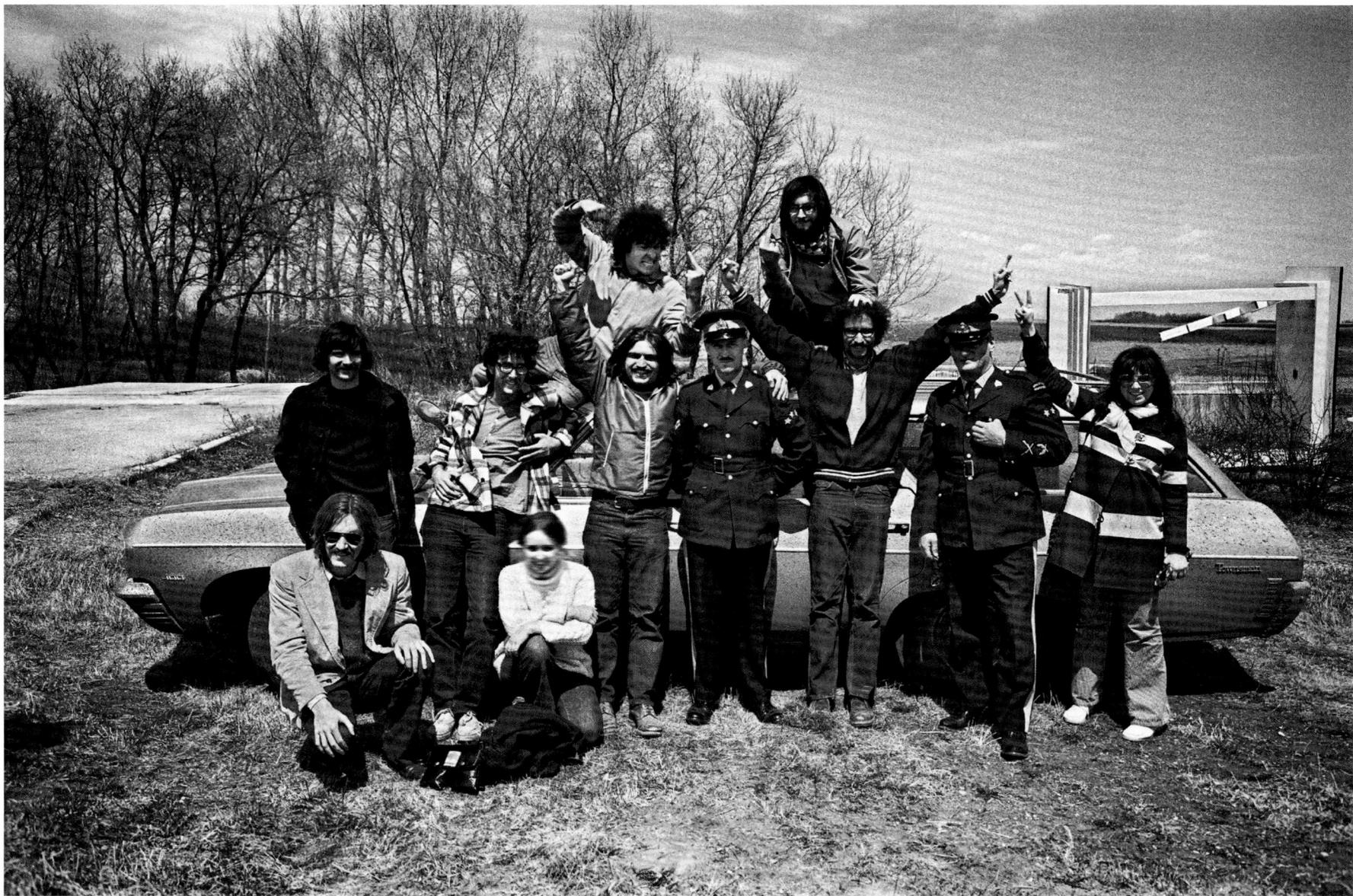

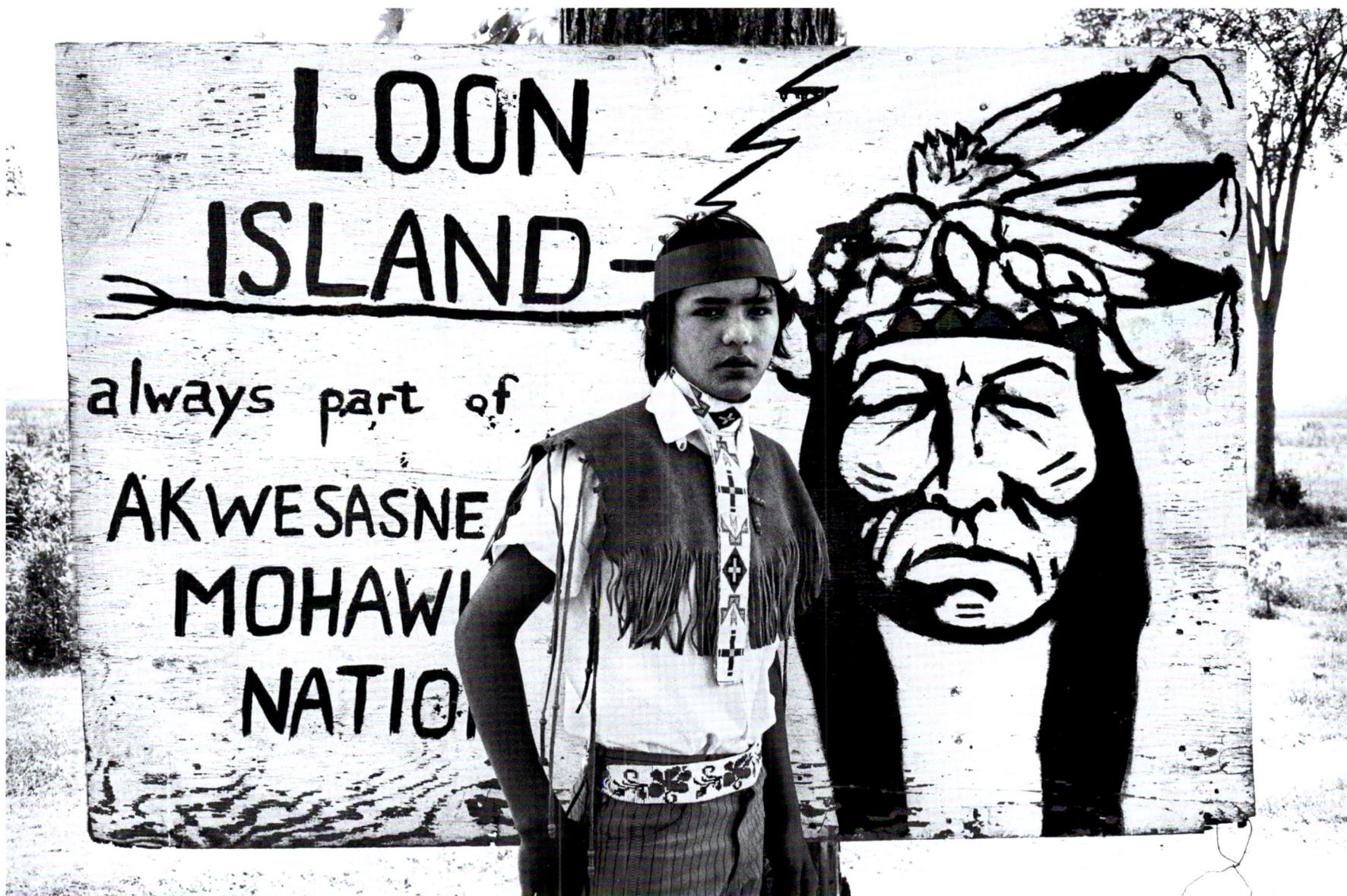

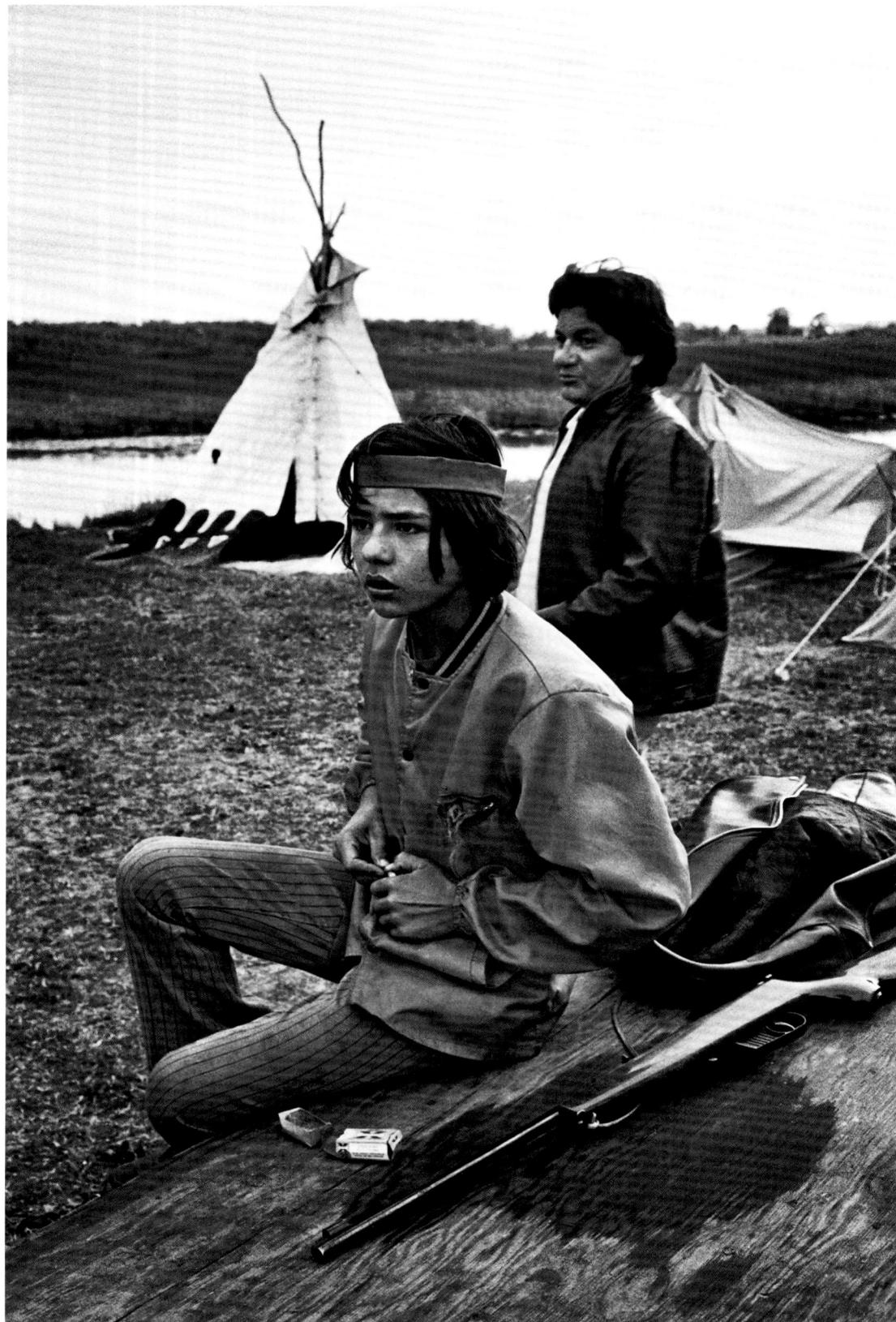

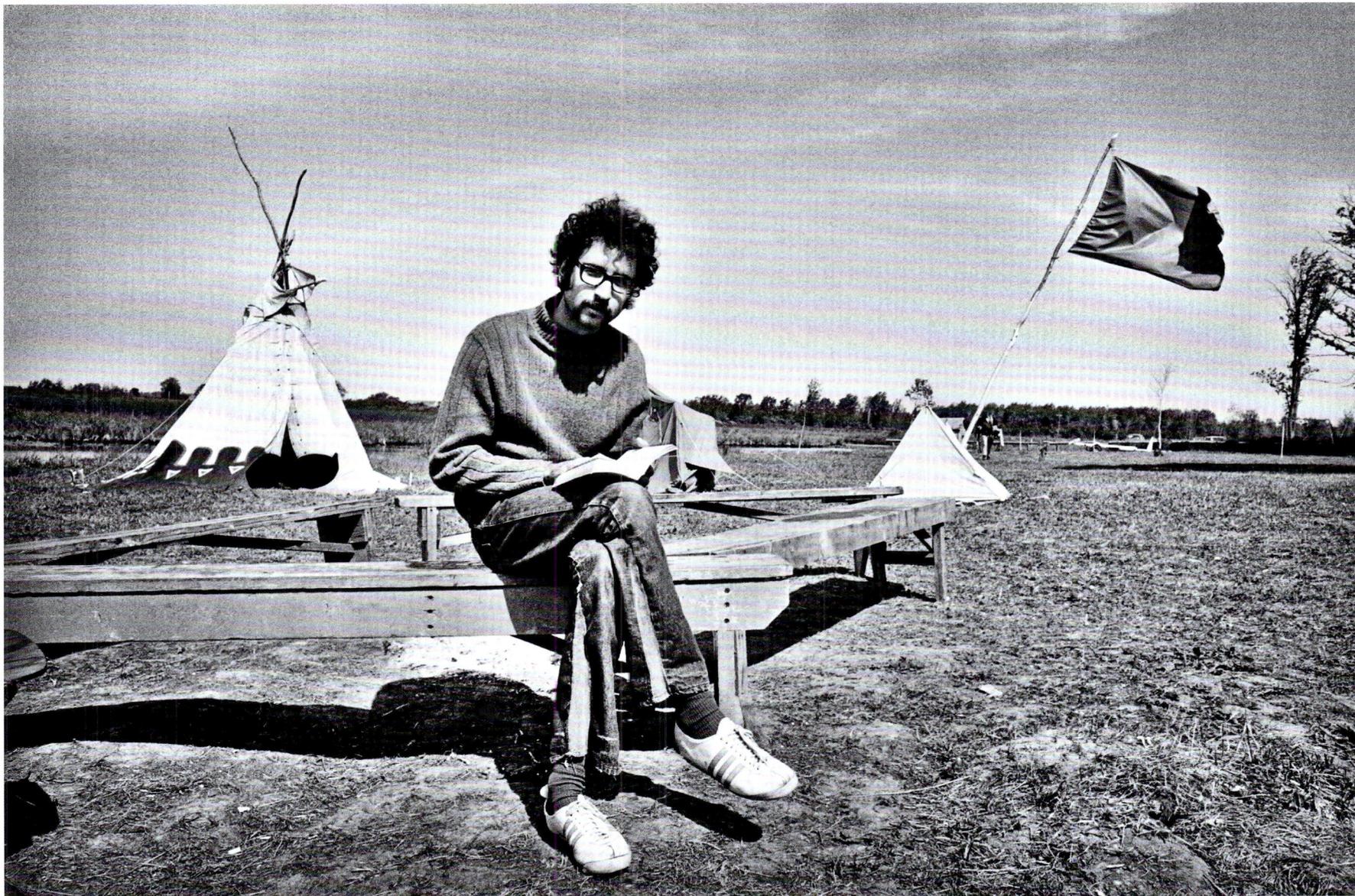

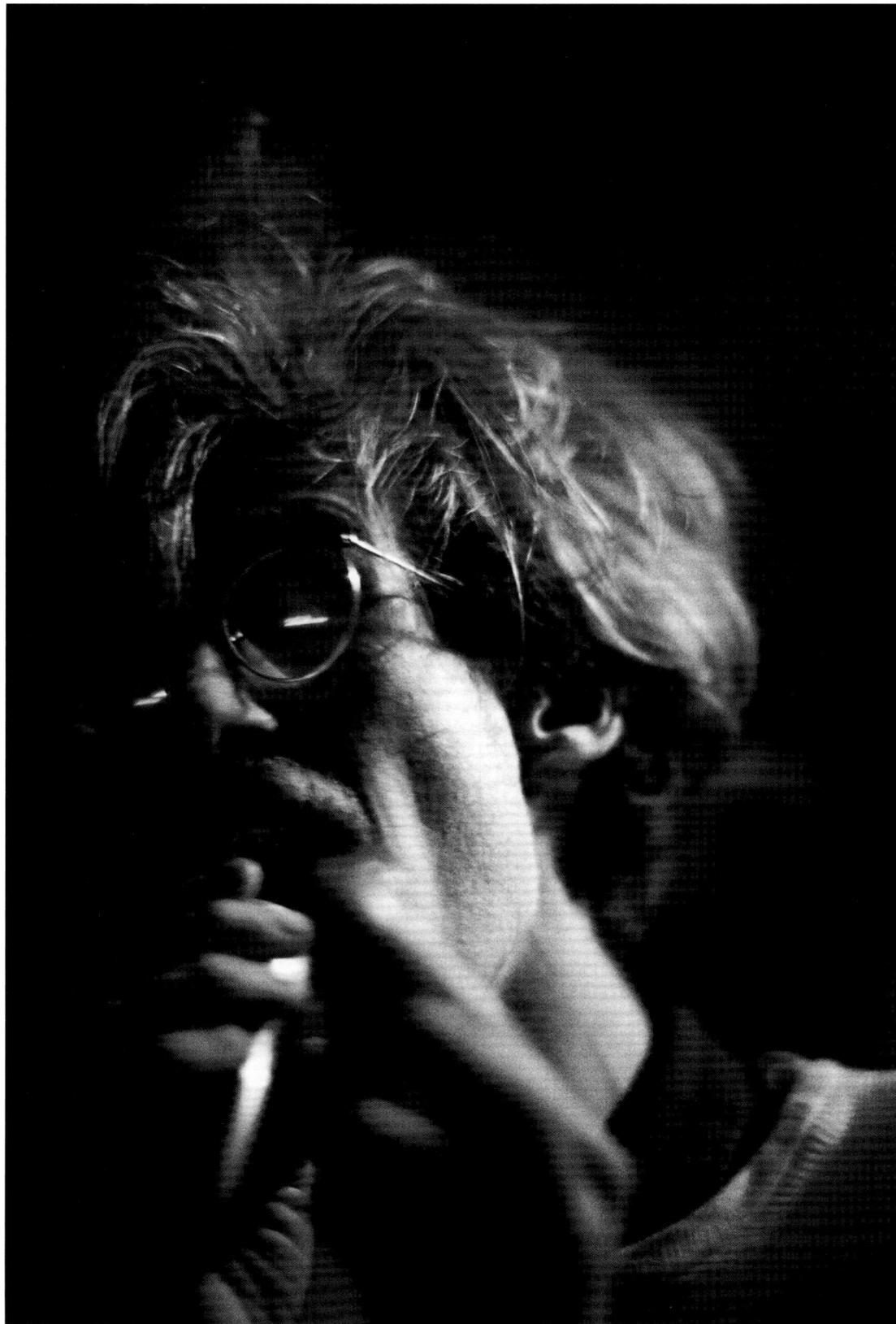

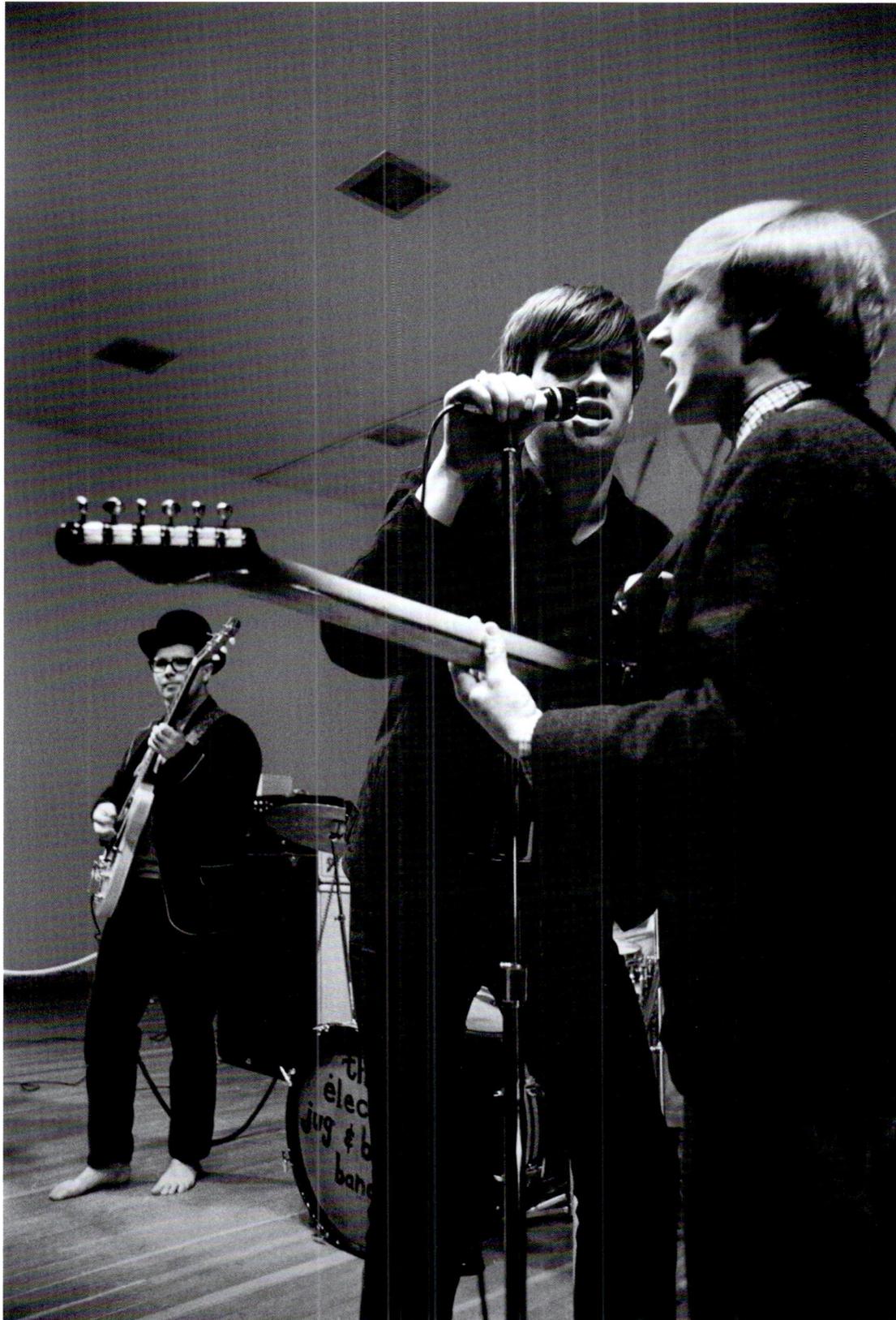

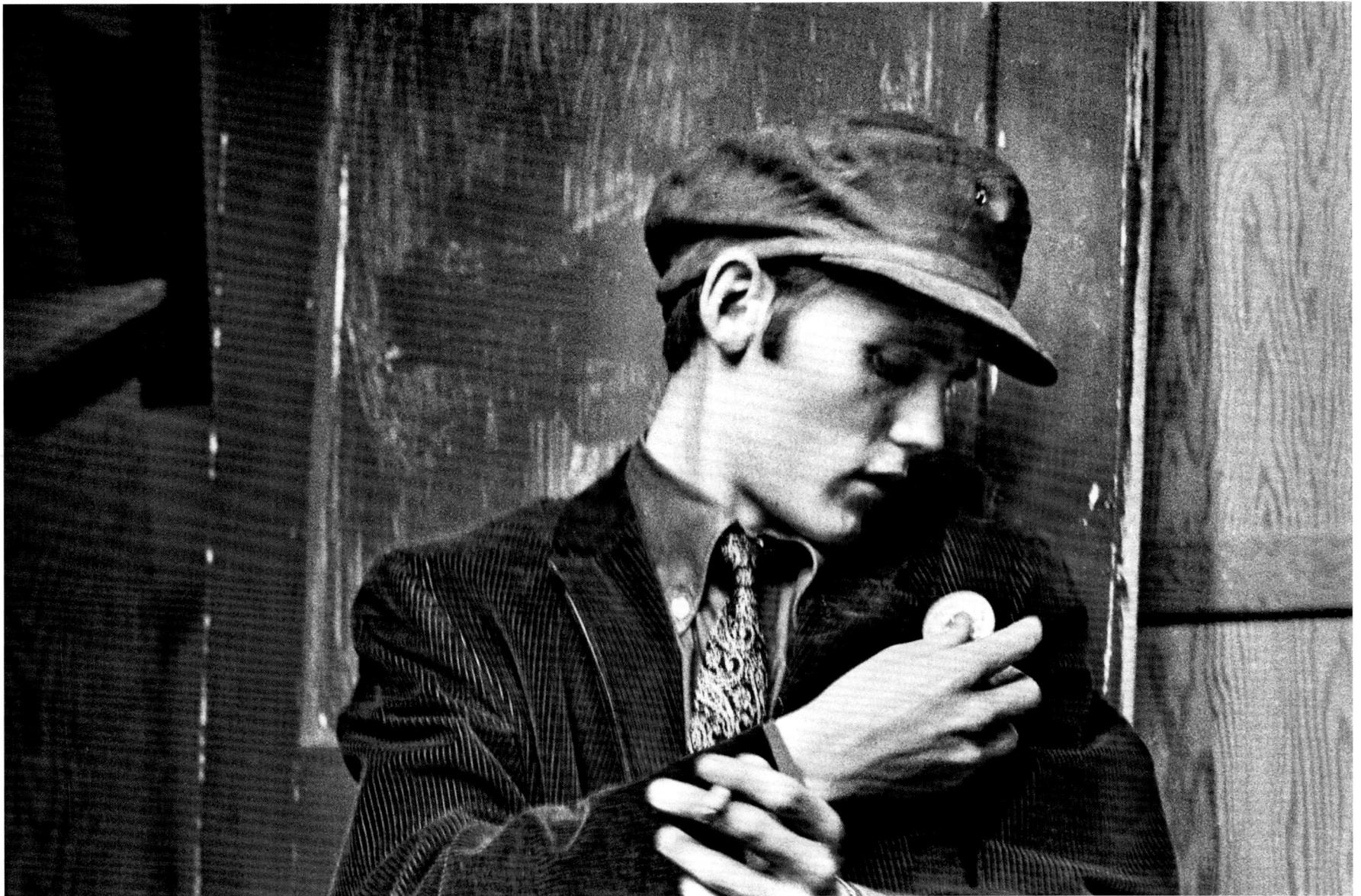

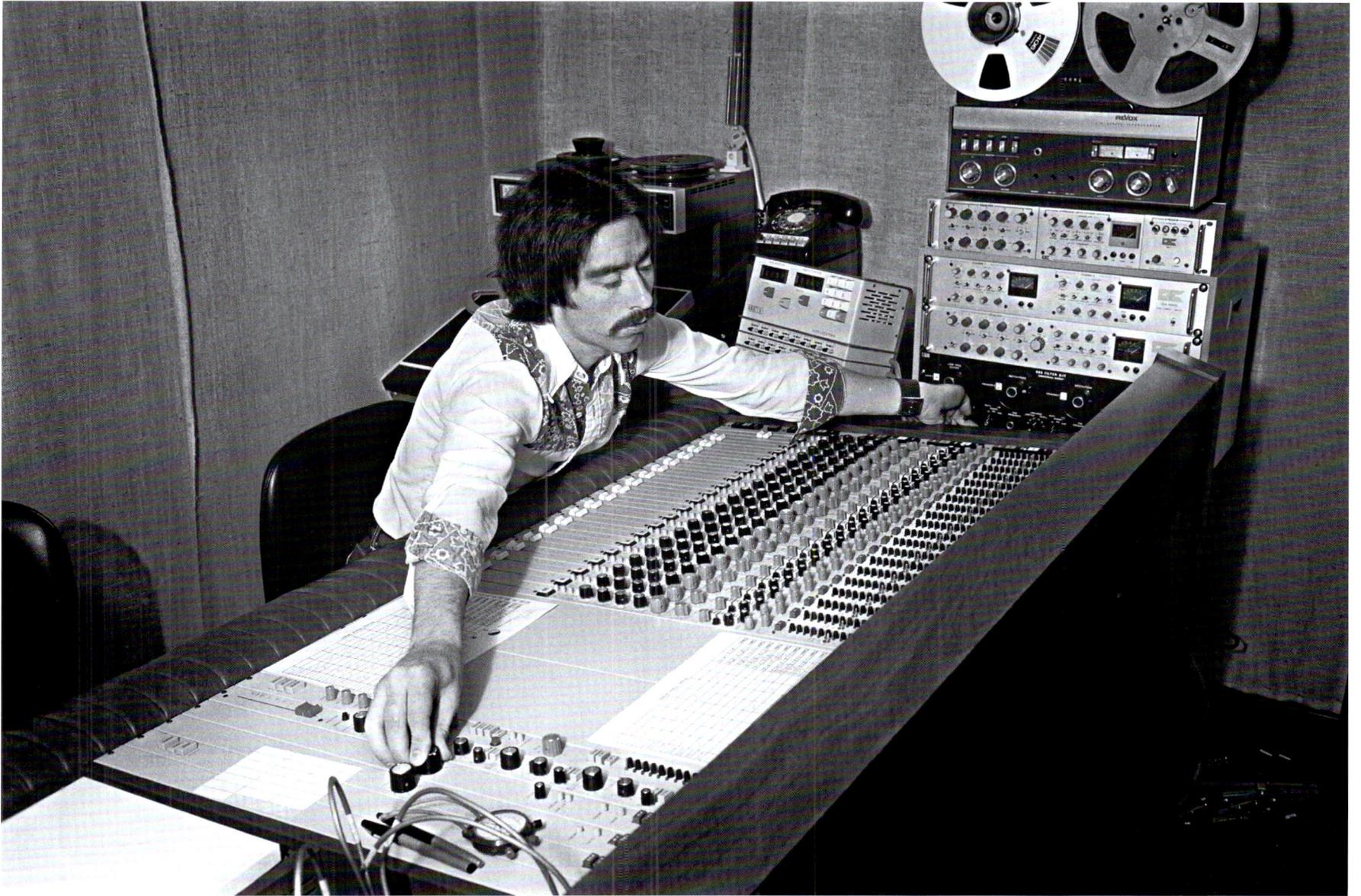

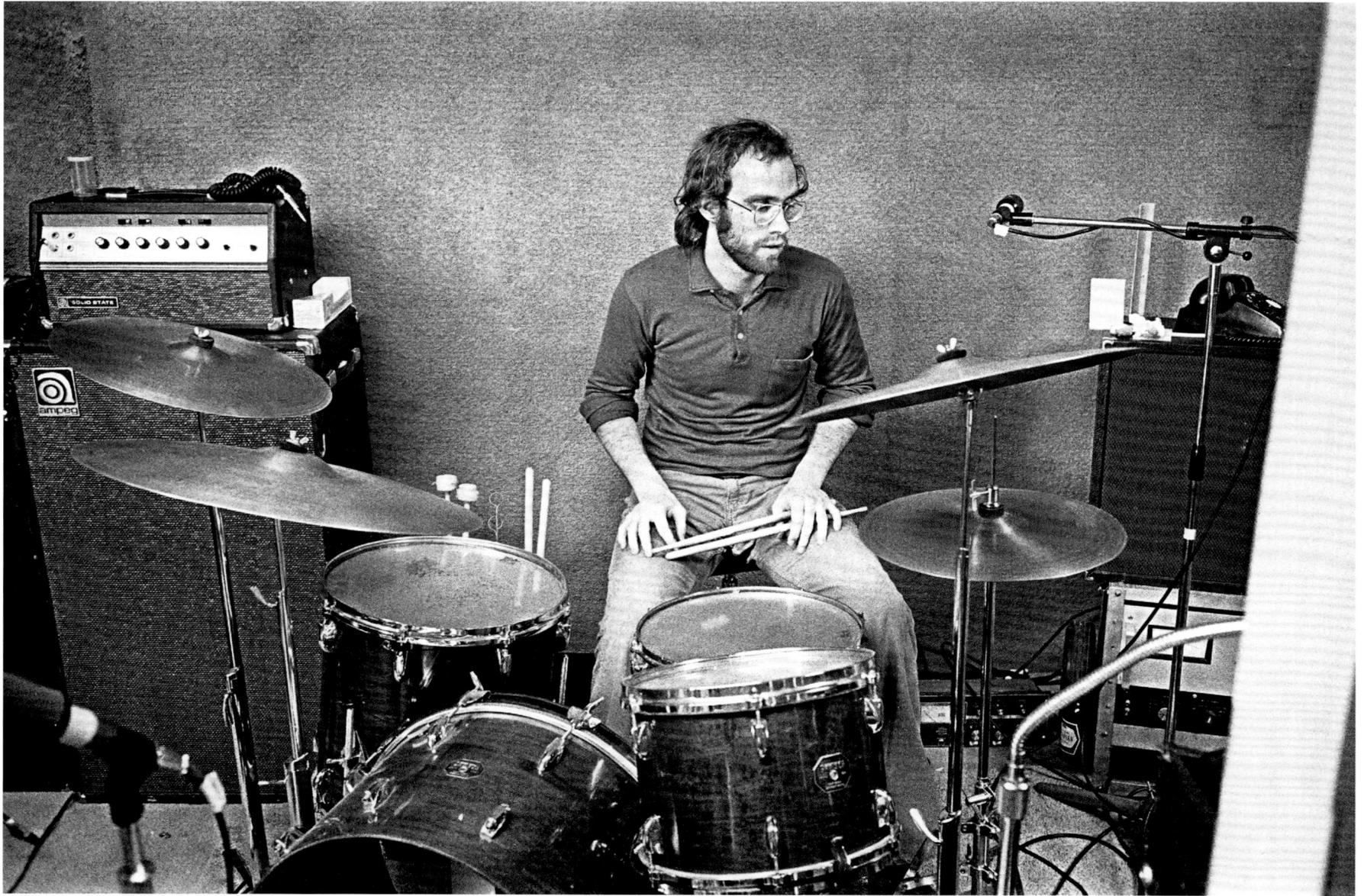

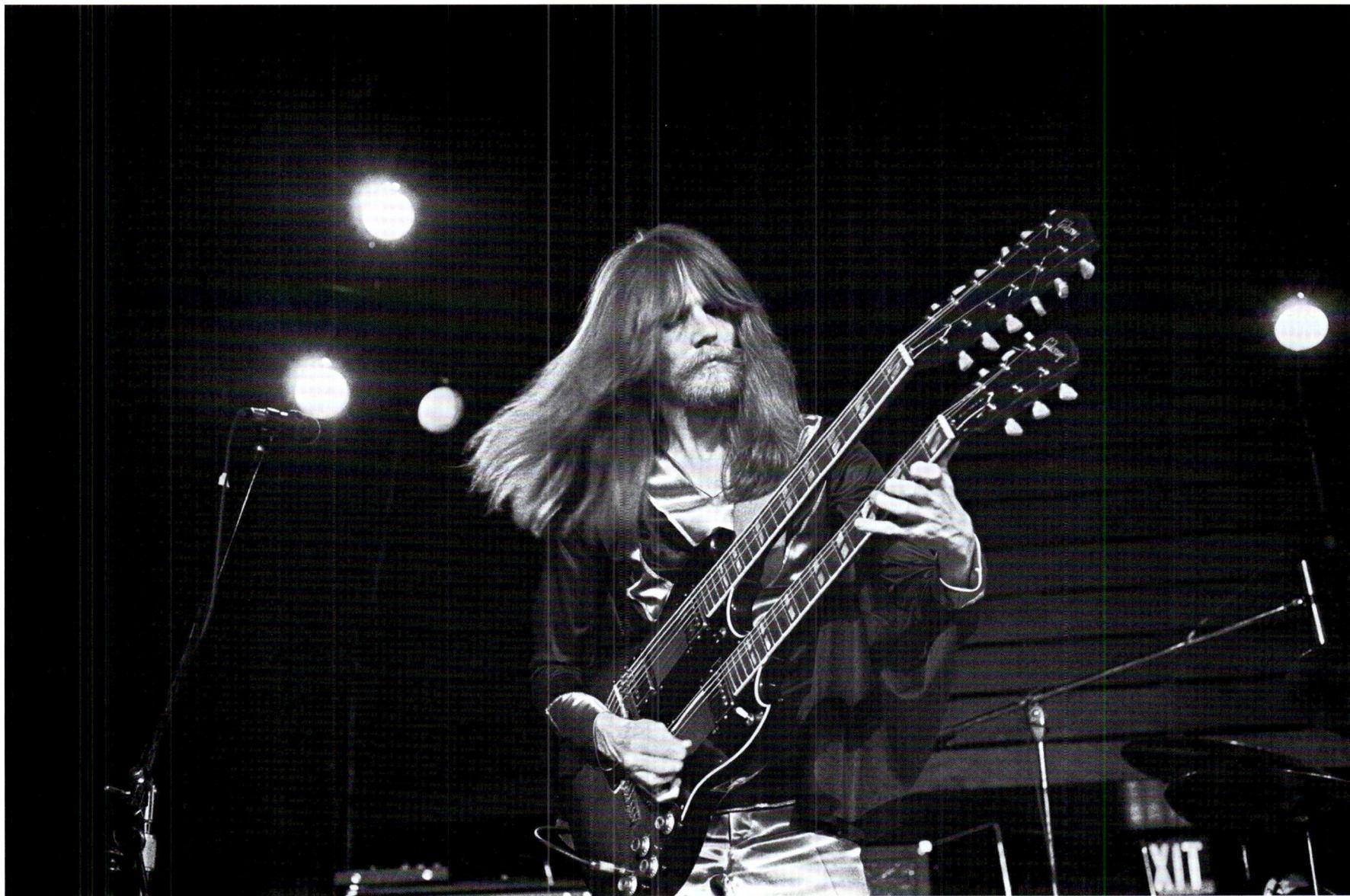

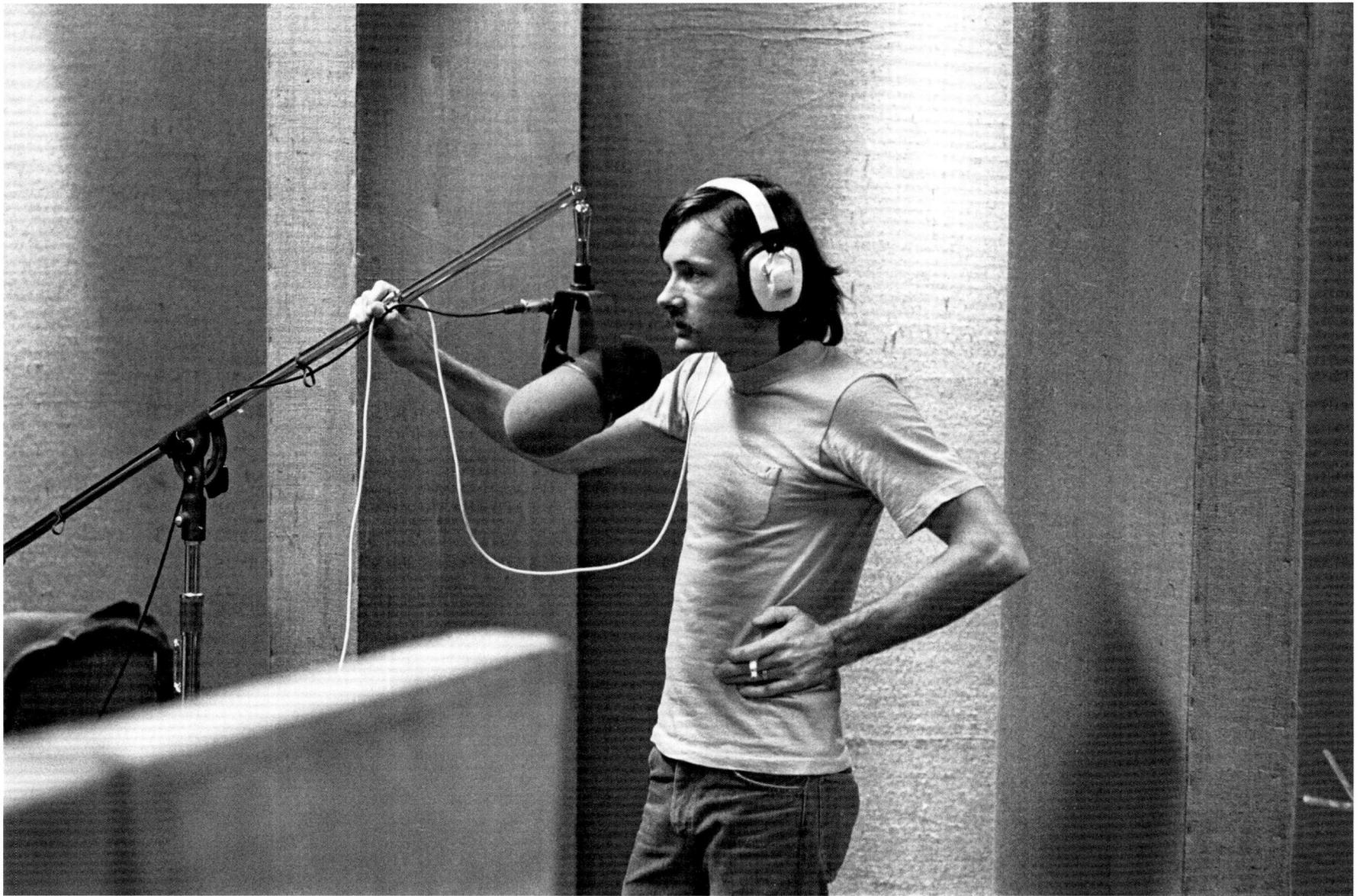

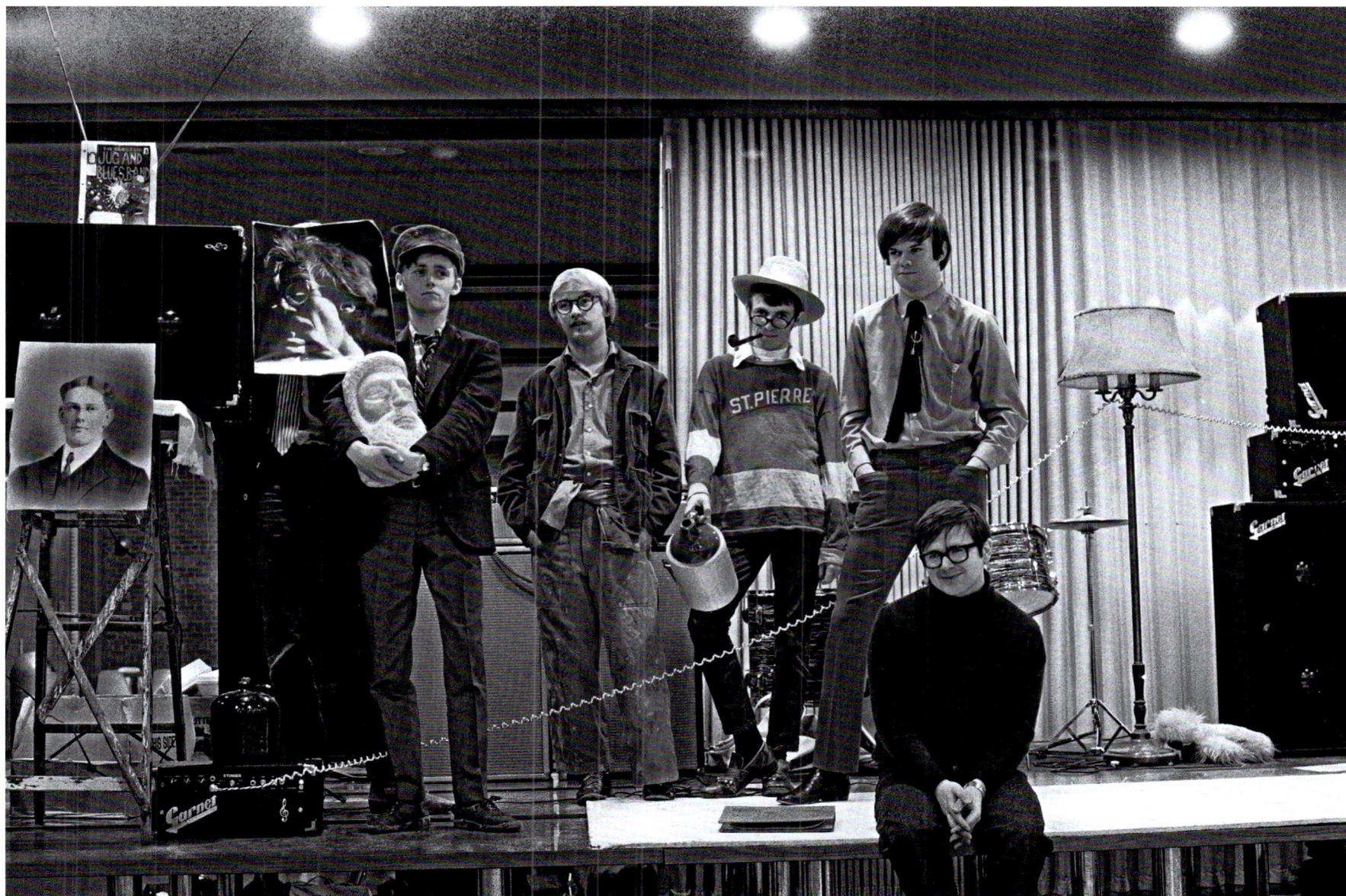

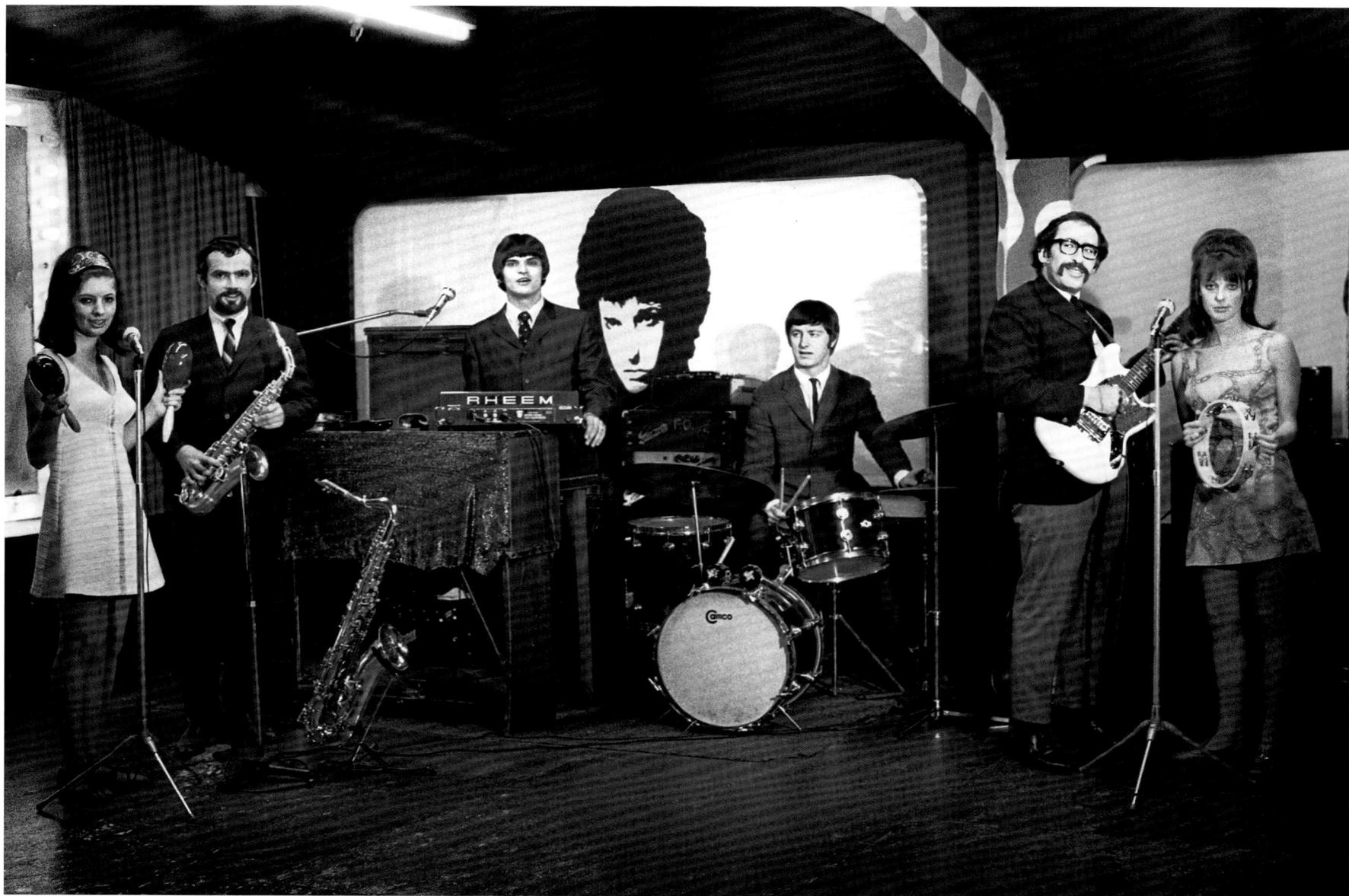

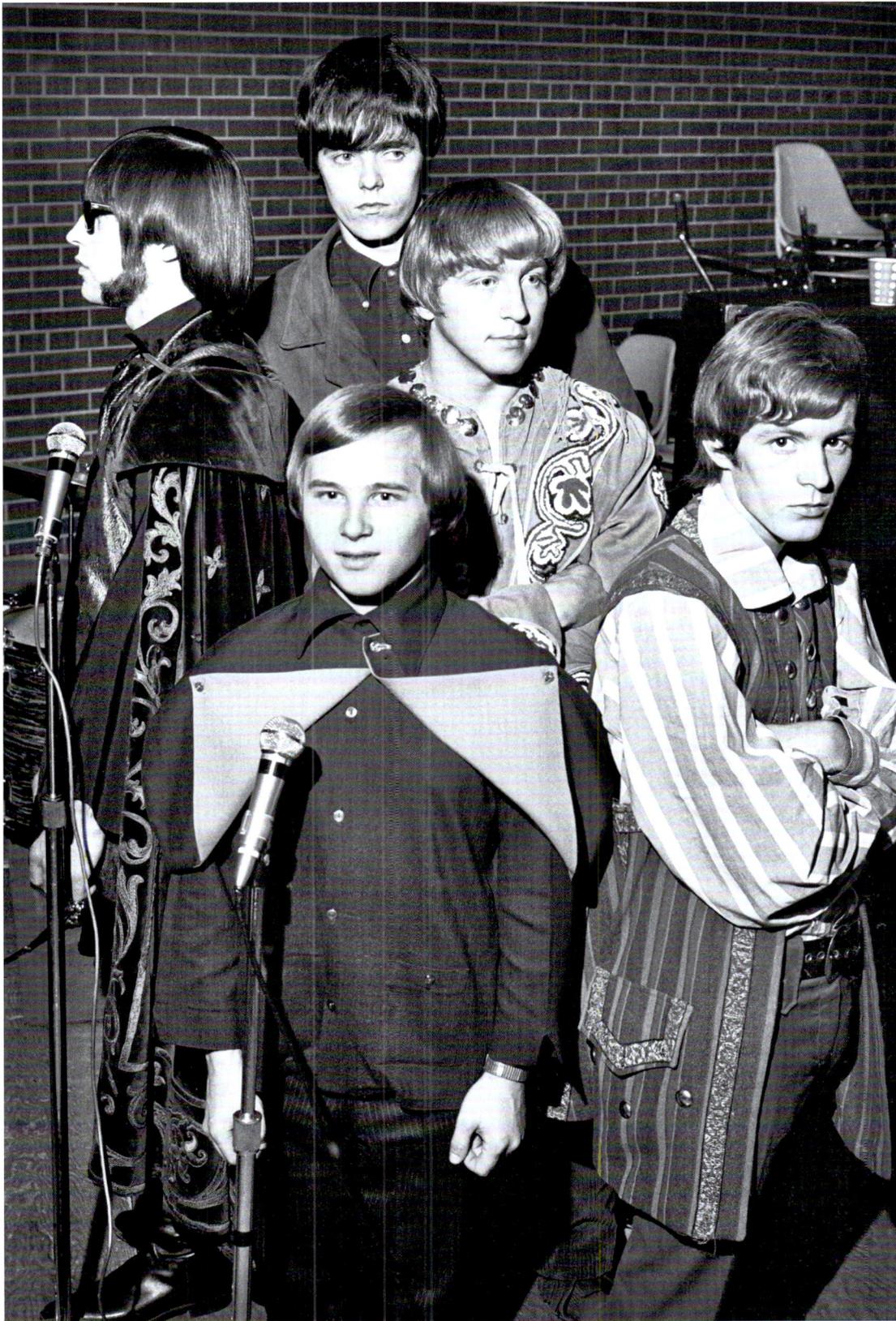

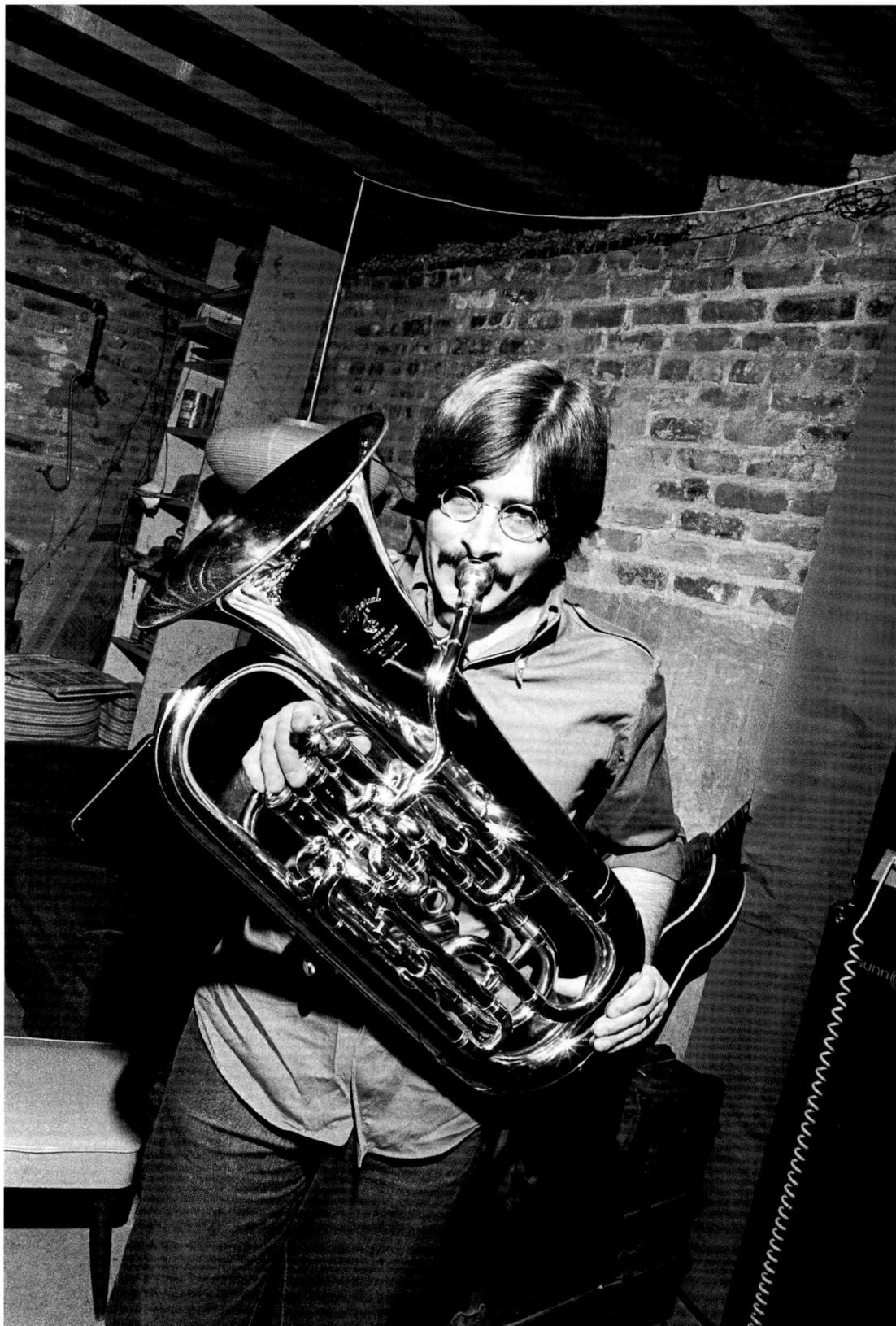

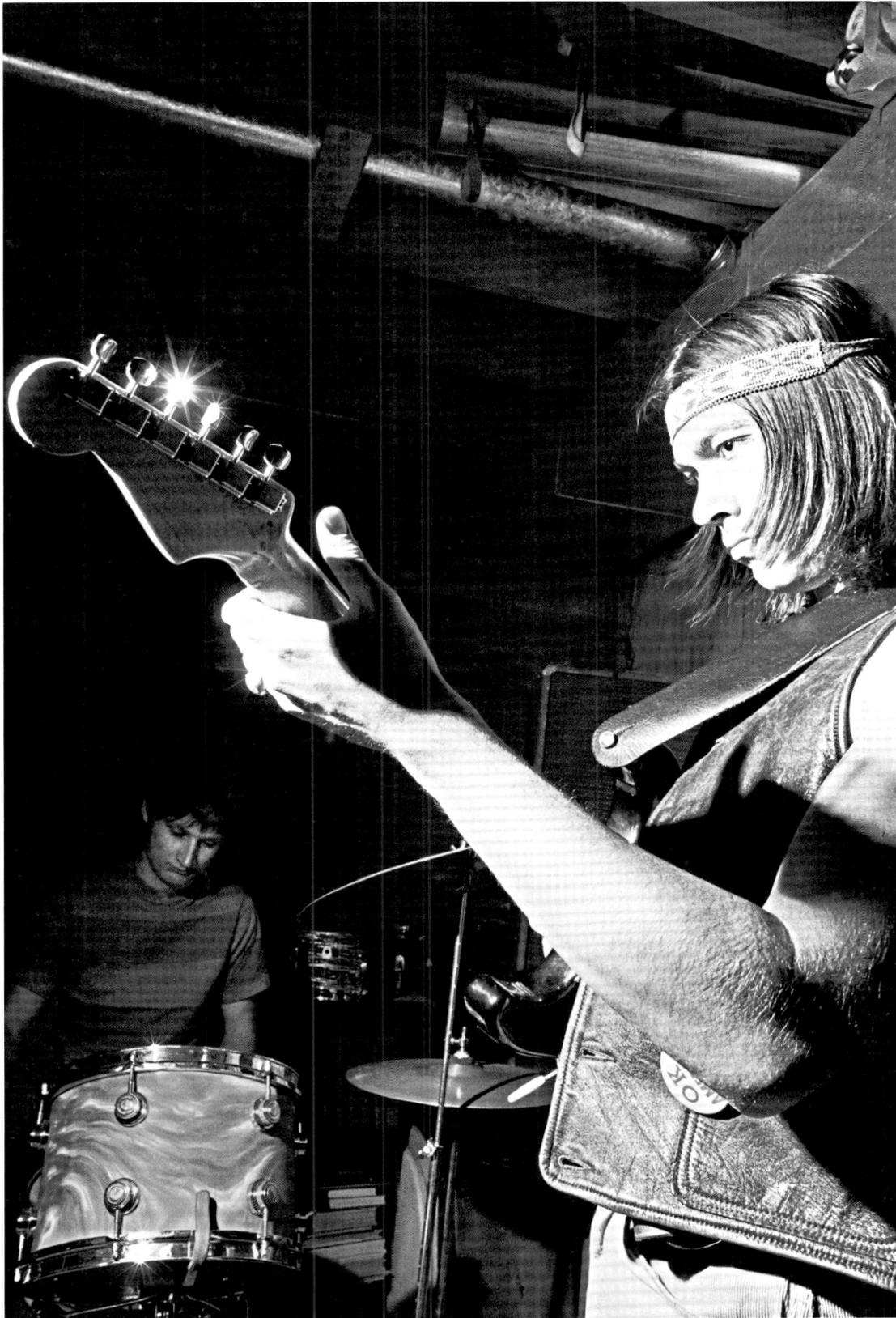

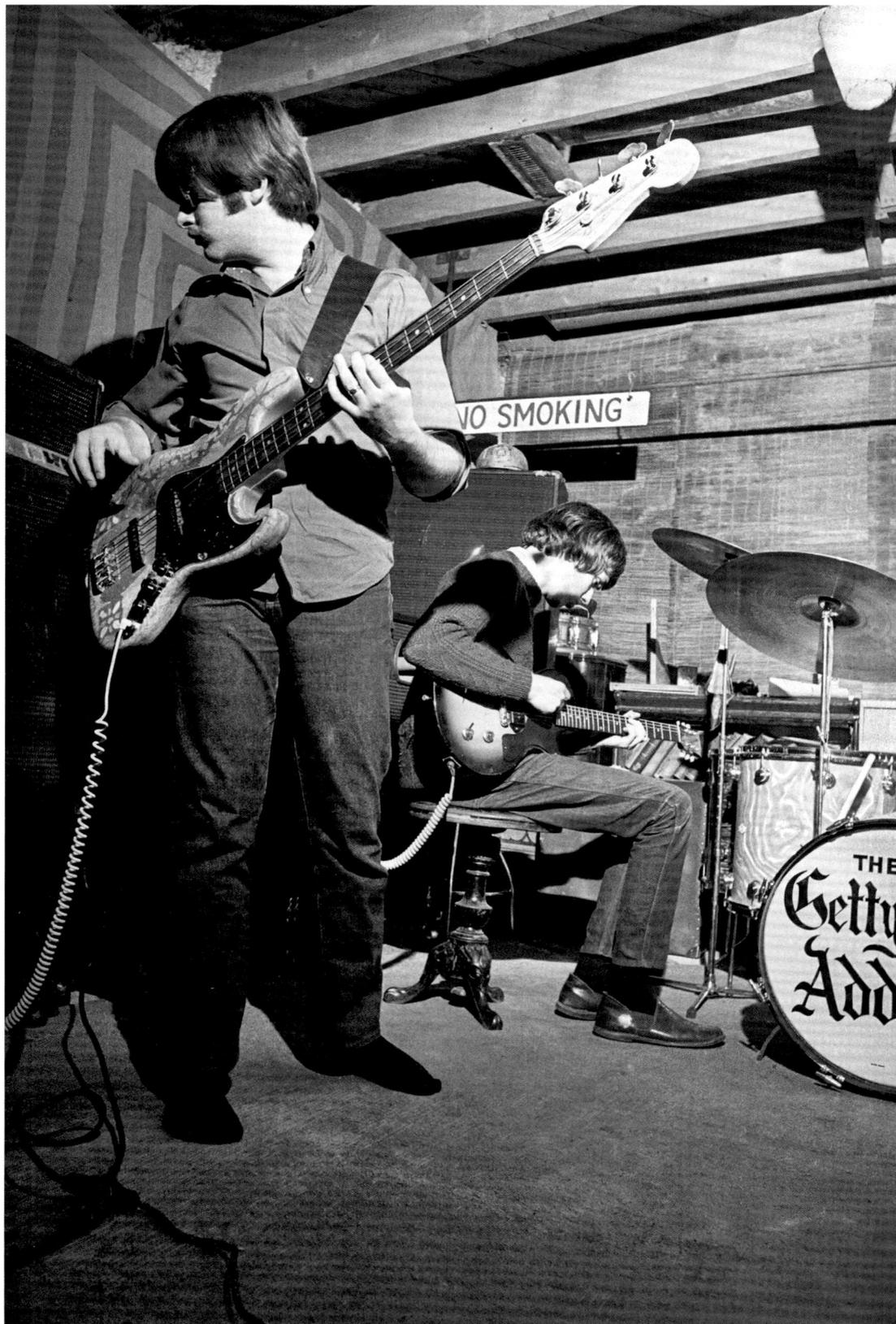

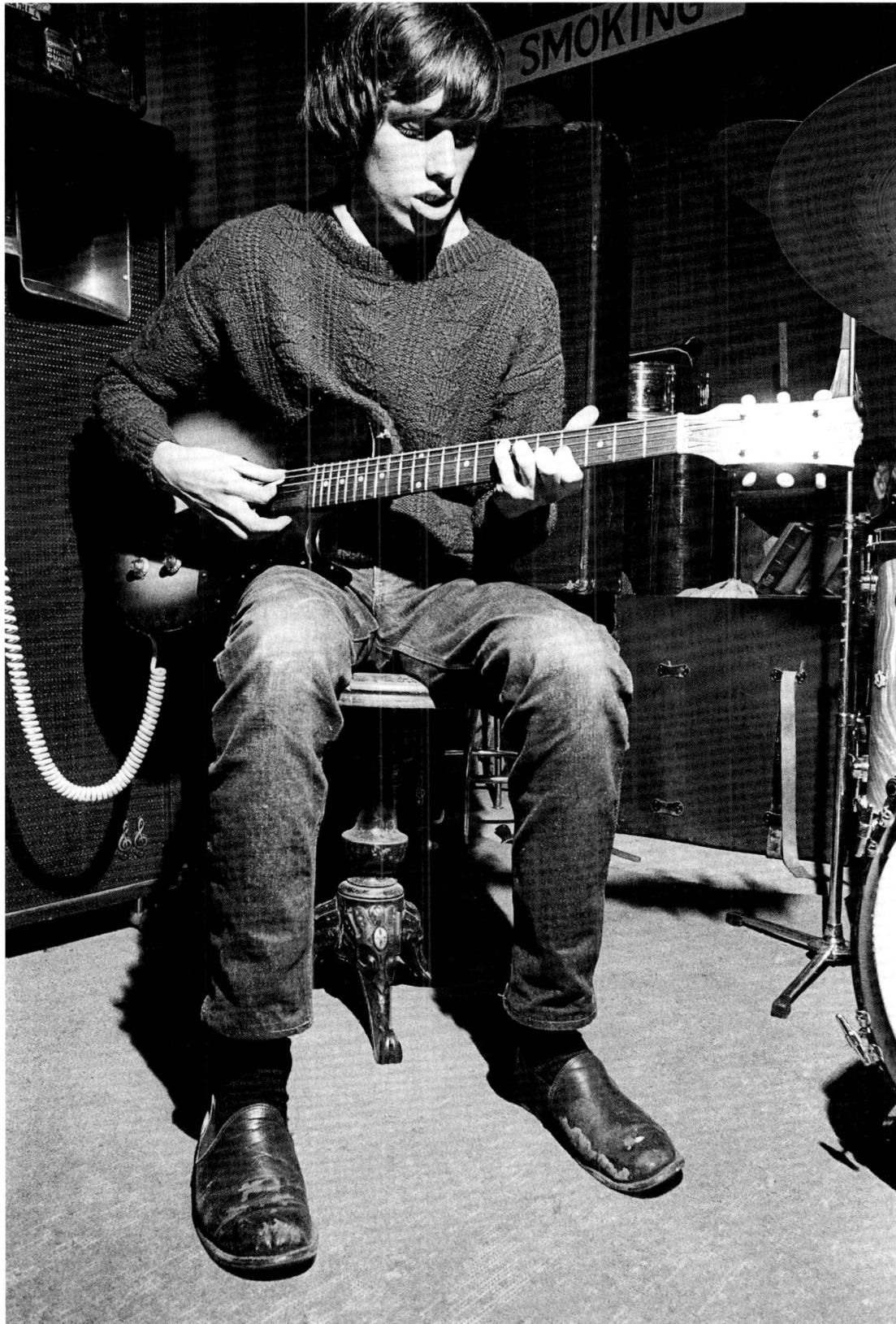

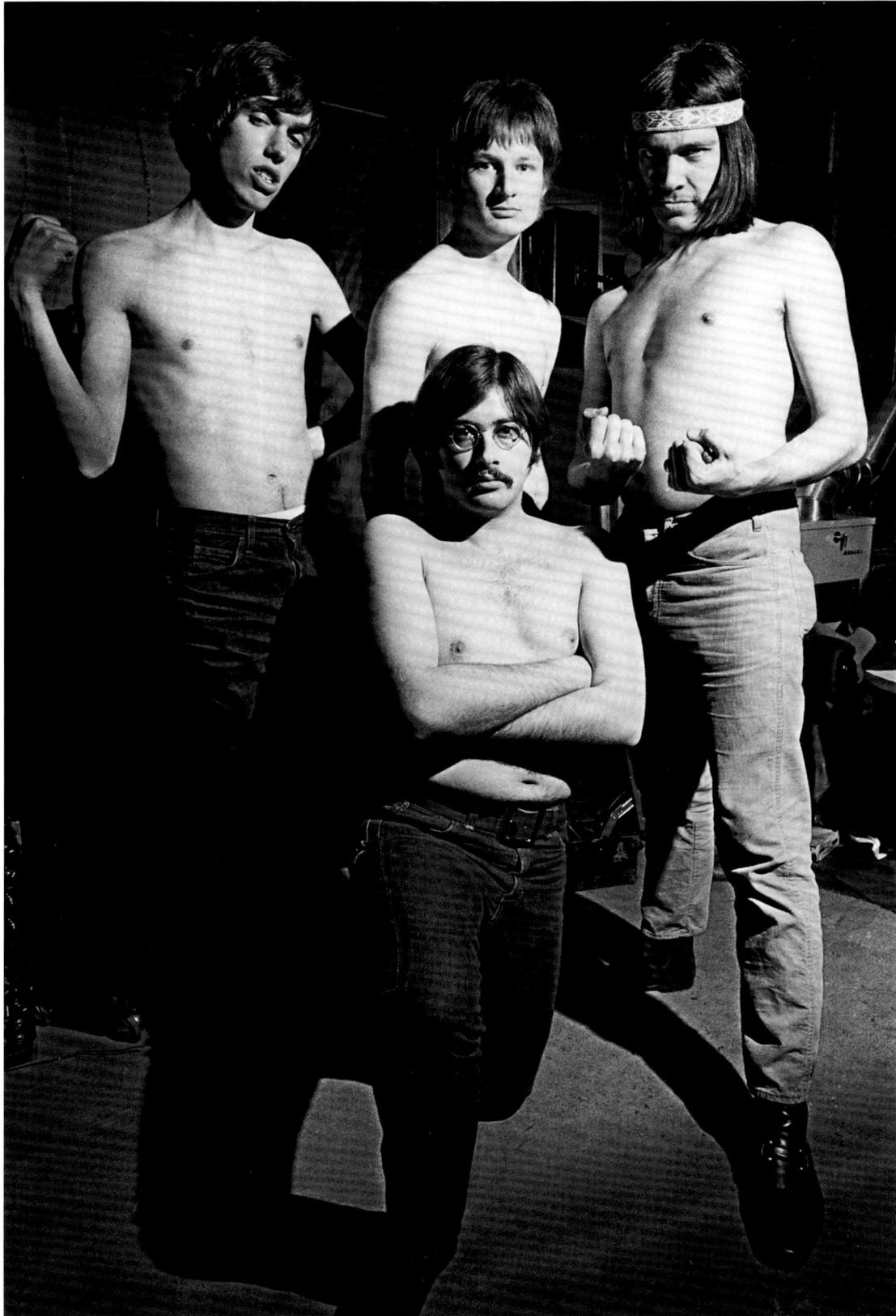

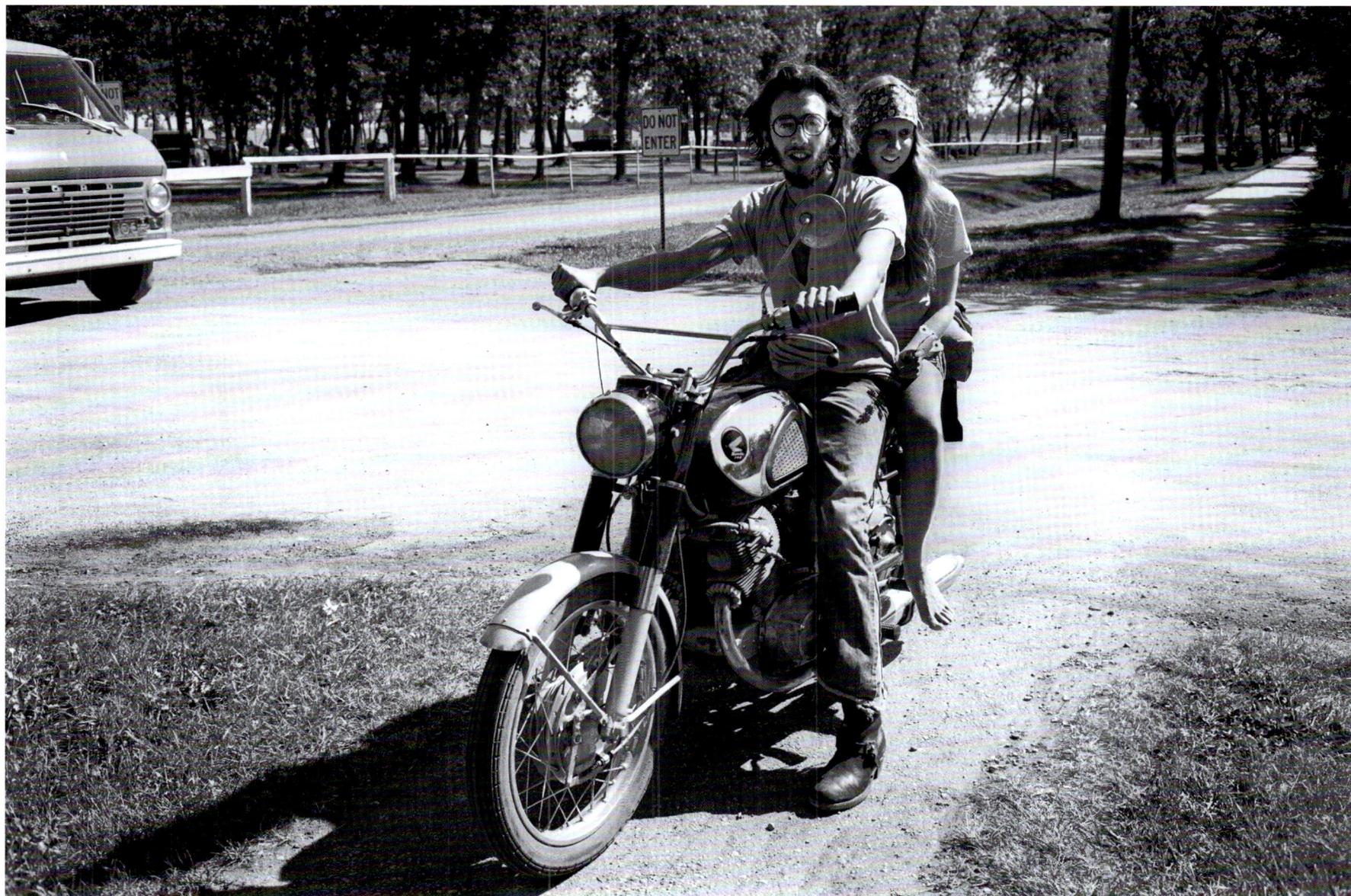

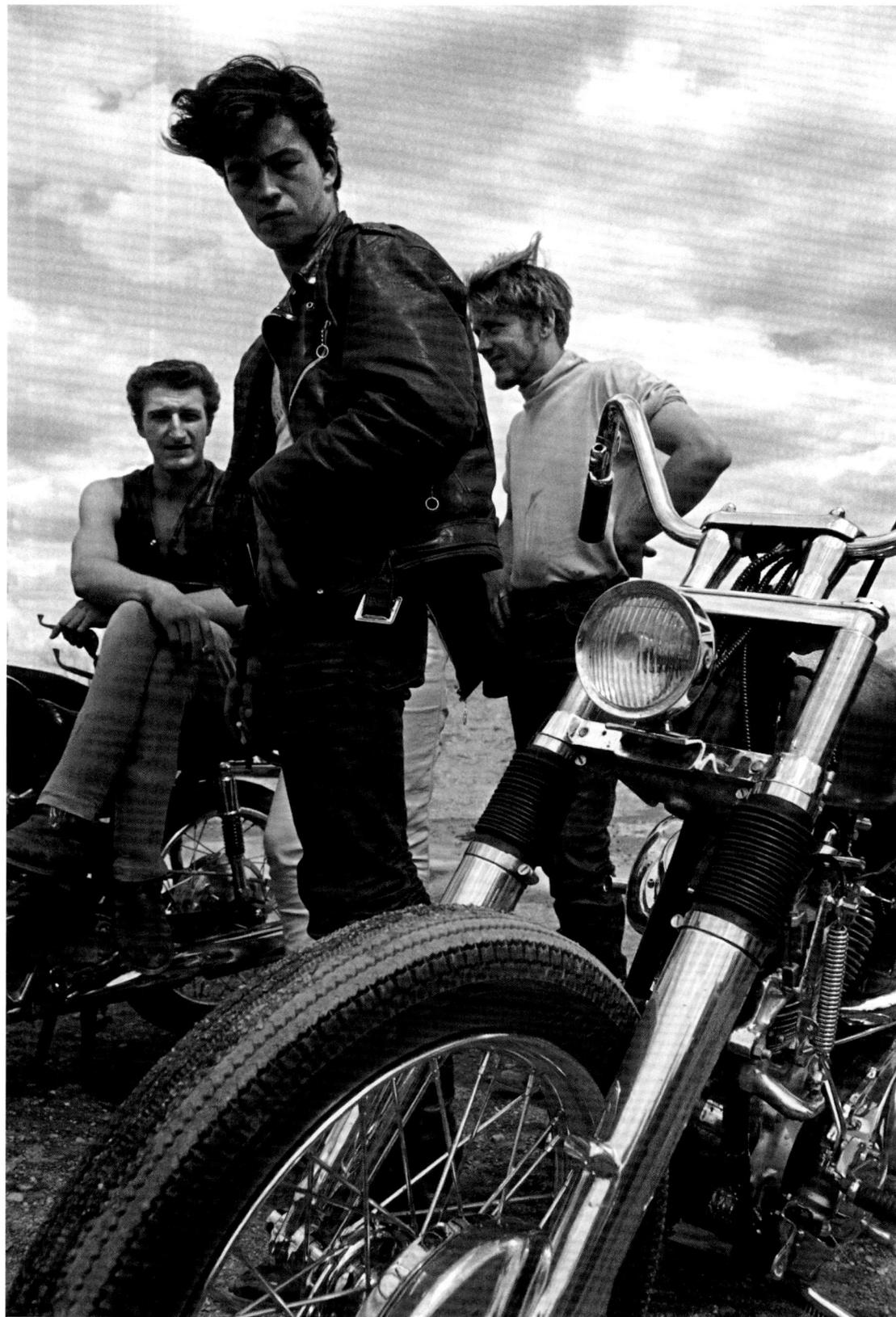

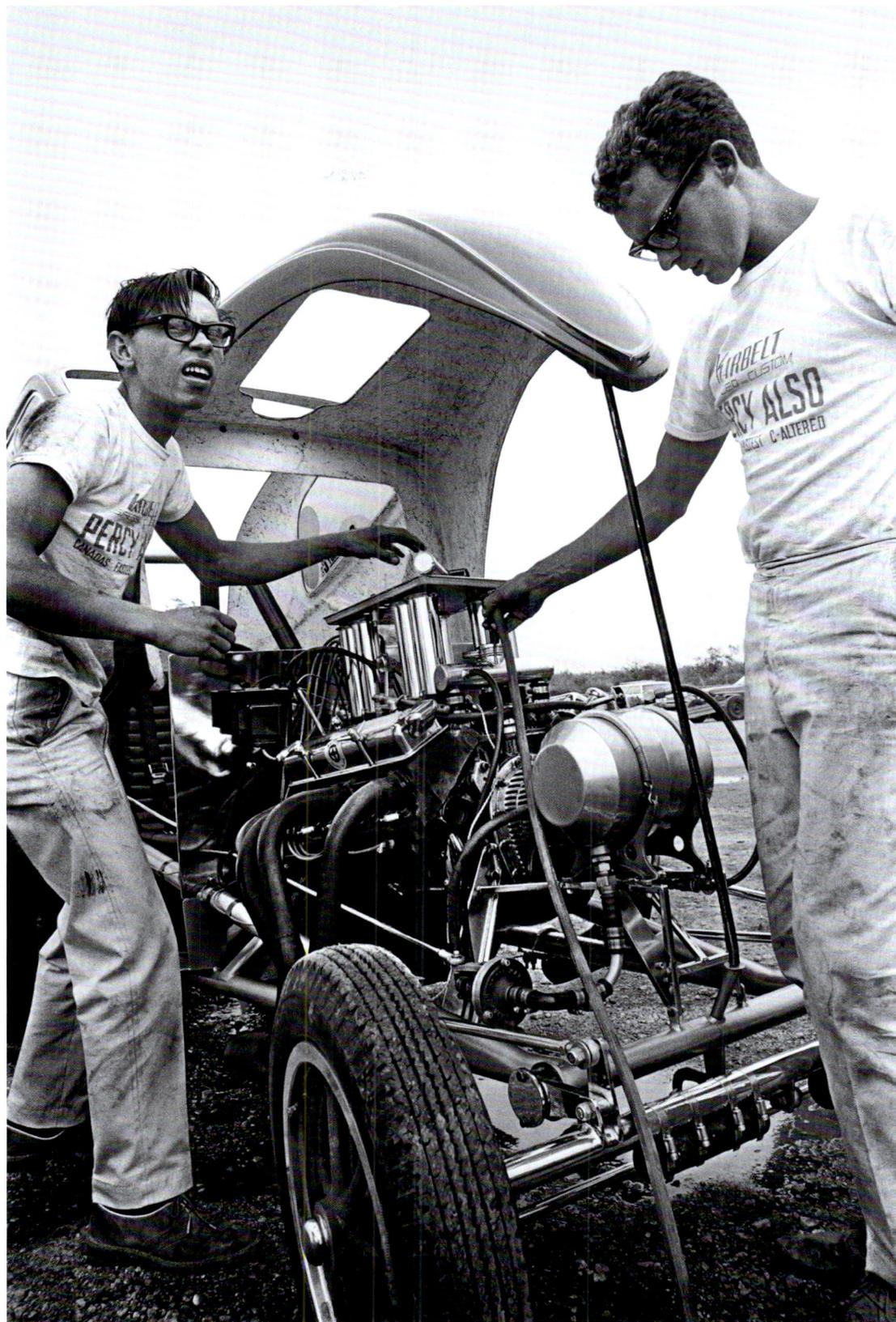

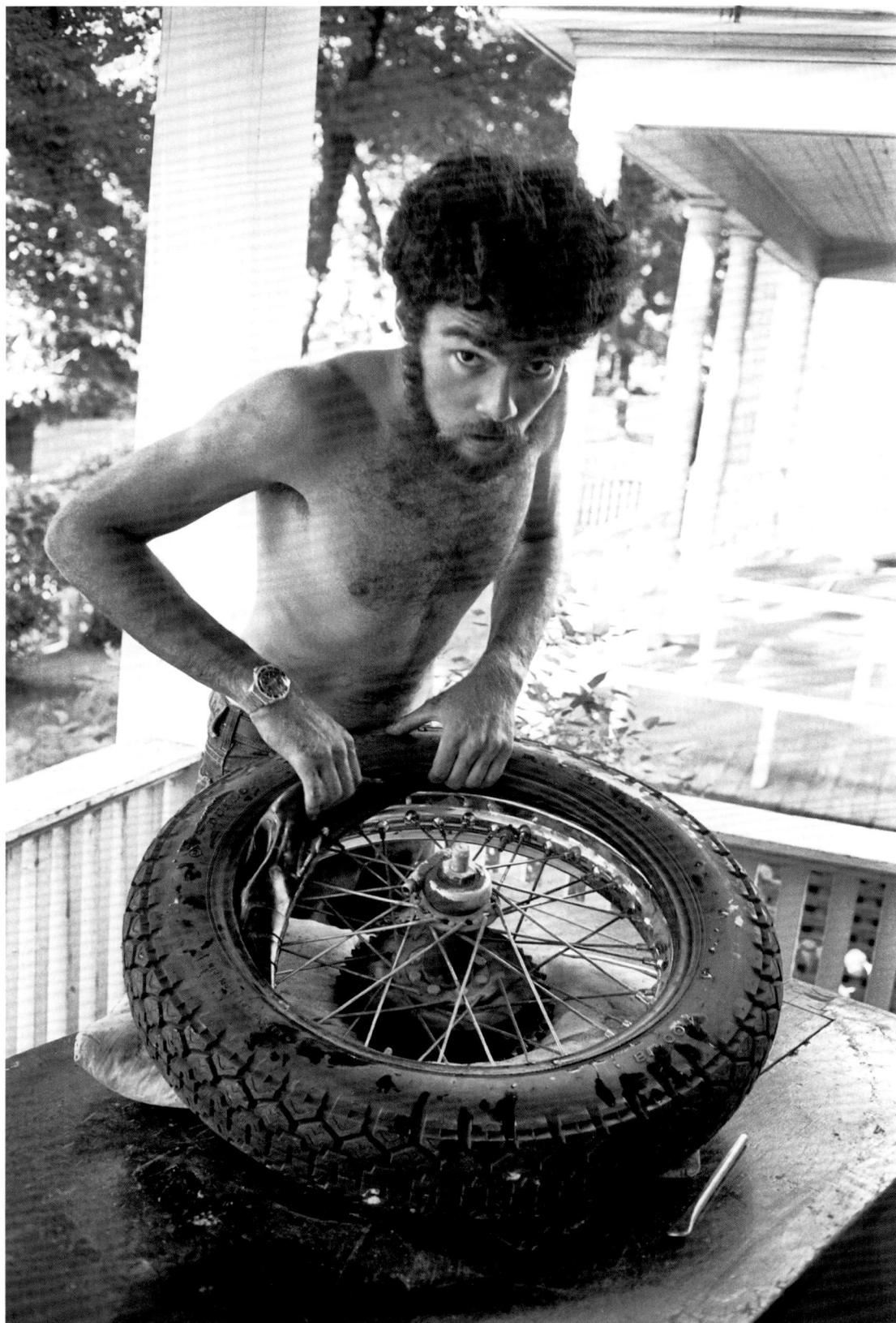

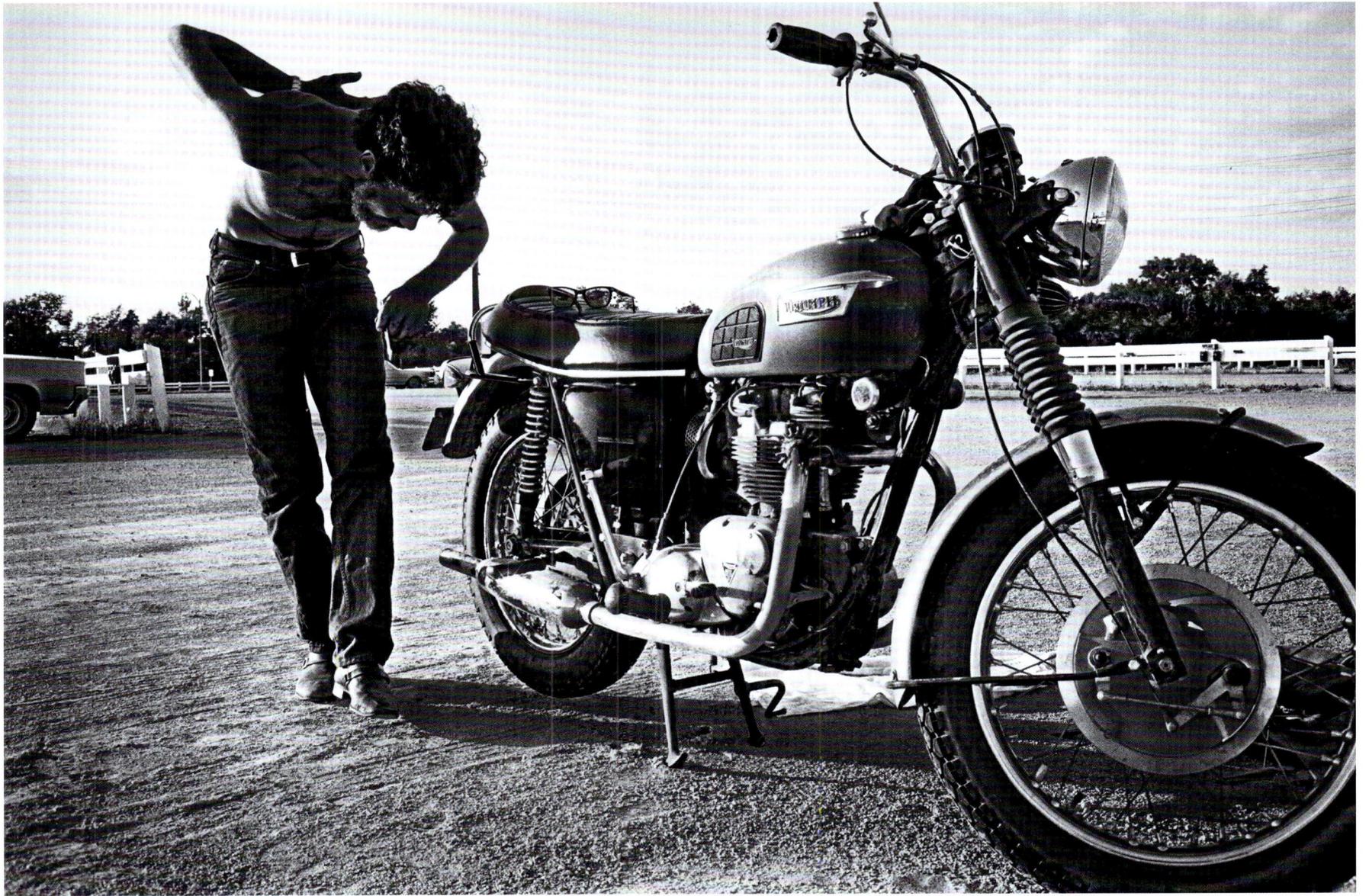

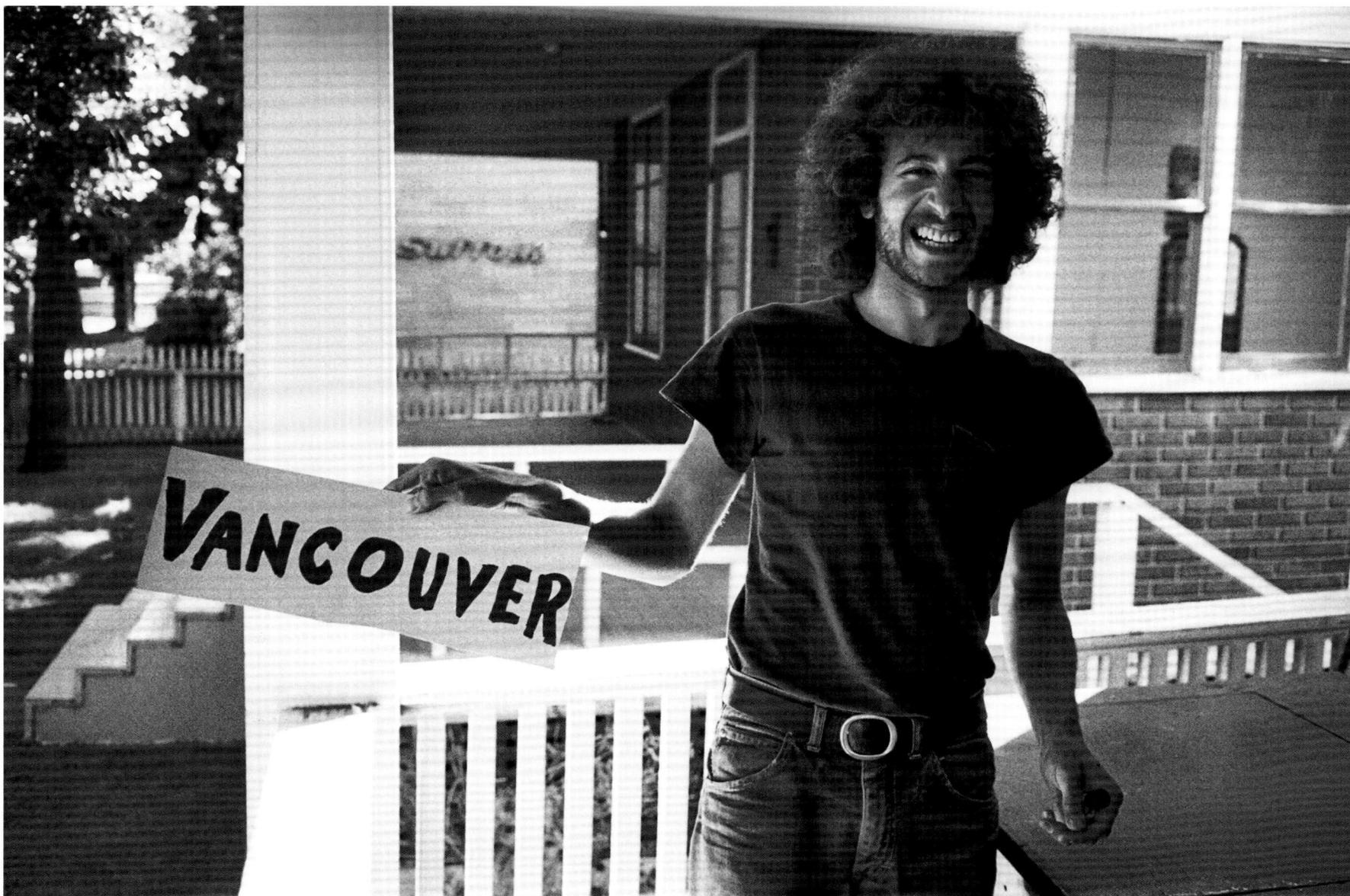

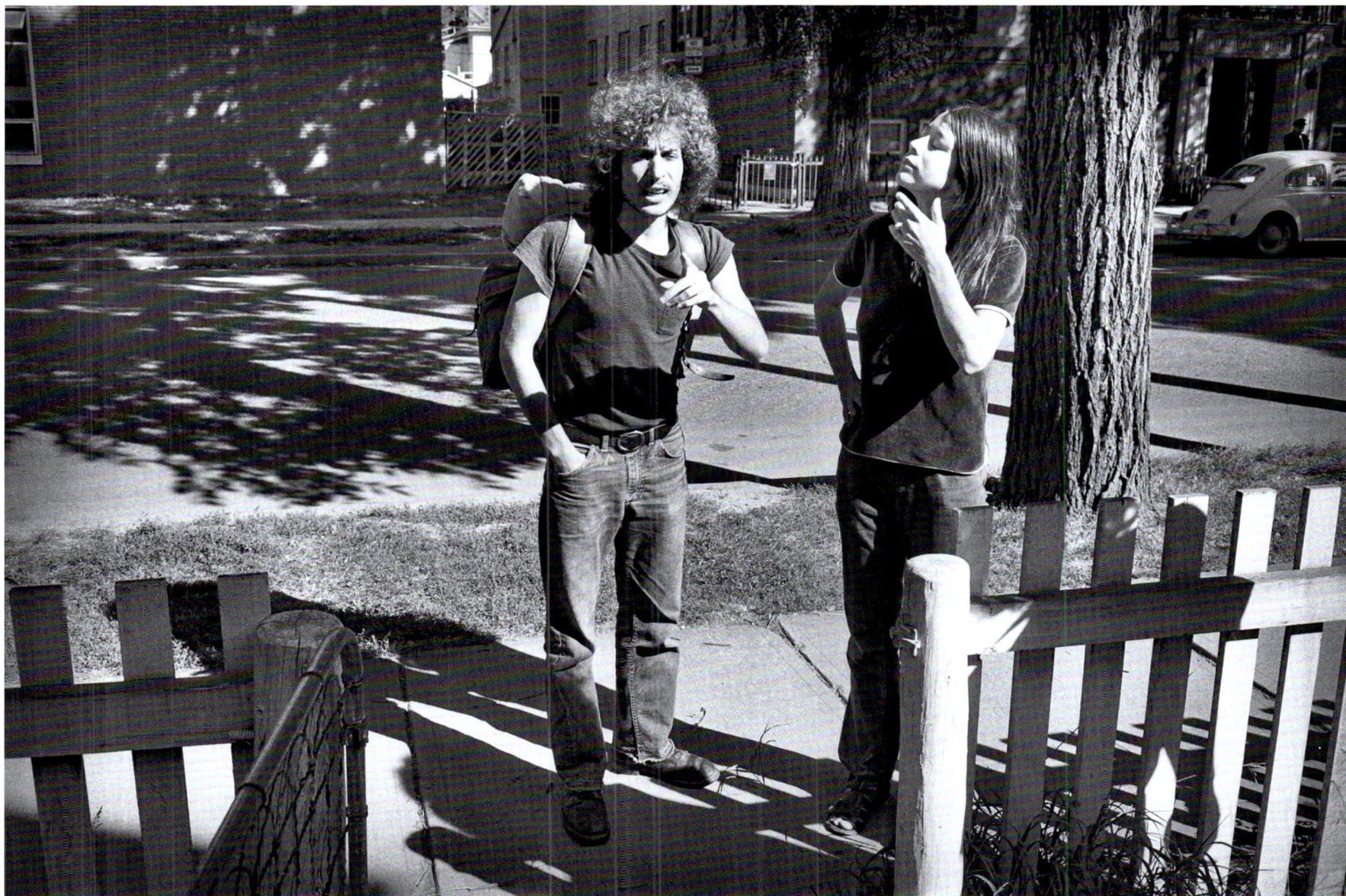

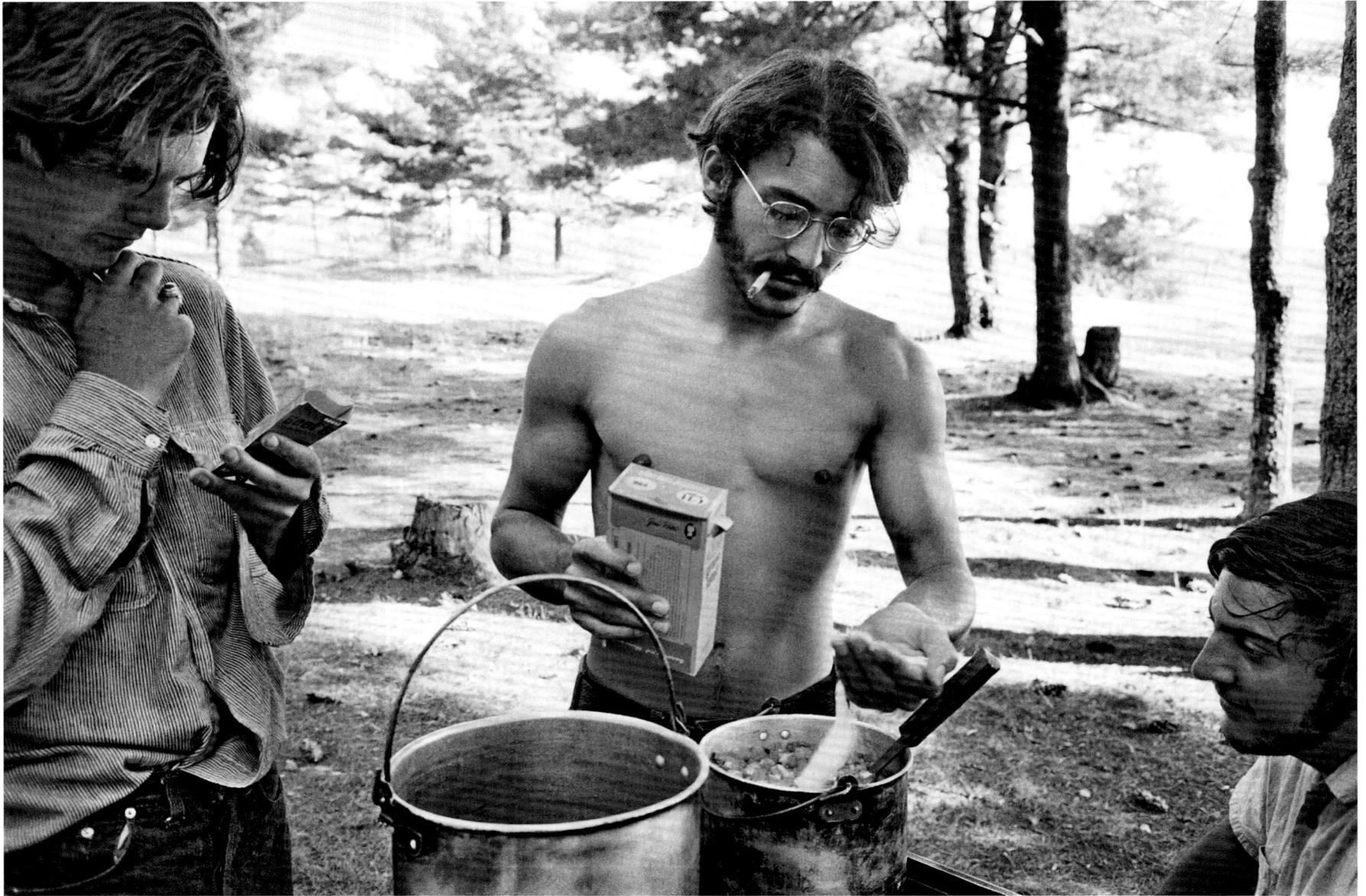

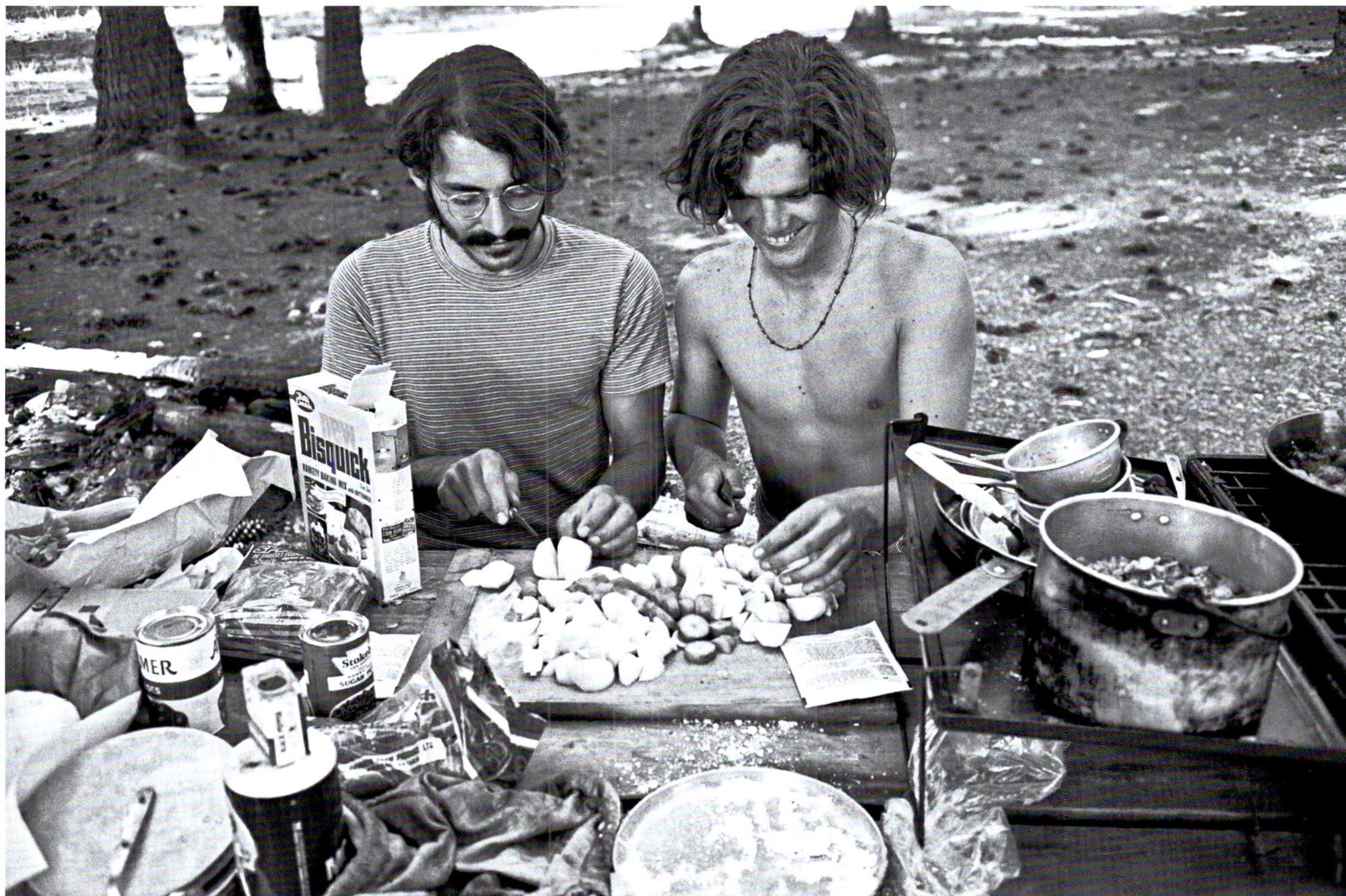

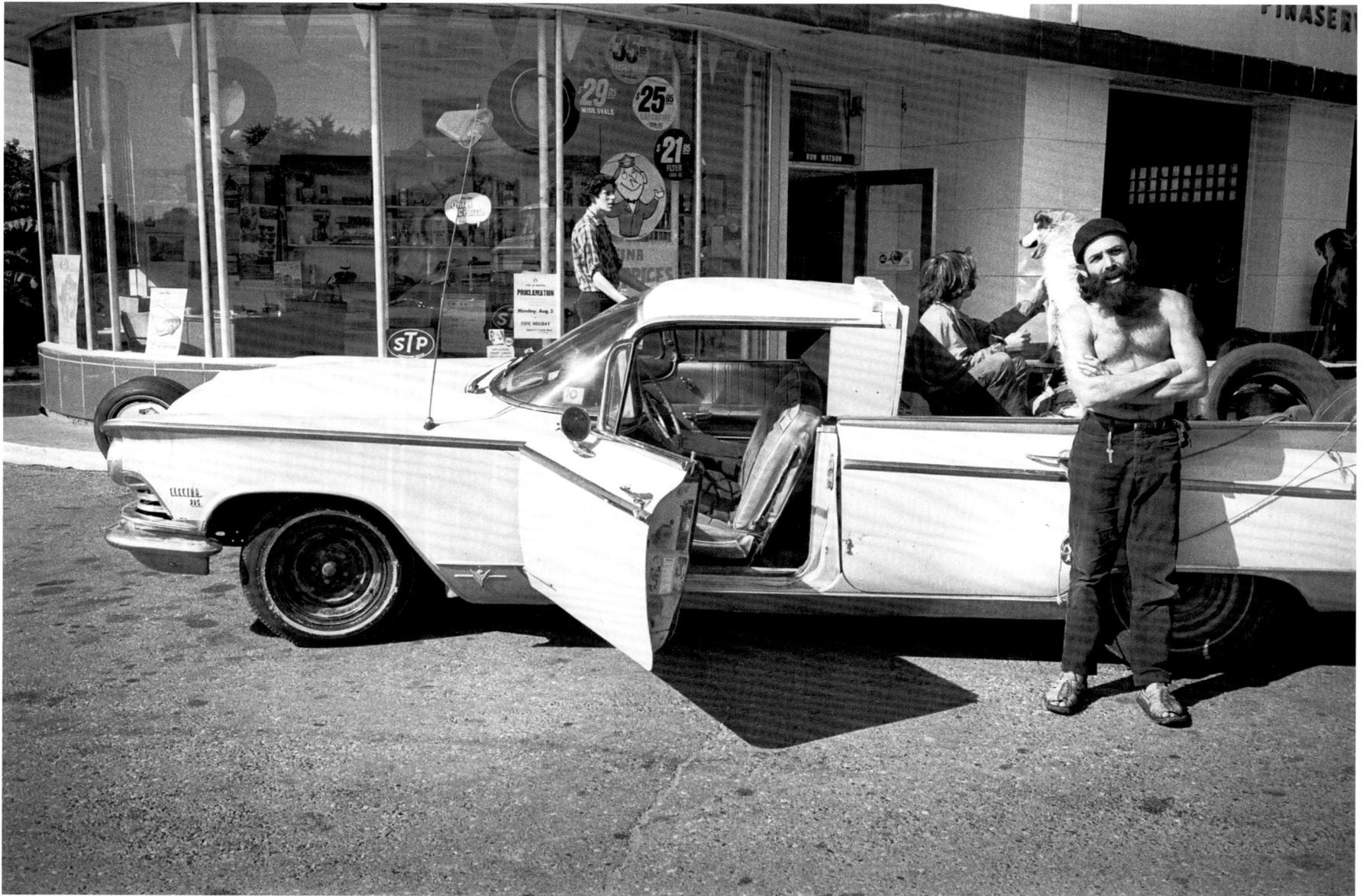

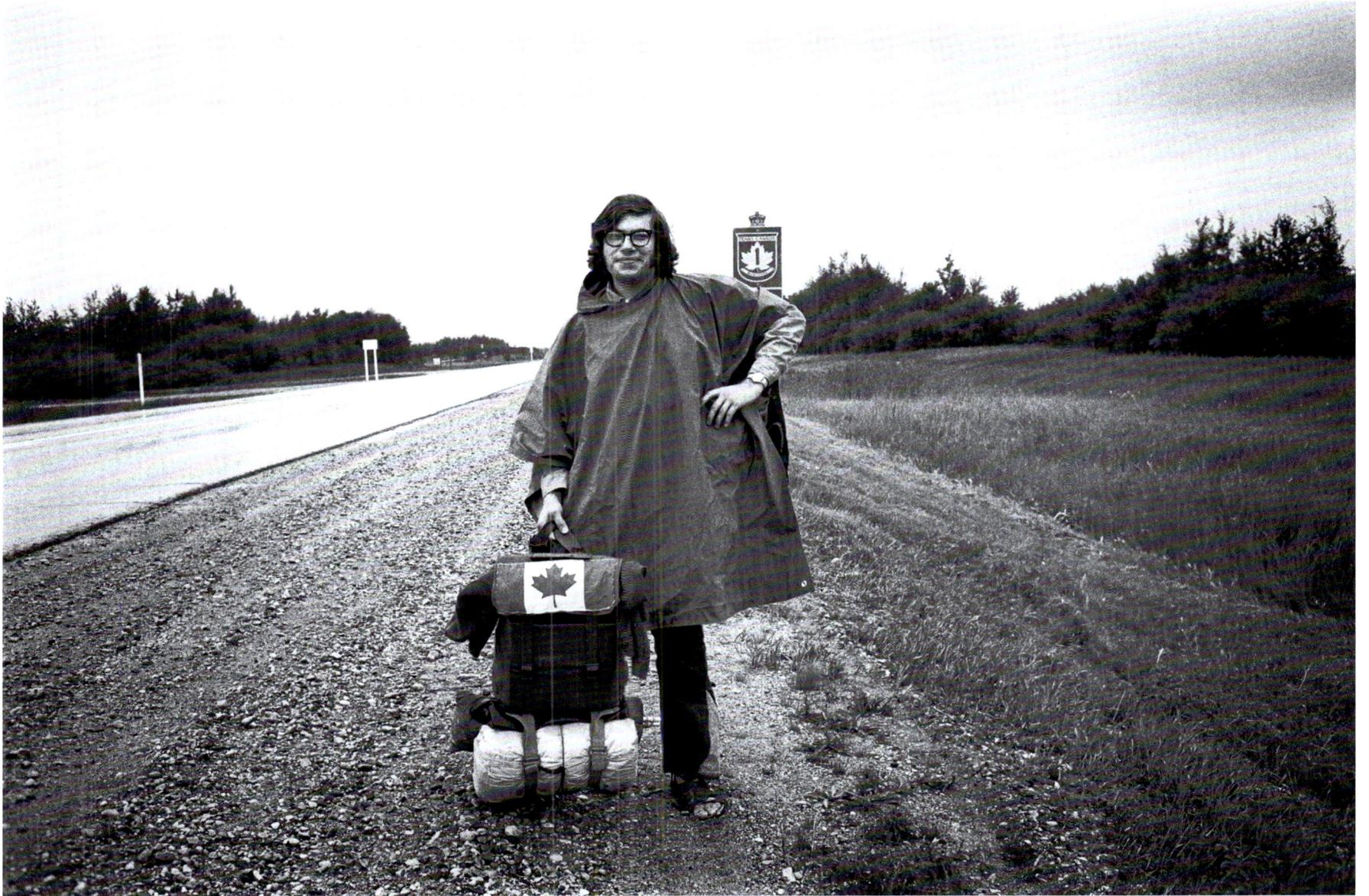

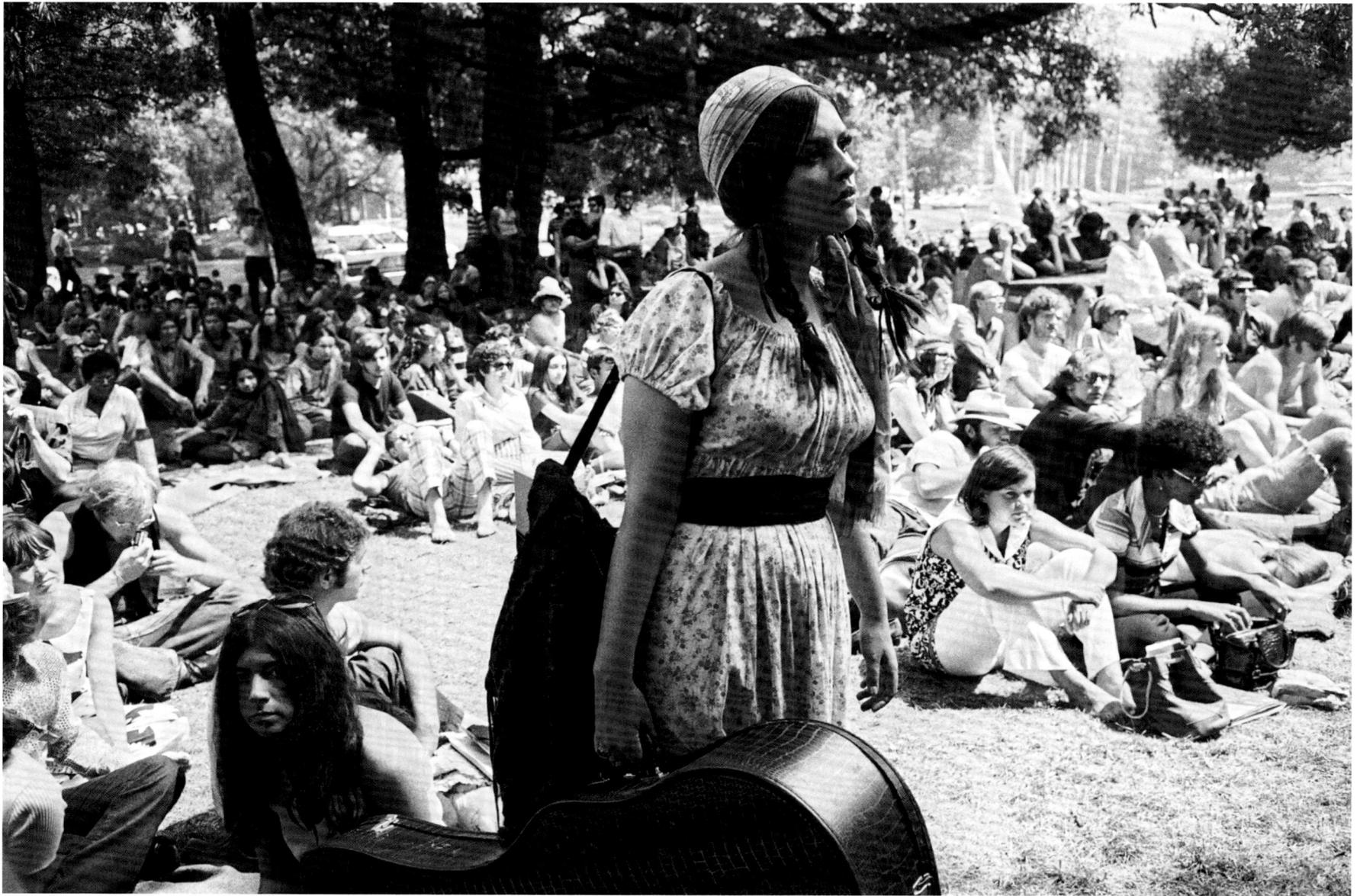

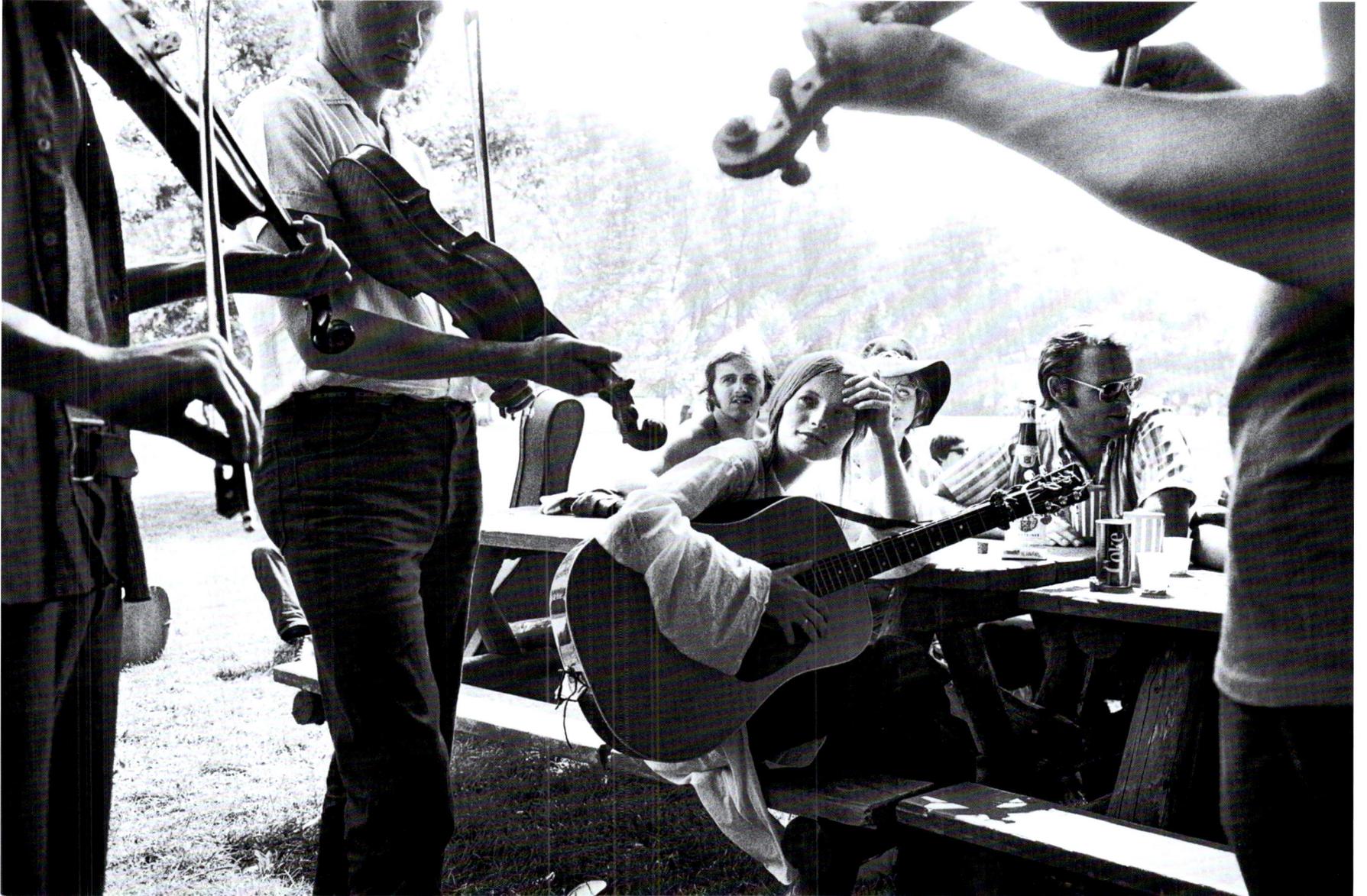

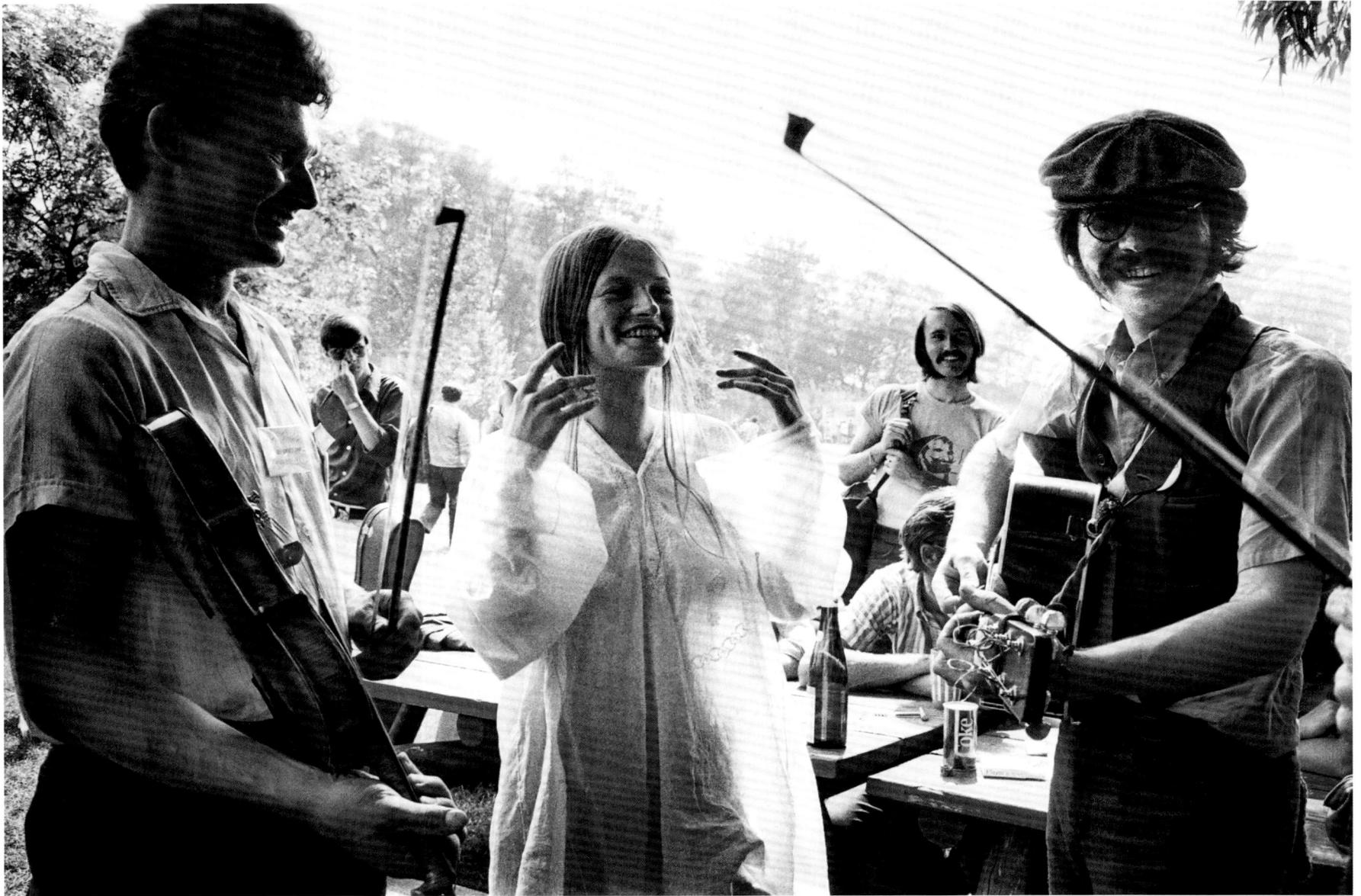

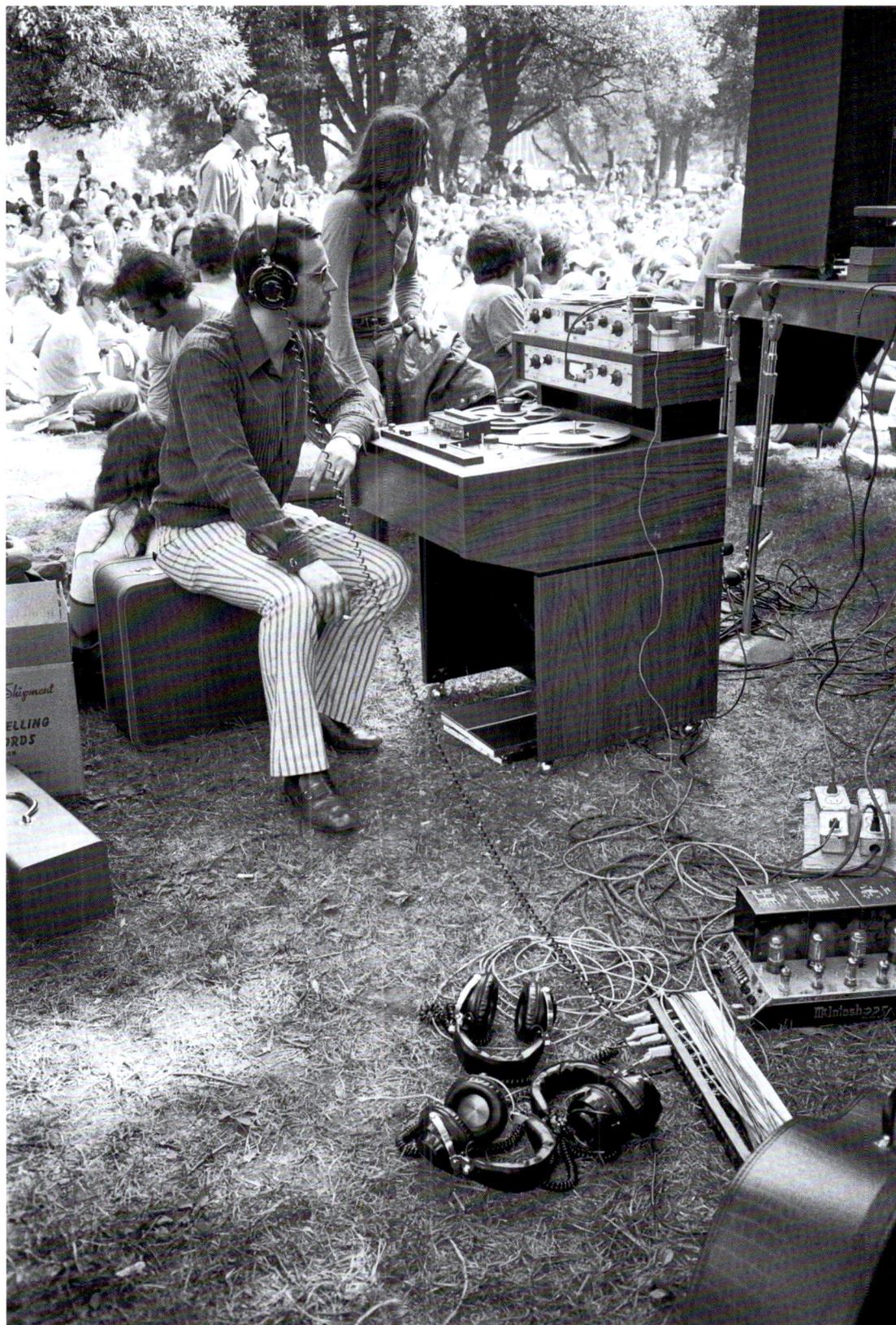

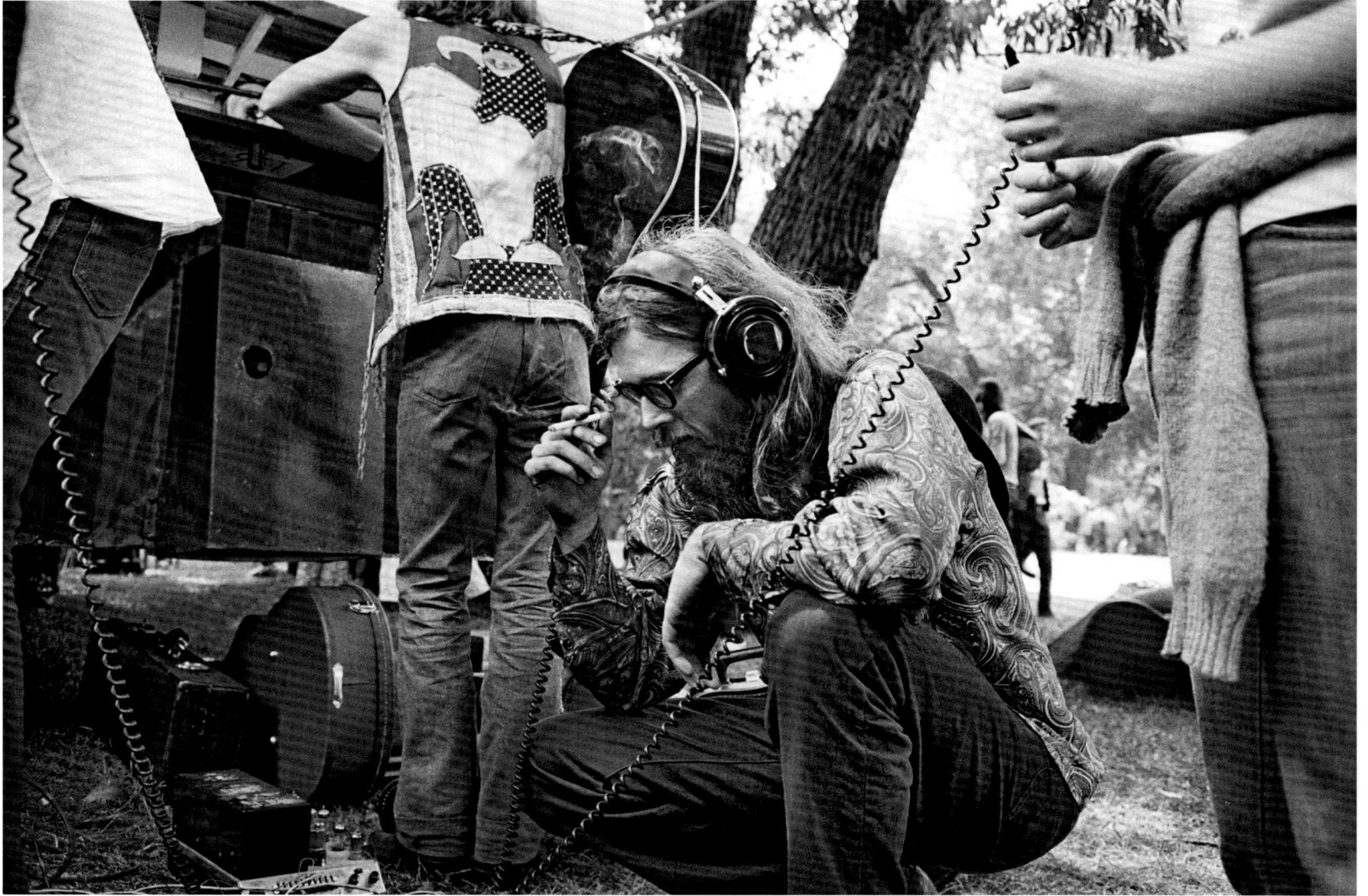

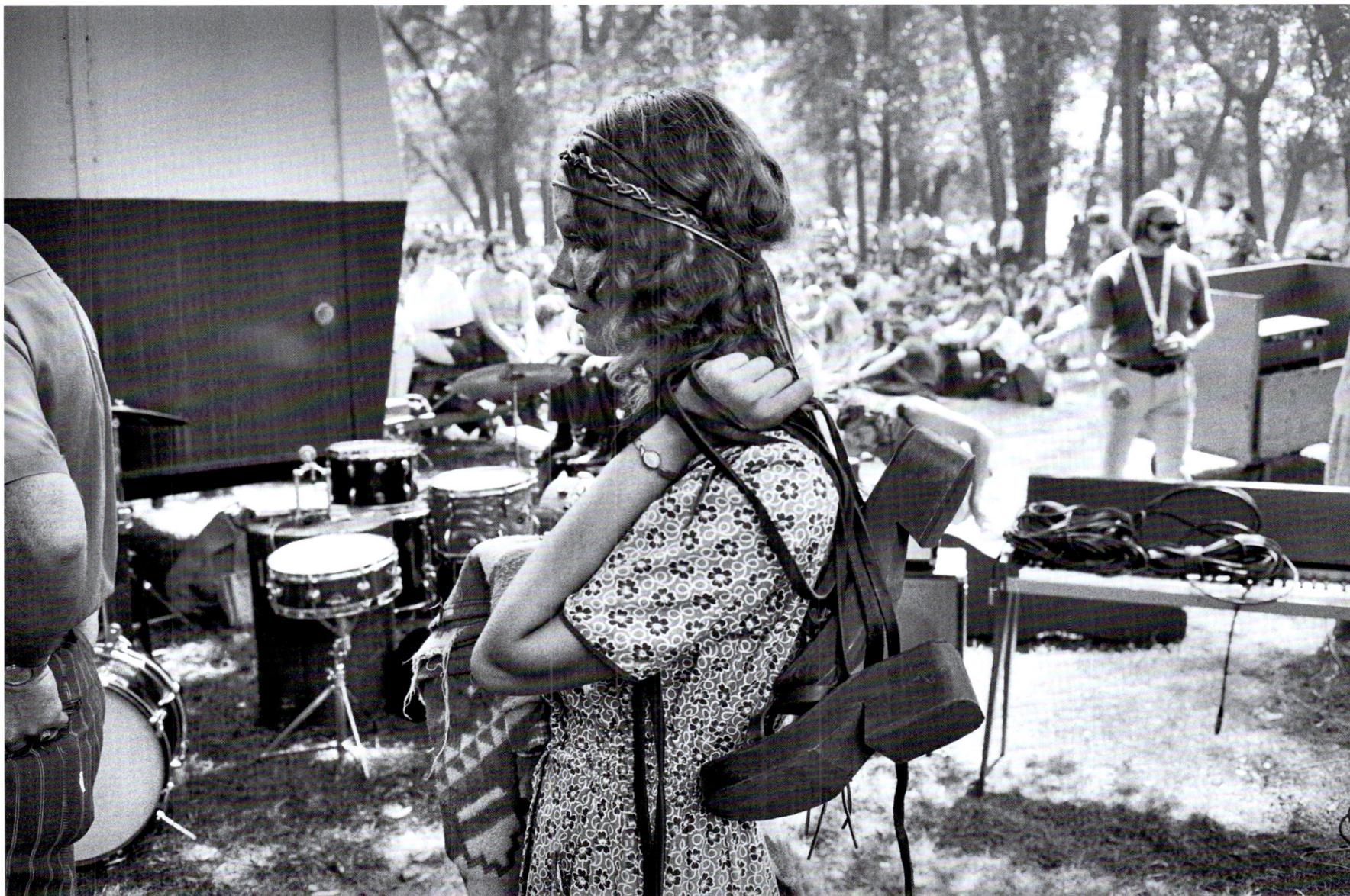

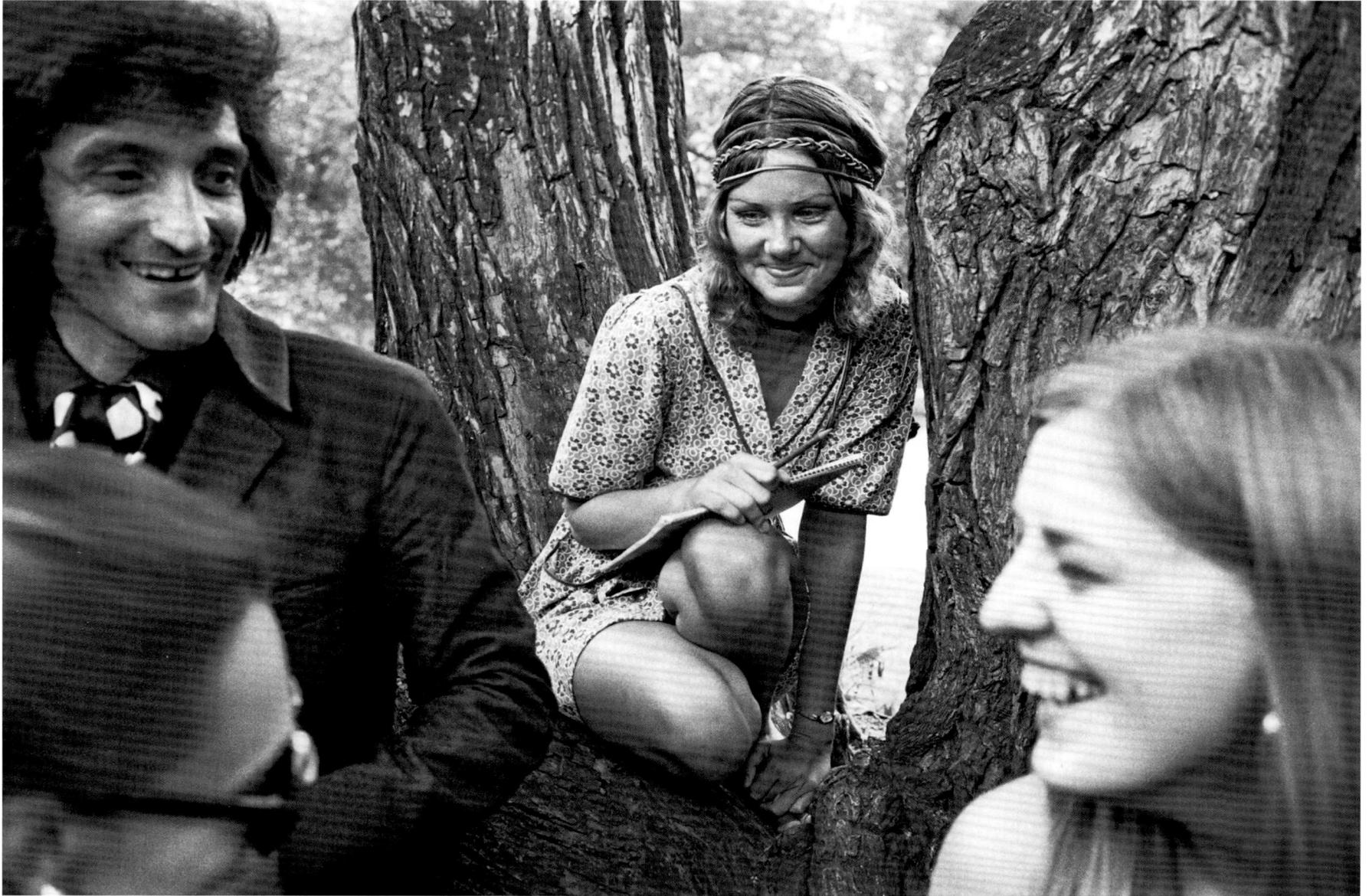

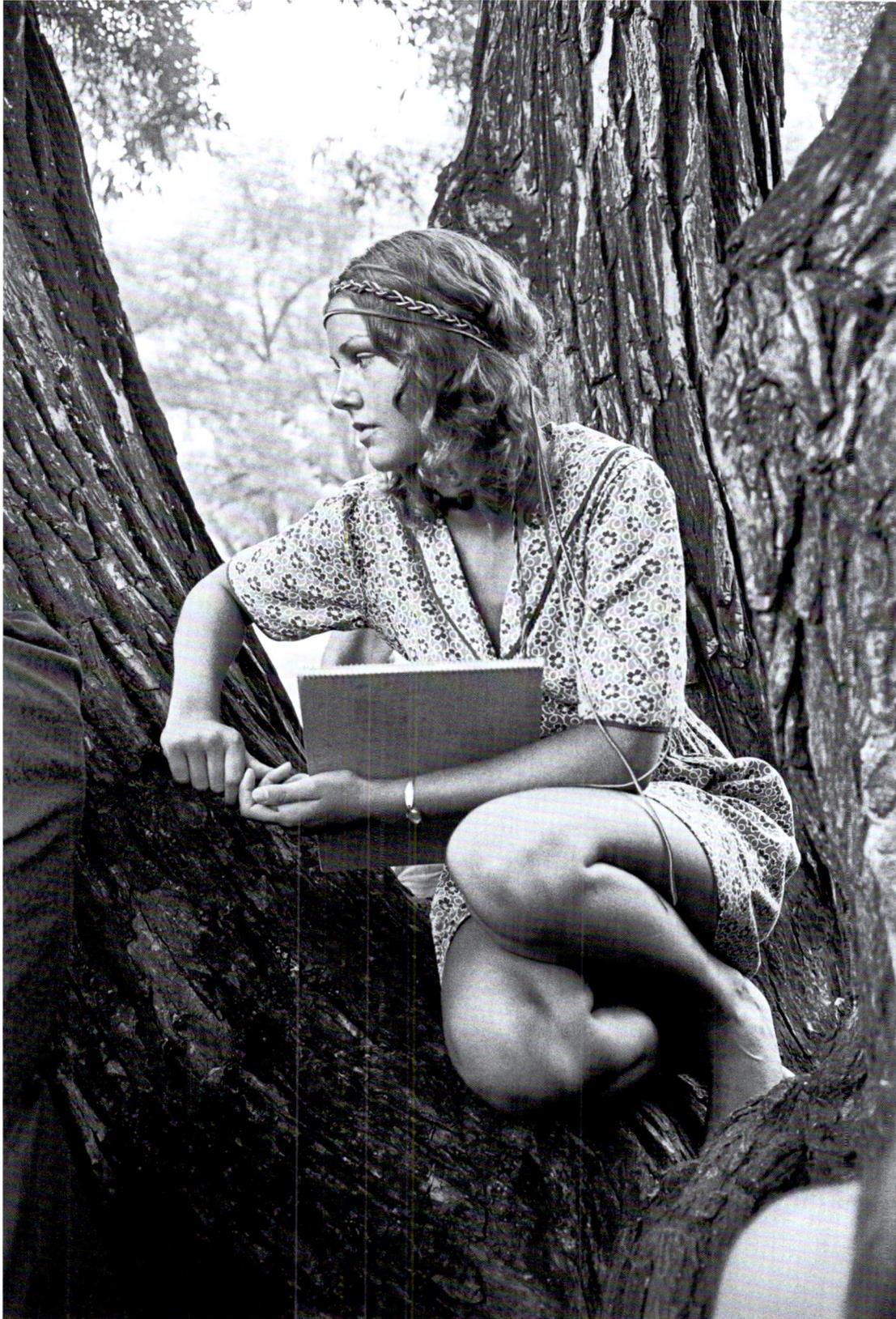

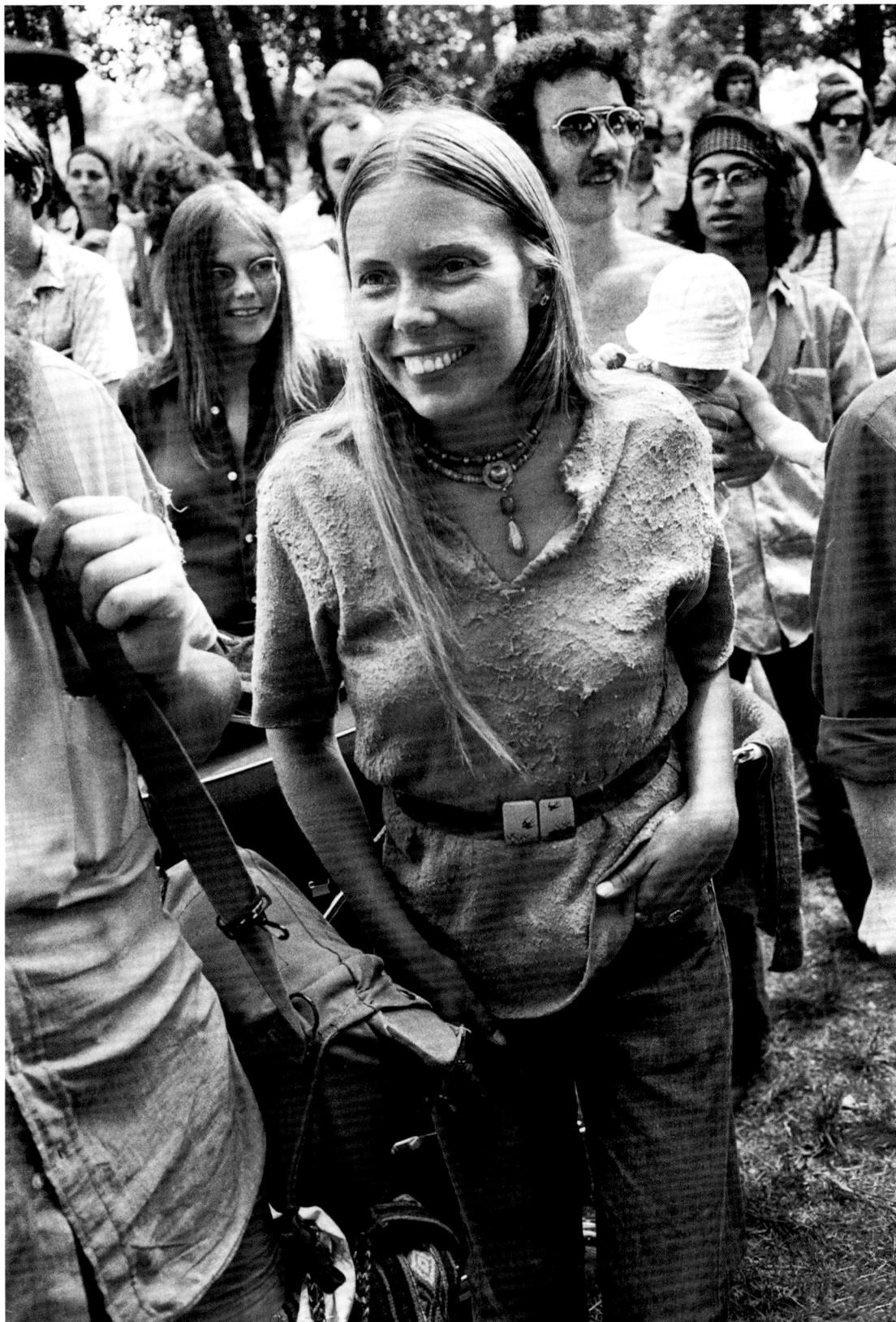

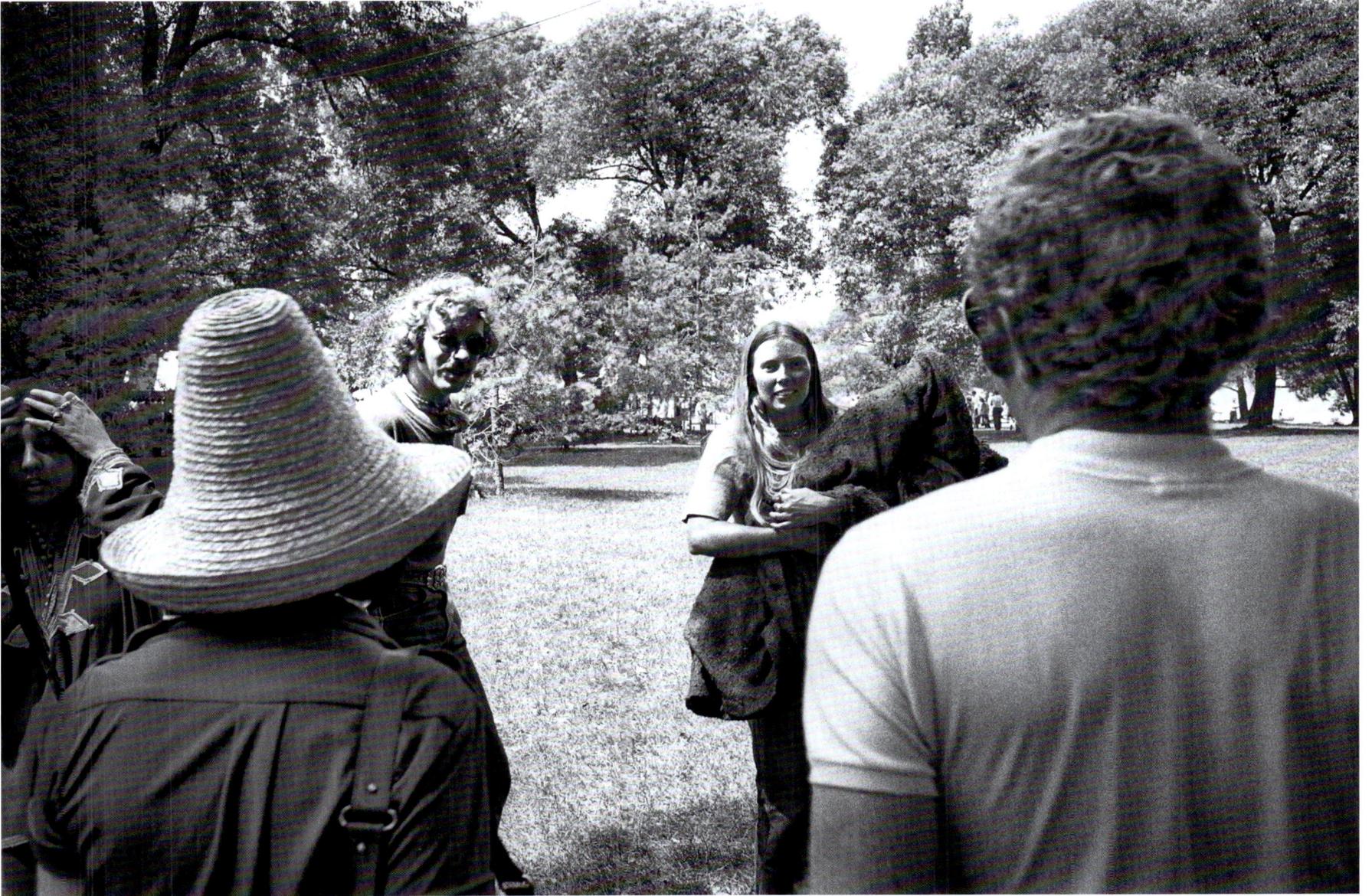

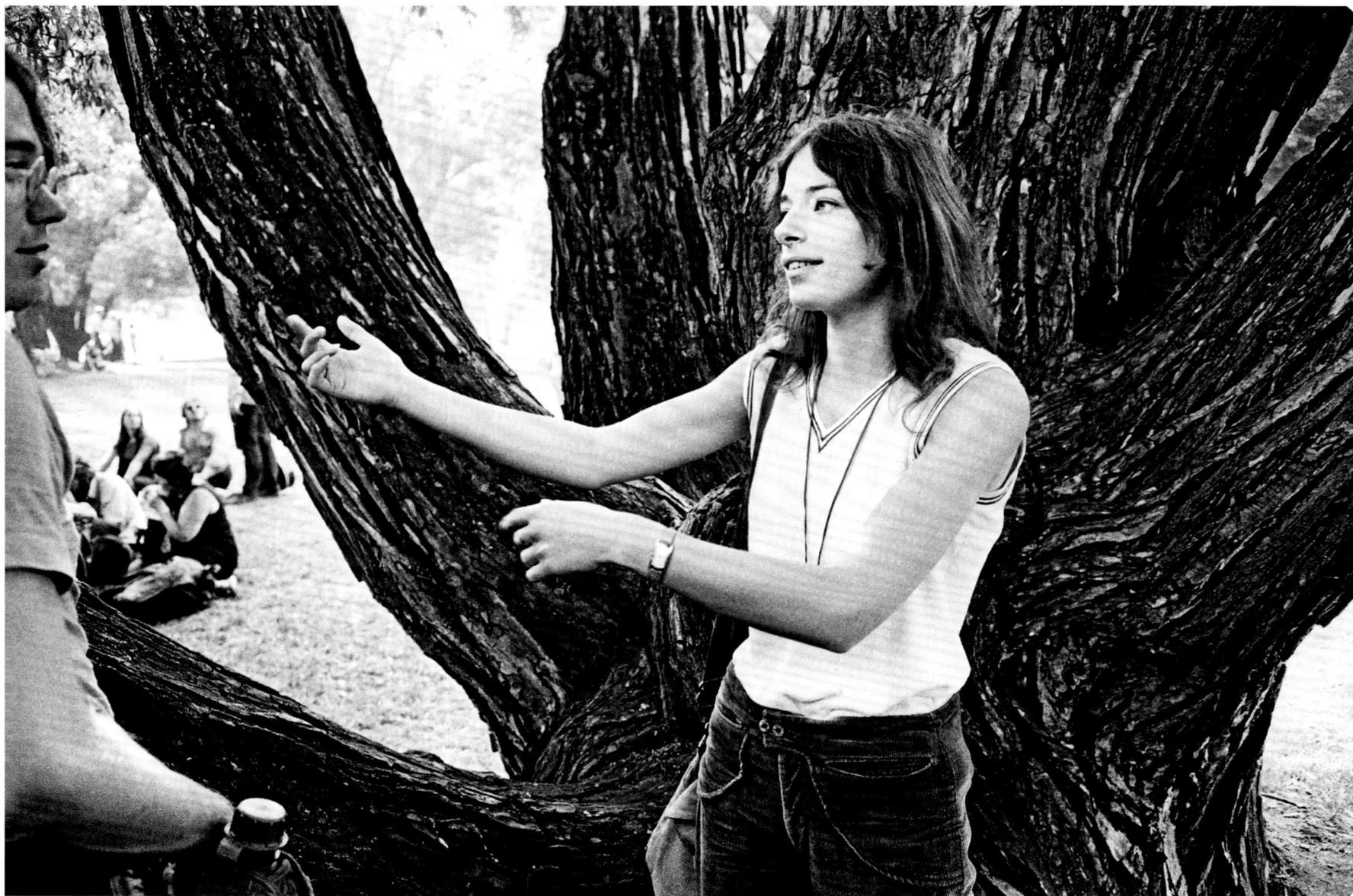

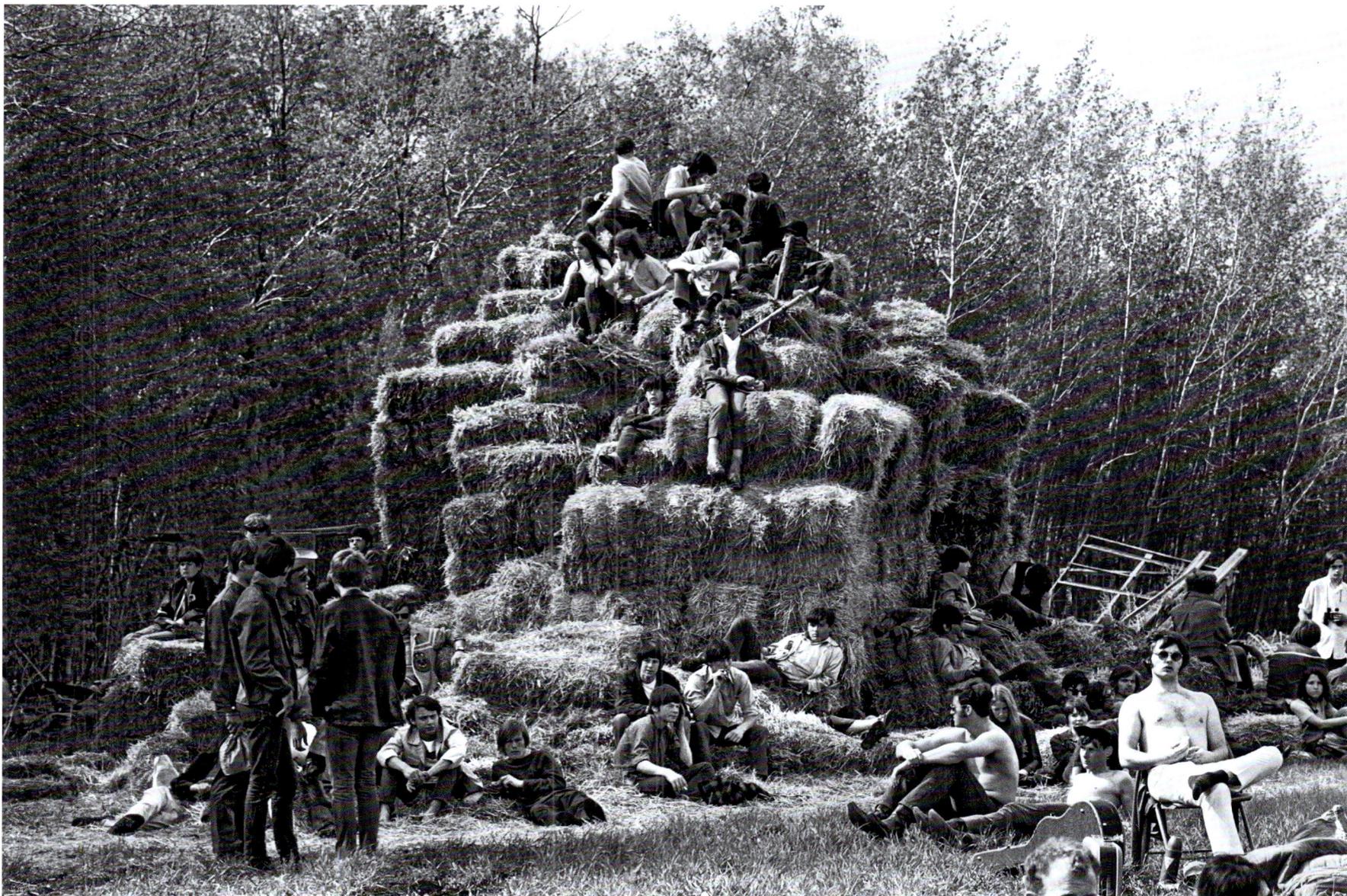

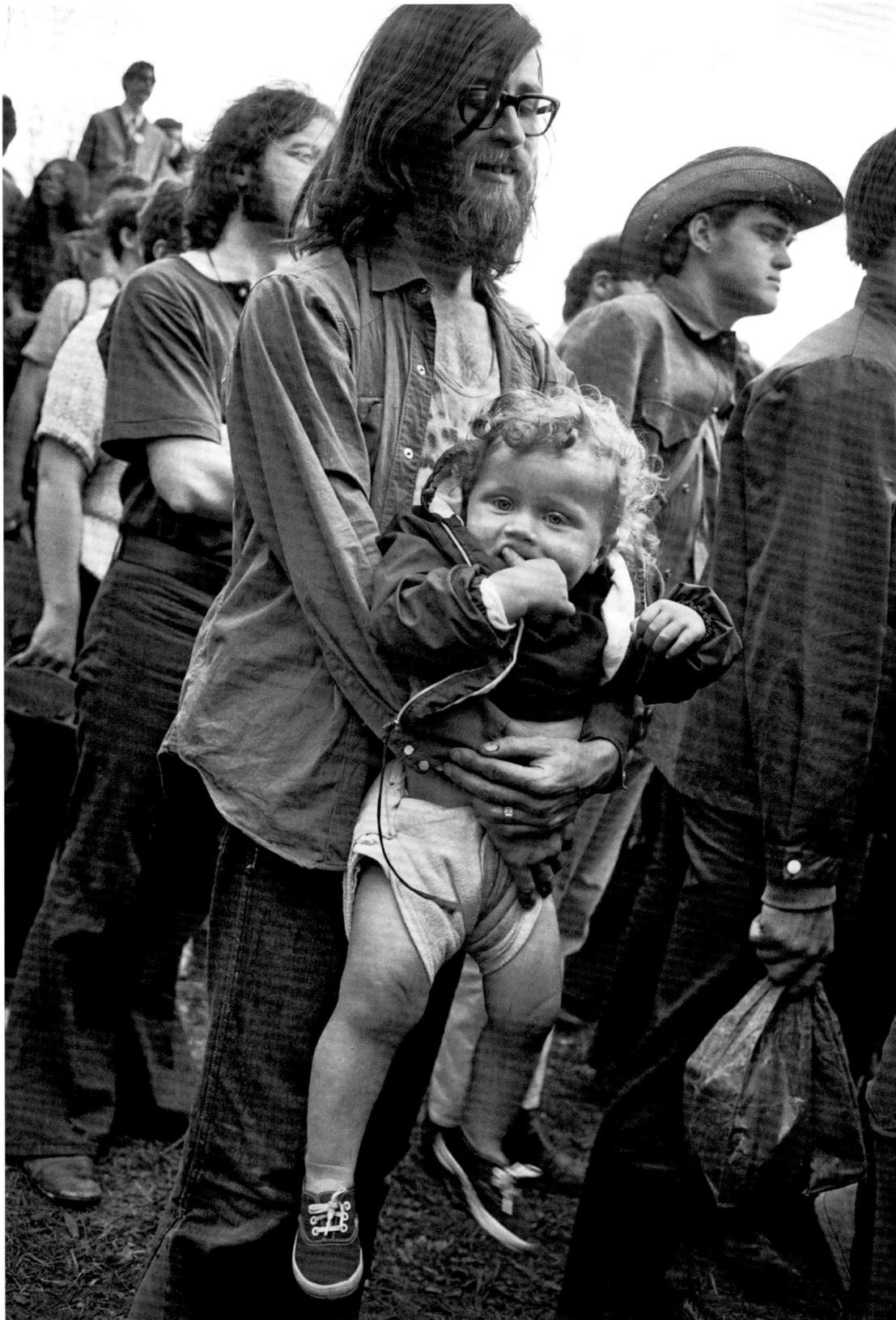

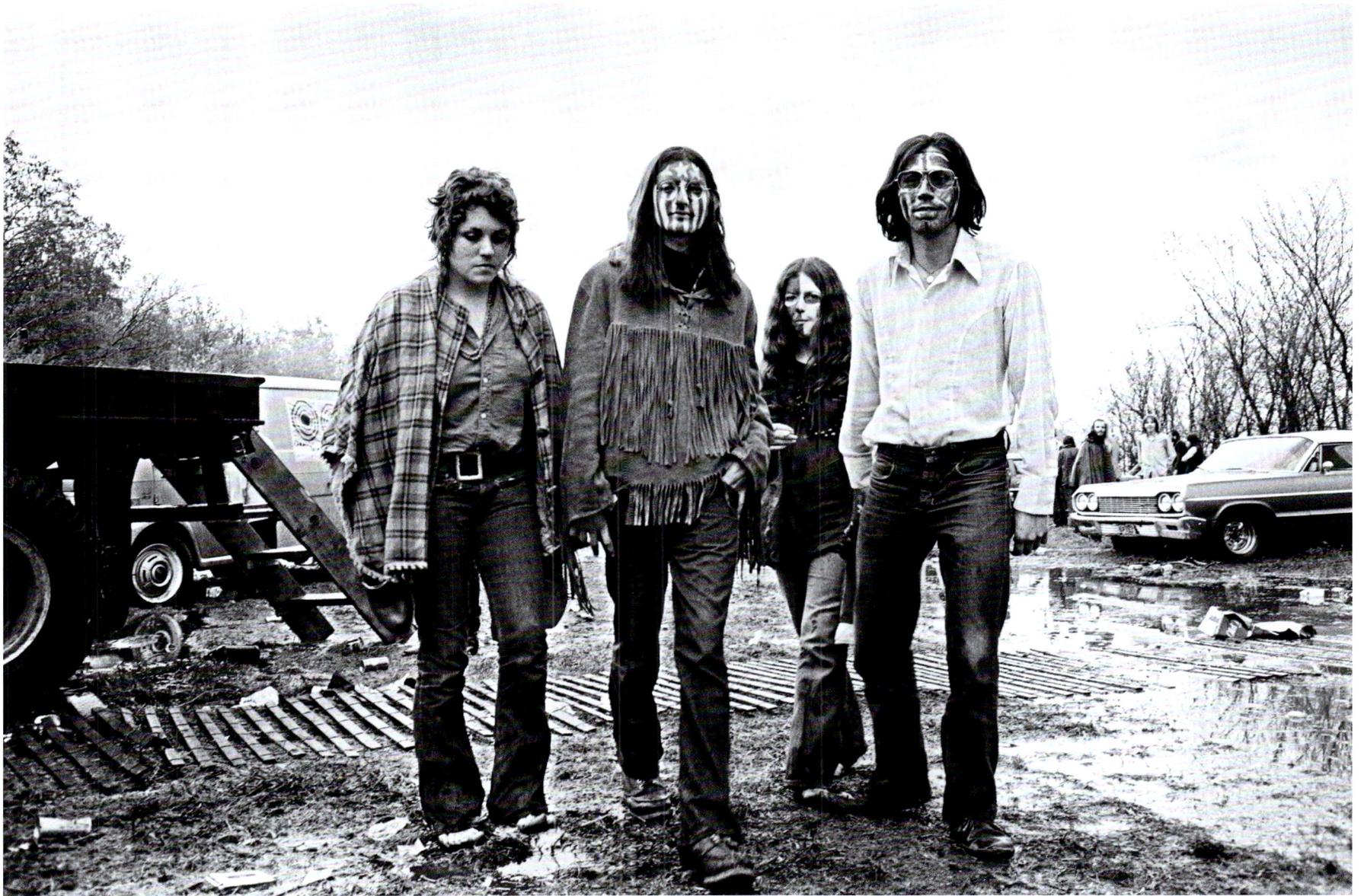

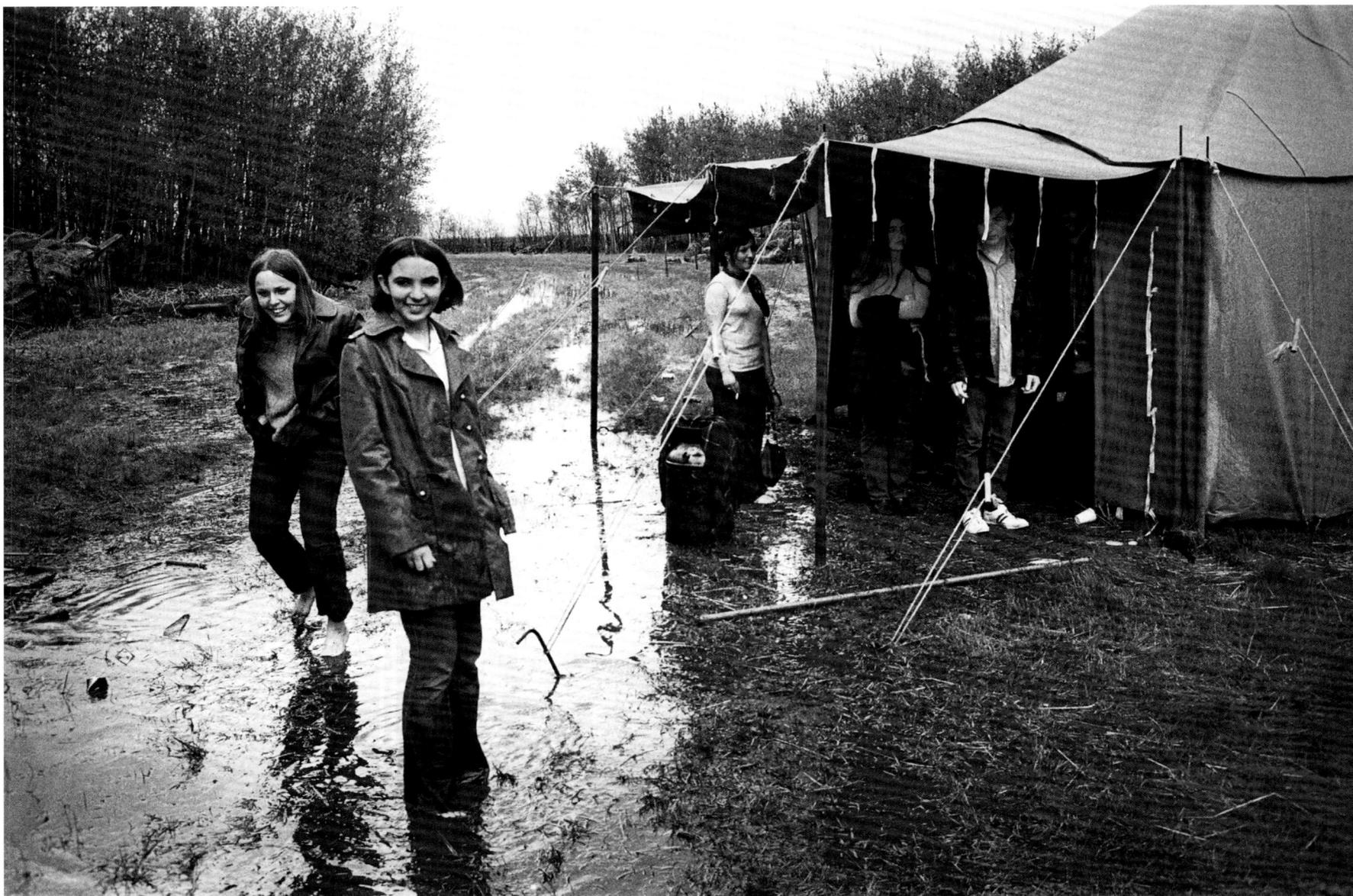

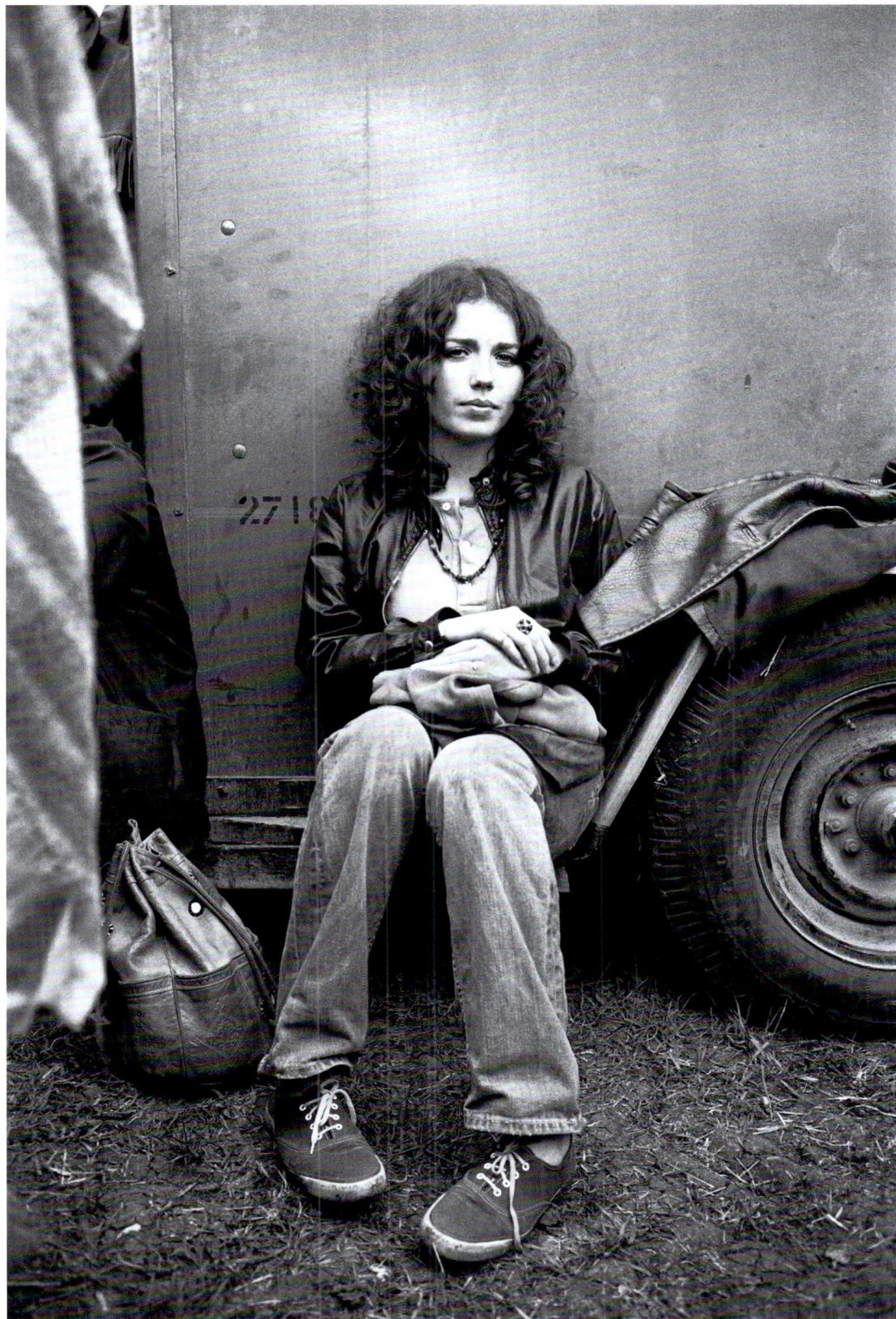

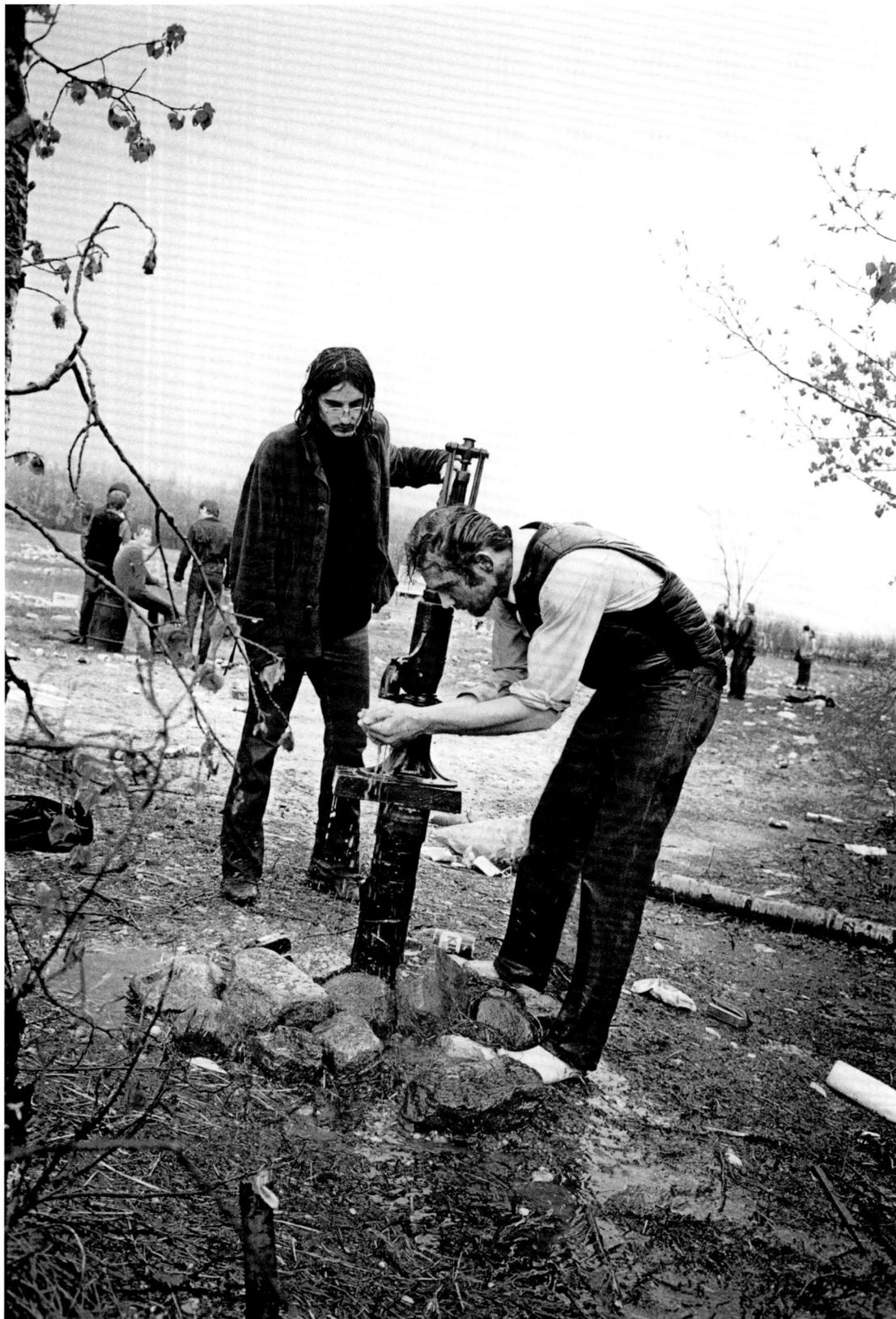

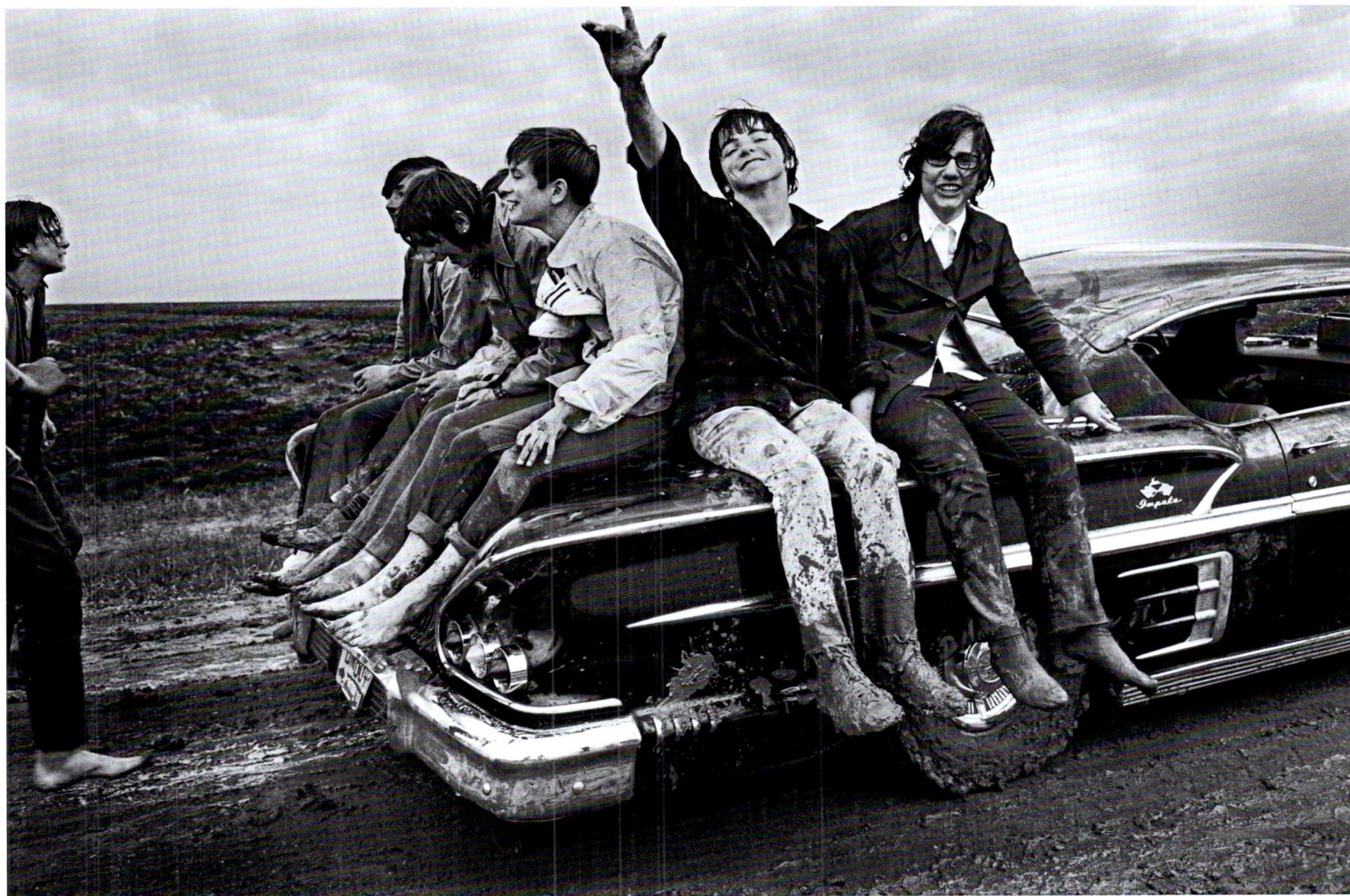

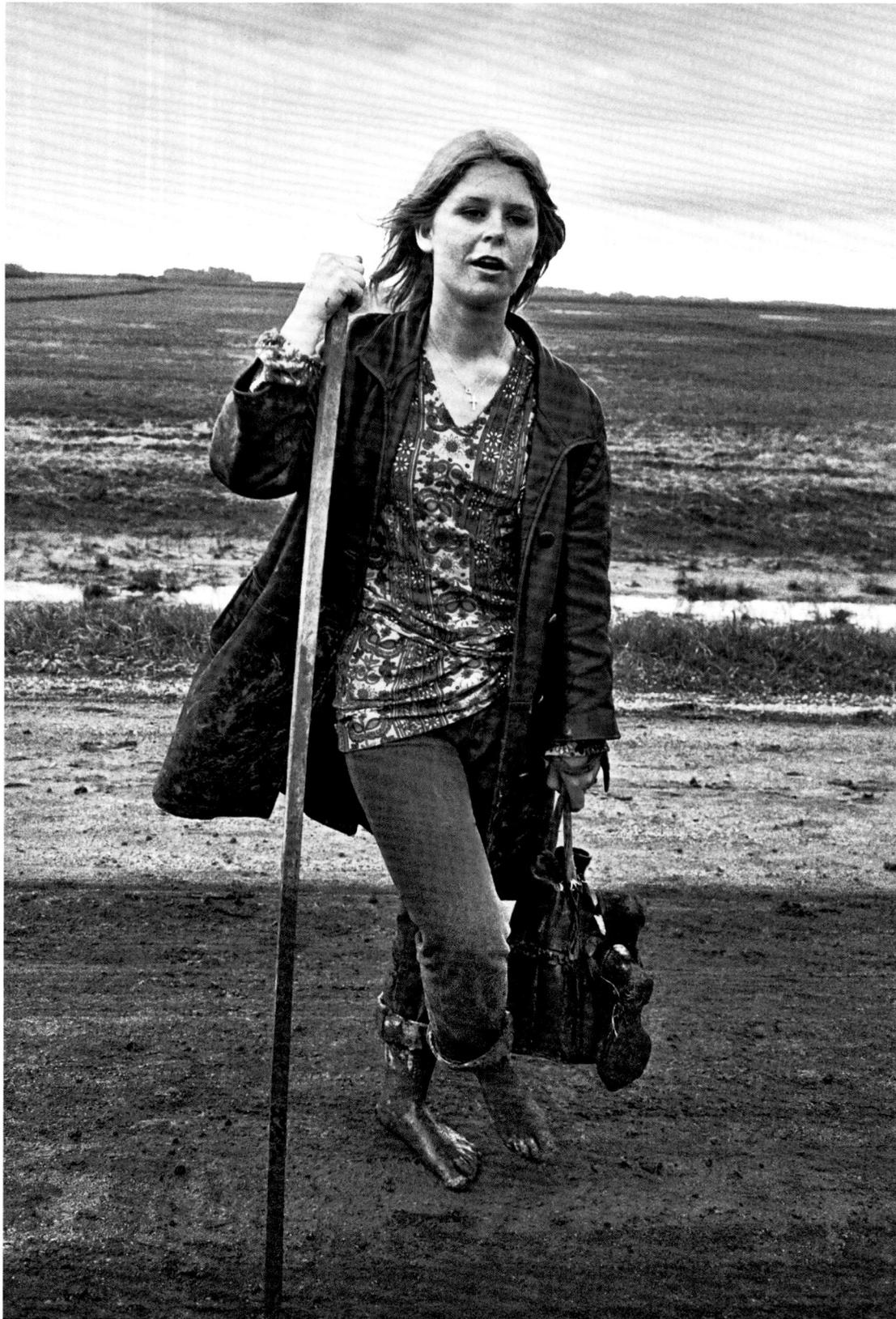

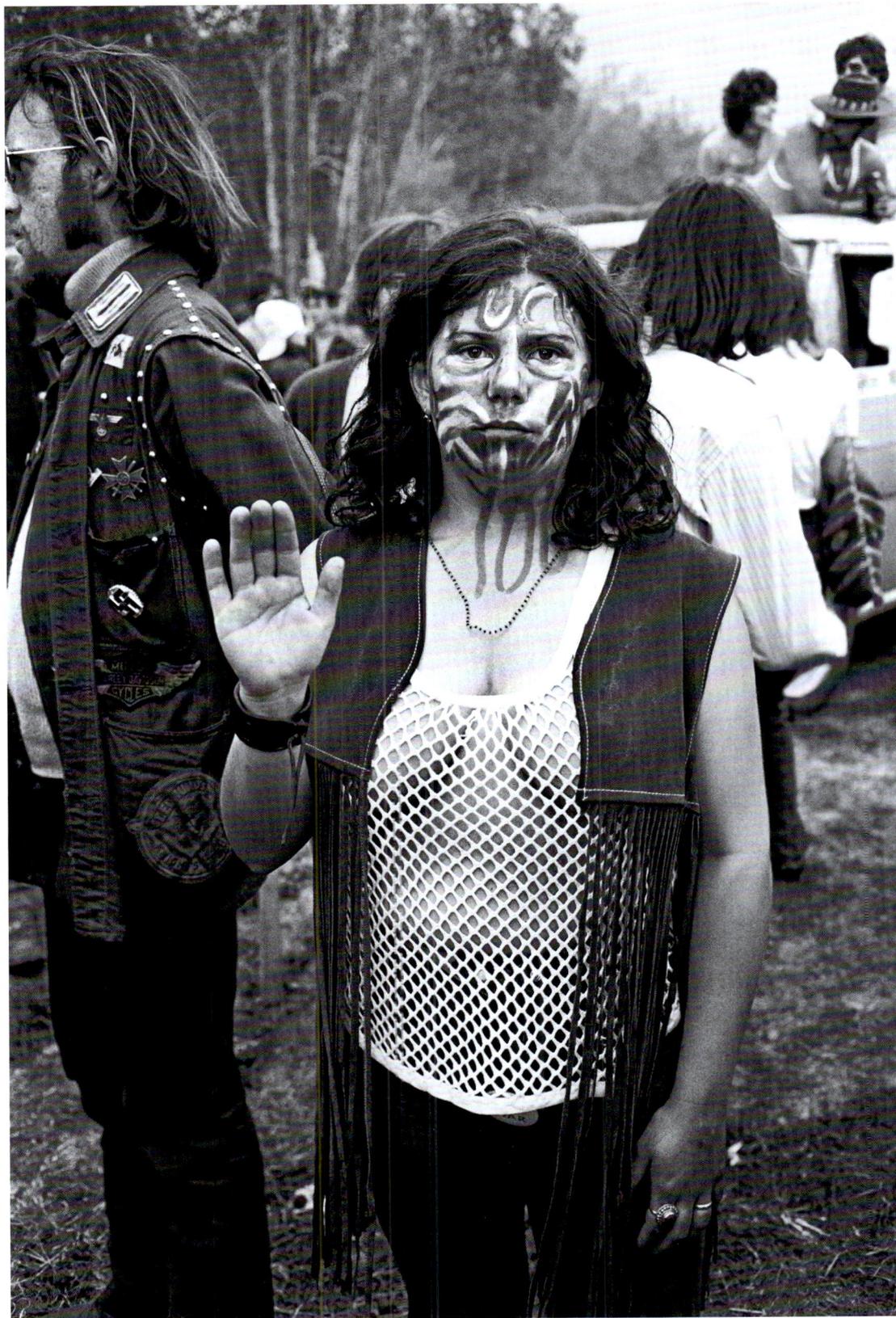

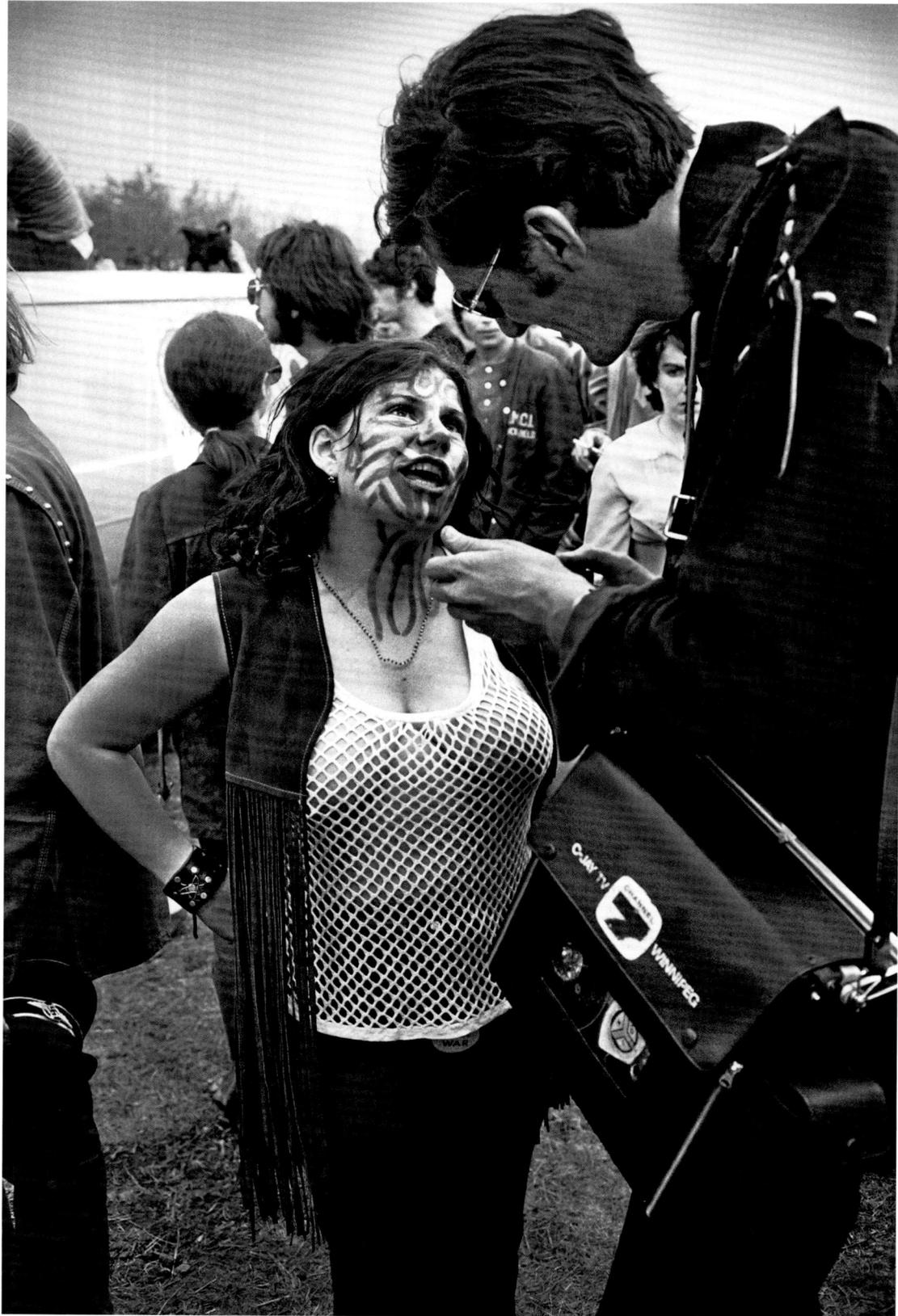

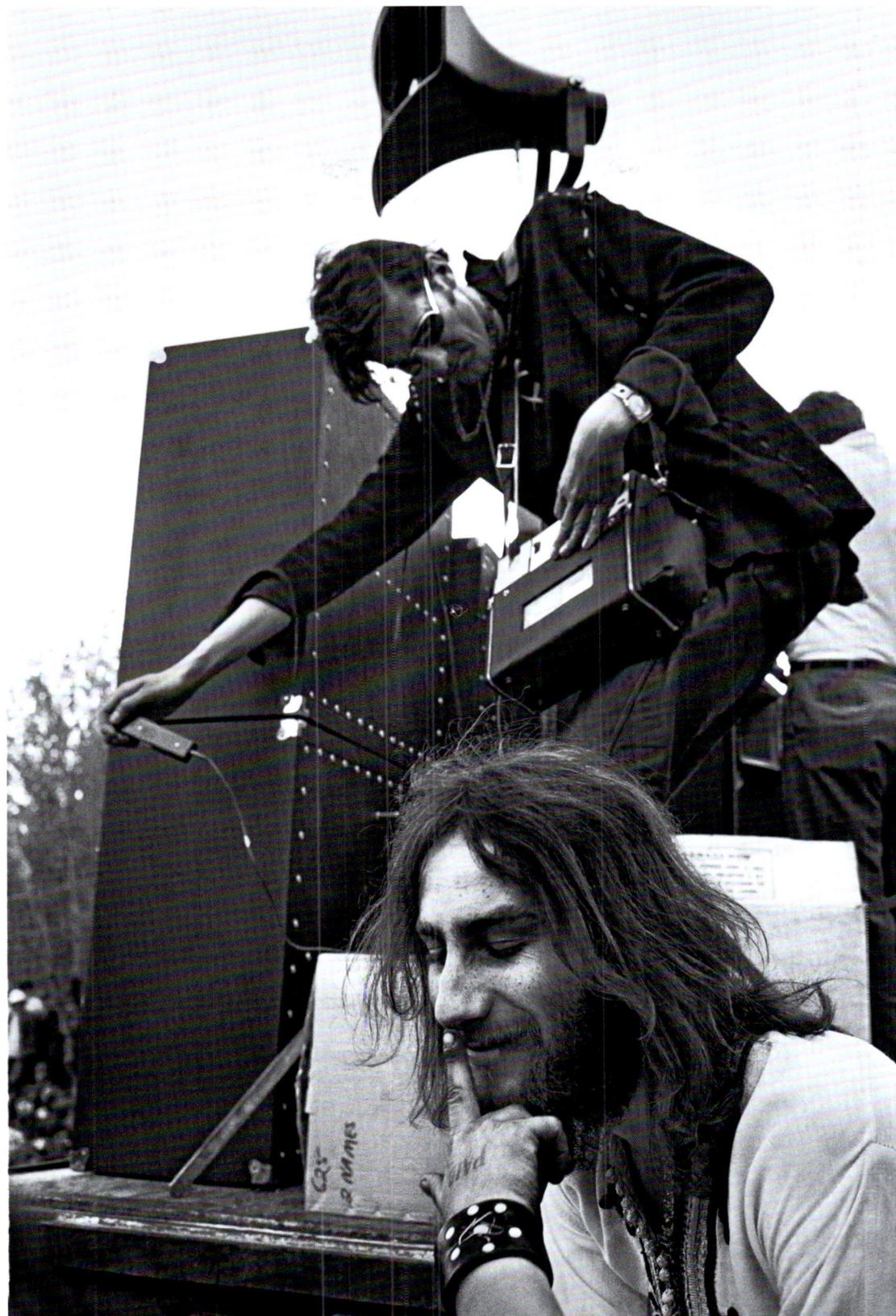

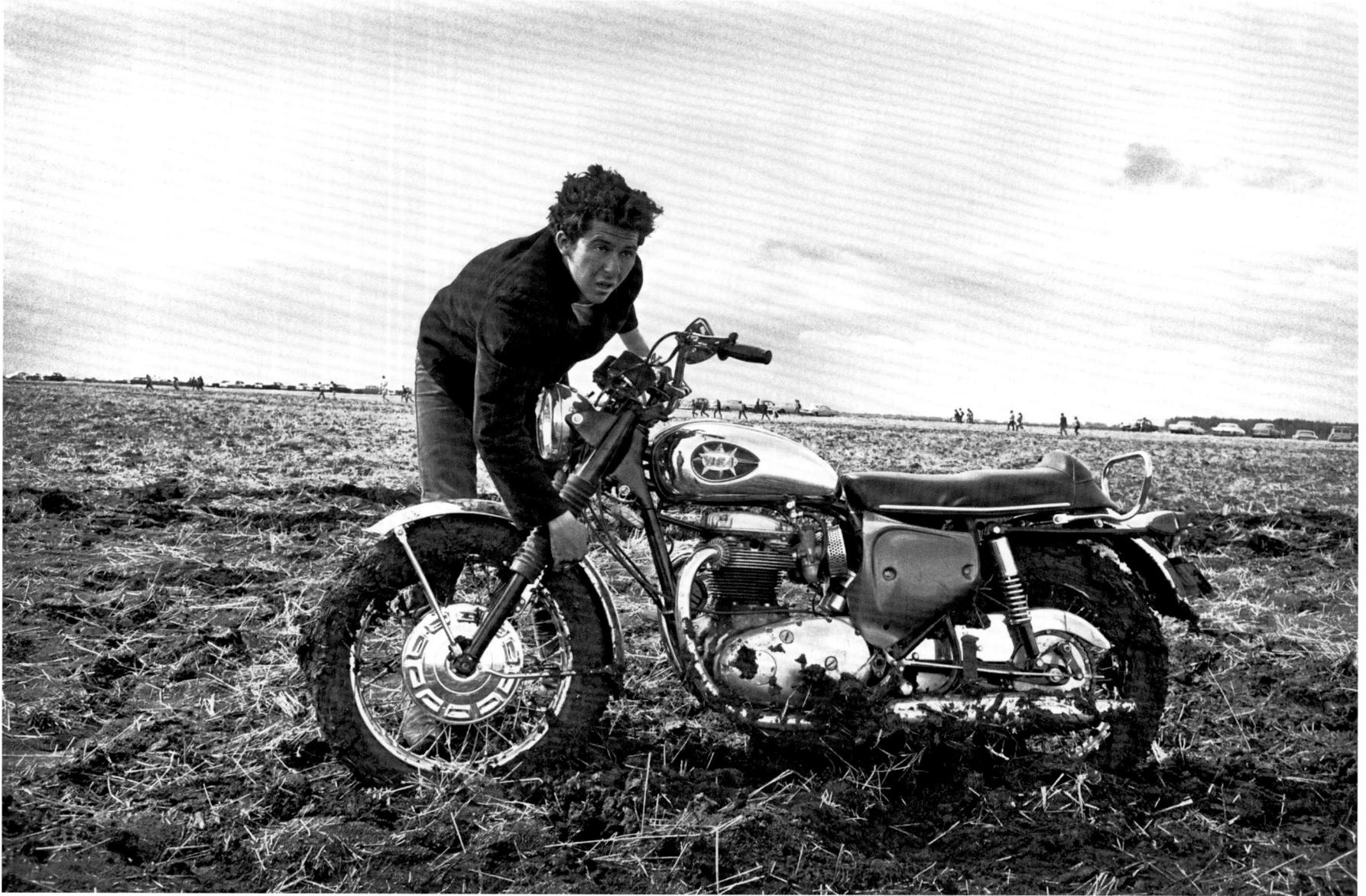

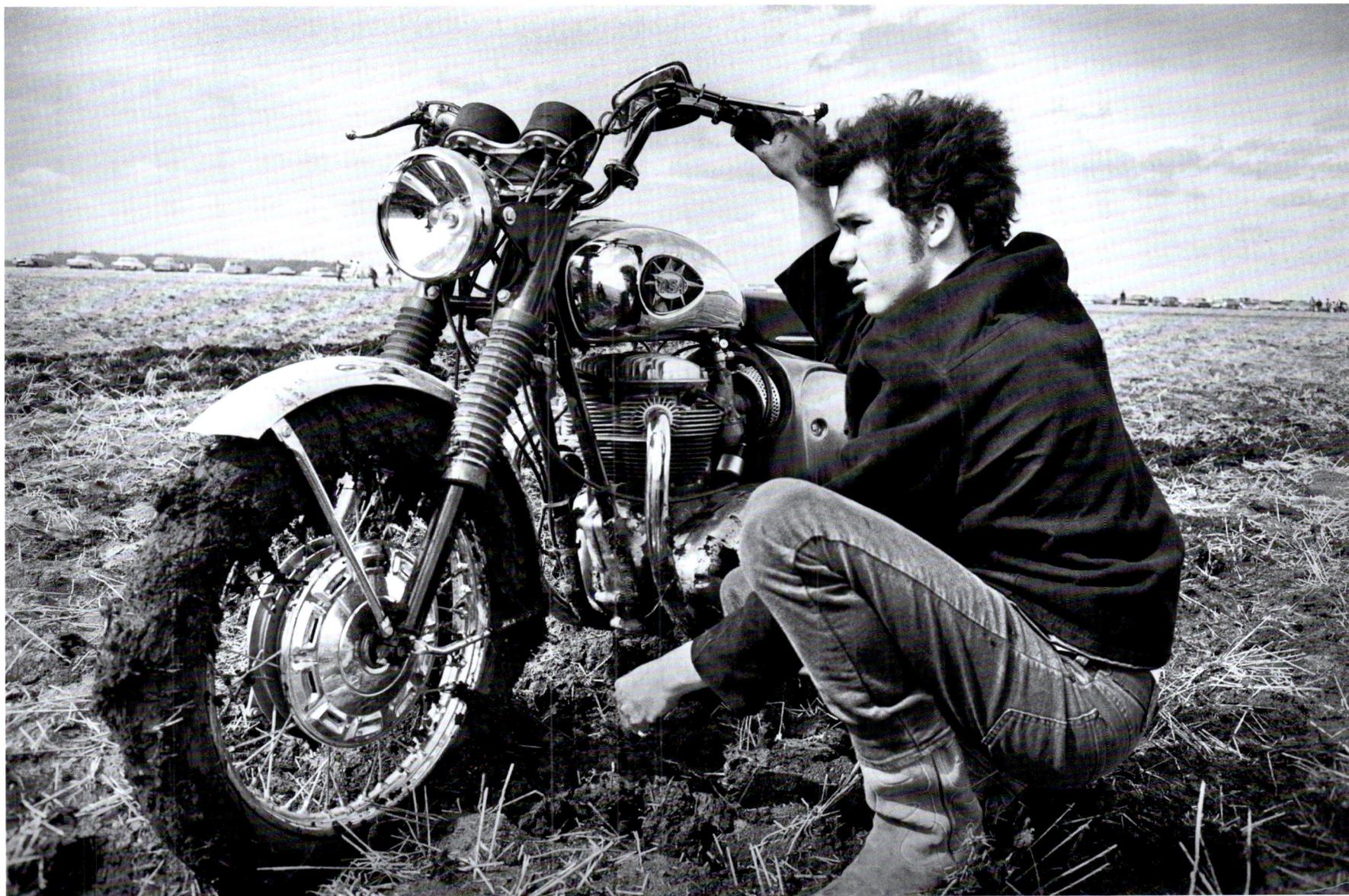

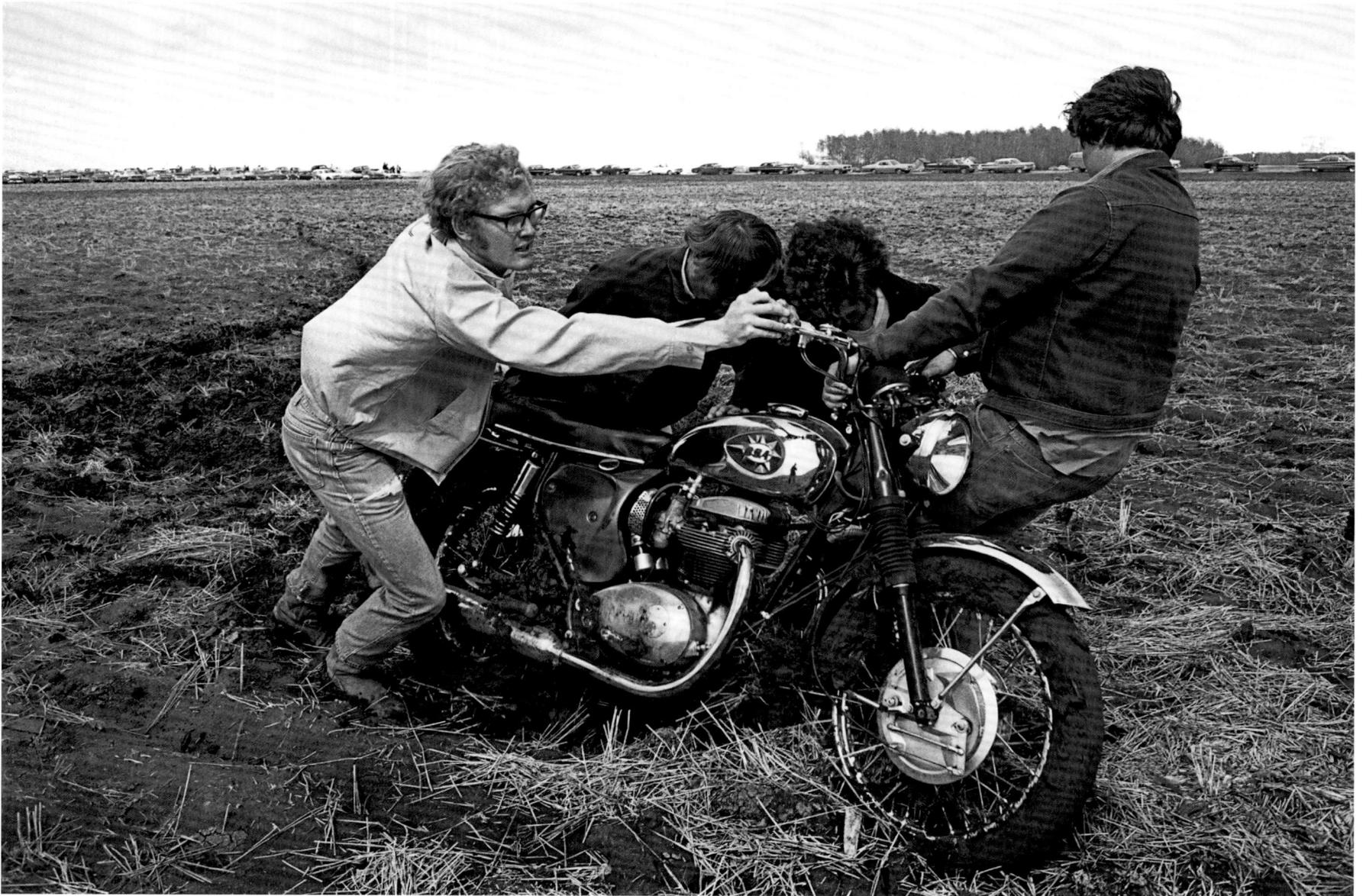

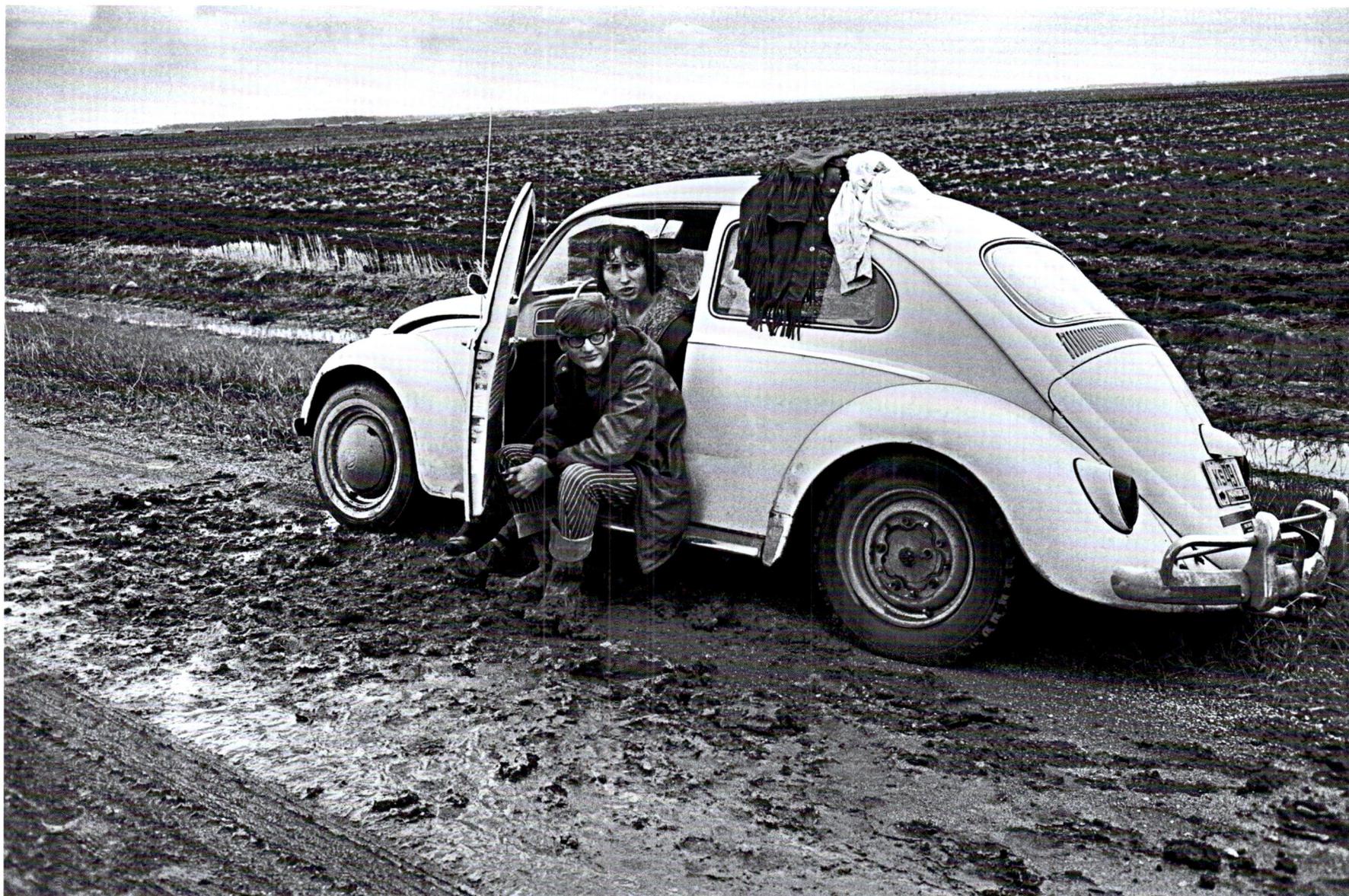

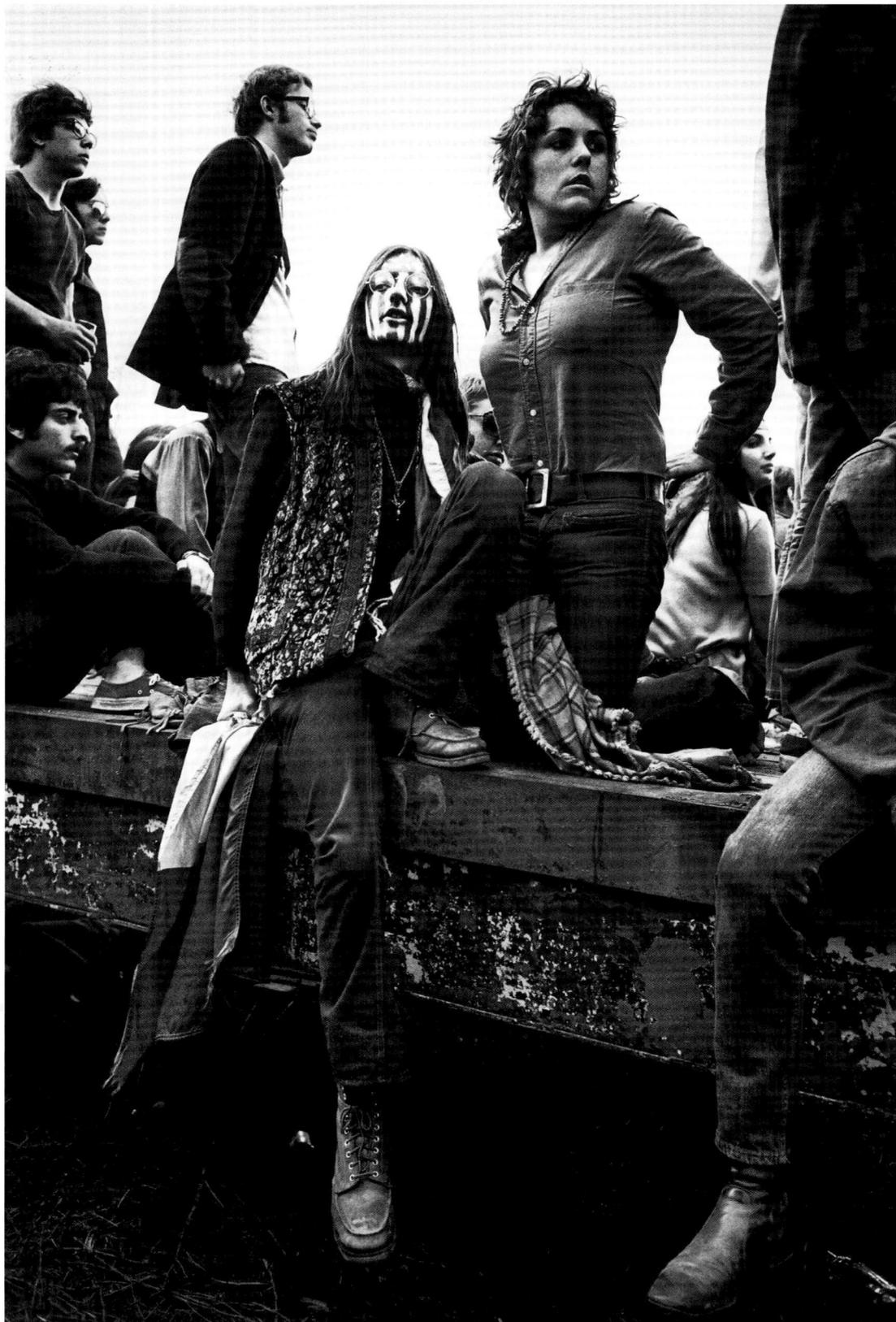

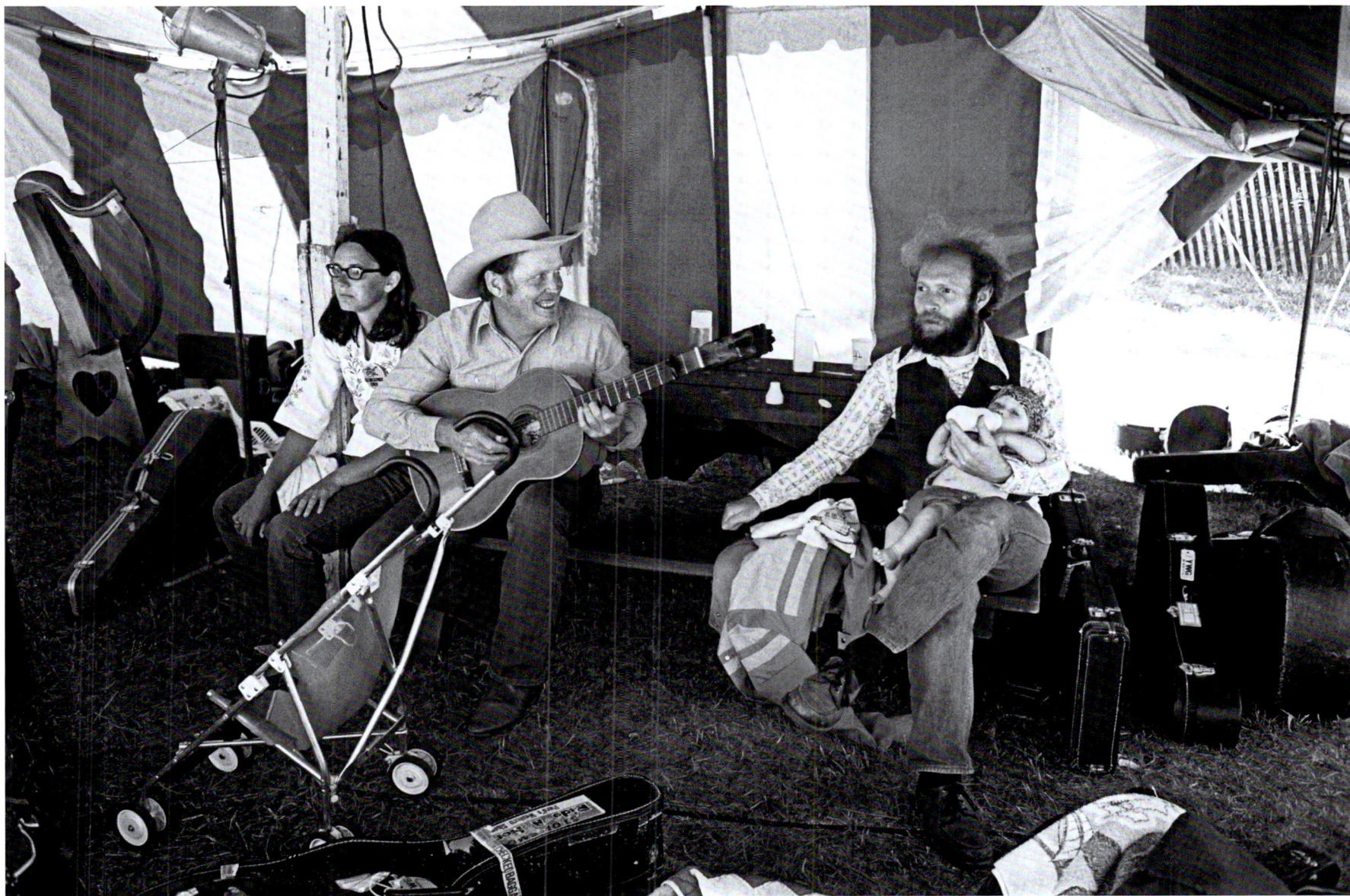

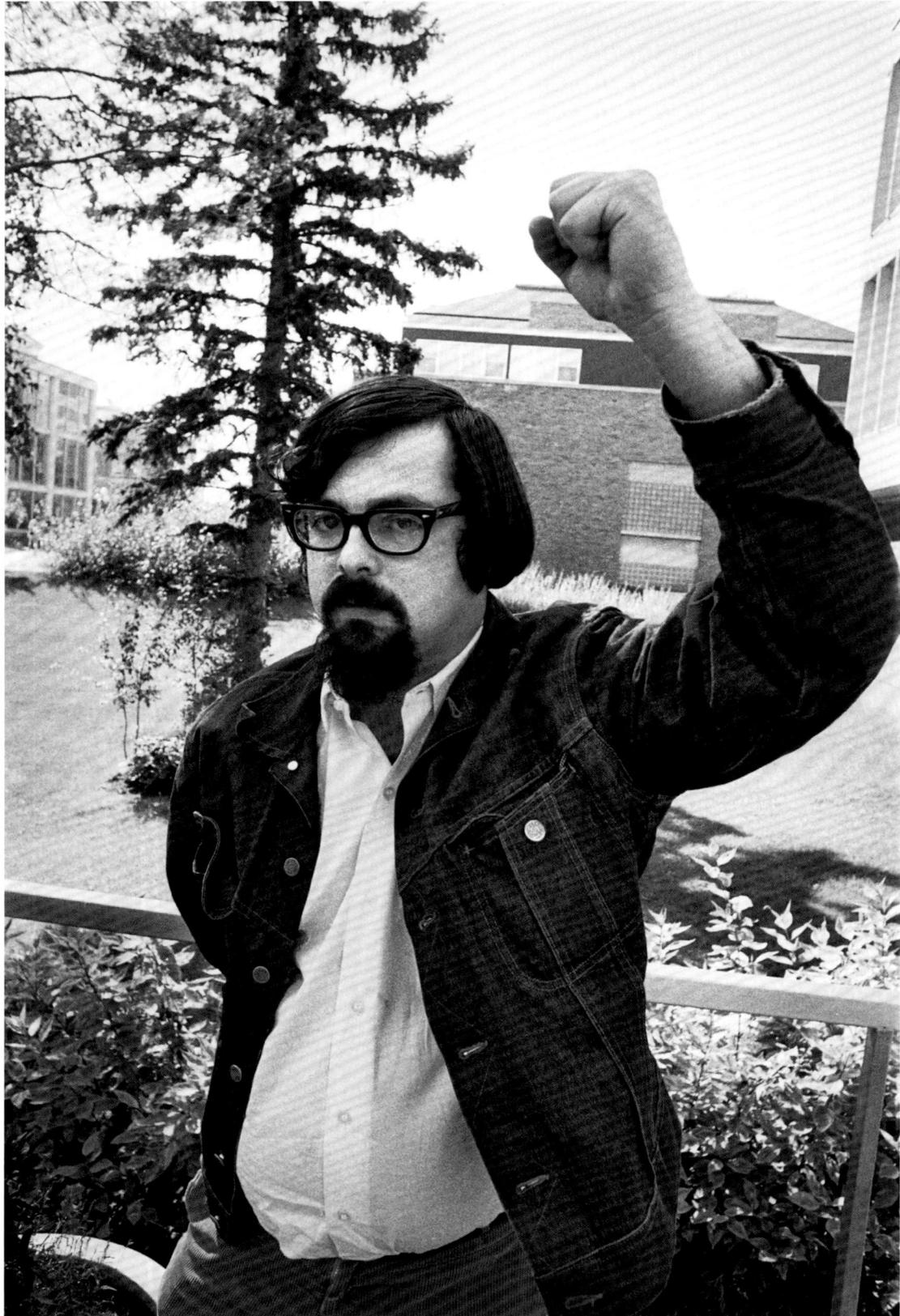

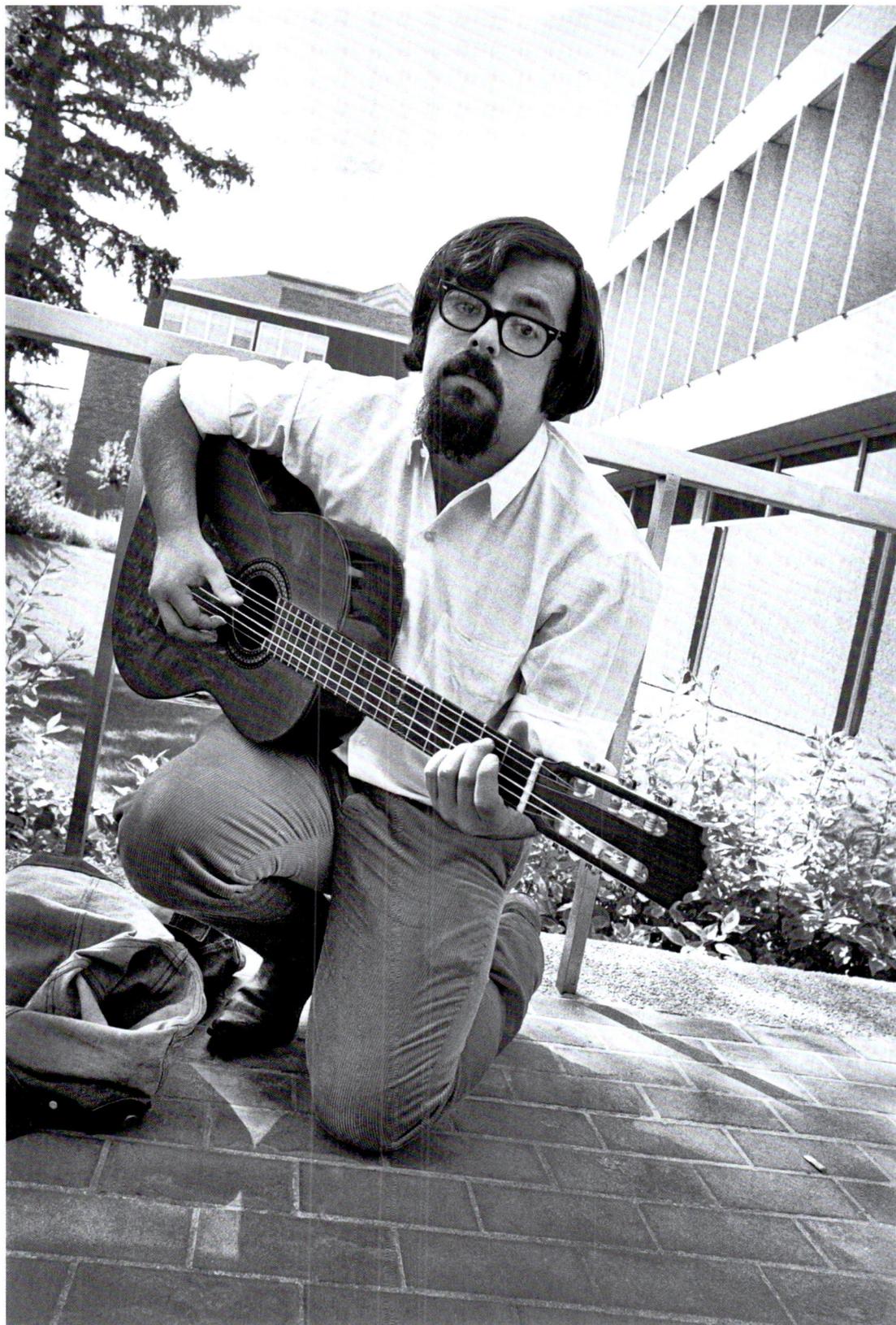

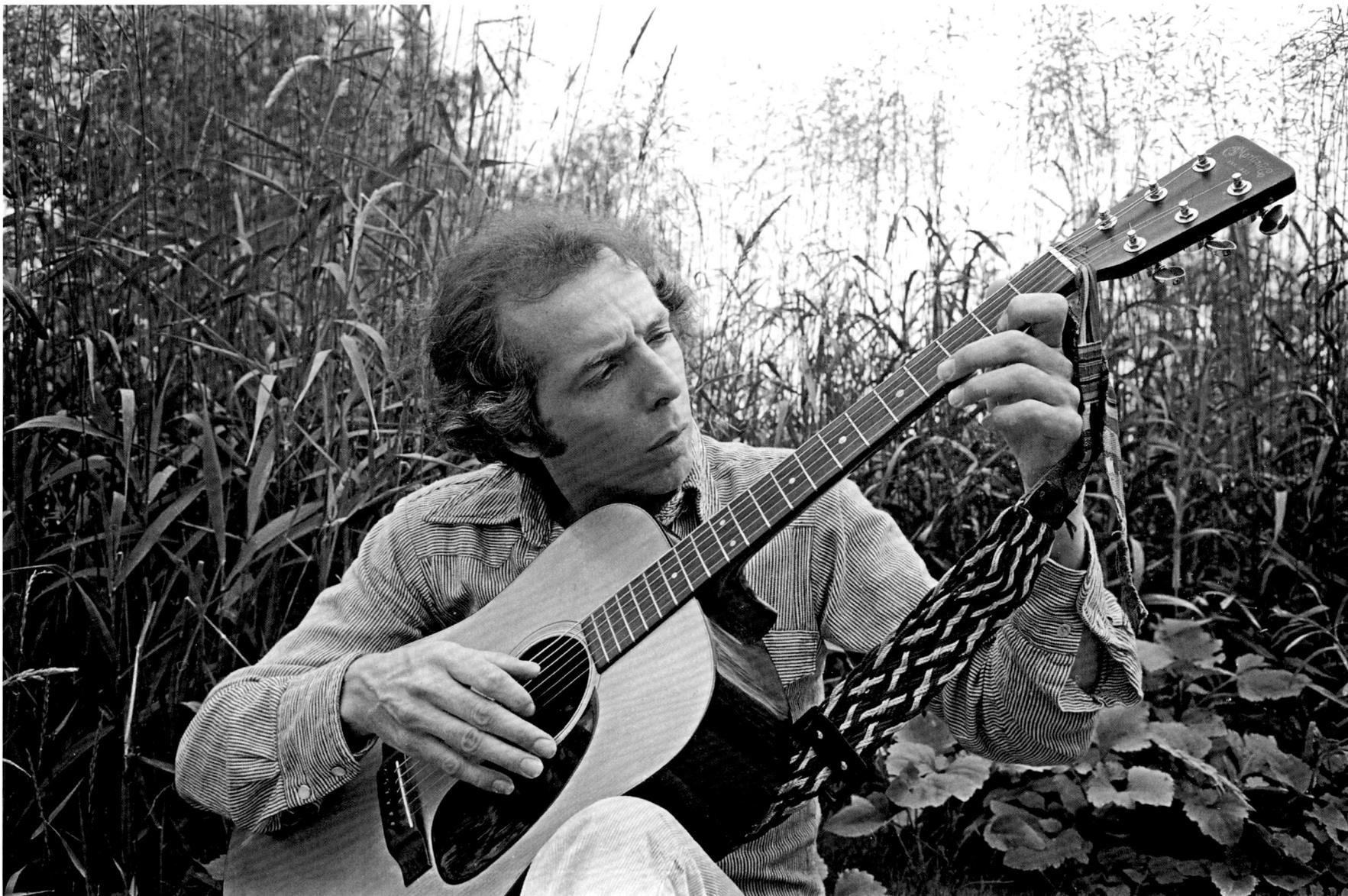

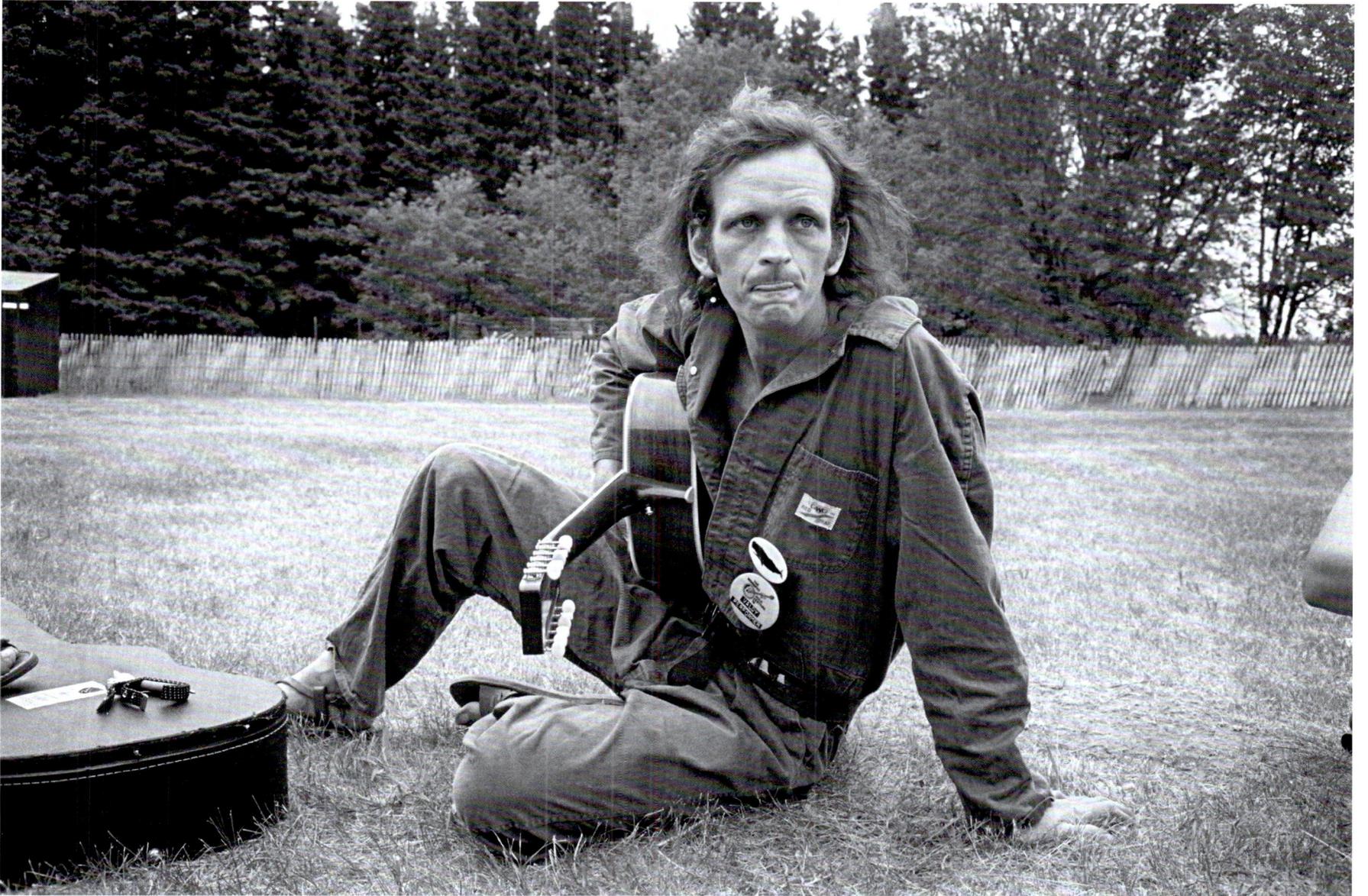

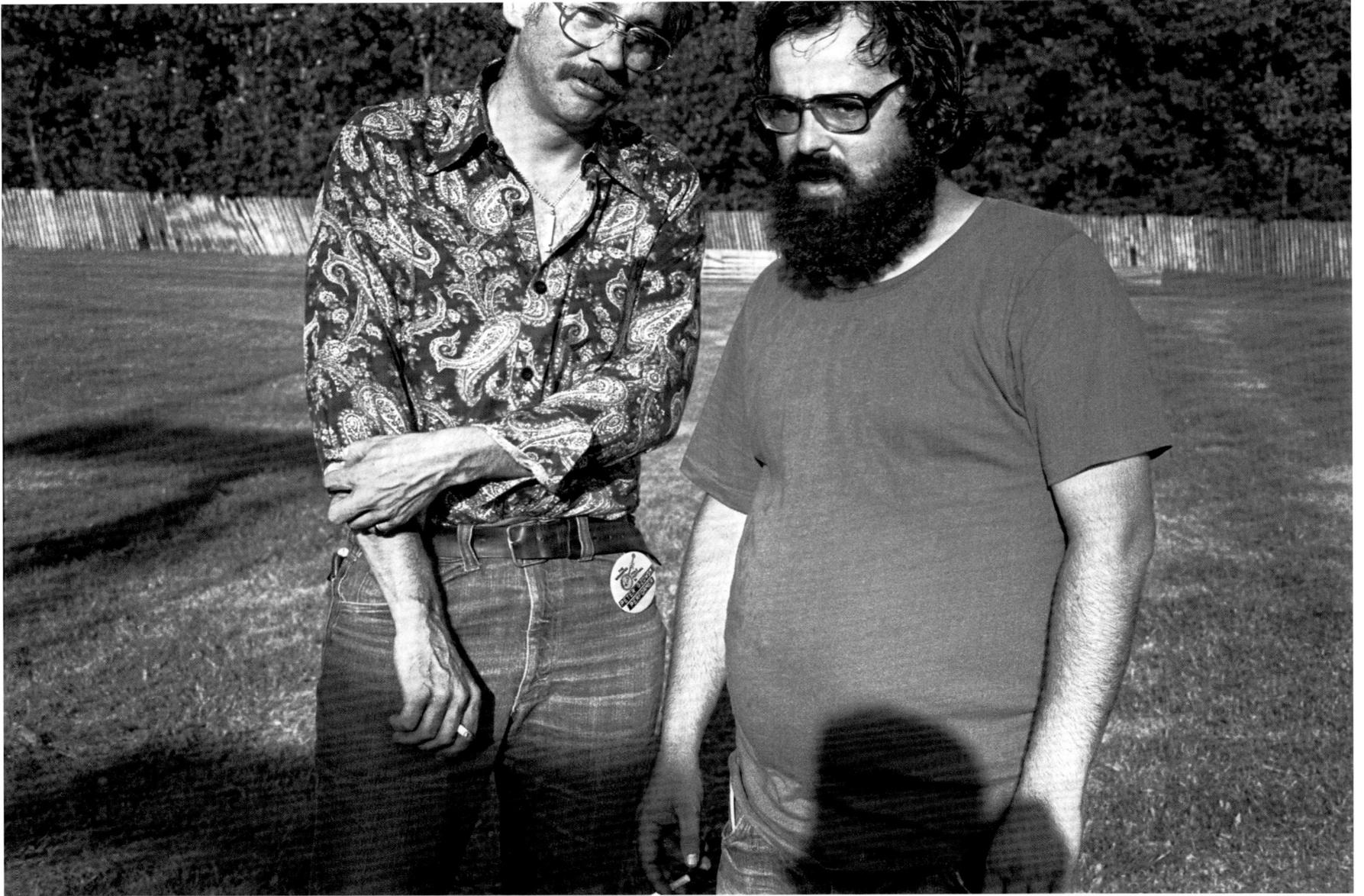

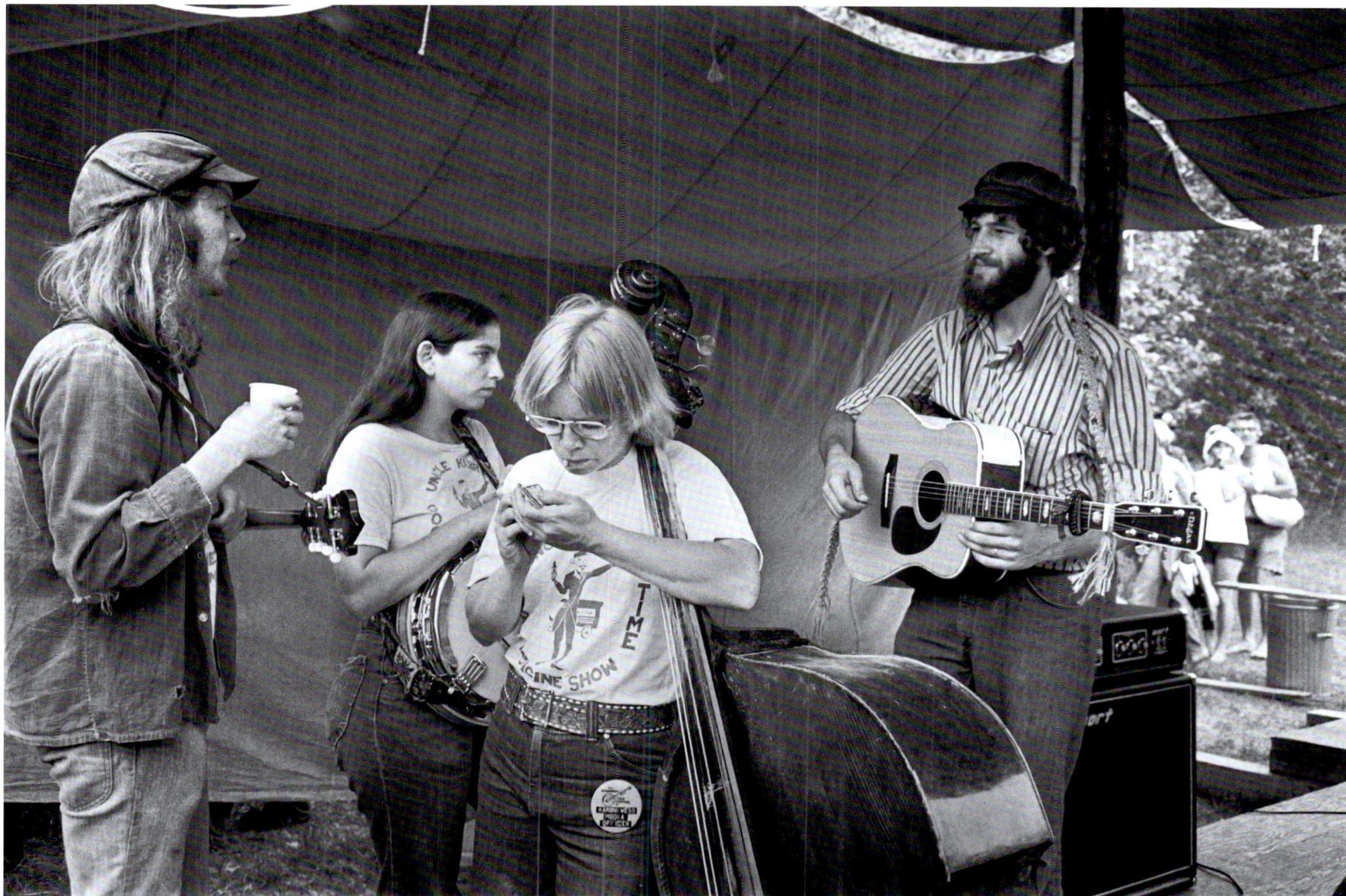

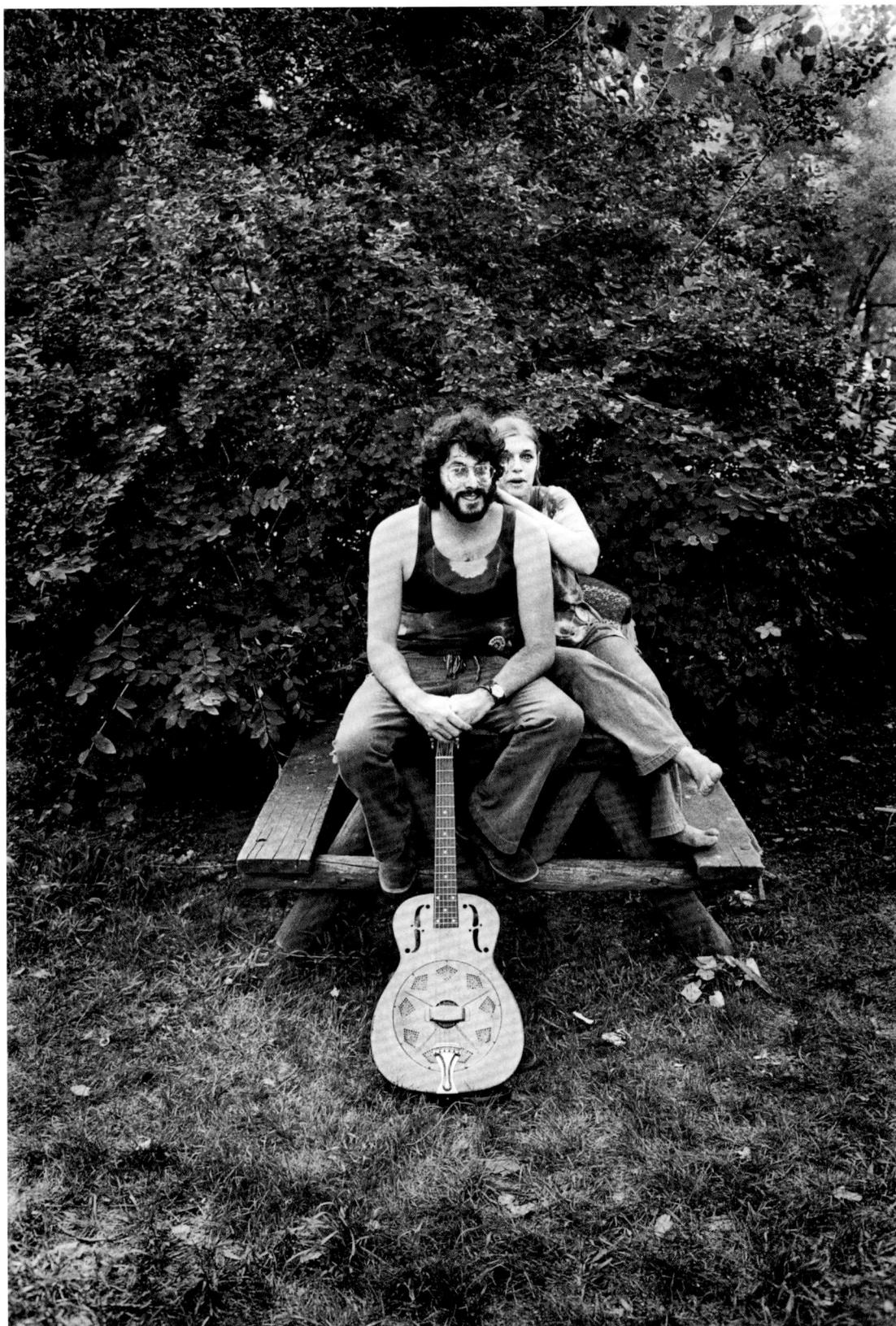

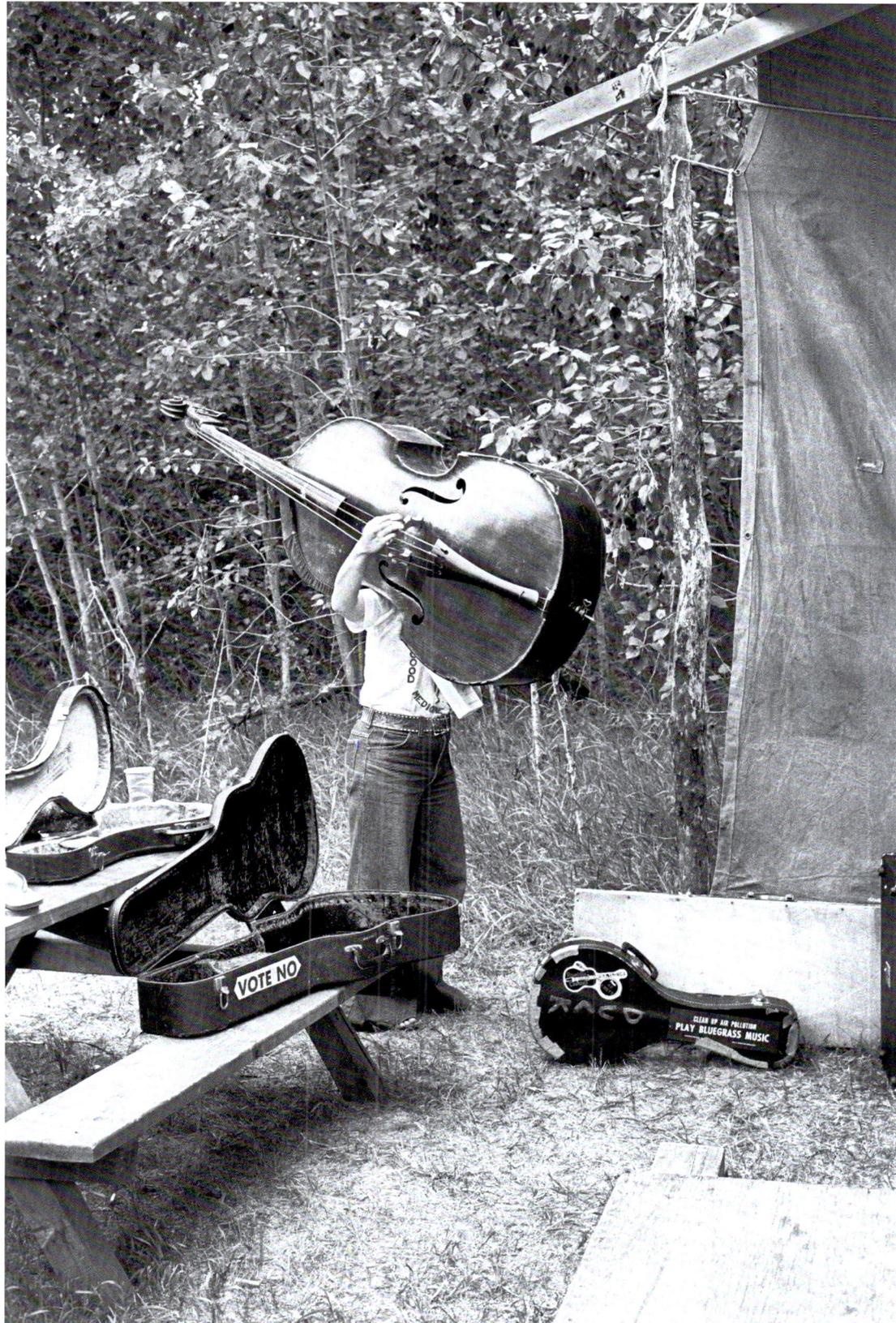

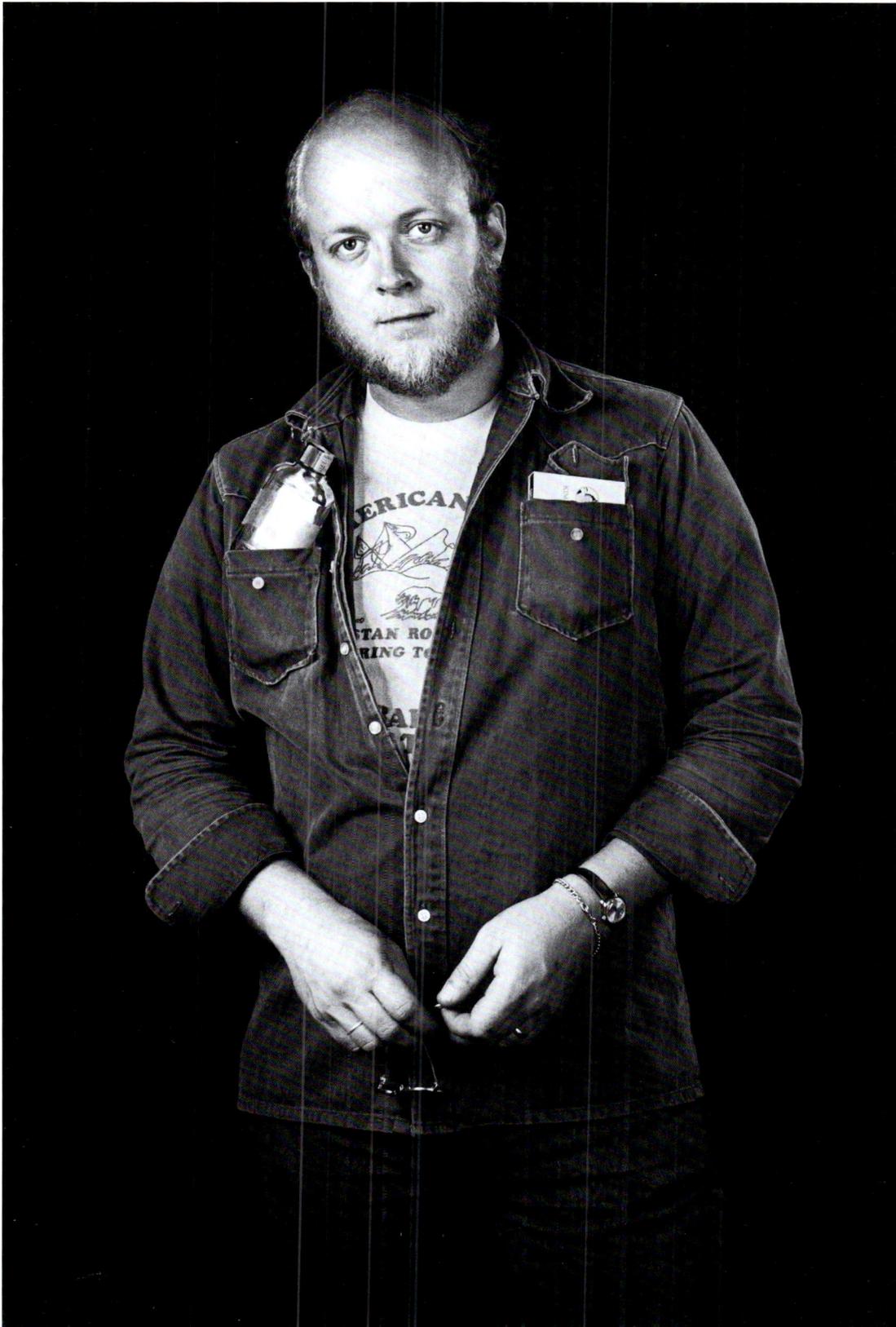

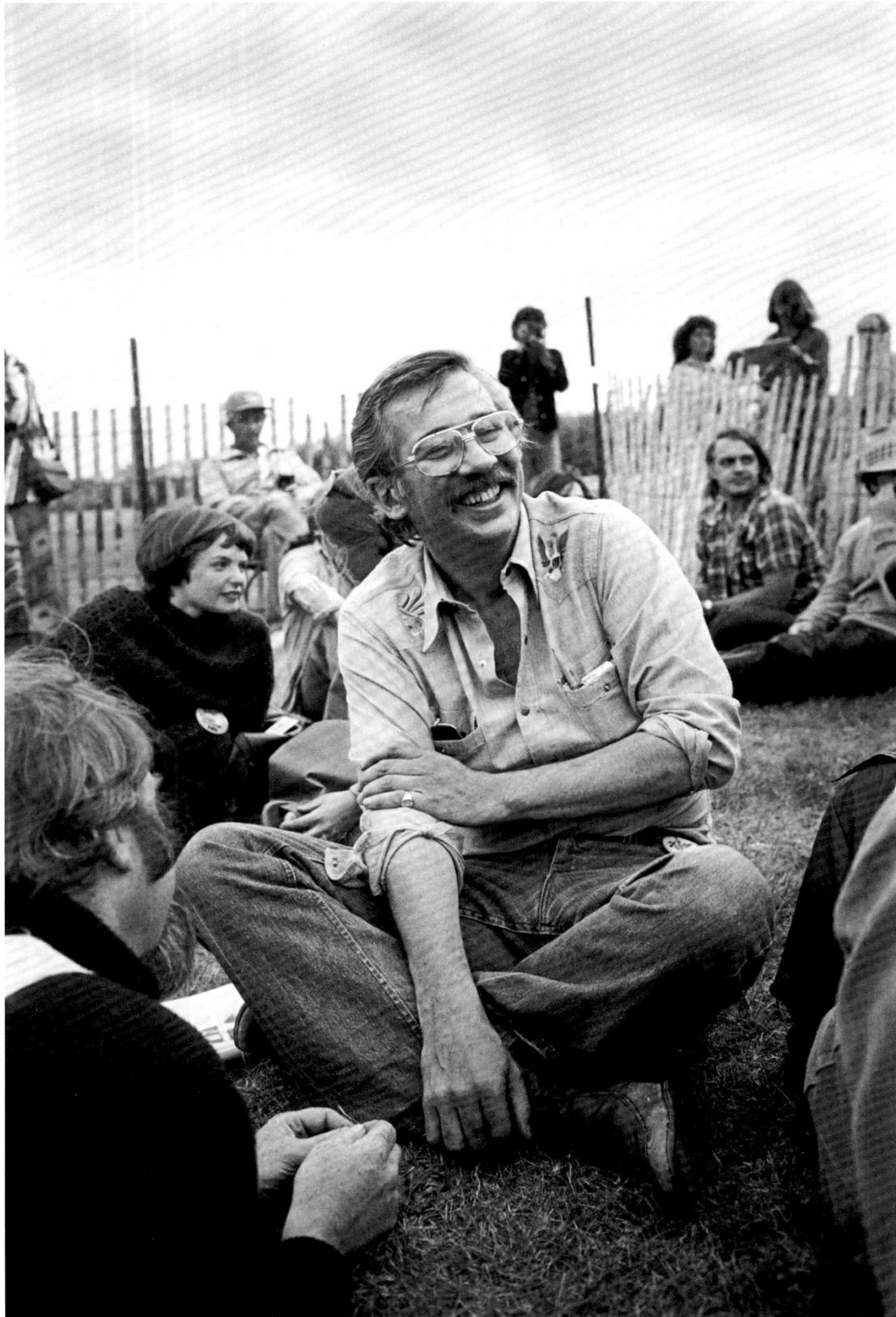

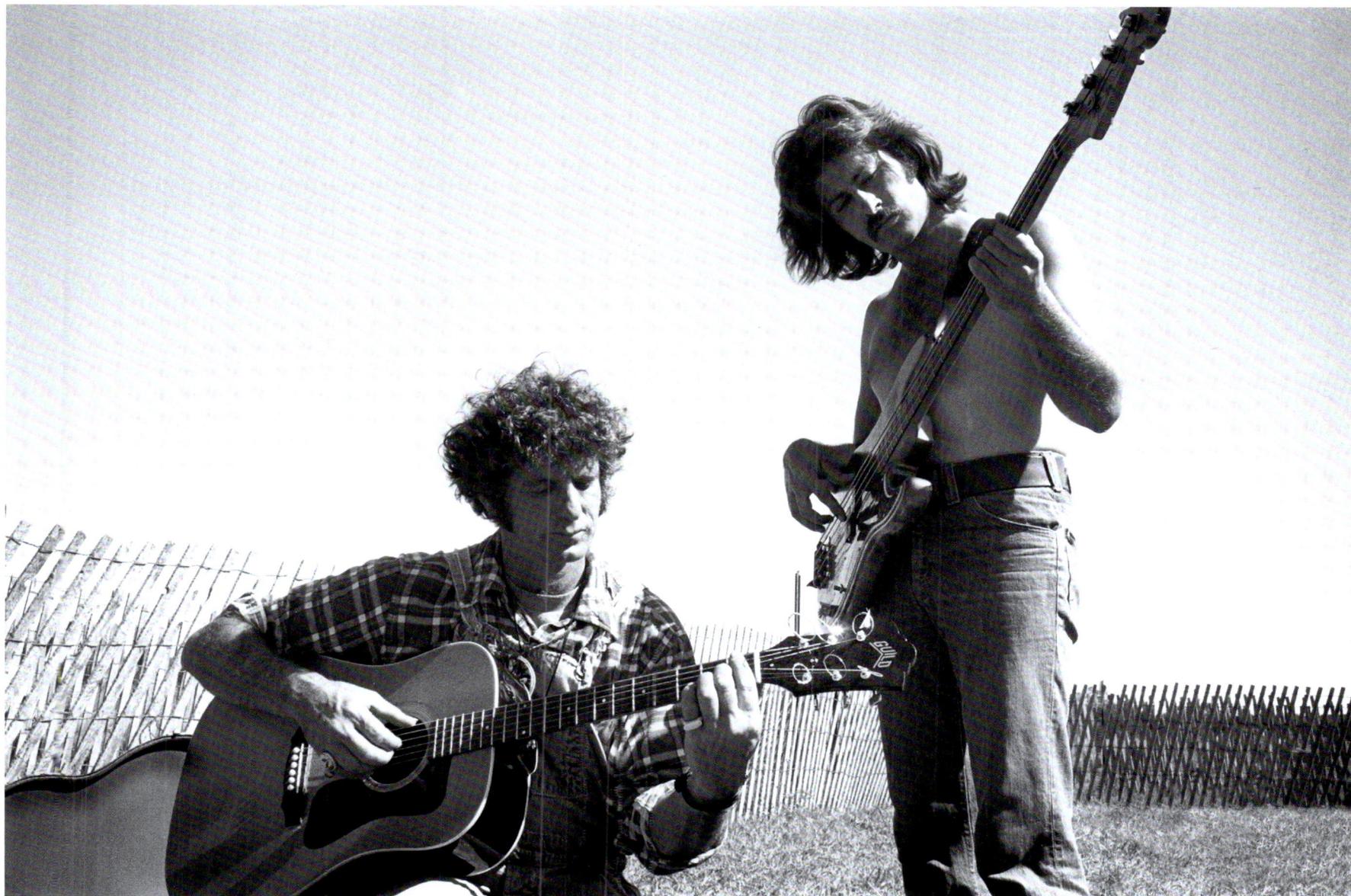

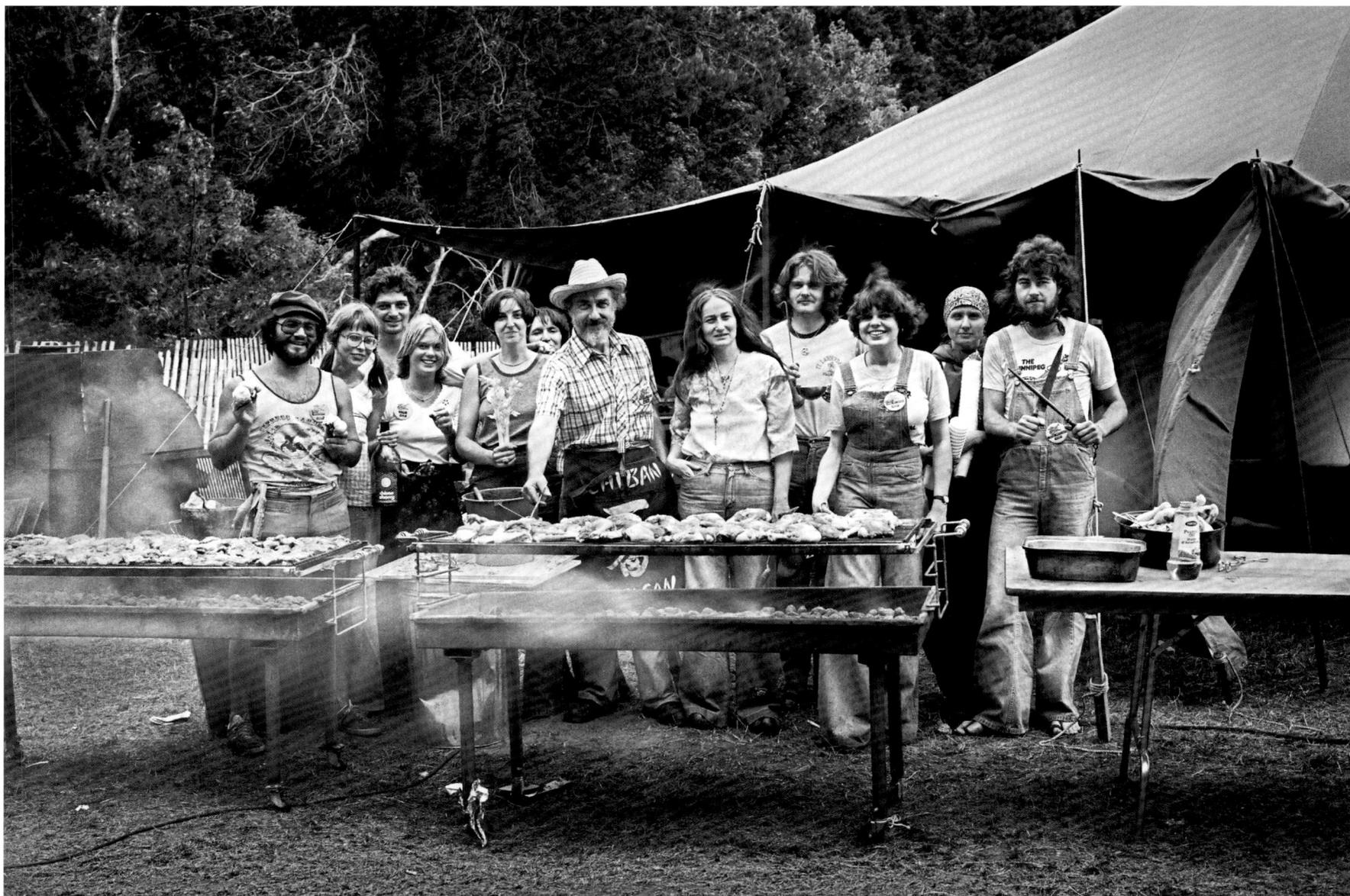

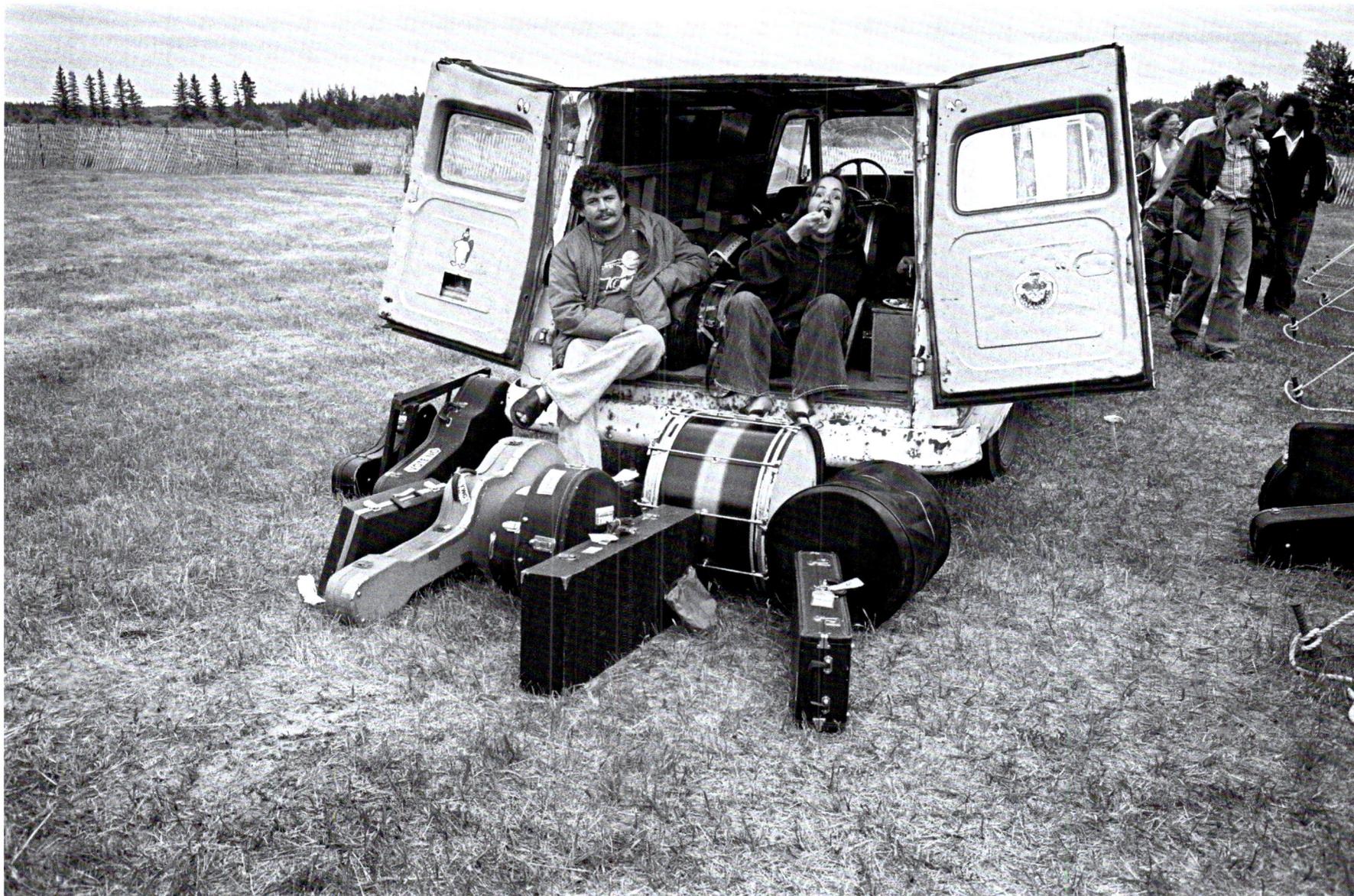

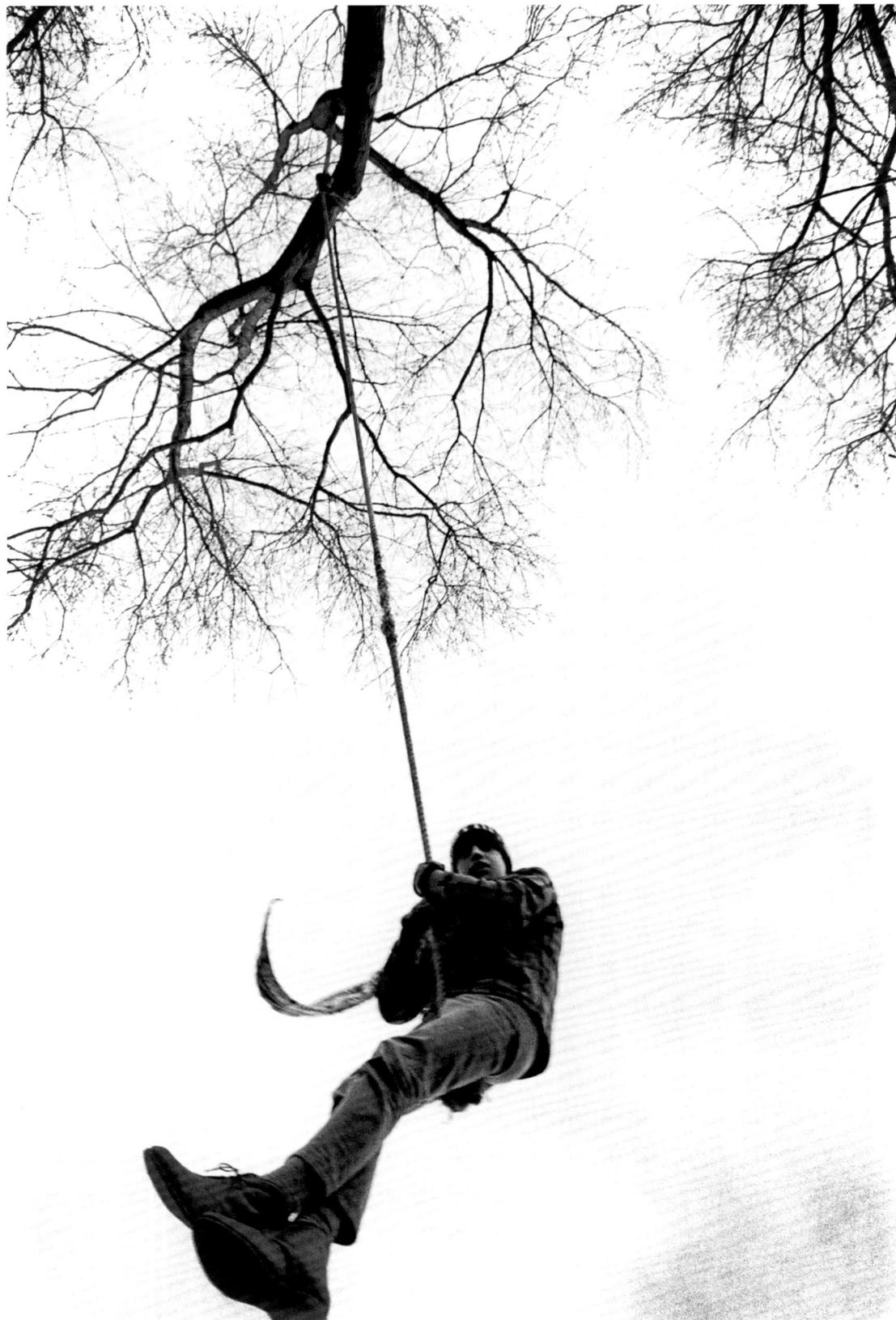

Index to Photographs

39–41 Bikers, in Winnipeg, c. 1969, a slightly tougher parallel lifestyle to the hippie culture. But back then, still innocent

42–44 Three cultures manifest at the University of Manitoba in 1969: A well-coordinated fashionista and an itinerant busker in the halls of University College, plus images of angst on the quadrangle.

45–47 Yorkville District, Toronto, 1970.

48–49 Two views of Ottawa, Ontario, in 1970. Untended children on the steps of an inner-city synagogue. The photographer's friend, Lyle, long before he became a civil servant.

50 La Pont des Arts, Paris, France, 1970.

51–58 Scenes from the Festival Express concert, Winnipeg, 1 July 1970.

59–68 Scenes from the Man-Pop Festival, Winnipeg, 29 August 1970. This event, too, was held as part of Manitoba's centennial celebrations.

69 Politics was an underlying theme of the counterculture, and the war in Vietnam was the main focus. This image, shot in front of the Manitoba Legislative Building, depicts the earnest energy that many Winnipeg Jewish intellectuals brought to the scene.

70 Protest, downtown Winnipeg.

71–75 Images from a single roll of film, shot on a summer evening in Winnipeg, 1 July 1970. Prime Minister Pierre Trudeau outside Government House, serious police intervention at a street protest on Broadway Avenue, and the photographer's well-put-together friend, Alicia, applies graffiti to Minister of Justice John Turner's car outside the Legislative Building.

76–79 Members of the May 4th Movement, Toronto, 1970. Activists joined the movement to remember the four students killed by US National Guardsmen at Kent State University, Ohio, on 4 May 1970.

80 Protestors opposed to intercontinental ballistic missiles based in North Dakota pose with Canadian border guards, Spring 1969.

81–83 Inspired by the Indians of All Tribes occupation of Alcatraz (1969-71), members of the Akwesasne Mohawk Warrior Society reclaim Loon Island, near Cornwall, Ontario, 1970.

83 The photographer's friend and travelling companion, Jack, relaxes with a book on Loon Island.

Colophon

All photographs were made with a pair of well-worn Leica M4 Rangefinder cameras. Film was either Ilford FP4 or Kodak Tri-X, developed in Agfa Rodinal. The original negatives were scanned with a Minolta Dimage Scan Multi Pro. The scans were prepared for reproduction in Adobe Photoshop CS4.

The book was printed in 175 line-screen duotone on 100 lb. Garda Art Silk Text.

Design and layout by Doowah Design Inc. A photo of the designer is found early in the book.

Printed by Friesens.